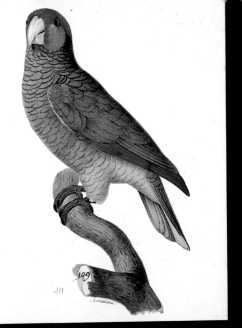

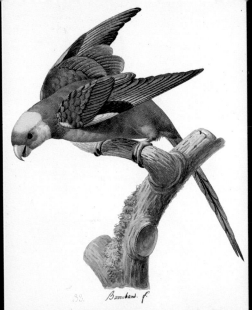

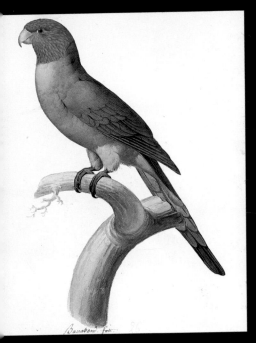

SOTHEBY'S

ART AT AUCTION 1987–88

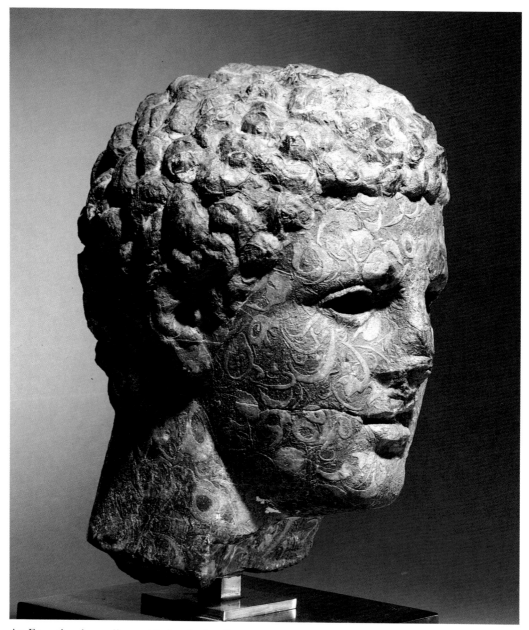

An Egyptian *lumacella* marble head, *circa* first century BC, height 10½in (26.7cm)
New York $74,250 (£41,481). 15.VI.88

SOTHEBY'S
ART AT AUCTION 1987–88

SOTHEBY'S PUBLICATIONS

First published for Sotheby's Publications by
Philip Wilson Publishers Ltd,
26 Litchfield Street, London WC2H 9NJ
and
Sotheby's Publications,
Harper & Row, Publishers, Inc.,
10 East 53rd Street, New York, NY 10022

ISBN 0 85667 358 7
ISSN 0084–6783
Library of Congress Catalog Card Number 88-060430

Editor: Sally Liddell
Assistant Editors: Miranda North Lewis; Iola Lenzi (London);
 Lynn Stowell Pearson (New York)

Design: Liz Jobling
Printed in England by Jolly & Barber Ltd, Rugby, Warwickshire,
and bound by Dorstel Press Ltd, Harlow, Essex

Note
Prices given throughout this book include the buyer's premium applicable in the saleroom concerned.
These prices are shown in the currency in which they were realized. The sterling and dollar equivalent
figures, shown in brackets, are based on the rates of exchange on the day of sale.

Sotheby's galleries at Bond Street, Bloomfield Place and Conduit Street are indicated by the designation
'London'.

Endpapers
Ornithological watercolours from the library of Marcel Jeanson, sold in Monte Carlo on 16th June 1988.

Contents

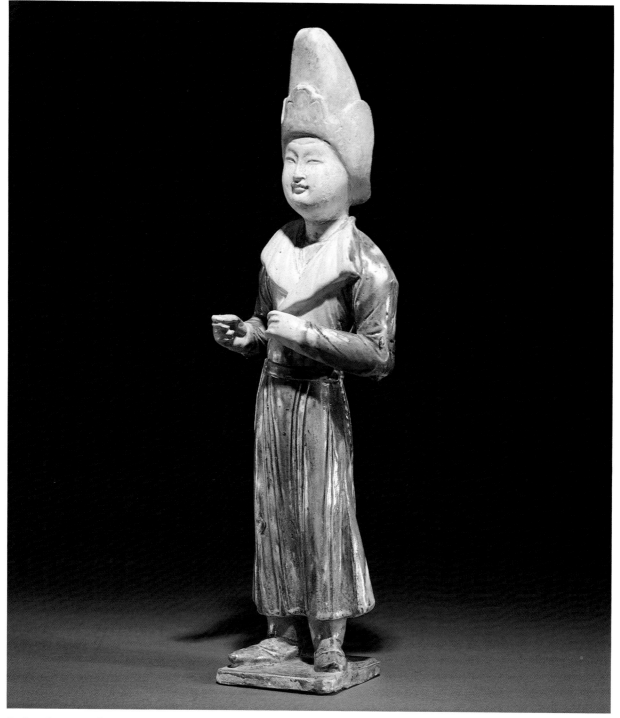

A glazed pottery figure of a falconer, Tang Dynasty,
height 16½in (41.9cm)
New York $74,250 (£41,250). 9.XII.87
From the collection of Warren C. Erickson

Preface

A. Alfred Taubman

Art at Auction celebrates the events of our 1987–88 season, which witnessed continued strength and expansion in the international art market. A year ago Sotheby's became the first auction house to achieve $1 billion in sales, and this year's results well surpassed that historic level.

The November sale of Vincent van Gogh's *Irises* for the world record price of $53.9 million excited the art world, and its momentum carried through to the end of the season when Monet's landscape *Dans la Prairie* brought £14.3 million. Throughout the year, Sotheby's offered exceptional objects, among them the largest flawless diamond ever to appear at auction. Many distinguished collections were presented, including medieval manuscripts from the Astor library; Ming and Qing porcelain from a private Hong Kong collection; Impressionist and Contemporary art and French furniture from the Estate of Belle Linsky; and the vast, eclectic collection of Andy Warhol.

In July I had the pleasure of attending the first international art auction ever held in Russia. Thanks in large measure to the extraordinary efforts of the Sotheby's team headed by Lord Gowrie and Simon de Pury, the Moscow sale was both a cultural and commercial triumph.

As the international art market becomes increasingly complex, Sotheby's remains committed to the hightest standard of service to its clients. During the past year, Sotheby's Educational Studies developed a new curriculum in Oriental art in conjunction with the University of London and brought nearly 100 collectors to Moscow to study Soviet art. We also expanded our financial services in the United States and extended our international capacity in real estate with the opening of a London office.

Our staff, worldwide, have responded with enthusiasm and professionalism to the tremendous growth in both the market and Sotheby's operations. Because of this performance, and in an effort to sustain it, we introduced last year a generous employee stock option plan, which led to a public offering of Sotheby's shares this spring.

Acknowledging the season's achievements, I congratulate, on behalf of the Board, Sotheby's senior management team: Michael L. Ainslie, President and Chief Executive Officer, Sotheby's Holdings, Inc.; The Rt. Hon. The Earl of Gowrie, Chairman, and Timothy Llewellyn, Managing Director, Sotheby's United Kingdom; Julian Thompson, Chairman, and Simon de Pury, Managing Director, Sotheby's International; and John L. Marion, Chairman, and Diana D. Brooks, President, Sotheby's North America.

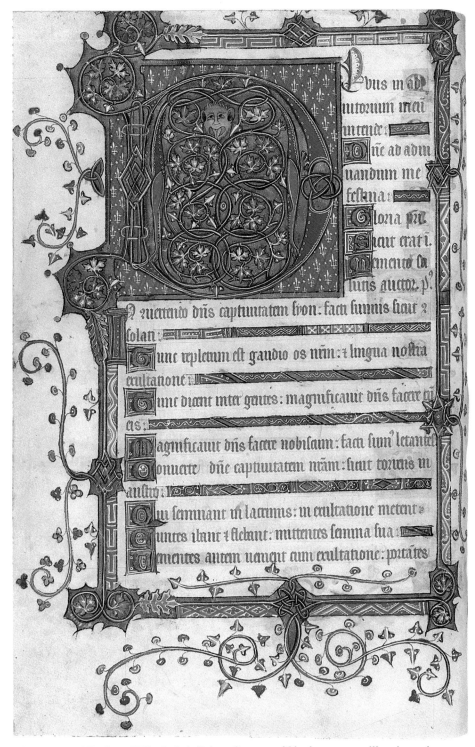

The Hours and Psalter of Elizabeth de Bohun, Countess of Northampton, an illuminated
manuscript on vellum, in Latin, East Anglia, *circa* 1340–45
London £1,540,000 ($2,910,600). 21.VI.88
From the collection of William Waldorf Astor, first Viscount Astor

Introduction

It is an engaging experience to see the previous twelve months displayed in *Art at Auction*; the pace of events in the auction world carries those involved inexorably onwards with not much time for reflection. Looking back, however, there can be little doubt about the landmarks. After 11th November 1987 it was always going to be the year of Vincent van Gogh's *Irises*. Nobody could fail to be impressed by this magnificent image which sold in New York for $53.9 million to become the most expensive painting in history.

With the announcement that Andy Warhol's vast collection was for sale in the spring, a new door opened on this artist's enigmatic personality. Hitherto unknown to all but a few, the collection was catalogued in six volumes, with articles by many of his friends and colleagues. It then left the privacy of Warhol's New York town house to tour the world, before scattering to a myriad of new owners in April and May.

Finally, 1988 was the year that the historic changes afoot in the Soviet Union touched the art market, when Sotheby's was invited to hold the first international art auction in Moscow. The prospect of an auction in Russia and the chance to play a part in introducing the work of contemporary Soviet artists to the West was a thrilling and complex challenge: from the selection of the paintings, the preparation of a bilingual catalogue and the organization of a travelling exhibition, to the July sale itself in the Sovincentr. Throughout the project, it was a pleasure and a privilege to work with the officials of the Soviet Ministry of Culture and we look forward to a continuing relationship.

These three landmarks, however, were only the peaks in a chain of memorable events. In spite of the crisis in the world stock markets last October, the art market remained vigorous with significant expansion in many collecting areas. Sales have been particularly lively in New York, where the relative strength of foreign currencies against the dollar has encouraged strong international competition. While the market has a broad base, Japanese participation has been particularly important in establishing high prices; and as their collecting interests diversify, an increasing number of items have gone to Tokyo for viewing.

Among the major collections of the year in New York were a group of paintings by Georgia O'Keeffe from the collection of her sister Anita O'Keeffe Young, old master paintings from the collection of Linda and Gerald Guterman and old master prints from the collection of the late Alfred Blum. The reputation of the collection of Jack and Belle Linsky, the great benefactors of the Metropolitan Museum of Art, contributed to the enthusiastic reception for the selection of modern and contemporary works, French furniture and bronzes offered in the spring. A cast of Degas's famous

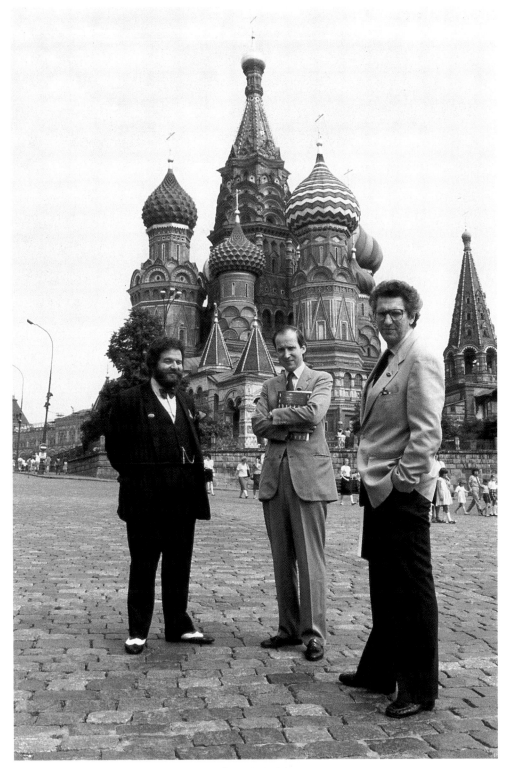

Peter Batkin, Simon de Pury and Lord Gowrie in Moscow.

Travelling exhibition of the Andy Warhol Collection, Tokyo.

sculpture *La Danseuse à Quatorze Ans*, brought a record $10,120,000 and *Search*, believed to be the last painting by Jackson Pollock, established a new record for contemporary art at $4,840,000.

In London, there were works of art from the collection of the late Ritter Rudolf von Gutmann, books from the library of Philip Robinson and outstanding western manuscripts from the Astor Collection: the illuminated fourteenth-century *Hours and Psalter of Elizabeth de Bohun, Countess of Northampton* made £1,540,000.

Van Gogh's *Irises* has perhaps obscured the broader success of Impressionist and modern art at Sotheby's this season. Quite apart from new record prices for Cézanne, Renoir and Matisse, it was an exceptional year for Monet – like van Gogh an enthusiast of flowers and, indeed, an admirer of his younger contemporary. In November *Le Jardin Fleuri*, a blaze of colour, set a new record at $5,830,000 in New York; the artist's idyllic landscape *Dans la Prairie*, 1876, depicting his wife reading in a field of long grass, came under the hammer in London in June. A masterpiece of Impressionism and the most important work by the artist to come on the market for years, it made £14.3 million.

It was also the year of the diamond, with rising prices bringing extraordinary stones onto the market. Diamonds such as the Porter Rhodes ($3,850,000) and the Jonker No.4 ($1,705,000), named after their first owners, recalled historic discoveries in the late nineteenth and early twentieth centuries. In St Moritz the Ashoka diamond weighing 41.37 carats, made FF5,390,000 on 20th February. The largest D-flawless stone ever to come to auction became the most expensive jewel in the world when it was sold in New York for $9.13 million.

It was a memorable year in Europe, a year of expansion that saw the re-emergence

Sotheby's at Sporting d'Hiver, Monte Carlo. Château de La Roche-Guyon.

of several ancient collections of remarkable quality. Regular sales of major German paintings were held in Munich for the first time and proved that buyers were happy to compete for such works in Germany itself. Antiquities and works of art from the collection of Martine, Comtesse de Béhague, assembled at the turn of the century, turned Monaco's Sporting d'Hiver into a treasure house for the viewing and auction. This was just one of three collections on offer in Monte Carlo last December: the firearms of Charles Draeger, whose printing company is a byword for quality in France, were a revelation of quality of another kind; while the extraordinary provenance of the long-untouched contents of the Château de la Roche-Guyon, a home of the de La Rochefoucauld family for 300 years, proved irresistible.

In Belgium, the auction of the contents of Château de Cleydael was one of six house sales, setting another theme for the year. The largest was at Tyninghame in East Lothian, on the Scottish Borders, seat of the Earls of Haddington since 1628. The contents, eventually realizing £3,505,000, included important French and English furniture, tapestries and a particularly good collection of early portraits. Thousands came to view and attend the sale, in the house and the marquee on the lawns, proving again the allure of a collection in its original setting. The sale at Wilsford Manor, Wiltshire, home of the late the Hon. Stephen Tennant, recalled the vanished world of England's 'Bright Young People' of sixty years ago.

Charity sales and exhibitions are a tradition at Sotheby's, but this season was distinguished by a remarkable 'first'. In July a party of 500 people from the West travelled to China for a week of entertainment and a charity sale in aid of the Great Wall of China and the Venice in Peril Appeal, sponsored by UNESCO. This was a rare meeting of cultures, from a champagne reception on the Wall itself and a

Sotheby's at the Workers' Palace, Peking.

HRH The Princess Royal and Lord Gowrie at the reception
for the 'Childhood' exhibition.

masked ball in the Imperial Pavilions of Lake Long Tan Hu to the sale in the
Workers' Palace. Other charity auctions included, in New York, fifteen works by
prominent contemporary artists sold for the benefit of the Supportive Care Program
of St Vincent's Hospital, one of the foremost organizations supporting AIDS patients
and their families; and in London a sale in favour of the Rhino Rescue Appeal,
which aims to open four sanctuaries in Kenya to save the seventy-million year old
species from extinction.

The 'Childhood' exhibition in aid of The Save The Children Fund opened with a
reception attended by the patron of the charity HRH The Princess Royal. Filling
the London salerooms to overflowing with evocations of childhood over four centuries,
it ranged in subject and date from the miniature armour of Henry VIII as a boy
(kindly loaned by HM Tower of London), to John Everett Millais' famous *Bubbles*
(kindly loaned by A. F. Pears Ltd). Earlier in the season the galleries had been
transformed for 'Chanel by Chanel', an elegant display put on by the fashion house
to raise money for The Save The Baby Fund, and commemorating sixty-five years of
revolutionary design and innovation in haute-couture.

In assessing the character of the last auction season we are led to contemplate the
nature of the next. It is impossible to know which great collections may appear on
the market or what rare and beautiful objects may emerge from unexpected sources,
but it is, in fact, this element of unpredictability that gives the auction world its
tremendous variety and special fascination.

Heritage sales

Since the eighteenth century, there has been concern at the thought of major works of art leaving this country, and the idea of a National Gallery was suggested in Parliament as early as 1777. However, not until 1823 did the nation take steps to prevent an important collection leaving these shores, when it acquired the Angerstein Collection, which later came to form the basis of the National Gallery. During the next century, the trend for works of art being acquired abroad and brought into Britain was gradually reversed, and by the twentieth century, the movement of works of art out of this country was as steady as the flow into it had been during the past 200 years.

A complete system that levied tax on the transmission of wealth from father to son was not introduced until the Finance Act 1894, and the pressure on estates to sell to pay taxes increased greatly over the next 30 years. That it was undesirable that estates should be depleted by the sale of their heirlooms was recognized as early as 1896, and the Finance Act of that year provided that works of art of national or historic interest should be exempt from duty until sold. Until 1921, it did not matter who the purchaser was; the outstanding duty was payable on the sale. However, from 1921 sales to the National Gallery, British Museum or other similar national institutions, any university, and County Council, any municipal corporation in the UK, or the National Art Collection Fund, did not give rise to a liability to tax. Unlike today, there was no arrangement for account to be taken of the tax saving to the seller in calculating what price the public body paid. Where the purchase was at auction obviously no account could be taken; but a private treaty sale gave the possibility of a deal. The Finance Act 1958 restricted the immunity to sales by private treaty.

At about the same time, legislation was passed enabling pre-eminent works of art to be accepted by the Revenue in satisfaction of estate duty. The Treasury decided that in determining what amount of duty was satisfied, account should be taken of the freedom from tax, and what emerged was the practice of working the amount out as if only 75 per cent of the tax were payable – the 25 per cent disregarded became known as the 'douceur'. This regime was soon applied to sales to museums and guidelines were drawn up to bring such sales into line. The mutual benefits to the seller of the work of art, to the recipient institution and, of course, to our national heritage are very clear. Thanks, too, to pressure exerted by Sir Denis Mahon and others, Lord Gowrie was able, as Minister for the Arts, to negotiate an end to the cash limits imposed by the Treasury on the acceptance of works of art in lieu of tax.

George Stubbs
PORTRAIT OF A YOUNG GENTLEMAN SHOOTING
Enamel on porcelain, 1781, 18in by 24½in (45.7cm by 62.2cm)
Sold by private treaty through Sotheby's to the Tate Gallery, London and reproduced
courtesy of the Trustees. Contributions to the purchase price were made by the National
Heritage Memorial Fund, the NACF and the Friends of the Tate Gallery.

Over the past year, Sotheby's have negotiated many sales of this type to different qualifying institutions throughout the country. Among these, is the splendid *Double Portrait of Lord John and Lord Bernard Stuart* by Sir Anthony van Dyck, described in the article by Sir Oliver Millar, GCVO. The Tate Gallery acquired an extremely rare enamel painting on Wedgwood by Stubbs and a superlative group portrait with Thomas, second Baron Mansel of Margam by Allan Ramsay; both major works of art. In addition, Gainsborough's House in Sudbury was able to benefit from the atmospheric *A Wooded Landscape with Cattle by a Pool and Rustics outside a Cottage* by Thomas Gainsborough, which was sold to Suffolk County Council and the Abbot Hall Art Gallery in Kendal now houses two delightful Windermere views by Philippe Jacques de Loutherbourg, previously in the house in Belle Isle in the middle of the lake, which were sold to South Lakeside District Council. Picasso's *Weeping Woman* of 1937, also the subject of an article and one of the most important twentieth-century works of art in Britain, was saved for the nation and now hangs in the Tate Gallery, London.

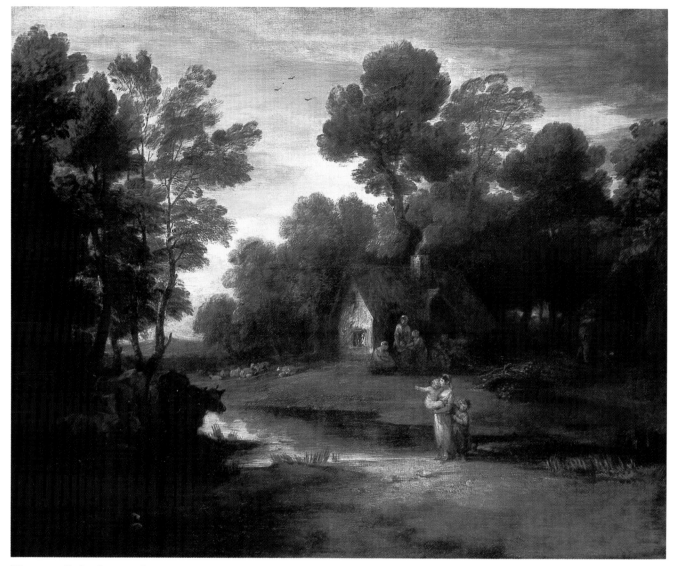

Thomas Gainsborough
A WOODED LANDSCAPE WITH CATTLE BY A POOL AND RUSTICS OUTSIDE A COTTAGE
1782, 47in by 57in (119.4cm by 144.8cm)
Sold by private treaty through Sotheby's to Gainsborough's House, Sudbury, Suffolk.
Contributions to the purchase price were made by the National Heritage Memorial Fund,
the NACF, Gainsborough's House Society Development Trust and other trust funds.

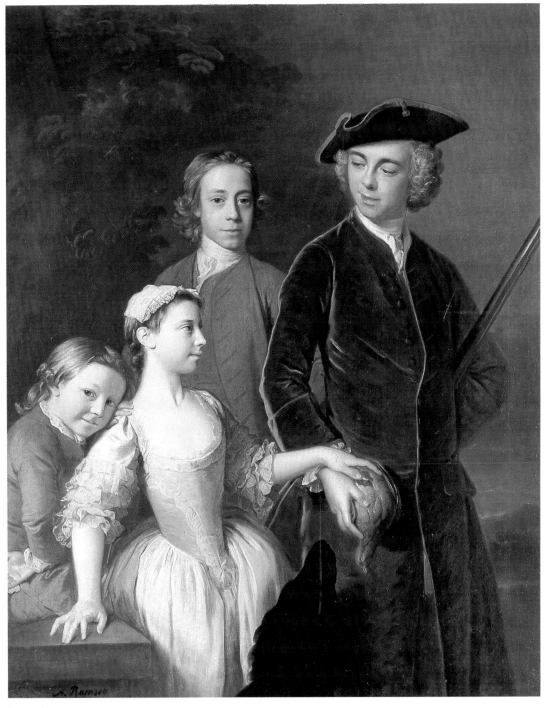

Allan Ramsay
PORTRAIT OF THOMAS, SECOND BARON MANSEL OF MARGAM WITH HALF BROTHERS AND SISTER
1742, 49½in by 39½in (125.7cm by 100.3cm)
Sold by private treaty through Sotheby's to the Tate Gallery, London and reproduced
courtesy of the Trustees. Contributions to the purchase price were made by the National
Heritage Memorial Fund, the NACF and private donors.

Sir Anthony van Dyck's
Double portrait of Lord John and Lord Bernard Stuart

Sir Oliver Millar, GCVO

The celebrated double portrait of the two younger sons of the 3rd Duke of Lennox is a notable addition to the National Gallery's holding of works by Van Dyck, for in every way it is an epitome of his English manner.

The two young men, who are probably about seventeen and eighteen respectively, are, with tragic and deceptive benefit of hindsight, archetypal 'cavaliers'. Both were to fall in the Civil War. The elder, Lord John, 'of a more choleric and rough nature than the other branches of that illustrious and princely family' died of wounds received at the Battle of Cheriton; Lord Bernard, 'of a most gentle, courteous and affable nature', fell at Rowton Heath. The portrait of them together has, therefore, in social and historical terms, something of the poignancy which a faded photograph of a House XI group of 1913 can evoke today.

The revolution which Van Dyck effected in the development of the British portrait is seen nowhere more plainly than in his large groups and his full-length double portraits. It is particularly instructive that at the moment the Gallery's new acquisition is hanging near the huge family group from Wilton and close by the recently acquired *Balbi Children* (so-called). In the latter, Van Dyck constructs his group, perhaps for the first time, on a flight of steps, at the foot of which the elder child stands with superb – and touching – assurance. The sinuous relation between the figures and the controlling structure of a column and a flight of steps, and the dramatic tensions implied in the group, are developed magnificently on the canvas from Wilton and, in a concentrated field, in the group under discussion. The figure in the foreground is more dramatically placed, his left leg raised on the step so as to conceal the far leg of his companion and his left elbow pushed out towards the spectator in a splendidly disdainful gesture. The figure, which probably sprang from Van Dyck's memories of Correggio, has affinities with the son-in-law who stands on the extreme right of the Pembroke group portrait from Wilton. In the same way, the tensions and rhythm that link the two eldest Pembroke boys are developed in the other masterpiece in this vein, the double portrait of Lords Digby and Russell at Althorp.

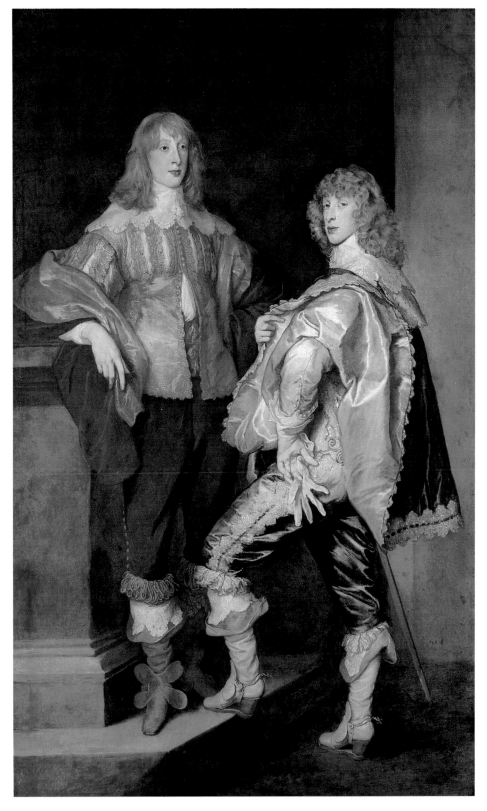

Sir Anthony van Dyck
DOUBLE PORTRAIT OF LORD JOHN
AND LORD BERNARD STUART
Circa 1639, 93½in by 47½in
(237.5cm by 120.6cm)
Sold by private treaty through
Sotheby's to the National Gallery,
London and reproduced courtesy
of the Trustees. A contribution to
the purchase price was made by
the J. Paul Getty, Jr. Fund.

The contrast in gesture and temperament between the two Stuart brothers is marvellously emphasised by Van Dyck's use of colour. The standing figure on the left is warm in colour. His breeches and boots are a warm brown, the latter enriched with gold lace; his brown cloak has a golden lining, only slightly less lustrous than his richly impasted golden doublet. His brother is entirely dressed in cool and silvery tones; even his spurs have a steely touch, his boots and gloves are a pale fawn and the ribbons on his boots have a silvered quality. The magnificent blue costume is laced with silver and his cloak is lined with silver-grey.

The group is also a splendid example of Van Dyck's method towards the end of his years in London (early in 1639 the two brothers set off on a three-year tour of the Continent). Particularly interesting is the artist's method in, for instance, articulating that magnificent left leg in the foreground by painting the background round it, and in defining a passage such as the suspended glove by sweeping the blue paint up to it. The central part of the figure in the foreground is one of the most beautifully constructed passages from any period in Van Dyck's career: one can linger for a long time over the drawing of the hand and the dangling glove and the glorious, shimmering handling of the left leg with its rich variety of texture in the clothing. It is perhaps significant that this section of the composition had been very carefully worked out by the artist in a (squared) drawing in the British Museum.

Painting, in its broadest sense, of this quality – such a combination of technical brilliance and psychological understanding and wit – had not been seen in England before Van Dyck's arrival in 1632; and it is not suprising that the double portrait should have epitomized for Gainsborough, whose passionate admiration for his predecessor was matched by his ability to reinterpret his style and, his spirit, the essence of the Van Dyck manner. His interest in Van Dyck's dates from his early years in the West Country; and at some point he made the remarkably close copy of the National Gallery's new picture which is now in the St Louis Art Museum. It was probably painted earlier than 1785, the year in which Gainsborough painted the 4th Earl of Darnley, who at that time owned the Van Dyck and subsequently acquired Gainsborough's copy. It had passed to him by descent at Cobham Hall from the sister of the last Duke of Richmond and Lennox, himself the nephew of Lord John and Lord Bernard. The subsequent owners of the picture, Sir George Donaldson, Sir Ernest Cassel and the Countess Mountbatten of Burma, had been generous in lending it to exhibitions. Lovers of Van Dyck's work will feel, therefore, that they are welcoming an old friend – or two young friends – to Trafalgar Square.

A Picasso saved for the nation

While Britain has had perhaps a lion's share of great old master collectors, collectors of Impressionist and twentieth-century art are rarer. Happily, we make up for it in quality, as names like Samuel Courtauld, the Misses Ross and Edward James suggest. The painter Sir Roland Penrose, one of the most perceptive English collectors of twentieth-century art, bought directly from artists whom he numbered among his friends. He was Picasso's closest English friend and also his biographer. When a masterpiece from the Penrose Collection, Picasso's *Weeping Woman*, was secured for the Tate Gallery in October 1987, the nation made an important addition to its stock of twentieth-century paintings and set a precedent for future acquisitions. Sotheby's is proud and pleased at having been able to help with an immediate need, as well as contributing to an exciting long term future in respect of Britain's heritage generally.

Throughout his long career Picasso's technical inventiveness never failed him, but there were times when his creative fury outpaced his ability to deliver paintings with the weight ascribed to masterpieces. It is relatively rare in his career for external events and inner emotions to coincide. The Spanish Civil War provided just such a catalyst. His 1937 painting *Guernica*, a timeless indictment of war's effect on the innocent, is possibly his greatest work. *Weeping Woman* is a pendant to *Guernica* and has the same intensity and force. The fractured features of Picasso's mistress, Dora Maar, course with tears and make her a candidate for the greatest representative of inner and outer grief in Western painting. The painting was finished in Paris on 26th October 1937 and Sir Roland Penrose purchased it wet off the easel.

As well as being a collector of perception, Sir Roland was involved in bringing contemporary art before the British public. He organized the first Surrealist show in London in 1936, founded the Institute of Contemporary Art and mounted a series of pioneering exhibitions at the Tate devoted to Picasso, Miró and Ernst, who was also a close friend. Towards the end of Sir Roland's life the Tate acquired two works by Ernst from his collection, *The Elephant of Celebes* and *Dadaville*. *Weeping Woman* had been on loan to the gallery since 1969.

After Sir Roland's death in 1984 it was imperative that so important a Picasso should be acquired for Britain. Lord Gowrie, Chairman of Sotheby's UK, had paved the way when he was Minister for the Arts. The inheritance situation was complicated. Sir Roland gave *Weeping Woman* away during his lifetime, but the estate was still faced with a massive bill for capital transfer tax generally. In an unprecedented step, the present Arts Minister, Richard Luce, allowed the combination of a tax write-off with a monetary payment by the Tate Gallery to secure the work.

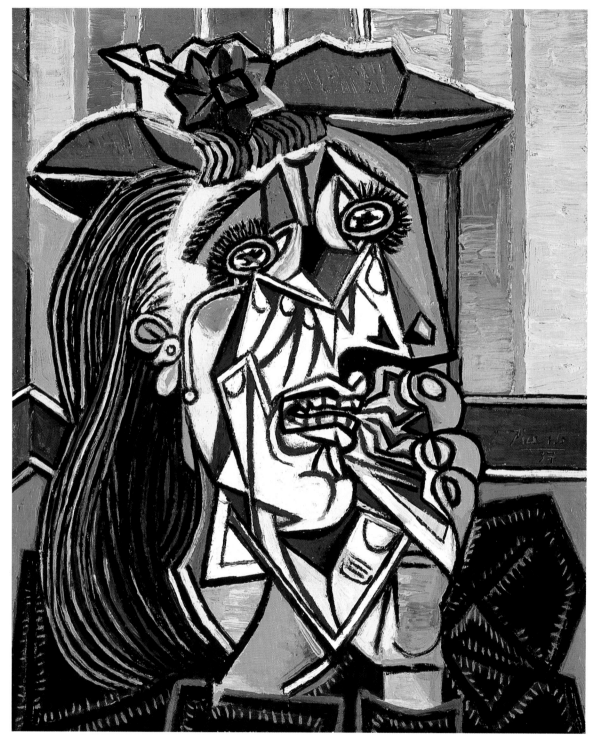

Pablo Picasso
WEEPING WOMAN
1937, 22$\frac{7}{8}$in by 19$\frac{1}{4}$in (60cm by 49cm)
Reproduced courtesy of the Trustees of the Tate Gallery, London.

In this the Tate was assisted by the National Art Collections Fund and the National Heritage Memorial Fund. The complex negotiations took over six months, during which Sotheby's Financial Services played a crucial part by lending the estate a substantial portion of the value of the painting interest free for this period, thereby allowing the executors to pay the capital transfer tax promptly and avoid incurring interest. Sotheby's were fortunate to work in close co-operation with the agent for the Penrose estate, James Mayor, of the Mayor Gallery, and great credit is also due to him.

Richard Luce's ruling, one of the most enlightened of modern times, will hold good for future cases, bringing a welcome flexibility to transfers of art to the nation. At just over £3 million, the Tate secured a bargain, for *Weeping Woman* is worth substantially more on the open market. The law which states that a work of art must have an export licence if it has been in Britain for more than fifty years is now beginning to apply to paintings acquired directly from artists in the 1930s. If the Tate had not bought *Weeping Woman*, taxation would have forced it out of the country before 27th October 1987. Instead, it stays precisely where its remarkable collector wanted it to be.

Tyninghame

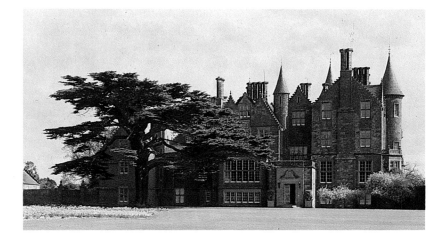

The most delightful aspect of viewing a house sale is being able to examine the contents *in situ*, surrounded by all their historical associations. The occasion is all the more exciting if the house has never before been open to the public; this was the case with Tyninghame, East Lothian, the contents of which were auctioned on 28th and 29th September 1987.

'Tyninghame' literally means 'the village of the dwellers by the Tyne'; the estate has been the property of the Earls of Haddington since 1628. The house was rebuilt by the 6th Earl in the eighteenth century but owes its present romantic, turreted skyline to alterations by William Burn in 1829. The contents of Tyninghame represented the accumulation of centuries, and included family portraits, fine furniture, ceramics and silver. They attracted buyers from Britain, Europe, the United States and Japan and prices often exceeded saleroom equivalents. Dealers and private buyers competed for objects which not only were exquisite objects in themselves, but had an important provenance and in many cases had not been on the market in living memory. At the other end of the scale, local people came out of curiosity about the house or intent on obtaining a souvenir of an era of Scottish history that was about to close.

Portraits reveal many of a family's dynastic and political alliances; in several cases, the Haddington portraits were also outstanding works of art. Thomas Hamilton, 1st Earl of Haddington, laid the foundation of the family fortune becoming Advocate to James VI of Scotland and later assuming greater responsibilities as advisor to the King, by then King of England, James I. James rewarded his loyal subject with his jewel-encrusted portrait by John de Critz (Fig.1). In complete contrast is Allan Ramsay's intimate *Portrait of Katharine, Countess of Morton (1736–1823)*, painted in the mid eighteenth century when cultural life in Edinburgh was flourishing. The subject's gentle demeanour and exquisite dress of pink silk under a transparent shawl of black

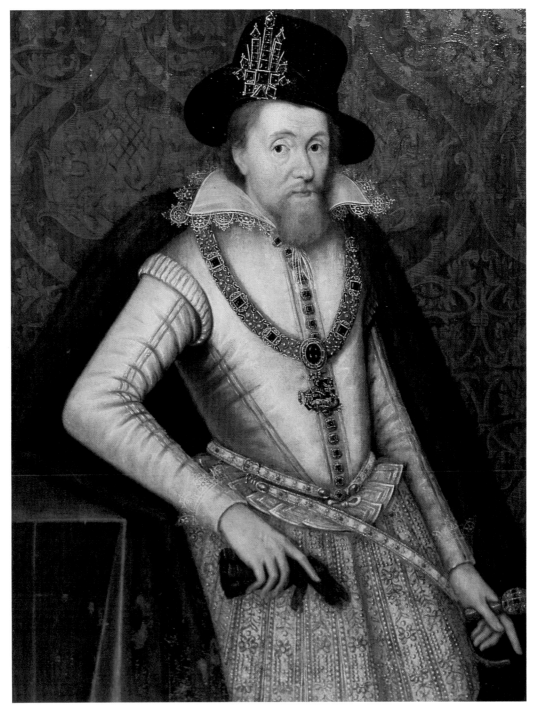

Fig.1
John de Critz
PORTRAIT OF JAMES VI OF SCOTLAND, JAMES I OF ENGLAND
Oil on panel, 42½in by 32½in (108cm by 82.6cm)
Tyninghame £105,600 ($182,688). 29.IX.87
From the collection of the Earls of Haddington, Tyninghame, East Lothian

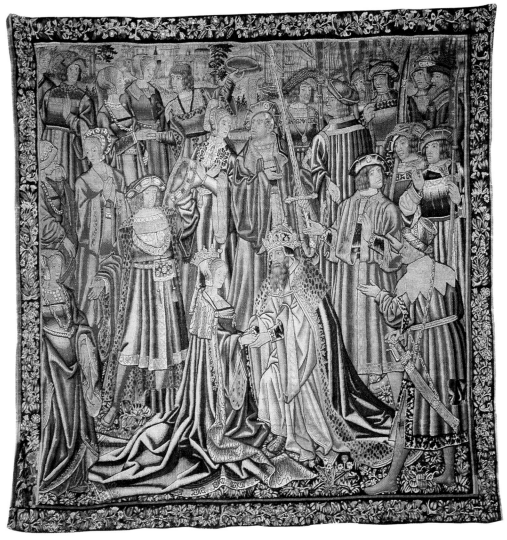

Fig.2
A Brussels tapestry of a court scene, *circa* 1520, 10ft 4in by 10ft 2in (315cm by 310cm)
Tyninghame £94,600 ($165,550). 28.IX.87
From the collection of the Earls of Haddington, Tyninghame, East Lothian

This tapestry was exhibited at the Victoria & Albert Museum in 1921.

lace make this one of the more enchanting portraits of the Scottish Enlightenment
(Fig.3). The 9th Earl of Haddington's political sympathies were indicated by Sir
Thomas Lawrence's *Portrait of the Rt Hon. George Canning (1770–1827)*, minister of
foreign affairs during the Napoleonic Wars and Prime Minister in 1827. The portrait
shows Lawrence at his finest, brilliantly conveying the obsession with power so dear
to that age.

The very eclecticism of Tyninghame's furnishings, accumulated over centuries
rather than being the result of a single decorative scheme, attracted a broad range of

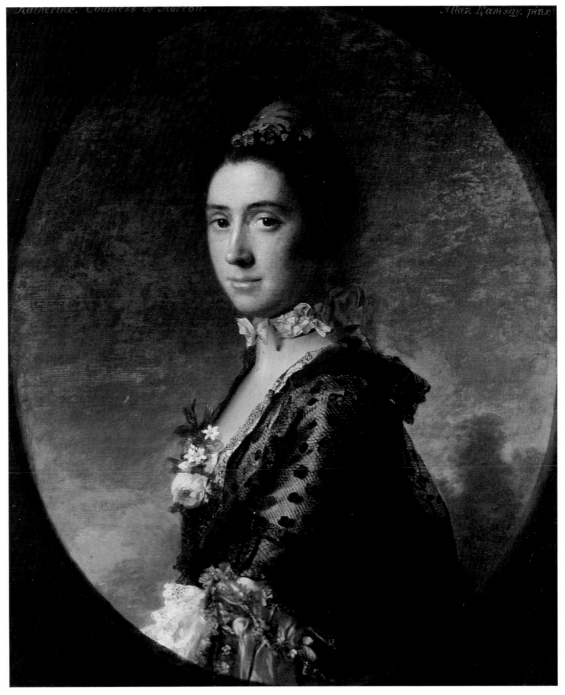

Fig.3
Allan Ramsay
PORTRAIT OF KATHERINE, COUNTESS OF MORTON (1736–1823)
Signed *Allan Ramsay pinxt* and inscribed *Katherine, Countess of Morton*
29in by 24in (73.7cm by 61cm)
Tyninghame £60,500 ($104,665). 29.IX.87
From the collection of the Earls of Haddington, Tyninghame, East Lothian

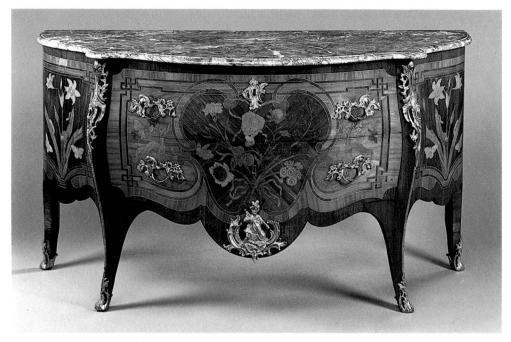

Fig.4
A Dutch ormulu-mounted marquetry commode, mid eighteenth century,
width 5ft 3in (160cm)
Tyninghame £110,000 ($192,500). 28.IX.87
From the collection of the Earls of Haddington, Tyninghame, East Lothian

buyers. A Belgian dealer bid on the telephone for a Brussels gothic tapestry, depicting an elaborate court scene, perhaps of Solomon and the Queen of Sheba (Fig.2). The contents of Tyninghame displayed craftsmanship from all over Europe as well as the work of many periods. Particularly outstanding was a Dutch marquetry commode (Fig.4) which displayed all the virtuosity of the contemporary French *ébéniste* but with unmistakable Dutch style and character.

Mirrors proliferated all over the house, adding light to the rich interiors and reflecting Tyninghame's superb gardens, the special achievement of the wife of the 10th Earl. The mirrors ranged from a late-seventeenth-century example with an elaborate armorial silver frame, made at a period when silver was a fashionable material for major items of furniture, to a graceful George III giltwood pier glass. The sale also featured a pair of glass and gilt-brass Regency chandeliers (Fig.5); the rarity of chandeliers of such size, delicacy and good condition was reflected in the price they fetched.

Competition for the silver at Tyninghame was especially keen, the distinguished provenance and fine condition of the pieces attracting London dealers. Interest centred on the 137 piece silver-gilt dessert service by William Chawner, 1827/28/33, which included a sugar sifter and grape scissors, in its original box, labelled 'Robert Garrard & Brothers, Goldsmiths and Jeweller to His Majesty [William IV]'. Not a

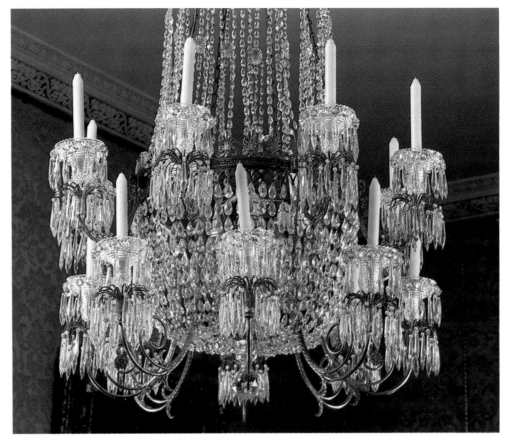

Fig.5
One of a pair of Regency glass and gilt-brass chandeliers, *circa* 1805, height 5ft 9in (175.3cm)
Tyninghame £79,200 ($138,600). 28.IX.87
From the collection of the Earls of Haddington, Tyninghame, East Lothian

single piece was missing, and the elaborate scallop shell chasing was in perfect condition.

There was an abundance of armorial silver, each piece recalling commissions by successive Earls of Haddington. A George II soup tureen and cover with its original ladle by William Cripps, 1750, made £35,200. It was engraved with the cypher of William IV and the arms of Thomas, 7th Earl of Haddington and his first wife Mary Lloyd. A year after her death in 1785 the 7th Earl scandalized the family by marrying Ann Gascoigne, forty years his junior. His taste in silver must have been approved, however, for in 1830 a second tureen, made to match and engraved with the same arms, was commissioned by the family from a Scottish silversmith, possibly Alex Edmonton. He copied exactly the foliate feet and artichoke finial of the Cripps tureen, rococo motifs which appealed to the revivalist taste of William IV's reign.

The sale at Tyninghame saw the dispersal of an important collection which reflected the changing tastes of members of a prominent Scottish family over 350 years. Their splendidly eclectic pieces, permanently recorded in the lavish sale catalogue, were carried off to be enjoyed by new owners.

Stephen Tennant's Wilsford

John Culme

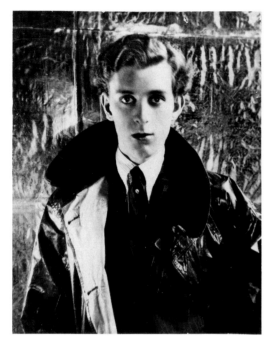

Fig.1
Cecil Beaton
THE HON. STEPHEN TENNANT, HALF FIGURE
PORTRAIT IN LEATHER JACKET
Silver print, signed, *circa* 1927–28,
11⅞in by 9½in (30.2cm by 24.1cm)
Wilsford £3,740 ($6,545). 15.X.87
From the collection of the late
the Hon. Stephen Tennant,
Wilsford Manor

A wilderness garden in Wiltshire, host to wood-pigeons and toppled statuary, suddenly yielded its secrets last October when the contents of the outwardly sober Edwardian-Jacobean mansion known as Wilsford Manor, were about to be sold. No latter-day visitor to this life-long home of the Hon. Stephen Tennant, youngest son of the immensely wealthy 1st Baron Glenconner, left unimpressed; Tennant had chosen interiors, one unexpected tableau after another, in deliberate contrast to the house itself. Such wilfulness, such a devotion to schemes of pink and gold and silver leaf in preference to the original stained oak panelling, aroused passionate debates between those who loved the place and those for whom the mix was objectionable. In sympathy with the former, a critic of his paintings who could equally have been referring to Wilsford Manor, wrote in the 1950s that Mr Tennant usually got away with the 'unsuitable' because it never occurred to him to ask whether it was otherwise; 'his tastes are his own and sure and precise.'

Stephen Tennant acquired Wilsford soon after the death of his mother, Lady Grey of Fallodon, in 1929. They had enjoyed a particularly fond relationship. They also shared a consuming interest in poetry and literature and it was she who had encouraged his early wish to be an artist. Upon his aunt Margot Asquith's suggestion, he was sent in 1922 to the Slade School of Art where he became intimate with Rex Whistler. Together with Stephen's childhood Nannie, the two young men spent

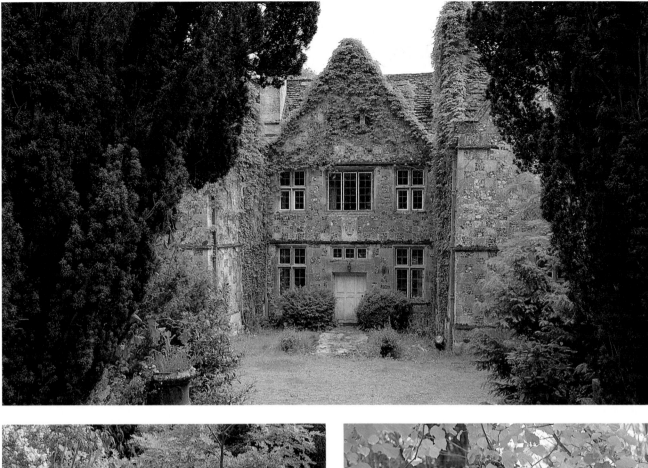

Fig.2
A stone bust of Pan, nineteenth century, height 29in (74cm)
Wilsford £7,150 ($12,513). 14.X.87
From the collection of the late the Hon. Stephen Tennant,
Wilsford Manor

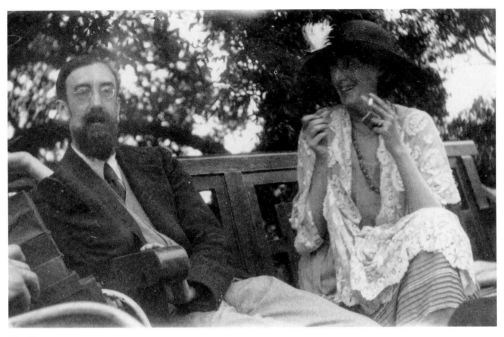

Fig.3
One of two photographs of Lytton Strachey and Virginia Woolf at Garsington,
silver prints, 1921, each approximately 2½in by 4⅛in (6.4cm by 10.5cm)
Wilsford £682 ($1,194). 15.X.87
From the collection of the late the Hon. Stephen Tennant, Wilsford Manor

many months over the next three years in Italy and Switzerland. By then, however, Stephen had already begun to show signs of tuberculosis. Dangerously undermining his health, the condition ironically heightened his already extraordinary good looks. In fact, Cecil Beaton, another friend who first visited Wilsford in 1927, took of Stephen Tennant, almost as soon as they became acquainted, some of the most memorable photographic portraits of his long career (Fig.1).

Just as the beauty of his mother, the former Pamela Wyndham, had been celebrated in the 1890s by John Singer Sargent, so now Stephen Tennant sat for the sculptor Jacob Epstein (Fig.4). 'I shall never forget . . . this lovely wraith growing beside me,' wrote Stephen of his bust soon afterwards; 'when I am dead & forgotten its loveliness will live, gazing back into the past at me – when Ghost meets Ghost.'

The sheer enjoyment of living eventually conquered Stephen Tennant's debilitating disease. In London and at Wilsford there were parties and fancy-dress balls, but he also valued simple pleasures, such as when during a summer stay with Siegfried Sassoon at Syracuse in 1929 he began a collection of sea-shells. Stephen's fascination for them lasted for the rest of his life; they became fixed in his mind as sentimental reminders of a loving yet doomed friendship. When it was all over, the bravura tone of a note in his diary for 1933/34 ('Juliet [Duff] told me that S.S. said to her that I had "– irresistible, compelling charm –" Attaboy Stephen!'), did not hide the fact

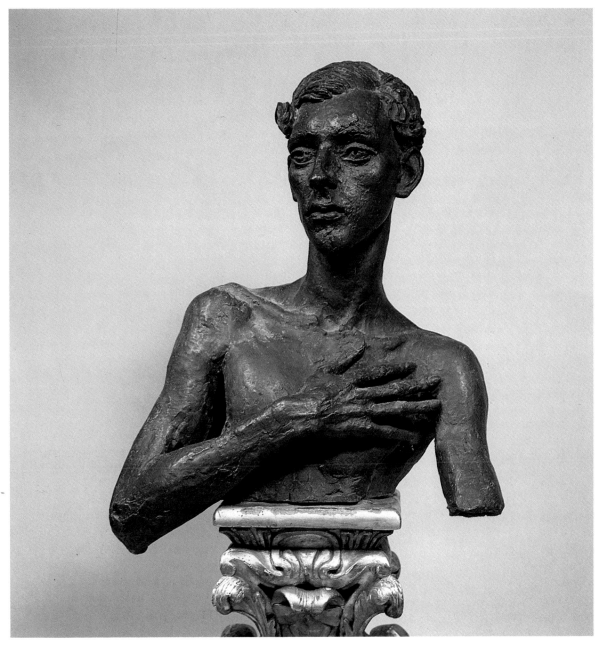

Fig.4
Sir Jacob Epstein
STEPHEN TENNANT
Bronze, 1927, height 27in (68.6cm)
Wilsford £24,200 ($42,350). 15.X.87
From the collection of the late the Hon. Stephen Tennant, Wilsford Manor

In his *Journals* for Tuesday 27th September 1927, Stephen Tennant wrote: 'I had an amusing letter from Jacob Epstein... My bust is ready... It is in bright gold bronze now and should look divine in my silver room – I shall never forget the magical sensation of being sculpted by this great sculptor...'

that he regretted the inevitable rift and that he looked back on his days with Sassoon as idyllic.

Self-absorbed to the point of narcissism, Stephen Tennant was paradoxically less confident than would apear. To be sure, he was outgoing and a witty and thoughtful companion, the acquaintance of many in literary and artistic circles, yet he became increasingly lonely. Throughout the 1930s he travelled widely in Europe and to America, almost always alone, returning frequently to favourite hotels in London or to his beloved Wilsford. Here, with help from Syrie Maugham the fashionable decorator, he altered the somewhat gloomy, old-world rooms. Together they transformed them into fresh, airy spaces where sunlight, diffused in its passage through climbing clematis and rose, could flicker on ephemeral arangements of rock crystal and shells, baskets of flowers, or perhaps the shoulder of a new ice-blue satin-covered sofa.

The Second World War trapped Stephen in Britain with little to do; with his history of poor health it was impossible that he should be considered for active service. Instead he drafted and re-drafted his monumental but ultimately unfinished novel, *Lascar*, about Marseilles and the seedy characters of its waterfront. Often depressed, he filled the time by constantly shuttling between hotels in London, his Bournemouth flat and Wilsford, part of which had been requisitioned as a hospital for the Red Cross. News of Virginia Woolf's death in 1941 furthermore turned his thoughts, never far from nostalgic longings, to past pleasures. He recalled her beautiful voice: 'perhaps the lovliest voice I ever knew.' It would then have been characteristic of him to rediscover two old snapshots given him by Lady Ottoline Morrell in which Lytton Strachey and Mrs Woolf sat together, smiling on a garden seat (Fig.3).

It was with unfeigned relief that Stephen told a friend in July 1945 of the Red Cross leaving Wilsford; he was overjoyed with happiness. 'I hunger to draw & paint again', he told himself on 11th August and before long was composing poems such as *The Empty Room*, inspired by his programme of redecoration, and another about the garden of statuary at Syon Lodge belonging to T. Crowther & Son from whom he was currently acquiring many marbles, urns and fountains (see Fig.2). During 1946 he commenced work on the mirrored pink bathroom with his own fancifully painted panels of doves and parasols, stars and hat boxes, all reminders of visits nearly twenty years before to Paul Poiret's wonderful shop in Paris. For the remainder of the house he purchased yet more furniture and furnishings. A friend advised him 'to buy only very good furniture,' which, Stephen thought, was 'first rate good sense. I shall only concentrate on a few lovely pieces now.' It was at this time, too, that he found the Dutch landscape by Vermeulen and probably the pair of views of Rome.

For the next thirty years Wilsford Manor was where Stephen preferred to be. The outside world heard strange stories of how he eschewed both radio and newspapers and of how he liked to languish in bed surrounded by heaps of old letters. Nor were these reports exaggerated, but he also maintained a lively, delightfully illustrated correspondence and worked tirelessly at his drawing and poetry. Between 1953 and 1983 he also held several exhibitions of his paintings, chiefly in London and New York.

The landing, Wilsford Manor (Courtesy of Lucinda Lambton)

Stephen Tennant died on 28th February 1987, just a few weeks before his 81st birthday. Leaving no will or other instructions, his entire estate had to be dispersed. Everything was included: artwork for *The Vein in the Marble*, the book which he and his mother had published jointly in 1925, letters from Edith Sitwell, Willa Cather and other friends, old photographs, the library, curtains, even his favourite stuffed toy monkey. For the sale itself, held on 14th and 15th October last, a green and white striped marquee was erected on the sloping lawn at Wilsford Manor. Within a few hours of the gavel falling on the final lot, however, the Great Hurricane demolished the marquee as thoroughly as the enthusiastic bidders had so recently cleared the house.

Now Stephen Tennant, Vita Sackville-West's 'dear, strange, beautiful, gifted Stephen', as well as his version of the Wiltshire mansion with which his name will always be associated, are no more. Having read of him and seen his home, many will conclude that the *Evening Standard* of 1937 was correct in dismissing him as merely 'one of the more bizarre figures of the nineteen-twenties.' But there was much more to this truly gentle man who lived so little in the world to which most are obliged to become accustomed. His joy of living was exhilarating to those who were fortunate enough to know him and who cared to listen. As Cecil Beaton once remarked, Stephen had the ability to make even the most ordinary things wildly exciting.

Old master paintings and drawings

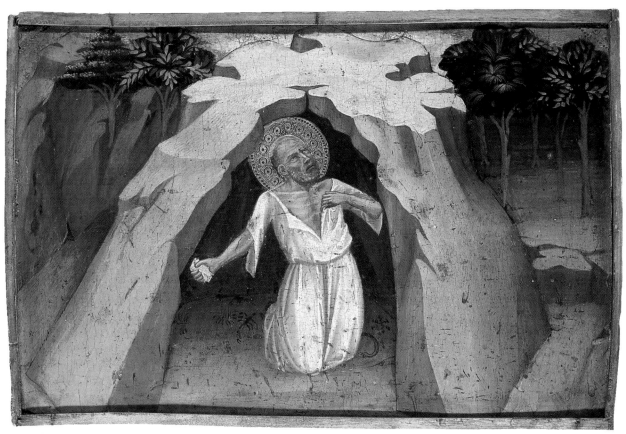

Lorenzo Monaco
SAINT JEROME IN THE WILDERNESS
Tempera on panel, 9in by 14⅛in (23cm by 36cm)
London £374,000 ($649,077). 6.VII.88

This panel was part of the predella of an altarpiece, probably from Santa Maria del Carmine, Florence.

Opposite
Sebastiano Ricci
THE LAST COMMUNION OF SAINT MARY OF EGYPT
80¾in by 54⅞in (205cm by 139.5cm)
London £407,000 ($706,349). 6.VII.88

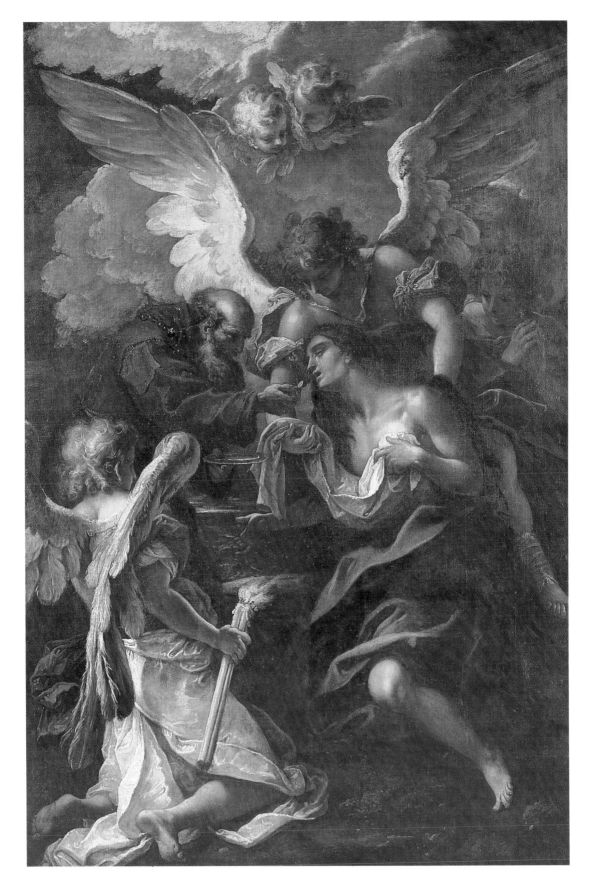

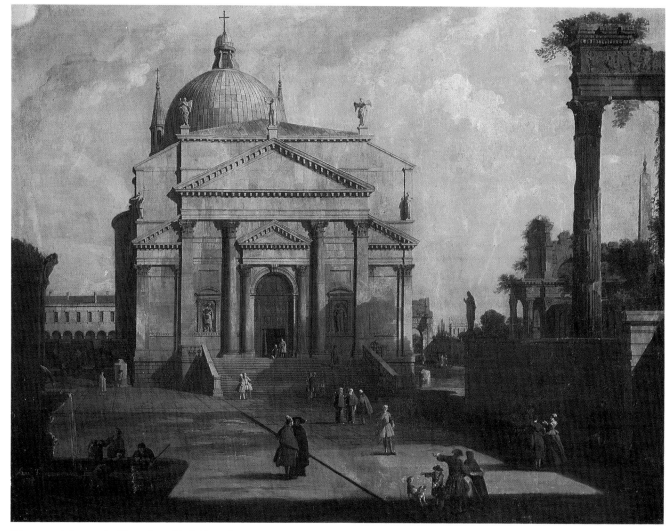

Giovanni Antonio Canal, called Canaletto
THE REDENTORE IN A CAPRICCIO SETTING
Signed and dated *1744*, 38½in by 50in (98cm by 127cm)
London £440,000 ($763,620). 6.VII.88

This painting is almost certainly one in a series of thirteen overdoors commissioned from
Canaletto *circa* 1742, by Joseph Smith, English Consul in Venice which were subsequently
sold to George III in 1762; nine of the overdoors remain in the Royal Collection.

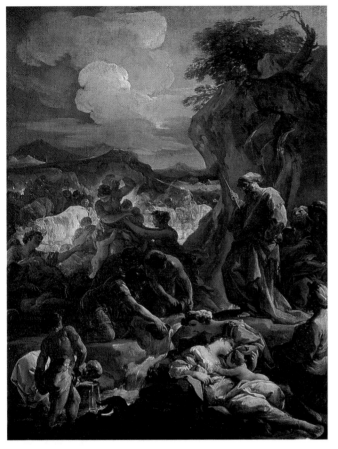

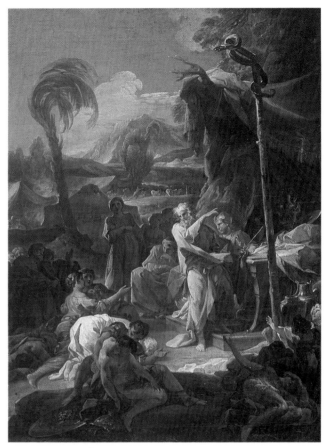

Corrado Giaquinto
MOSES DRAWING WATER FROM THE ROCK
24¾in by 18¾in (63cm by 47.5cm),
Ptas 6,806,400 (£33,695:$41,251)

Corrado Giaquinto
THE BRAZEN SERPENT
24¾in by 18¾in (63cm by 47.5cm),
Ptas 6,806,400 (£33,695:$41,251)

Both paintings were sold in Madrid on 16th December 1987.

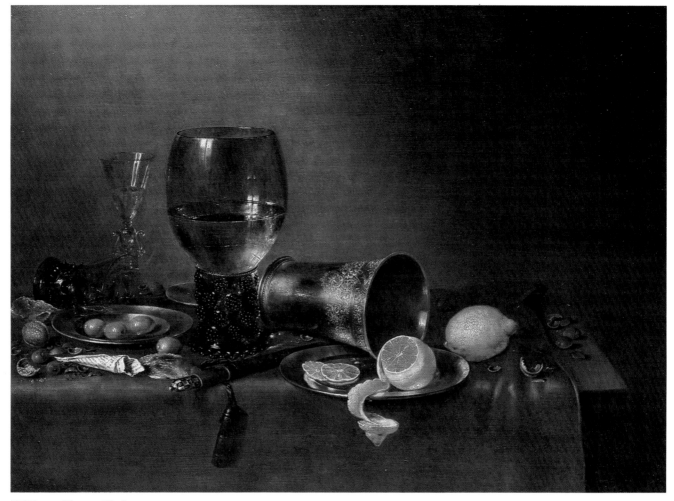

Willem-Claesz Heda
A STILL LIFE
Oil on panel, signed and dated *1633*, 23¼in by 31⅛in (59cm by 79cm)
Monte Carlo FF8,436,000 (£803,429:$1,406,000). 17.VI.88

Opposite
Cesare Dandini
A WOMAN CROWNED WITH LAUREL, HOLDING A CHILD
20½in by 15¼in (52.1cm by 38.7cm)
New York $85,250 (£46,585). 14.I.88

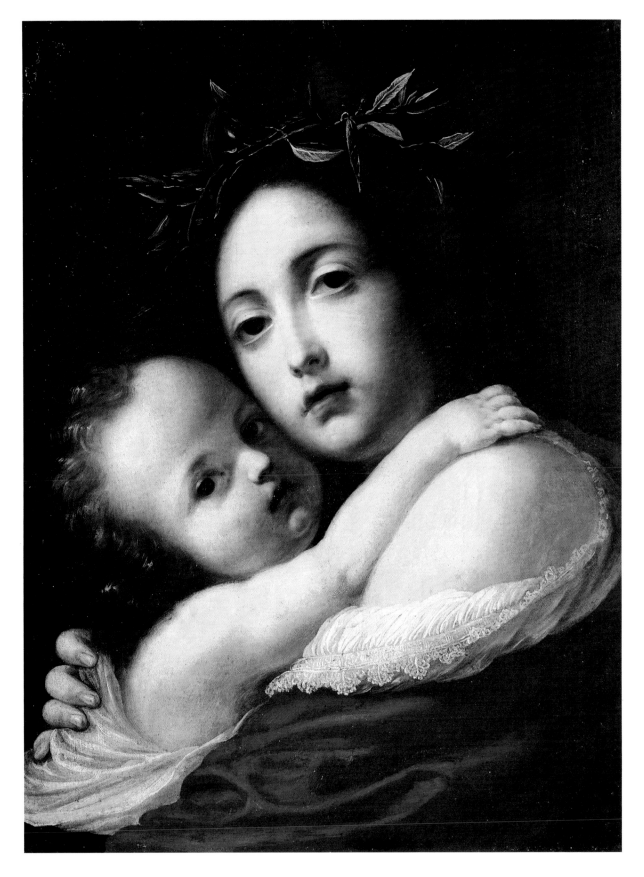

Philips Wouverman
AN EXTENSIVE LANDSCAPE WITH A HAWKING PARTY
Signed with monogram, 29½in by 44½in (74.9cm by 113cm)
Monte Carlo FF4,773,000 (£454,571:$795,500). 17.VI.88

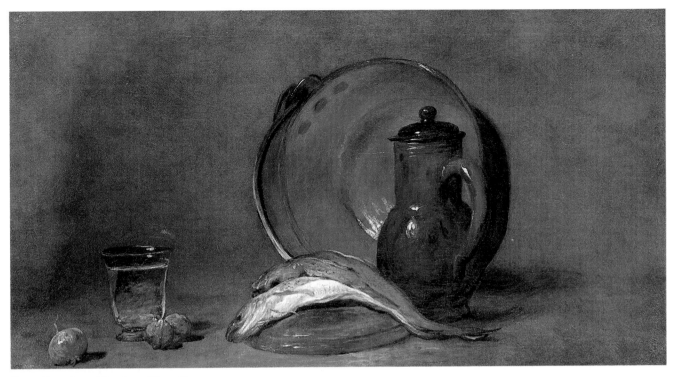

Jean-Baptiste-Siméon Chardin
STILL LIFE OF A COPPER POT, A PITCHER, FISH, A GLASS, TWO NUTS AND AN ONION
$18\frac{1}{2}$in by $33\frac{1}{4}$in (47cm by 84.5cm)
New York $792,000 (£432,787). 14.I.88

This still life, one of the earliest in which Chardin paints kitchen utensils, may have been a pendant to a work from the Kaiser Friedrich Museum, Berlin, that was destroyed in the Second World War.

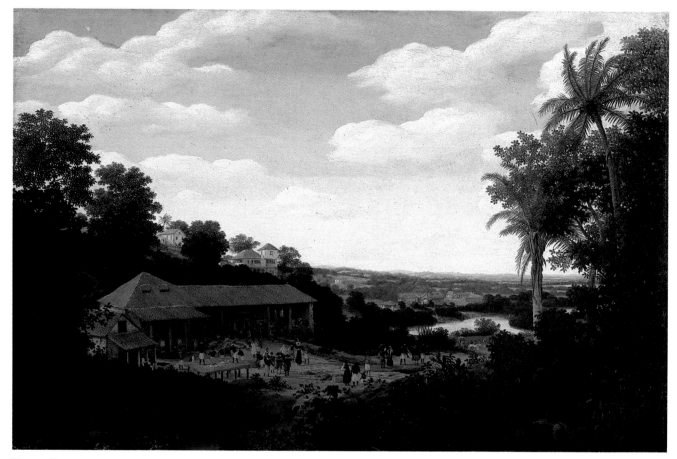

Frans Post
ENGENHO REAL
Oil on panel, signed and dated *1668*, 22¾in by 35in (57.8cm by 88.9cm)
New York $962,500 (£525,956). 14.I.88

Opposite
Gerard Terborch
PORTRAIT OF JOHANNA QUADACKER BANNIER
28in by 20in (71.1cm by 50.8cm)
New York $478,500 (£265,556). 3.VI.88

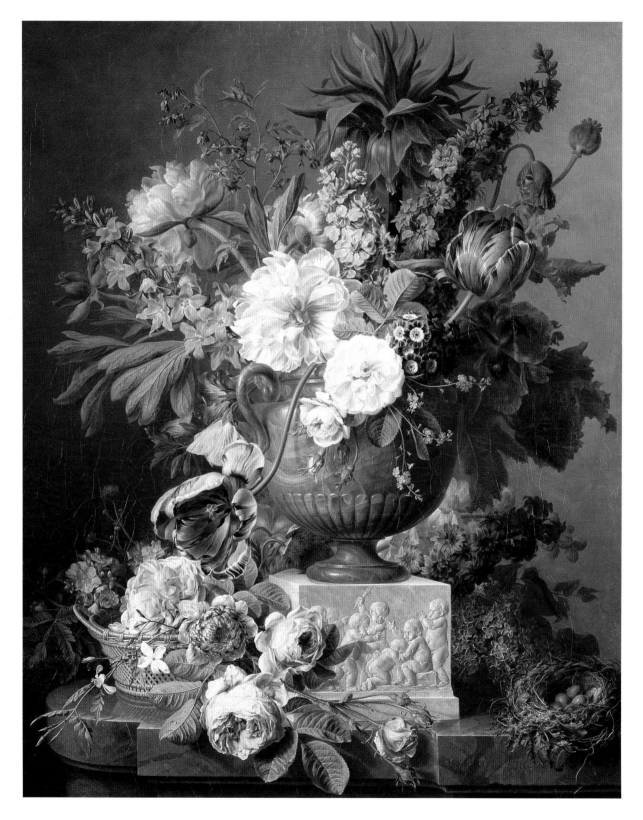

Opposite
Gerard van Spaendonck
STILL LIFE WITH FLOWERS IN A STONE VASE
ON A CARVED PEDESTAL, WITH A BASKET
OF FLOWERS AND A NEST
Signed, 31¼in by 25in
(79.4cm by 63.5cm)
New York $797,500 (£443,056). 3.VI.88

François-André Vincent
A WOMAN FROM SANTA LUCIA IN NAPLES
Signed and dated . . . *nt F. Naple 177* . . ., 32in by 19¾in (81.3cm by 50.2cm)
New York $462,000 (£256,667). 3.VI.88

The Guterman Collection of old master paintings

The sale of Dutch and Flemish old master paintings assembled by Linda and Gerald Guterman established a record for an old master paintings collection in America, totalling $10.3 million. The auction, which comprised sixteenth- and seventeenth-century Baroque art, set several new levels for Dutch artists, establishing eleven records. Mr and Mrs Guterman sought only the finest examples in the best condition. Their collection included biblical paintings by members of the Rembrandt school as well as still lifes, landscapes, seascapes and portraits.

Foremost among the still lifes was Jan Davidsz. de Heem's elaborate *Still Life of Fruits, Meat Pie, Crustaceans, and Silver and Gold Objects* (Fig.1). Signed and dated 1649, it was painted thirteen years after de Heem settled in Antwerp. According to Sandrart, the seventeenth-century historian, de Heem moved to the bustling and successful commercial city of Antwerp because 'there one could have rare fruits of all kinds, large plums, peaches, cherries, oranges, lemons, grapes, and others in finer condition and state of ripeness to draw from life.' De Heem's interest in pictorial effects is evident in the profusion of luscious foodstuffs and intricately-crafted precious objects that crowd the table and in the brilliant and exacting execution of each detail. In this and other paintings, de Heem formulated a new style combining traditional elements of both Dutch and Flemish art, which significantly influenced contemporary painters as well as later artists in Holland and Flanders.

Another record for an artist was established with Jan Jansz. den Uyl's *Still Life of a Jug, an Overturned Tazza, Glasses and Plates* (Fig.2). A masterwork of chromatic subtlety, this work belongs to the other great tradition of Dutch still-life painting, the monochrome banquet-piece, characterized by restrained tonality and spare composition. In this extraordinary work, all the main elements are placed on the left of the picture, balanced only by the strong architectural elements on the right.

The Guterman Collection also featured several important landscapes. Salomon van Ruysdael's *Nijmegen with the Valkhof and a Ferry Crossing the River Waal* (Fig.3) depicts a man-made fortress on a riverbank with citizens going about their everyday business: fishing, sailing, and ferrying travellers across the water. This landscape glorifies the majesty and beauty of nature, not only admitting but extolling the reality that it is a nature altered by man who lives and works in it. By contrast Meindert Hobbema's *Entrance to a Wood with a Farm and Horsemen Riding on Two Roads* depicts a luscious foliage which abounds in a landscape where the figures play a secondary role.

Fig.1
Jan Davidsz. de Heem
STILL LIFE OF FRUITS, MEAT PIE, CRUSTACEANS AND SILVER AND GOLD OBJECTS
Signed and dated *1649*, 29½in by 44in (74.9cm by 111.8cm)
New York $2,530,000 (£1,382,514). 14.I.88
From the Linda and Gerald Guterman Collection

Fig.3
Salomon van Ruysdael
NIJMEGEN WITH THE VALKHOF AND A FERRY CROSSING THE RIVER WAAL
Signed in monogram and dated *1652* on the ferry, 27½in by 36¼in (69.9cm by 92.1cm)
New York $907,500 (£495,902). 14.I.88
From the Linda and Gerald Guterman Collection

Fig.2 *Opposite*
Jan Jansz. den Uyl
STILL LIFE OF A JUG, AN OVERTURNED TAZZA, GLASSES AND PLATES
Signed with an owl on the tablecloth and dated *1633* on the handle of the jug,
35½in by 28¼in (90.2cm by 71.8cm)
New York $2,200,000 (£1,202,186). 14.I.88
From the Linda and Gerald Guterman Collection

Giovanni Domenico Tiepolo
A TRAVELLING SHOWMAN WITH A DROMEDARY AND MONKEYS
Pen and brown ink and grey-brown wash over black chalk, signed in brown ink,
11¾in by16⅛in (28.9cm by 41cm)
New York $159,500 (£90,113). 12.XI.87
From the collection of Jo-Ann Edinburg Pinkowitz, John Edinburg and Hope Edinburgh

Formerly part of a series of twenty-two drawings in the Beurdeley Collection, this is, like
many similar works by Giovanni Domenico, an independent study and not a preparatory
drawing relating to a subsequent painting or print.

Opposite
Piero Buonaccorsi, called Perino del Vaga
STUDIES OF FIGURES IN CLASSICAL DRESS, *RECTO*
Pen and brown ink and brown and grey-brown wash, inscribed by the artist,
12⅝in by 8⅞in (32.1cm by 22.4cm)
New York $374,000 (£205,495). 13.I.88

On the *verso* are studies of figures in classical dress, with classical and grotesque heads drawn
over a geometrical pattern.

Jacopo da Ponte, called Jacopo Bassano
CHRIST CHASING THE MONEYCHANGERS FROM THE TEMPLE
Black and coloured chalks on blue paper, 16½in by 20⅞in (41.8cm by 53.1cm)
London £110,000 ($196,900). 4.VII.88

Executed *circa* 1569 and from the eighteenth-century collection of Marchese Jacopo Durazzo,
this drawing is similar thematically to many works by Bassano and his studio, but
stylistically is rare in his *œuvre*.

Giovanni Battista Piazzetta
HEAD OF THE GUARDIAN ANGEL
Black chalk heightened with white chalk on faded blue paper,
15⅝in by 11⅞in (39.9cm by 30.1cm)
London £242,000 ($433,180). 4.VII.88

This study is for Piazzetta's altarpiece *The Guardian Angel with SS. Anthony of Padua and Luigi Gonzaga* in S. Vitale, Venice.

Jean-Honoré Fragonard
LE CANAL
Black chalk, pen and brown ink and watercolour heightened with gouache,
$10\frac{7}{8}$in by $15\frac{5}{8}$in (27.6cm by 39.7cm)
Monte Carlo FF 1,087,800 (£108,780:$189,183). 20.II.88

It is likely that this early drawing was inspired by the countryside at Rambouillet,
Fontainebleau or Versailles.

Sir Anthony van Dyck, attributed to
STUDIES OF THE HEAD OF A FOX
Pen and brown ink and wash over black chalk,
11¼in by 7in (28.7cm by 17.7cm)
Amsterdam DFl 276,000 (£82,635:$143,005).
2.XI.87

Ornithological watercolours from the Jeanson Library

George Gordon

Nicolas Robert (1614–1683), appointed *Peintre du Roi* in 1666, was the greatest Natural History artist of his age. His reputation depended on his watercolours of plants, and in particular of flowers. The eighteenth-century connoisseur and collector Pierre-Jean Mariette, who wrote at length about Robert in his *Abecedario* (vol. IV, pp. 408–11), mentions only his skill as a botanical artist, laying emphasis on the spread of his reputation through his own and others' engravings.

This unbalanced view of Robert's work is understandable because most of his output was for a single collection. This was the famous *Vélins du Roi*, started by Louis XIII's brother Gaston d'Orléans, and vastly expanded by Gaston's nephew Louis XIV, who inherited it in 1665. The *Vélins du Roi* contained large numbers of animals and birds but, famous though it was, only a privileged few would have had access to it (it is now housed in the Musée d'Histoire Naturelle in Paris, and may be viewed by appointment). Robert's reputation therefore spread through the small number of *vélins*, mostly of flowers, painted for various private patrons, and through prints.

The eighty or so *vélins* of birds from the Jeanson Library, which were sold in Monaco on June 16th, have rectified, albeit belatedly, this imbalance in Robert's reputation. Previously unknown, they are of breathtaking quality and form the only group of ornithological works by Robert apart from the *Vélins du Roi*. They give the impression of an artist who is supremely confident and at ease with his subject, and are clearly not the work of a botanical specialist struggling to cope with unfamiliar material. Mariette's assessment of Robert's work is therefore misleading in its botanical emphasis.

Although there was no clear division between art and science in Robert's day, some artists were more scientific than others. Robert used specimens supplied by the Jardin des Plantes in Paris and the Ménagerie at Versailles, but he was not responsible for their classification. Nevertheless he was highly regarded by scientists in his own time and in the eighteenth century.

If subsequent refinements in the art of recording nature have rendered Nicolas Robert's work obsolete in scientific terms, the same cannot be said of the watercolours of Jacques Barraband (1767–1809). These, painted in the early 1800s, are of an ornithological accuracy rarely matched by any artist, before or since. Like the Robert *vélins*, they are of breathtaking beauty, and bring forward by some 150 years the same *de facto* critique of modern preconceptions about art and science. They were made in preparation for the plates in François Le Vaillant, *Histoire Naturelle des Perroquets* (Paris, 1801–5), *Histoire Naturelle des Oiseaux de Paradis et des Rolliers . . .*, (Paris, 1803) and *Histoire Naturelle des Promerops et des Guépiers . . . faisant suite a celle des Oiseaux de Paradis* (Paris, 1806). Barraband's work for these volumes was a colossal

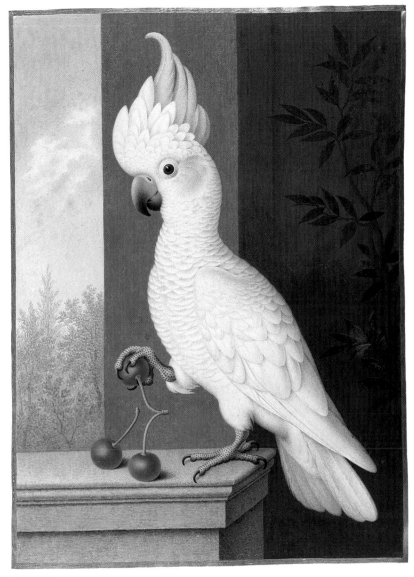

Nicolas Robert
SULPHUR-CRESTED COCKATOO, *Cacatua galerita*
Watercolour on vellum, $16\frac{5}{8}$in by $12\frac{1}{2}$ (42.2cm by 31.6cm)
Monte Carlo FF421,800 (£40,171:$70,300). 16.VI.88
From the library of the late Marcel Jeanson

undertaking, and must be considered the climax of his short career. Barraband's reputation, more than that of Robert, stands to benefit from the exposure it has received from the sale of the Jeanson Library, because very little of his work survives anywhere else; indeed, he has until now virtually only been known through the plates engraved after him in the volumes of Le Vaillant. Attractive though these may be, they only hint at the beauty of their preparatory watercolours.

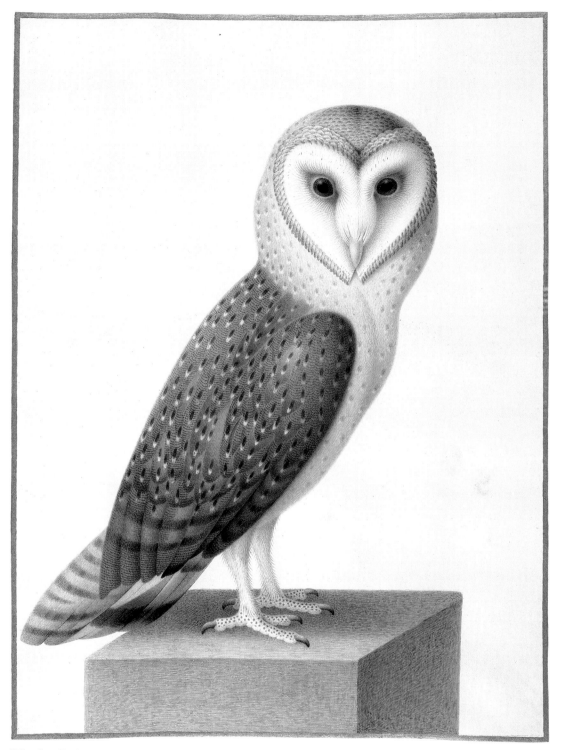

Nicolas Robert
BARN OWL, *Tyto alba*
Watercolour on vellum, 15$\frac{7}{8}$in by 12in (40.4cm by 30.4cm)
Monte Carlo FF421,800 (£40,171:$70,300). 16.VI.88
From the library of the late Marcel Jeanson

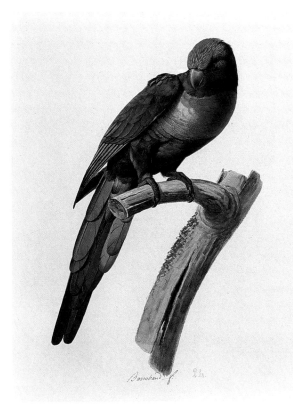

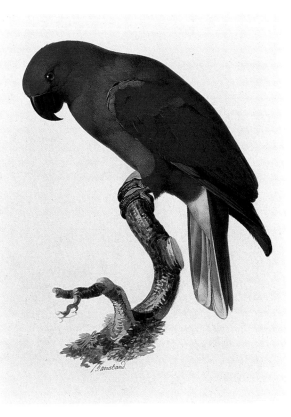

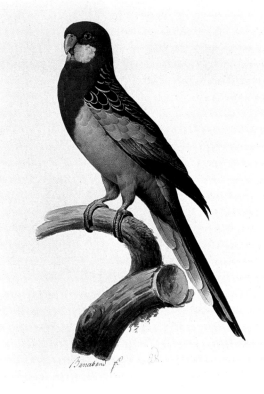

Above
Jacques Barraband
RAINBOW LORIKEET, *Trichoglossus haematodus*
Watercolour and gouache, signed, 20½in by 15¾in
(52cm by 40cm)
Monte Carlo FF266,400 (£25,371:$44,400). 16.VI.88
From the library of the late Marcel Jeanson

Above, right
Jacques Barraband
ECLECTUS PARROT, *Eclectus roratus*
Watercolour and gouache, signed, 20½in by 15¾in
(52cm by 40cm)
Monte Carlo FF222,000 (£21,143:$37,000). 16.VI.88
From the library of the late Marcel Jeanson

Right
Jacques Barraband
EASTERN ROSELLA, *Platycercus eximius*
Watercolour and gouache, signed, 20½in by 15¾in
(52cm by 40cm)
Monte Carlo FF410,700 (£39,114:$68,450). 16.VI.88
From the library of the late Marcel Jeanson

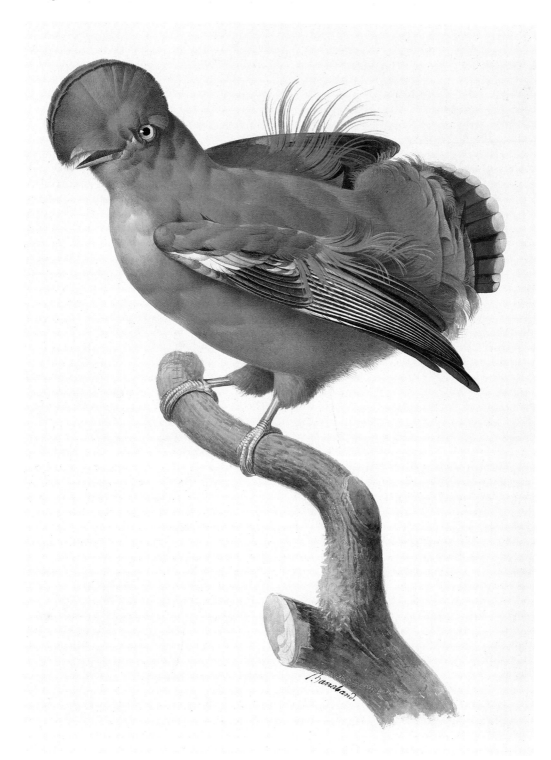

Jacques Barraband
COCK OF THE ROCK, *Rupicola rupicola*
Watercolour and gouache, signed, 20½in by 15¾in (52cm by 40cm)
Monte Carlo FF299,700 (£28,543:$49,950). 16.VI.88
From the library of the late Marcel Jeanson

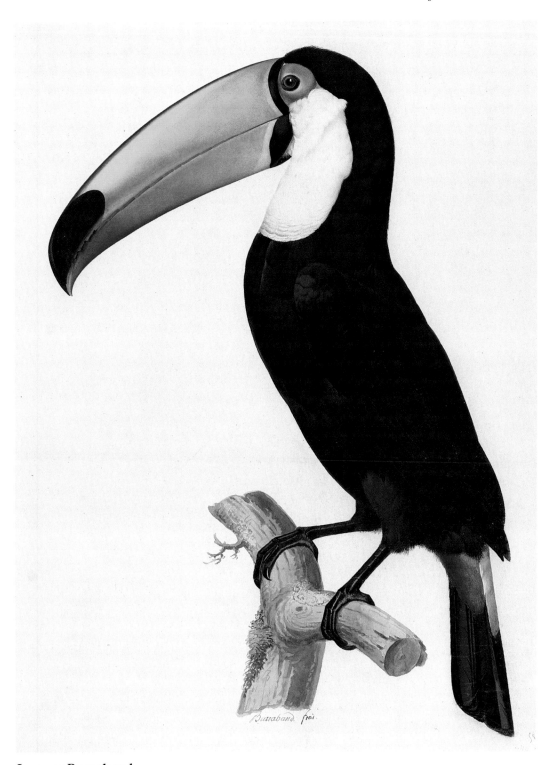

Jacques Barraband
TOCO TOUCAN, *Ramphastos toco*
Watercolour and gouache, signed, 20½in by 15¾in (52cm by 40cm)
Monte Carlo FF299,700 (£28,543:$49,950). 16.VI.88
From the library of the late Marcel Jeanson

British paintings and watercolours

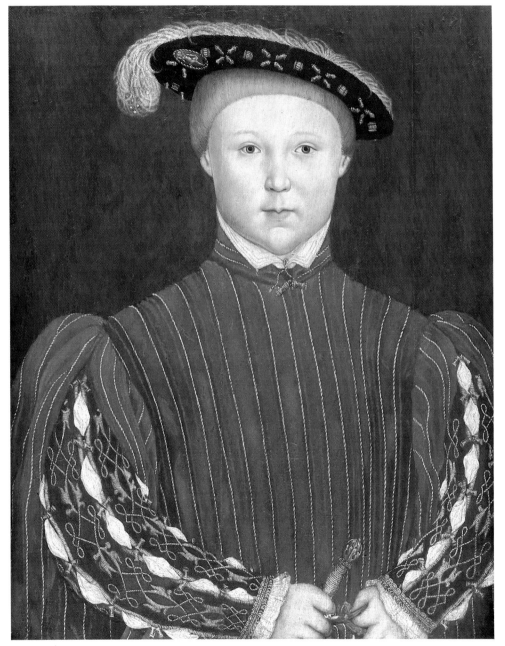

Follower of Hans Holbein
PORTRAIT OF EDWARD, PRINCE OF WALES, LATER EDWARD VI OF ENGLAND
Oil on panel, 20⅞in by 16⅜in (53cm by 41.5cm)
London £90,200 ($175,890). 9.III.88

Arthur Devis
PORTRAIT OF PHILIP HOWARD OF CORBY CASTLE, CUMBERLAND
Signed and dated *1753*, 27⅜in by 35⅝in (69.5cm by 90.5cm)
London £90,200 ($162,360). 13.VII.88
From the collection of John Howard

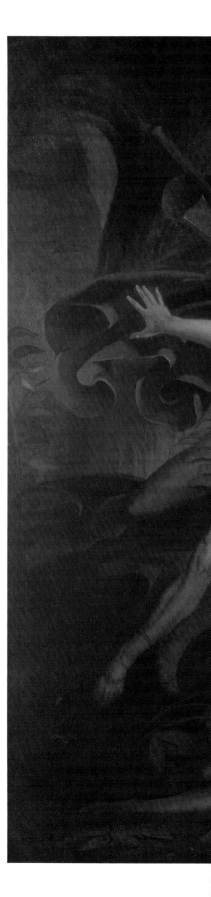

Johann Heinrich Fuseli, RA
SATAN STARTING FROM THE TOUCH OF ITHURIEL'S LANCE
83⅝in by 108in (212.5cm by 274.5cm)
London £770,000 ($1,386,000). 13.VII.88

Fuseli executed three drawings of the same subject from Book IV of Milton's
Paradise Lost before returning to England from Rome in 1778. This hitherto untraced
painting was exhibited at the Royal Academy, London in 1780.

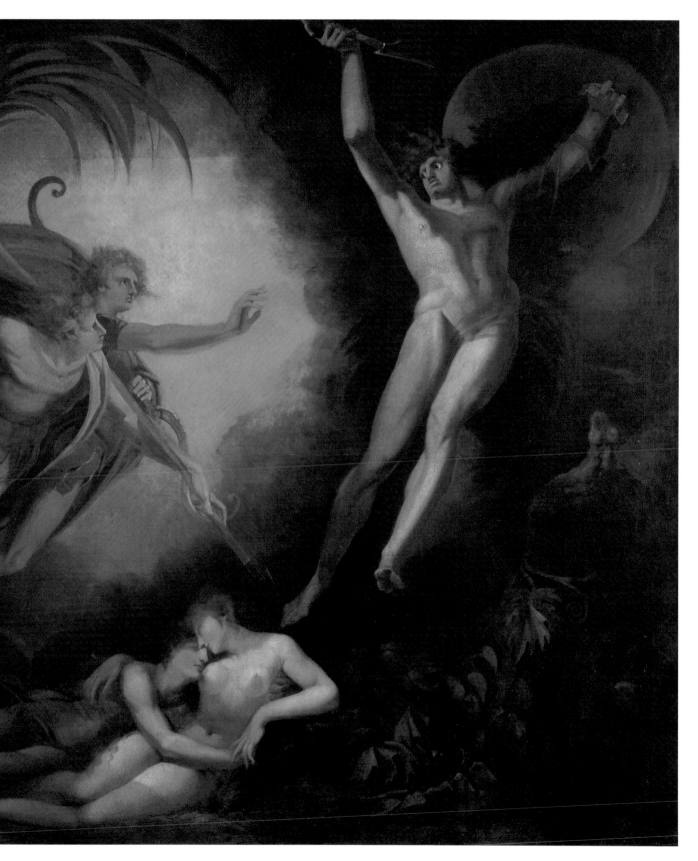

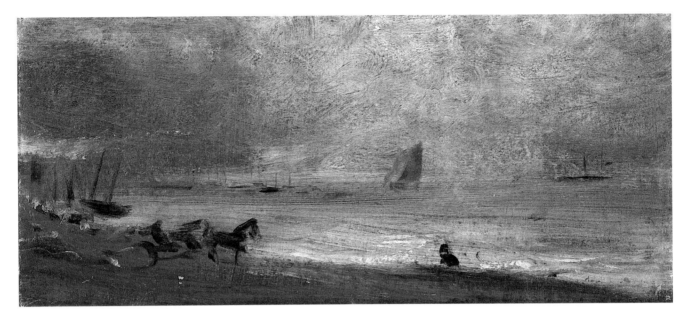

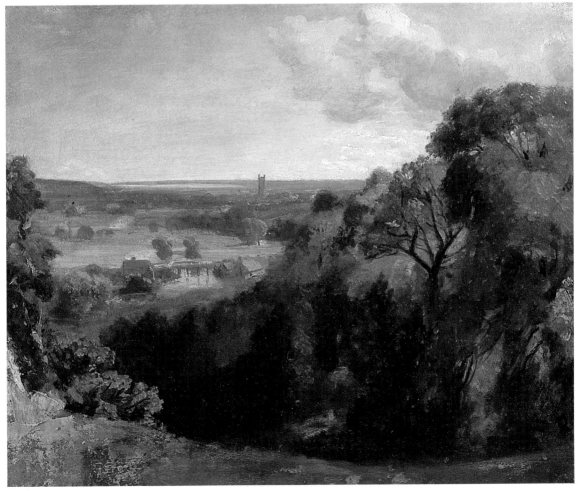

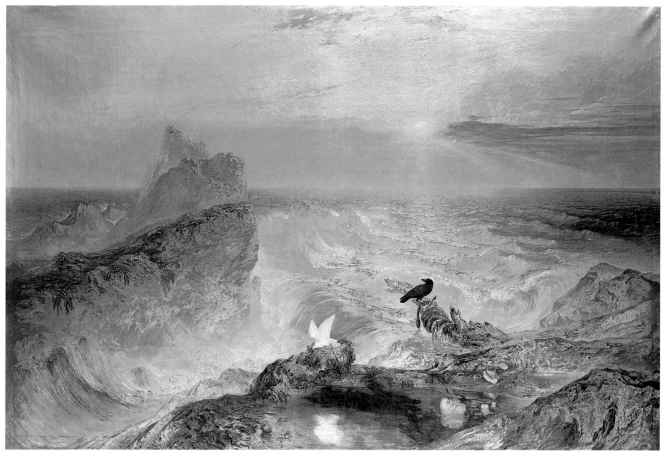

John Martin
THE ASSUAGING OF THE WATERS
Signed and dated *1840*, 56½in by 85¾in (143.5cm by 218cm)
London £495,000 ($965,250). 9.III.88
From the collection of the General Assembly of the Church of Scotland

This painting was exhibited at the Royal Academy, London in 1840 accompanied by
quotations from Byron's *Heaven and Earth*. Commissioned the preceding year by Harriet,
Duchess of Sutherland, it remains in its original frame with water and shell decorations
designed by Martin.

Opposite, above
John Constable, RA
BEACH SCENE NEAR BRIGHTON WITH BOATS
Oil on paper laid down on board, 1824, 5in by 11¼in (12.5cm by 28.5cm)
London £132,000 ($257,400). 9.III.88

Below
John Constable, RA
A VIEW OF DEDHAM VALE
Oil on paper laid down on canvas, 1802, 18⅞in by 23¼in (48cm by 59cm)
London £209,000 ($376,200). 13.VII.88

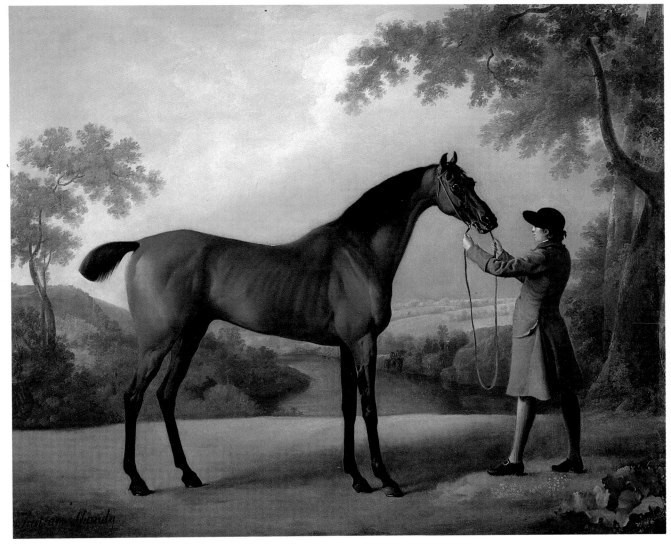

George Stubbs, ARA
TRISTRAM SHANDY
Signed and inscribed with the horse's name, *circa* 1765, 40in by 50½in (101.6cm by 128.3cm)
New York $1,127,500 (£655,523). 29.X.87

Painted as a companion to the portrait *Molly Long Legs*, now in the Walker Art Gallery, Liverpool, *Tristram Shandy* was one of a series of racehorse portraits painted by Stubbs in the 1760s for the 2nd Viscount Bolingbroke, an important early patron of the artist.

Opposite, below
Samuel Scott
SHIPPING ON THE THAMES AT ROTHERHITHE, WITH ST SAVIOUR'S DOCK, BERMONDSEY IN THE DISTANCE
39⅜in by 49¼in (100cm by 125cm)
London £165,000 ($297,000). 13.VII.88

Thomas Luny
MEN-OF-WAR OFF TORBAY
Signed and dated *1828*,
33⅝in by 50⅝in (85.5cm by
128.5cm)
London £45,100 ($87,945).
9.III.88
From the collection of the
Bristol Royal Society
for the Blind

Above
George Vertue
THE ROYAL PROGRESS OF QUEEN ELIZABETH
Gouache on vellum wrapped around panel,
signed in gold, inscribed and dated *1740*,
16in by 22in (40.5cm by 56cm)
London £20,350 ($38,258). 19.XI.87

Left
Sir Thomas Lawrence, PRA
PORTRAIT OF A LADY
Black, red and white chalk on canvas,
29⅞in by 25in (76cm by 63.5cm)
London £44,000 ($85,800). 10.III.88

Joseph Mallord William Turner, RA
WINDSOR CASTLE FROM THE GREAT PARK
Watercolour over pencil, signed, *circa* 1795, 8⅞in by 12¼in (22.5cm by 31cm)
London £48,400 ($90,992). 19.XI.87
From the collection of Mrs Peter Gray

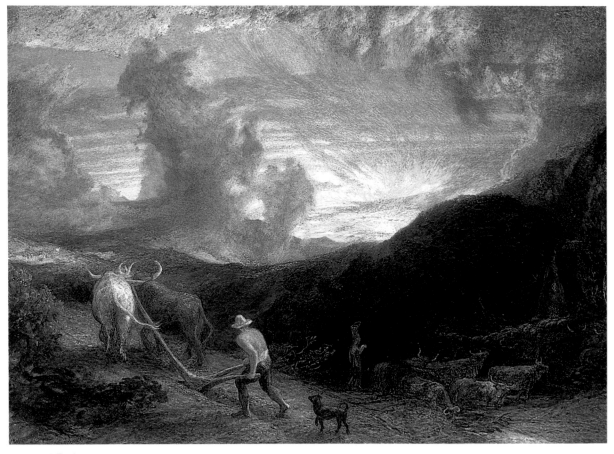

Samuel Palmer
THE EASTERN GATE
Gouache over pencil with scratching out, signed, inscribed on a label, 19⅝in by 27½in
(50cm by 70cm)
London £143,000 ($243,100). 14.VII.88

Opposite, above
John Sell Cotman
IN THE GRAMPIANS: MINDING CATTLE
Watercolour, signed, *circa* 1830, 8⅞in by 13⅛in (22.5cm by 33.5cm)
London £46,200 ($78,540). 14.VII.88
From the collection of Mrs Dorothy Cotman

Below
Joseph Mallord William Turner, RA
LAUSANNE, FROM LE SIGNAL
Pencil and watercolour, 1841, 9in by 13in (22.9cm by 33cm)
New York $330,000 (£186,441). 12.XI.87
From the collection of Jo-Ann Edinburg Pinkowitz, John Edinburg and Hope Edinburgh

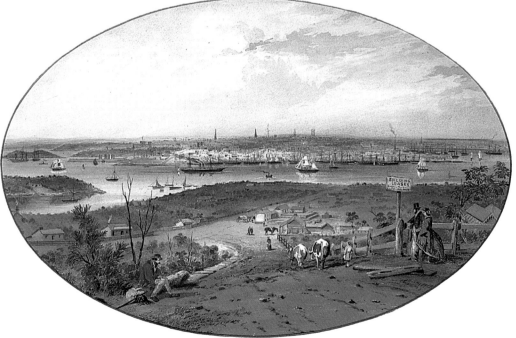

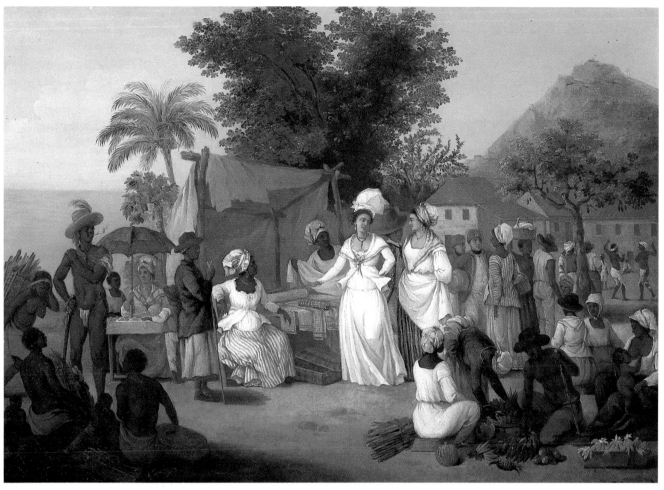

Agustino Brunias
A LINEN MARKET WITH A LINEN-STALL AND VEGETABLE SELLER IN THE WEST INDIES
21½in by 29½in (54.5cm by 75cm)
London £90,200 ($177,694). 27.V.88

Opposite, above
Richard Parkes Bonington
THE PONT DES ARTS AND THE ILE DE LA CITE, PARIS
Watercolour over pencil heightened with bodycolour and gum arabic, signed and dated
1828, 5⅝in by 8⅝in (14.5cm by 22cm)
London £94,600 ($184,470). 10.III.88
From the collection of the late Edwin P. Rome

Below
Samuel Thomas Gill
GENERAL VIEW OF SYDNEY FROM THE NORTH
Watercolour over traces of pencil heightened with gum arabic and bodycolour, signed,
13¾in by 21½in (35cm by 54.5cm)
London £82,500 ($162,525). 27.V.88
From the collection of Mr and Mrs C.A. Maxsted

Victorian and modern British paintings

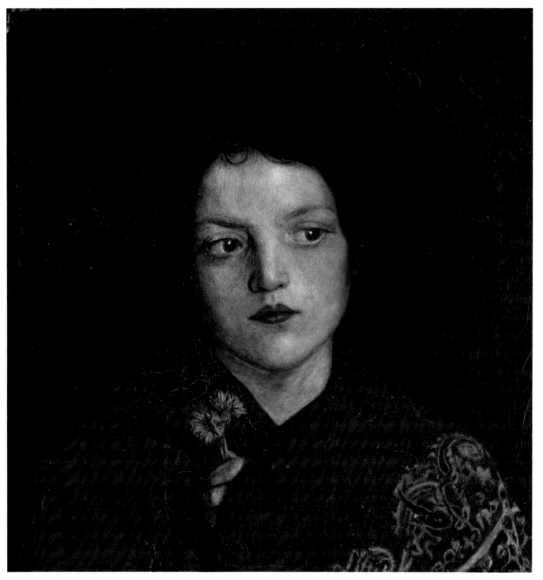

Ford Madox Brown
THE IRISH GIRL
Signed and dated *1860*, 11in by 10⅞in (28cm by 27.5cm)
London £90,200 ($170,478). 21.VI.88

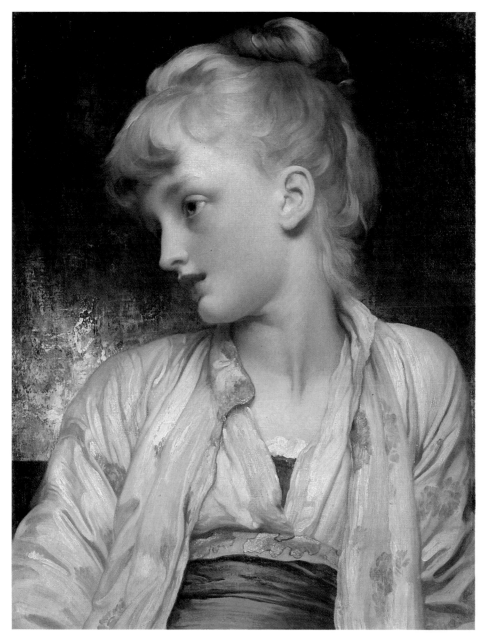

Frederic, Lord Leighton, PRA, RWS
GULNIHAL
Last quarter nineteenth century, 22¼in by 17⅛in (56.5cm by 43.5cm)
London £192,500 ($365,750). 25.XI.87

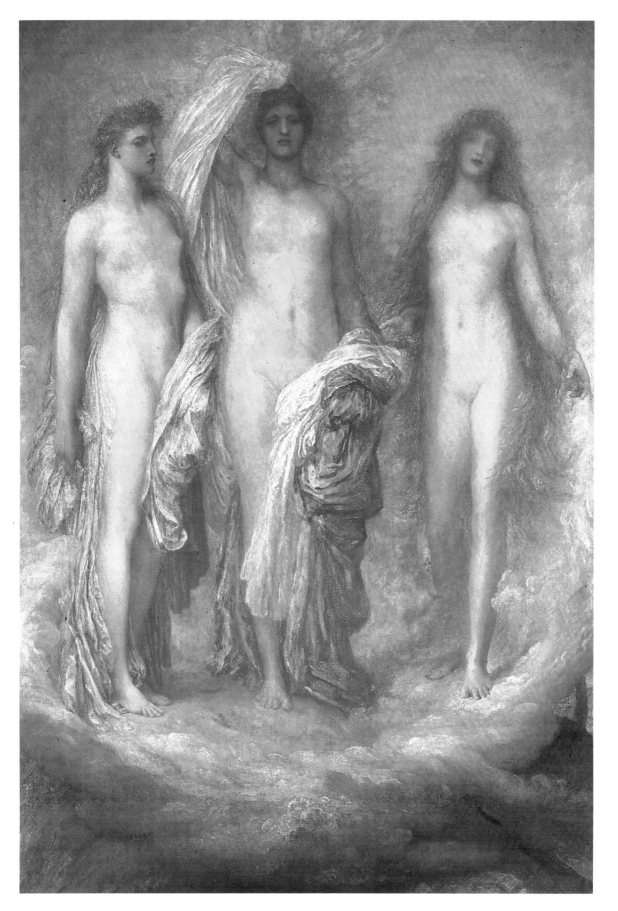

Albert Joseph Moore, ARWS
TOPAZ
Signed with enthemion, 1879,
36in by 17in (91.4cm by 43.2cm)
New York $715,000 (£382,353). 24.V.88
From the Estate of the late
Lillian Bostwick Phipps

Opposite
George Frederick Watts, OM, RA
OLYMPUS ON IDA
Signed and dated *1885*,
58⅛in by 40in (147.5cm by 101.5cm)
London £165,000 ($311,850). 21.VI.88

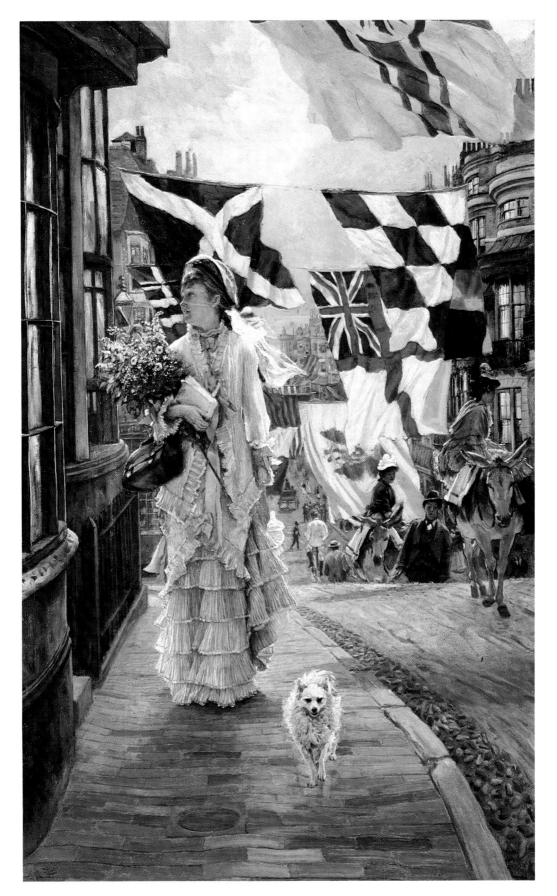

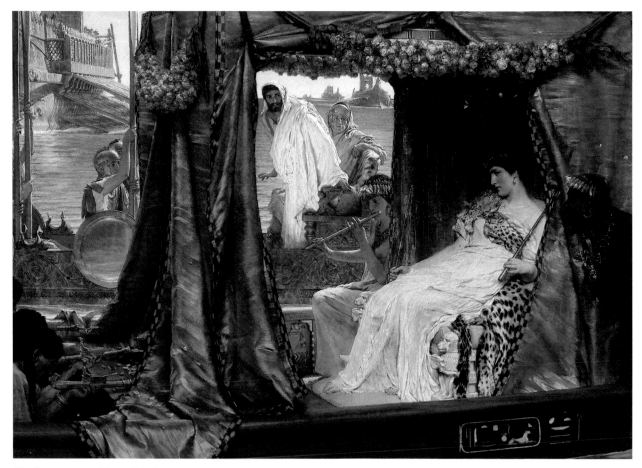

Sir Lawrence Alma-Tadema, OM, RA
ANTHONY AND CLEOPATRA
Oil on panel, signed and inscribed *Opus CCXLVI*, 1883,
25¾in by 36¼in (65.5cm by 92cm)
London £115,500 ($219,450). 25.XI.87

Opposite
James-Jacques-Joseph Tissot
A FETE DAY AT BRIGHTON
Signed, *circa* 1875–78, 34in by 21½in (86.4cm by 54.6cm)
New York $962,500 (£514,706). 24.V.88
From the Estate of the late Lillian Bostwick Phipps

Sir Alfred Munnings's
Start at Newmarket

In the eighteenth and nineteenth centuries, the British created a great tradition both of field sports and, to celebrate them, of sporting painting. Enthusiasm for the sports crossed the Atlantic, and so did an appreciation of the pictures. Sir Alfred Munnings has been a firm favourite with American collectors who have admired his bold brushwork and impressionistic palette. By the time he visited the United States in 1924 he already had a number of American clients whom he had met at hunts, race courses, and country homes in England. During this trip he painted numerous equestrian portraits of his wealthy admirers. Today Munnings remains popular, and in October 1987 *Start at Newmarket* brought a record price of $1,210,000, passing from one American collection to another.

Alfred Munnings was a passionate race-goer, who had seen 'quite a thousand starts on Newmarket Heath' and never tired of them. Of Newmarket Heath he once wrote, 'I am standing on the course – the most beautiful course in the world.' He painted many pictures on the theme, of which this is one of a series. Here the monumental size carries enormous visual impact and the horizontal format, emphasized by drifting clouds and long shadows, focuses on the tension and electricity at the beginning of the race. Munnings had developed this format almost ten years earlier employing as a support some old wardrobe doors with Newmarket studies of 'unruly horses starting up the canter: The long shape of the panels was new and interesting.' Munnings achieved excellent results on wood and used board rather than canvas for the present broadly painted oil. Dating from late in his career, this picture proves that Munnings had lost none of his ability to convey the personality of riders and horses, a skill acquired from a lifetime of observing them in action.

Munnings, who began drawing horses as a child, enjoyed long rides along country lanes and continued to ride up until the last months of his life. He spent much of his early career portraying the English countryside of his native Suffolk and later recording life around his country home in Essex, as well as the gypsy encampments and caravans that followed horse fairs throughout England. During the First World War, he was sent to France as an official war artist, which may have been the turning point in his career. He wrote, 'I have often wondered had there been no 1914–18 War whether painting people on horseback would have absorbed the greater part of my efforts in the years that followed.' Musing about horses, Munnings commented, 'Although they have given me much trouble and many sleepless nights, they have been my supporters, friends – my destiny in fact. Looking back at my life, interwoven with theirs – painting them, feeding them, riding them, thinking about them – I hope that I have learned something of their ways. I have never ceased trying to understand them.'

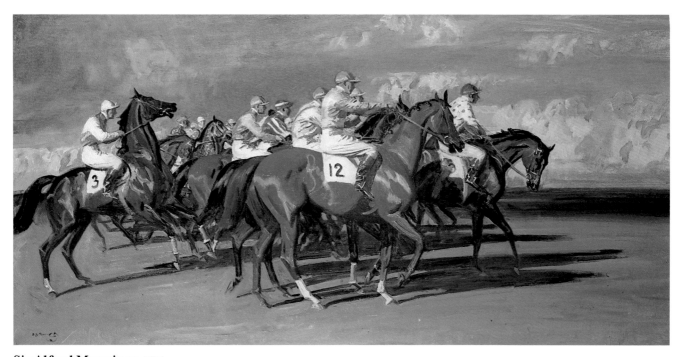

Sir Alfred Munnings, PRA
START AT NEWMARKET: STUDY NO.4
Oil on board, signed, 36½in by 72in (92.7cm by 182.9cm)
New York $1,210,000 (£703,488). 29.X.87

Sir Alfred Munnings, PRA
THE BLUE JOCKEY
Oil on panel, signed, 22½in by 26in (57.2cm by 66cm)
New York $275,000 (£159,884). 29.X.87

Sir William Nicholson
FLOWERS IN A LUSTRE POT
Oil on panel, signed with initial, *circa* 1932, 16in by 13in (40.5cm by 33cm)
London £39,600 ($74,844). 11.XI.87

Paul Nash
CHANGING SCENE
Signed, 1937, 26⅛in by 19¾in (66.5cm by 50cm)
London £57,200 ($113,828). 11.V.88
From the collection of Miss Ruth Clark

Stanley Spencer's *Punts Meeting*

Andrew Causey

Punts Meeting, painted in 1954, is part of the most ambitious project of Stanley Spencer's last decade, his scheme to recreate on a grand scale childhood memories of the annual summer regatta in his native village of Cookham. It is a fully realized vision. There is nothing that is tentative or indecisive, each image is complete and sharply bounded by a firmly drawn contour. Spencer exaggerates to gain extra effect, but his sharp eye for gesture and expression and his acute observations of styles of behaviour are nonetheless components of realism not caricature. *Punts Meeting* is Victorian in its love of narrative and meticulous devotion to detail: Spencer revells in the patterns and textures of the lavish clothes exposed in the bright sunlight. He had, as his brother Gilbert observed, 'a terrifying preoccupation with extraneous detail', reflected here especially in his obsessive attention to the pattern of woodgraining of the punts which did not, according to Gilbert, actually exist, but came out of Spencer's memory of the work of a Mr Bailey who used to 'produce this counterfeit on our kitchen doors and dressers'. Yet the painting's erotic undertones, recorded without apology, form an unabashed realism that is Spencer's challenge to the Victorians' ambivalence about the expression of emotion in art.

Gilbert Spencer remembered how the regatta emphasized class distinctions: 'There were those on the river and those on the bank. Those on the river collected themselves in groups, according to rank, and floated about together, holding onto one another's boats and punts, looking rather like gay little floating islands.' 'The regattas we knew,' he added, 'were Edwardian, but our attitude to them was Spencerian.' The Spencers were not members of the gentry, they belonged among those who viewed from the bank, outsiders observing the goings on with a certain awe. As Stanley later recalled with just a hint of bitterness in a letter to his wife Hilda in April 1953, when he was planning this picture, 'to sit in one of the punts seemed an unattainable Eden.'

Spencer took a high viewpoint for the composition of *Punts Meeting*, the viewpoint of someone looking down from Cookham bridge. This is the road bridge over the Thames next to Turk's boatyard which also features in *Swan Upping* (1915–19), now in the Tate Gallery. As children Stanley and Gilbert used to stand on the bridge on regatta evenings while their elder brother Will who, like their father, was a musician took part in concerts in the horseferry barge anchored below.

Punts Meeting is one of six pictures Spencer made out of a larger group he planned on the theme of 'Christ Preaching at Cookham Regatta'. In his mind the canvases were much more than nostalgic recollections of his Cookham boyhood, they were an attempt to make out of Cookham a heaven on earth, a happy and united community listening to the voice of Christ calling on the faithful at his Second Coming. *Punts Meeting* may seem peripheral to this theme in the sense that the occupants of the punts do not seem to be paying any attention to Christ (who appears in the central canvas of the group), as they greet one another and chat among themselves. The

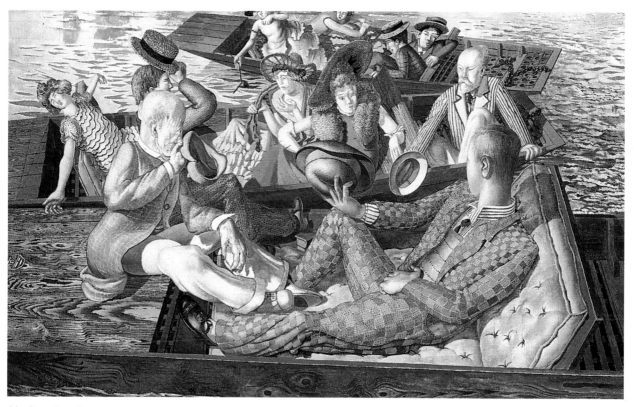

Sir Stanley Spencer, RA
CHRIST PREACHING AT COOKHAM REGATTA: PUNTS MEETING
1954, 31⅛in by 51in (79.1cm by 129.5cm)
London £429,000 ($810,810). 11.XI.87

One of six regatta scenes completed by Spencer, in addition to the large unfinished canvas, *Christ Preaching at Cookham Regatta*.

design is nonetheless a religious one in Spencer's terms, because he regarded community spirit as a form of spiritual expression, and Christ more as an inspirational figure spreading a message of fraternity and love than a figure of authority.

The history of Spencer's idea for this series goes back to the late twenties when he made a drawing, now lost, for a Christ with upraised arms preaching from the same horseferry by the Ferry Hotel next to Cookham bridge. It was not until 1952–53 that he started in earnest drawing out the compositions for the series attempting, almost certainly, to develop ideas presented in his astonishing picture *A Resurrection, Cookham*, the vast canvas that occupied much of his time in the mid-1920s before being bought for the Tate in 1927. *A Resurrection, Cookham* is a painting about the blessed rising from their tombs in the churchyard at the Second Coming and making their way not to heaven but in the direction of the river where a pleasure steamer is plying. Religious emotions were expressed there, as in the 'Christ Preaching' series, through a narrative that is largely secular. The religious/secular theme was developed in the 1930s in a plan for what Stanley called his Church House, a building that was to have been shaped like a church and filled like an art gallery with many of his own paintings on the theme of the Cookham community, biblical scenes realized in Cookham locations and images of sacred and profane love.

The 'Christ Preaching' series was a late addition to Spencer's plans for the Church House, which continued to be entertained as an idea even after he had come to realize that it would never be built. After the First World War he had been exceptionally fortunate in finding a patron, Louis Behrend, to sponsor the Memorial Chapel at Burghclere where he painted a record of his wartime experiences in Macedonia. For years Spencer hoped that another Louis Behrend would pay for his Church House scheme. But even when no patron emerged he could not put the idea of a massive celebration of Cookham out of his mind, and as Cookham Church was just by the river he came to think of the 'Christ Preaching at Cookham Regatta' series as appropriate decorations to what he called the 'river aisle' of the Church House. In the unfinished canvas, nearly eighteen feet long, that was to have been the 'altarpiece' of the group (The Viscount Astor Collection, on loan to the Stanley Spencer Gallery, Cookham), Christ is seen preaching to the redeemed on the Last Day. (Spencer disliked the phrase Last Judgement because he believed that everybody would be redeemed without the need for judgement.)

Spencer never finished the series. His ambition outran his physical strength and he was still working on the central canvas when he died in 1959. In effect Spencer acknowledged that the pictures would never hang together since he delivered *Punts Meeting* direct to his dealers, Arthur Tooth, in June 1954 as soon as it was finished, and it was quickly sold. In a sense this hardly matters since the individual pictures stand perfectly well by themselves.

Genuinely fascinated though he was by his curious secularized theology, what interested Spencer most of all was people. He cared about human beings, their everyday preoccupations and eccentricities. In *Punts Meeting* he enjoyed the little formalities of life like the raising of a hat (it is very much a picture about hats), people's gestures of surprise and pleasure as they meet and talk, and the self-absorption, by contrast, of a girl trailing a stick in the water, or the lassitude of another stretching her arms in the midday sun.

Sir Stanley Spencer, RA
SELF PORTRAIT
1951, 15in by 11in (38cm by 28cm)
London £79,200 ($149,688). 11.XI.87

Laurence Stephen Lowry, RA
UP NORTH
Signed and dated *1957*, 11⅝in by 15¾in (29.5cm by 40cm)
London £66,000 ($131,340). 11.V.88

Roderic O'Conor
NATURE MORTE AUX POMMES
Stamped with the mark of the atelier on the
reverse, 21⅜in by 14¾in
(54.5cm by 37.5cm)
London £55,000 ($109,450). 11.V.88

Francis Campbell Boileau Cadell, RSA, RSW

FLORIANS, ST MARKS, VENICE

Oil on panel, signed, inscribed *Venice* and dated *'10*; also inscribed with title on the reverse
and signed and inscribed with a title on a label, 18in by14$\frac{3}{4}$in (46cm by 37.5cm)

Hopetoun House £44,000 ($86,680). 26.IV.88

Samuel John Peploe, RSA
PEONIES AND FRUIT
Signed, 26¼in by 22in (66.5cm by 56cm)
Hopetoun House £127,600 ($251,372). 26.IV.88

Nineteenth-century European
paintings and drawings

Eduard Gaertner
BERLIN, A VIEW OF THE OPERNPLATZ, THE OPERA AND UNTER DEN LINDEN
Signed and dated *1845*, 16½in by 30¾in (41.9cm by 78.1cm)
Munich DM1,012,000 (£319,243:$595,294). 18.V.88

Opposite
Johan Laurentz Jensen
A STILL LIFE WITH FLOWERS AND CHERRIES ON A MARBLE LEDGE
Oil on panel, signed and dated *1848*, 31⅛in by 23½in (79cm by 59.5cm)
London £162,800 ($315,832). 23.III.88

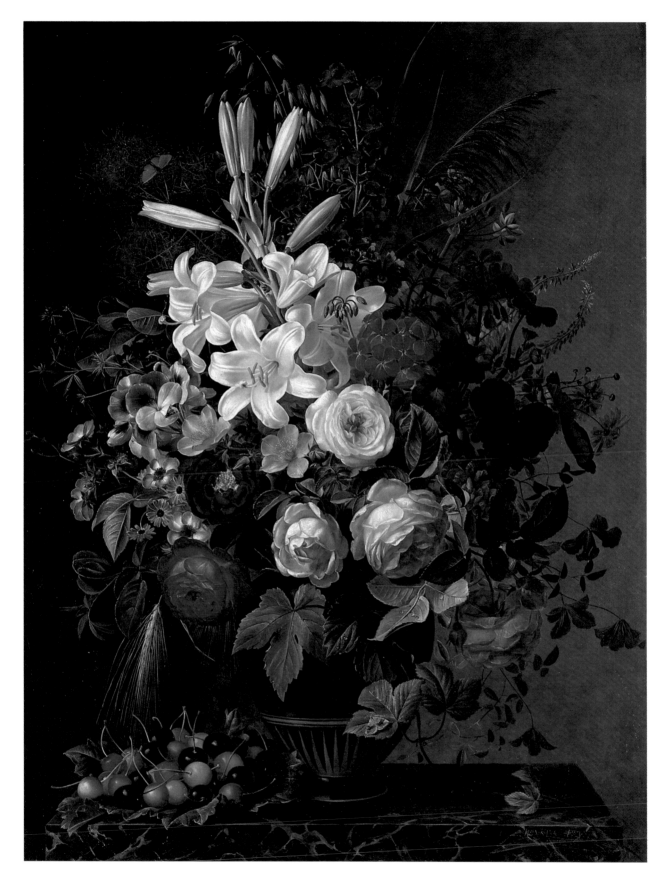

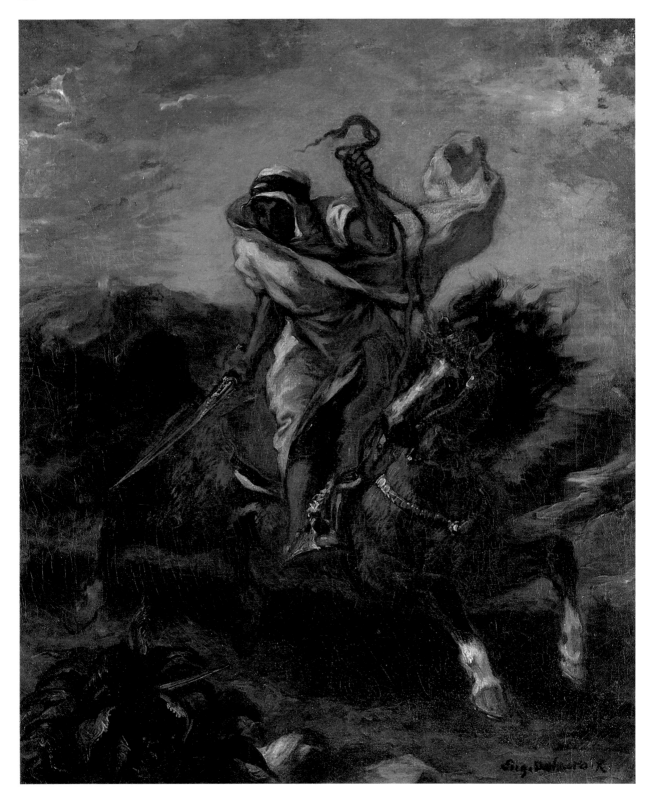

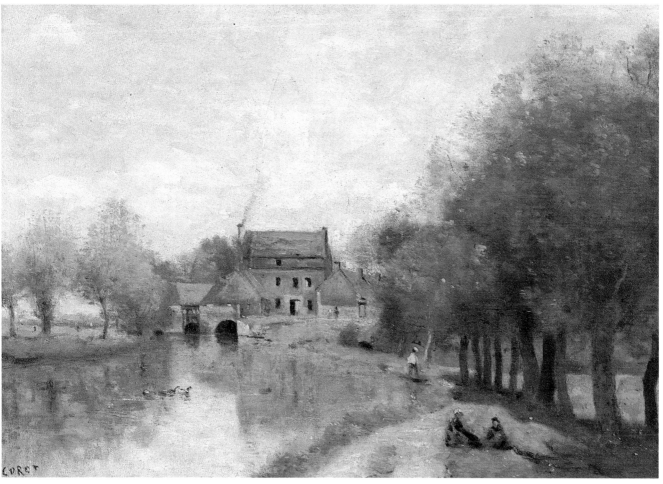

Jean-Baptiste Camille Corot
ARLEUX-DU-NORD.-LE MOULIN DROCOURT, SUR LA SENSEE
Signed, 1871, 16in by 22⅛in (40.6cm by 56.2cm)
New York $418,000 (£223,529). 24.V.88
From the collection of Mrs Charles Shipman Payson

Opposite
Eugène Delacroix
AN ARAB HORSEMAN AT THE GALLOP
Signed, 1849, 21¼in by 17¾in (54cm by 45cm)
London £913,000 ($1,725,570). 21.VI.88
From the collection of M. Alain Delon

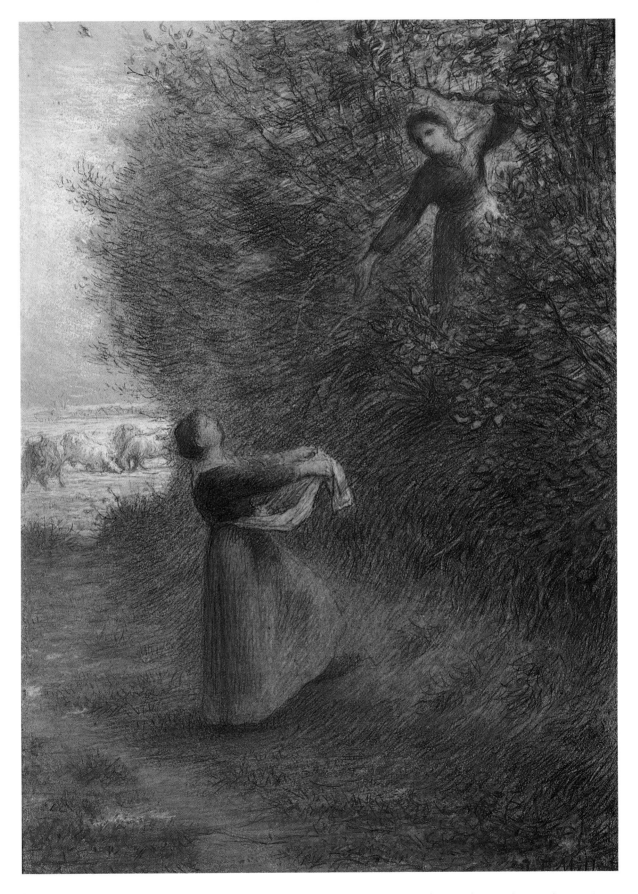

Gustave Courbet

LE CHENE DE FLAGEY, APPELE CHENE DE VERCINGETORIX

Oil on canvas laid down on board, signed and dated '*64*, 35in by 43¾in (88.9cm by 111.1cm)
New York $462,000 (£268,605). 29.X.87

This painting, the fifth in which Courbet chose a tree as the subject, follows in the Barbizon
tradition of celebrating particular trees. The oak, for Courbet, represented the strength of
the people and may also have been an unconsciously chosen self-image.

Opposite

Jean-François Millet

LES PETITES MARAUDEUSES

Pastel on paper, signed, *circa* 1865–66, 18⅝in by 13⅜in (47.3cm by 34cm)
New York $363,000 (£211,047). 29.X.87

Rupert Charles Wulsten Bunny
FEMME LISANT
Oil on board, signed, 20¾in by 29½in (52.7cm by 74.9cm)
New York $209,000 (£118,750). 24.II.88

The most important Australian painter of his generation, Bunny settled in Paris in 1886 to advance his career. He began exhibiting at the Royal Academy in 1887 and at the Paris Salon in 1889.

Opposite
Federico Zandomeneghi
JEUNE FILLE ARRANGEANT DES FLEURS
Signed, 24in by 19¾in (61cm by 50.2cm)
New York $209,000 (£121,512). 29.X.87

Giuseppe De Nittis
LA LEZIONE DI PATTINAGGIO
Signed, 1880, 21¼in by 29in (54cm by 73.7cm)
New York $313,500 (£182,267). 29.X.87

Opposite
Anders Zorn
HINDAR
Signed and dated *1908*, 35½in by 23½in (90.2cm by 59.7cm)
London £495,000 ($960,300). 23.III.88

Carl Moll
A PARK UNDER SNOW
Signed, 1904, 39⅜in by 39⅜in (100cm by 100cm)
London £93,500 ($175,780). 10.II.88

Opposite
Ferdinand Hodler
DIE EMPFINDUNG
Oil and pastel on paper laid down on canvas, signed, *circa* 1901–02,
14⅜in by 9⅞in (36.5cm by 25cm)
Zurich SF220,000 (£89,796:$164,179). 3.XII.87

Impressionist and modern art

Claude Monet
DANS LA PRAIRIE
Signed and dated '76, 23⅝in by 32¼in (60cm by 82cm)
London £14,300,000 ($24,882,000). 28.VI.88
From the collection of the late David David-Weill

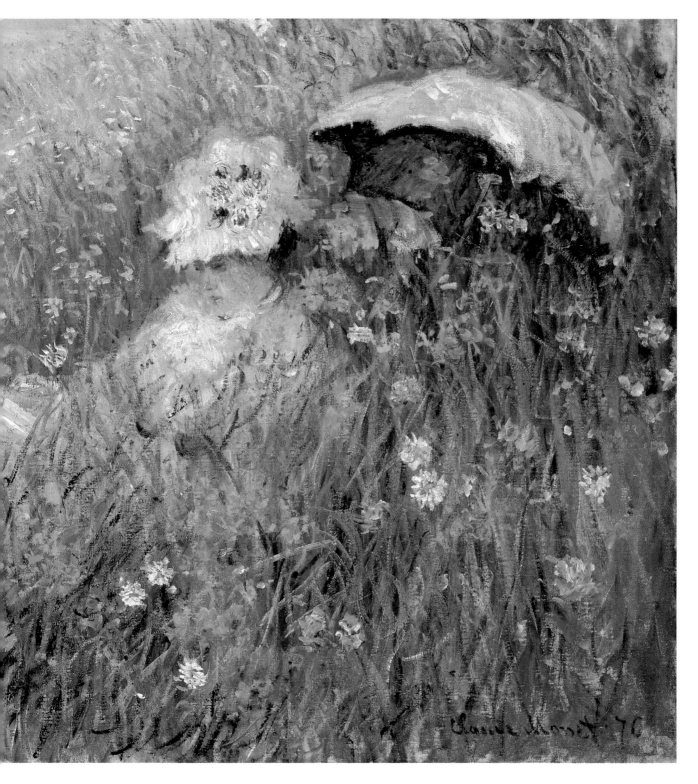

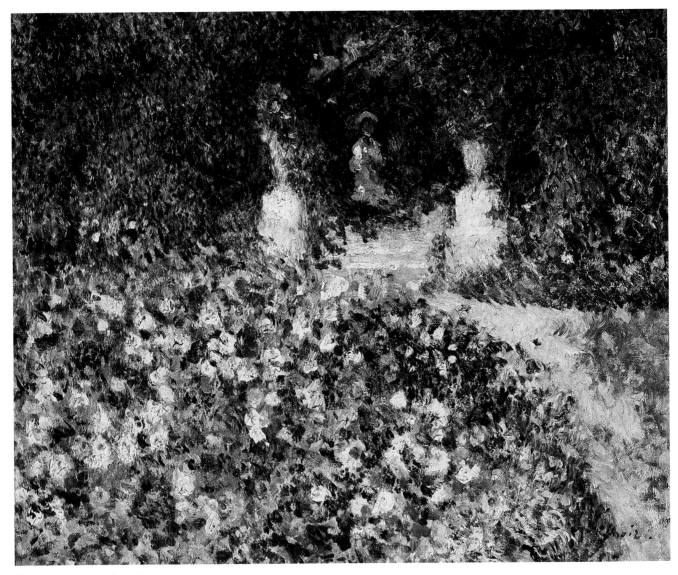

Pierre-Auguste Renoir
LE JARDIN OU DANS LE PARC
Signed, *circa* 1875, 21½in by 25⅝in (54.6cm by 65.1cm)
New York $6,600,000 (£3,510,638). 10.V.88

Opposite
Edgar Degas
PETITE DANSEUSE DE QUATORZE ANS
Bronze, muslin and satin ribbon, stamped with the foundry mark *A.A.Hébrard cire perdue* and
inscribed *HER*; inscribed *Degas* and inset with the foundry mark on the base, height 37½in
(95.3cm)
New York $10,120,000 (£5,382,979). 10.V.88
From the Estate of Belle Linsky

This work was the only one of Degas' sculptures exhibited during his lifetime.

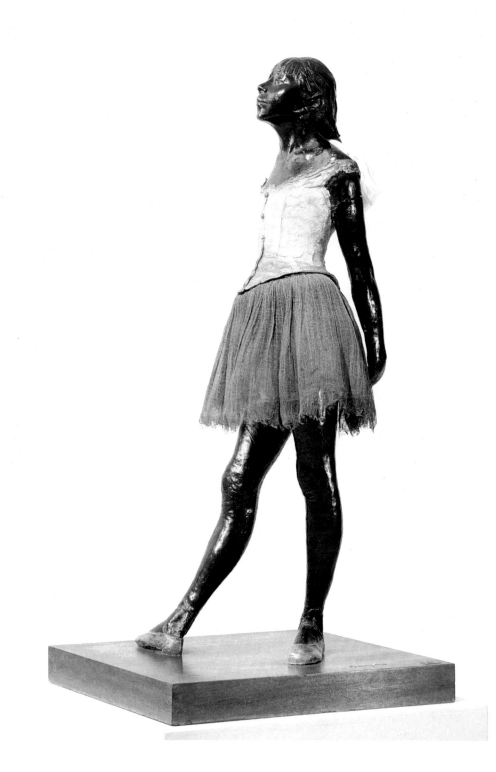

Paul Cézanne
SAINT-HENRI ET LA BAIE DE L'ESTAQUE
26¼in by 32⅝in (66.7cm by 83cm)
New York $6,820,000 (£3,627,660). 10.V.88

Cézanne worked in the region of the Bay of l'Estaque in 1876 and continued to do so for the next three years.

Paul Cézanne
LA COTE DU GALET, A PONTOISE
Circa 1879–80, 23⅝in by 29¾in (60cm by 75.6cm)
New York $9,240,000 (£4,914,894). 10.V.88

Claude Monet
LE JARDIN FLEURI
Signed and dated *1900*, 35in by 36¼in (88.9cm by 92.1cm)
New York $5,830,000 (£3,256,983). 11.XI.87
From the collection of Dr Alfred Blum

Opposite
Pierre-Auguste Renoir
MATERNITE OU FEMME ALLAITANT SON ENFANT
Signed and dated *86*, 29in by 21in (73.7cm by 53.3cm)
New York $8,800,000 (£4,680,851). 10.V.88

Painted in June 1886 at Essoyes, the sitters are Aline Charigot, whom Renoir married in
1890, and Pierre, their first son.

Van Gogh's *Irises*

Ronald Pickvance

Van Gogh's majestic *Irises*, sold by Sotheby's in New York on 11th November 1987, has a very distinguished French pedigree, for the painting remained in or near Paris for almost fifty years. Its first recorded owner was the influential writer and art critic Octave Mirbeau (1848–1917), who acquired it from the colour merchant Julien Tanguy. The manner of its acquisition was recounted in 1951 by Francis Jourdain in his autobiography, *Né en 76*:

'250 francs: that was, in 1891, the asking price for the *Irises*, that Mirbeau madly – yes, *madly* – wanted. And the *Sunflowers* were also priced at 250 francs. So? . . . He had only to buy the two canvases! But Mirbeau, the redoubtable and awesome Octave Mirbeau, in front of whom so many people trembled, trembled himself in front of his wife. At least he did not want to cause any suffering to the beautiful and very dear companion whose near morbid avarice must have often caused him cruel sufferings. How could he admit to her that he had succumbed to temptation and committed folly? He didn't admit it to her. She never knew the truth . . . Instead, Mirbeau wrote to Tanguy, asking him to collect from the publisher Charpentier, not 500 but 600 francs, then to send to his house the two coveted pictures. The pictures were to be accompanied by a letter ("This is very important for me and absolutely between ourselves") whose terms were precisely set out by Mirbeau and were not to be changed in any way. These were the lines that Tanguy had to copy carefully: "My dear Monsieur Mirbeau, you will receive today two canvases by Vincent that you admired at my shop. I have been charged to send them to you in gratitude for the articles you have written and for the faithful campaign that you have always led in favour of the painter of talent, misunderstood and unhappy . . . Tanguy".'

John Rewald has suggested that *Irises* may have been shown in the small exhibition of sixteen works by Van Gogh at the Barc de Boutteville gallery in April 1892. It was certainly lent by Mirbeau to the large retrospective exhibition held at Bernheim-Jeune in March 1901, where Hugo von Hoffmansthal and Vlaminck, each in his own way, discovered Van Gogh. Mirbeau lent the picture again to the Salon des Indépendants in 1905, when, with some forty-four other works by Van Gogh, it exercised its potent influence upon the burgeoning Fauves.

Shortly afterwards, Mirbeau sold *Irises*, which then entered the collection of the successful industrialist Auguste Pellerin (1852–1929). By 1900, Pellerin had formed a major collection of Manet's work. But his major claim to lasting fame was his collection of Cézannes: he eventually owned almost a hundred paintings from all phases of Cézanne's career. By contrast, he appears to have owned only three Van Goghs, none of them for very long, such was his all-consuming passion for Cézanne.

Irises – at what date and by whose intermediary we do not yet know – was then acquired by Jacques Doucet (1853–1929), the great Paris couturier. Doucet built up three notable collections of European paintings: first, of French eighteenth-century

paintings and drawings (sold in 1912), then of Impressionists and Post-Impressionists (partly sold in 1917) and finally, in his seventies, of twentieth-century works, among them Picasso's *Demoiselles d'Avignon* and examples by the Surrealists. Doucet owned three paintings by Van Gogh, two of which once belonged to Mirbeau: *Sunflowers* (F453), the first of the sequence of four painted in Arles in August 1888, as well as *Irises*. The distinctive 'Doucet-frame', heavy, polished and in the Art Deco style, still surrounds the painting.

Jacques Doucet died in 1929. In that year, *Irises* crossed the Atlantic to be part of the 'First Loan Exhibition, Cézanne, Gauguin, Seurat, Van Gogh', at the Museum of Modern Art in New York. Mme Jacques Doucet retained the painting, lending it to exhibitions in Paris (1931), Brussels (1935) and, most importantly, to the large display of Van Gogh's work during the 'Exposition Internationale' of 1937, in Paris. Soon afterwards Mme Doucet sold the picture to the art dealer Jacques Seligmann. *Irises* was subsequently acquired in 1947 from Knoedler's in New York, by Mrs Joan Whitney Payson and it remained in her family until the November sale.

Three very enlightened French collectors, then, shared *Irises* for almost half-a-century. Of these, the picture's first owner, Octave Mirbeau was certainly the most committed towards Van Gogh. He was among the pioneer collectors of the artist's work in Paris, eventually owning five examples. As well as *Irises* and *Sunflowers* (now in a private collection), Mirbeau acquired the small portrait of Tanguy (F263; Ny Carlsberg Glyptotek, Copenhagen), a small still-life of herrings (F285; Oskar Reinhart Collection, Winterthur), and *Wheatfield with Cypress* (F615; National Gallery, London).

One of the most astute and imaginative French art critics of the late nineteenth century, Mirbeau wrote perceptively and sympathetically on Degas, Monet, Pissarro, Rodin and Gauguin. After Aurier's ecstatic trail-blazing in his famous article on Van Gogh written in January 1890, it was Mirbeau's extended exposition on the front page of *L'Echo de Paris* in March 1891 that brought the Dutch artist before a wider public. Mirbeau regretted that he never met 'this painter, so magnificently gifted . . . this so thrilling, so instinctive, so visionary an artist.' While he may have seen *Irises* when it was shown at the Salon des Indépendants in 1889, he seems not to have written about it then. But once the picture entered his collection, friends often commented upon it. For example, Léon Daudet, son of Alphonse (whose novels Van Gogh greatly admired), recalled in 1926:

'I can see again, not many years ago, Monet talking with Mirbeau about another famous painter, Vincent van Gogh, on the subject of a path of irises that in Mirbeau's nervous, blond-haired hands shimmered gloriously in the light. "How" said Monet "did a man who so loved flowers and light, and who rendered them so well, how then did he still manage to be so unhappy".'

Mirbeau wrote another historic article on Van Gogh, at the time of the Bernheim-Jeune show in 1901. By then, he had read selections of the artist's letters: 'there isn't a more balanced spirit than his', insisted Mirbeau. He wrote of the paintings: 'The truth is that there isn't an art more healthy . . . there isn't art more really, more realistically painterly than the art of Van Gogh.' And in summing-up Van Gogh's paintings of flowers in 1891, the first owner of *Irises* unreservedly exclaimed: 'How well he has understood the exquisite nature of flowers!' ('Ah! comme il a compris l'âme exquise des fleurs!').

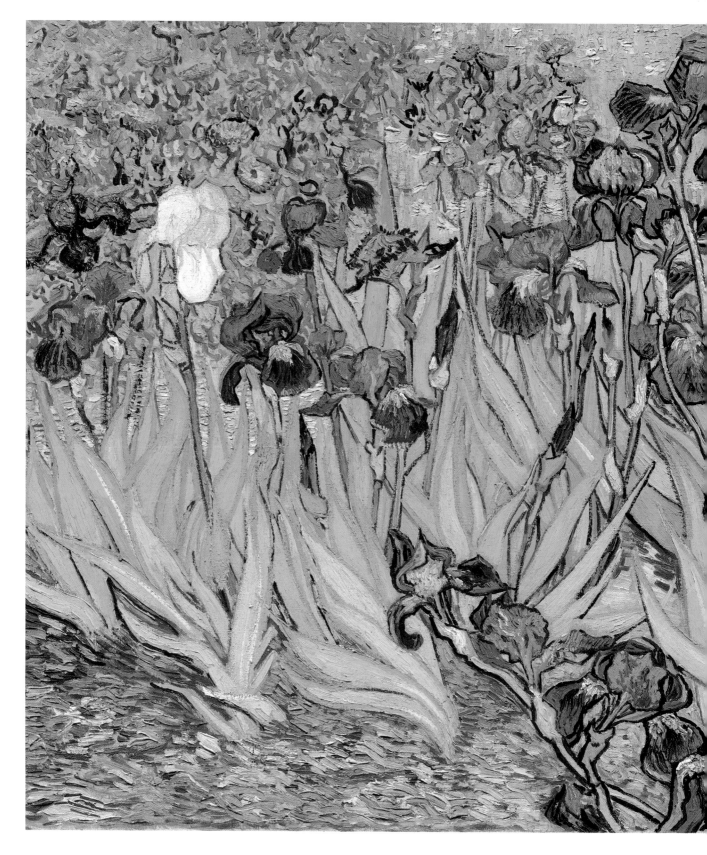

Vincent van Gogh
IRISES
Signed, 1889, 28in by 36⅝in (71cm by 93cm)
New York $53,900,000 (£30,111,731). 11.XI.87

This is the world record price for a work of art sold at auction.

Odilon Redon
LA GLOIRE
Charcoal on tan paper,
signed, *circa* 1890,
21in by 14½in
(53.3cm by 36.8cm)
New York
$418,000 (£236,158).
12.XI.87

Georges Seurat
HOMME ASSIS, LISANT, SUR UNE TERRASSE (LE PÈRE DE SEURAT)
Conté crayon, *circa* 1884, 12⅛in by 9⅛in (30.7cm by 23.3cm)
London £374,000 ($714,340). 2.XII.87

Lyonel Feininger
LES VELOCEPEDISTES
Signed and dated '*10*, 37⅝in by 33½in (95.5cm by 85cm)
London £781,000 ($1,538,570). 29.III.88

Painted in Berlin–Zehlendorf, this picture is one of the key works in Feininger's Fauve
period, which lasted from 1908 to 1911.

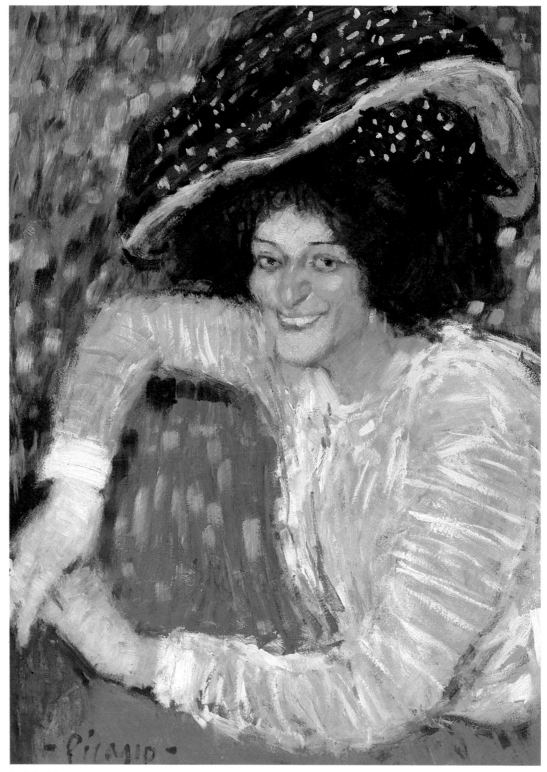

Pablo Picasso
BUSTE DE FEMME SOURIANTE
Oil on board laid down on panel, signed, 1901, $30\frac{1}{4}$ in by $22\frac{1}{2}$ (76.8cm by 57.2 cm)
New York $4,400,000 (£2,340,426). 10.V.88
From the Estate of Belle Linsky

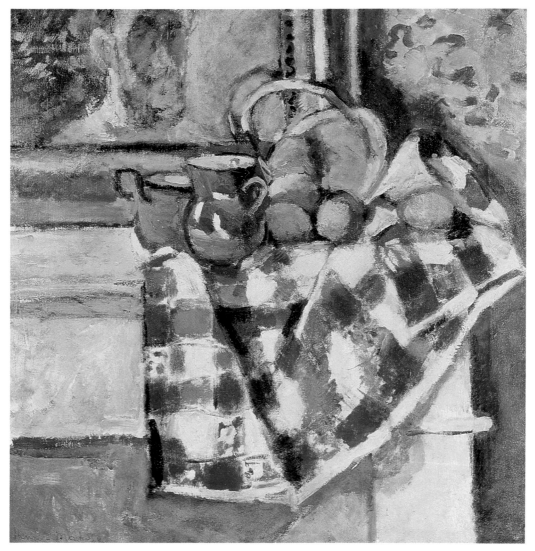

Henri Matisse
NATURE MORTE, SERVIETTE A CARREAUX
Signed, *circa* 1903–4, 20⅝in by 21¼in (52.5cm by 54cm)
London £1,375,000 ($2,640,000). 1.XII.87

This is one of Matisse's earliest Fauve paintings.

Opposite
Henri Matisse
NATURE MORTE AUX CITRONS SUR FOND FLEURDELISE
Signed and dated *3/43*, 1943, 28⅞in by 24⅛in (73.4cm by 61.3cm)
New York $5,720,000 (£3,042,553). 10.V.88
From the collection of the Museum of Modern Art, New York

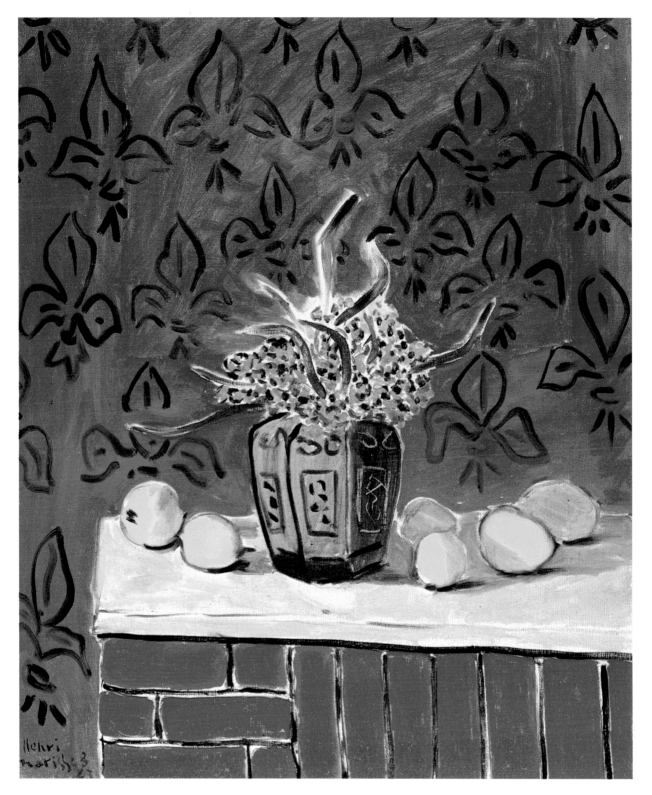

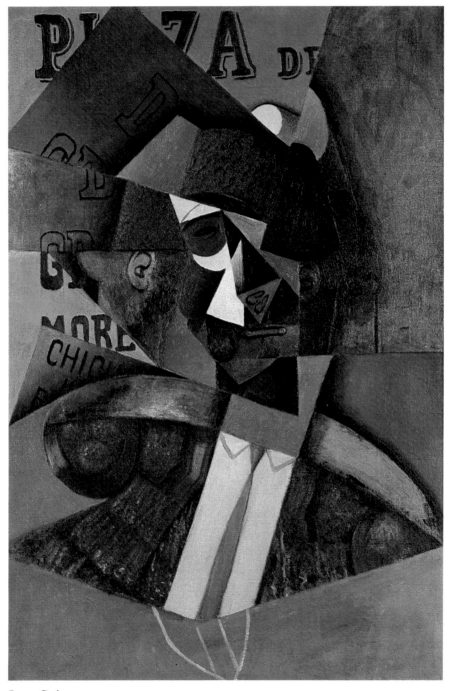

Juan Gris
LE TORERO
Signed and dated *Céret 8–13* on the reverse, 36¼in by 23⅝in (92cm by 60cm)
New York $1,980,000 (£1,106,145). 11.XI.87
From the collection of Mr and Mrs Jack Hemingway

Ernest Hemingway chose this painting as the colour frontispiece for the first
edition of his novel *Death in the Afternoon*, published in 1932.

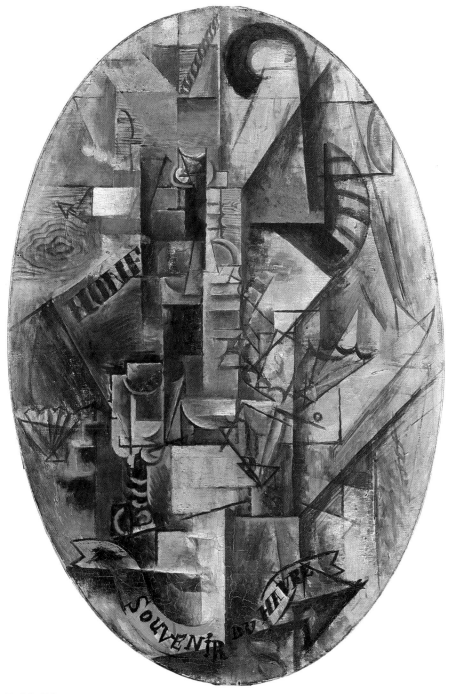

Pablo Picasso
SOUVENIR DU HAVRE
Signed on the reverse, 1912, 31¾in by 21⅛in (80.7cm by 53.8cm)
London £4,180,000 ($8,025,600). 1.XII.87

This picture is part of a group that forms a decisive turning-point in the
development of Picasso's Cubism. With the seven other oval paintings in the
group, it charts the artist's move away from the high 'analytic' style towards a
new 'synthetic' style that occupied him until 1914.

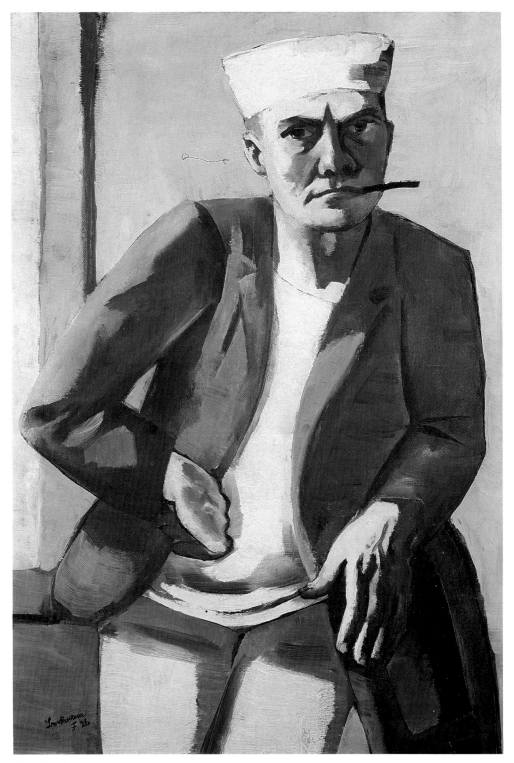

Max Beckmann
SELBSTBILDNIS MIT WEISSER MÜTZE
Signed and dated *F.26*, 39⅜in by 27¾in (100cm by 70.5cm)
New York $1,540,000 (£860,335). 11.XI.87

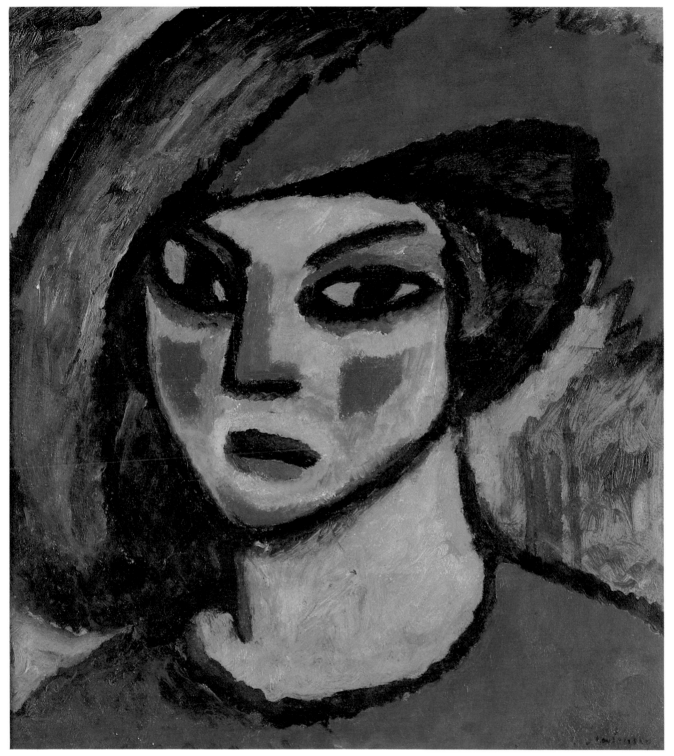

Alexej Jawlensky
DER ROTE FEDER
Oil on card laid down on board, signed, 1912, 21⅛in by 19¼in (53.5cm by 49cm)
London £539,000 ($937,860). 28.VI.88

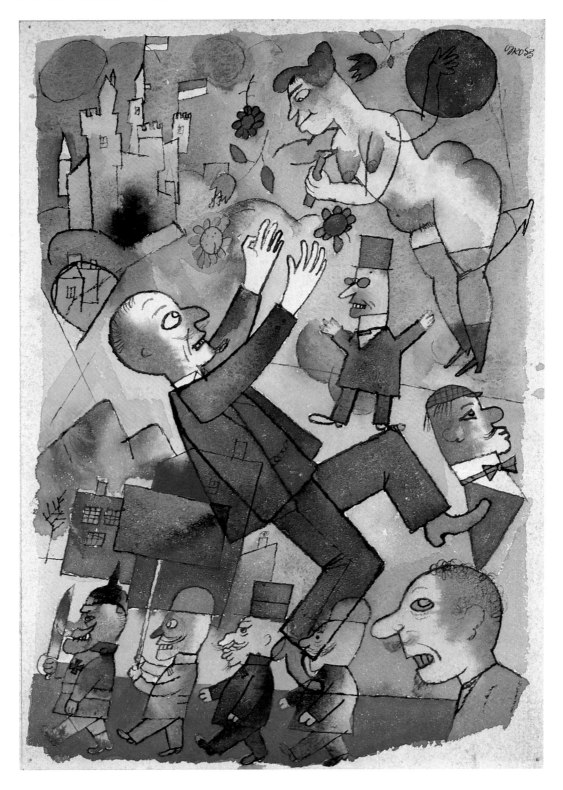

Paul Klee
AUF DER WIESE
Watercolour on paper, mounted on board, signed; also titled, numbered *93* and dated *1923* in the border, 9in by 12in (22.9cm by 30.5cm)
New York $742,500 (£394,947). 11.V.88

This is one of a group of whimsical compositions in which Klee used children's art with its disparities of scale. The stick-like figures, strung together, are suspended as notes from the lines of a musical score.

Opposite
George Grosz
SEHNSUCHT DES BÜROBEAMTEN
Watercolour and pen and indian ink, signed, 1918, 13⅜in by 9¾in (33.8cm by 24.9cm)
Munich DM286,000 (£91,666:$167,252). 8.VI.88

Pierre Bonnard
NU DANS LA BAIGNOIRE
Stamped with the signature, *circa* 1925,
40½in by 25¼in (103cm by 64cm)
London £2,200,000 ($3,828,000). 28.VI.88

Emil Nolde
GROẞER ROTER MOHN
Watercolour, signed, 13¾in by 18½in (35cm by 47cm)
Munich DM396,000 (£126,923:$230,233). 8.VI.88

Henri Matisse
NU ALLONGE
Pastel, signed, 1925, 12½in by 19in (31.7cm by 48.2cm)
London £594,000 ($1,140,480). 1.XII.87

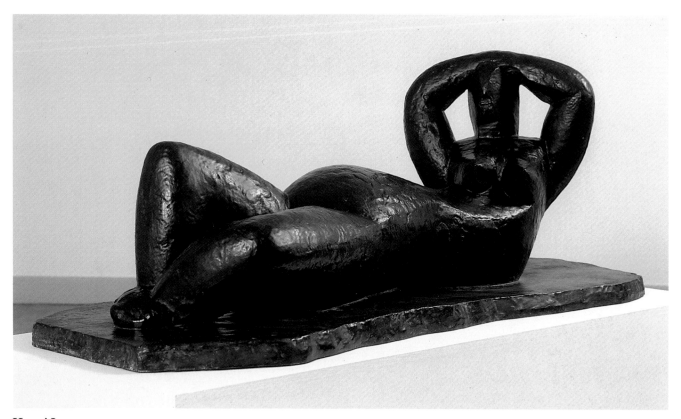

Henri Laurens
GRANDE MATERNITE
Bronze, signed and numbered *2/6* and stamped with the foundry mark *C. Valsuani, cire perdue*, 1932, length 55⅞in (142cm)
London £330,000 ($574,200). 28.VI.88

Russian avant-garde and contemporary Soviet art in Moscow

Matthew Cullerne Bown

The auction of avant-garde and contemporary Soviet art held by Sotheby's in July 1988 in Moscow, took place just over a year after the Soviets' own first attempt to sell the work of their young artists in this way. That event was vigorously conducted by a man who specialized in selling horses. Despite his charmingly forceful manner, many lots were unsold. Most people attending had no intention of buying: they were simply curious to see this unwonted commercial enterprise, taking place in a refurbished palace on Karl Marx Street. As a social event, however, it was a triumph: Raisa Gorbachev paid it a visit. Auctions had acquired *cachet*; it remained to make them effective.

Both the above auction and that held by Sotheby's are clear signs that a new dawn is breaking in Soviet art, characterized by official tolerance of all sorts of styles and tendencies which were once opposed by the authorities. Pride is now taken in artists who were previously excluded from favour, including many of those who belonged to the non-conformist art movement. The content of Sotheby's auction provided a concise overview of this movement. It allowed one to outline the descent and development of ideas from artists who emerged in the early 1960s to those who have begun to make a name in the 1980s.

In the years after Stalin's death in 1953, the Soviet art world polarized. The non-conformist, or unofficial, artists who emerged made work that was resolutely opposed to the prevailing norms. The first coherent manifestation of non-conformism was an informal studio run in the late 1950s and early 1960s by Eli Belyutin in Moscow's Arbat. Belyutin was also a teacher at the Polygraphic Institute, a leading art school. Like so many pioneers of that time, he wore two hats, one official, the other unofficial, and in this way the cultural Establisment already began to lose the monolithic quality which Stalin had prized.

Two artists associated with Belyutin in those days were Ilya Kabakov and Vladimir Yankilevski, both now in their fifties. Yankilevski took part in the famous Manezh exhibition of 1962, where the sculptor Ernst Neizvestny and Mr Khruschev had a blazing row. Kabakov and Yankilevski typify the two main ways in which non-conformist artists strove to create an alternative to the unquestioning social enthusiasm of Soviet art of the period.

Grisha Bruskin at his studio.

Yankilevski's work represents a withdrawal from overt social engagement in favour of spiritual contemplation. The core of his work over the last 25 years is a body of large triptyches. The complex interrelation of different parts of a painting helps Yankilevski present what he calls 'the simultaneity of various existential states in one work'. This presentation is always highly metaphorical, as close to surrealism as to simple narrative. Yankilevski's art seeks, ultimately, to transcend the intellect. This unites it with a recurrent mystic yearning in Russian art, originating with the tradition of icon-painting imported from Byzantium.

Other artists of Yankilevski's generation, such as Dimitri Plavinski and Vladimir Nemukhin, make work which demands an equally metaphorical reading. His influence can also be seen on younger artists. Evgeni Dybsky, like an icon-painter working with a template sanctified by usage, returns always to the landscape of the Crimea for inspiration. Dybsky's understanding of the spiritual mission of Russian art is combined with an awareness of the central tenet of Western Modernism, that of the canvas-as-object. This combination makes him one of the most highly-developed of young Russian artists.

While the auction afforded a view of this meditative tendency in contemporary Russian art, it also presented the work of artists who have chosen to engage explicitly with the challenges posed by communist ideology. Ilya Kabakov recognizes the demand, deeply-rooted in Russian culture, for art which operates in an avowedly

social context. He has chosen to use for his own ends some of the stereotypical means of expression which permeate Soviet visual art. Paradoxically, these very stereotypes – dry academic paint-handling, for example, and the combined use of image and text (see Fig.3) – are conventionally the vehicles for the kind of unsophisticated, but pervasive, proselytism which Kabakov is at such pains to counteract.

Kabakov also counters lack of sophistication. His utterances are Aesopian. He is an intellectual – a role he vindicates by the concerned and influential nature of his art. But for all his ceaseless attempt to define the nature of his relationship to the Soviet State, Kabakov's art draws on a reserve of simple human experience. He sometimes returns, for example, to his recollection of life in communal apartments during the 1950s as a source for the snatches of dialogue in his paintings. This enables him to avoid the dryness which must otherwise attach to such an astringent critique.

Many young artists are indebted to Kabakov. Vadim Zakharov contrives equally enigmatic, if less sedate, fragments of text, and seems to aspire to the same kind of oracular persona as Kabakov possesses. The exploitation by Kabakov and spiritual *confrères* such as Erik Bulatov of some of the cliches of Soviet art has paved the way for younger artists. Grisha Bruskin is ironically fired by the ubiquitous cheap statuary, expressing ideals of health, beauty and moral achievement, which peppered the Soviet Union during his childhood (see Fig.4).

While Kabakov, Yankilevski and others represented one pole of Soviet art in the difficult decades of the 1960s and 1970s, the diametrically opposed ice-cap was beginning to thaw. The narrow boundaries of official art were being pushed wider and wider. The auction allowed us to see the work of some of the pioneers of this process, one which has continued to the point where, today, the old official-unofficial distinction is often difficult to justify.

The odd figure, such as Ilya Tabenkin, already stood out in the 1960s as someone following his own lonely path. Born in 1914, he attended art school in Samarkand, that being where the Surikov Institute removed to during the War, and emerged from painting conventional realist pictures in the 1950s to create his own intimate, poignant world. Around 1970, Nataliya Nesterova, Tatiana Nazarenko and Arkadi Petrov were among those ambitious painters who found a way out of the thickets of academic technique and hackneyed subject-matter by turning to neglected aspects of the Russian artistic heritage. They were inspired variously by folk-art,

Fig.1 *Opposite*
Alexander Rodchenko
LINE
Stamped with the signature, numbered *125* and dated *1920* on the reverse,
23in by 20⅛in (58.5cm by 51cm)
Moscow £330,000 ($567,600). 7.VII.88
From the collection of the Rodchenko family

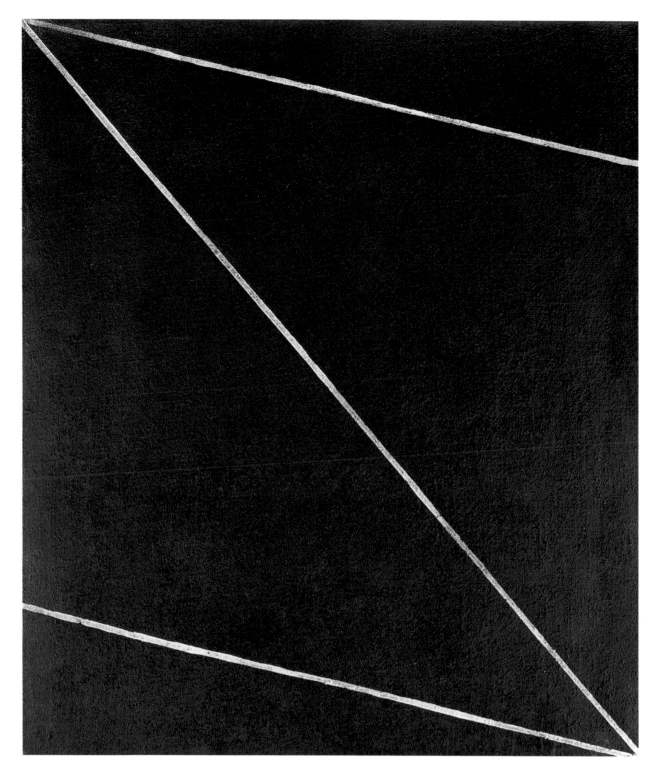

serf-painting, popular religious imagery, and even, in Petrov's case, by the sentimental effusions of Russian kitsch.

All this bespeaks a self-absorption which is indeed one of the traits of Russian art, and has been ever since the ascetic manner of Byzantium arrived many centuries ago. Even so, artists in Moscow and Leningrad, in the so-called European part of Russia, are acutely aware of their cultural proximity to the West. They realize that much of their practice is coloured by what they have shared, at one time or another, with Europe, be it the academic technique of Socialist Realism or the striving towards abstraction in the Revolutionary period.

The movements of this period – Constructivism, Suprematism, Rayonism, Cubo-Futurism – are the best-known manifestations of Russian art in the West. This is understandable in view of the influence artists such as Malevich, Tatlin and Rodchenko have exerted on the development of Western art. The auction, by prefacing the sale of contemporary paintings with a selection of work by Rodchenko (see Figs 1 and 2), Stepanova, Udaltsova and others, implicitly raised the question: what is the relationship of artists today to the art of the Avant-garde?

All manner of artists owe it an obvious stylistic debt. Edward Steinberg is an excellent example (his father actually attended one of the *VKhUTeMas*, the revolutionary art-schools of the 1920s). But even in his case it is clear that the debt to Suprematism is not acknowledged in the purely formal terms of, say, Frank Stella, but on a metaphorical level as well. The form of a cross, familiar from the work of Malevich, is re-invested in Steinberg's work with religious significance, as an element in his lament for the passing of traditional Russian village life.

However, for many artists the era of the Avant-Garde has a broader significance. It was an era of enormous creative vitality, of great idealism, a period when artistic and social ideas were bandied about with an adventurousness that has not been seen since. It was also the one time in their history when Soviet artists participated fully in the cultural life of Europe as a whole. The decade or so before Stalin's suffocating curtain began to fall is now widely extolled in the USSR as a Golden Age of Soviet art.

Vadim Zakharov is one of a number of young artists who perform collectively as the self-styled Club of Avant-Gardists. They attempt to animate the contemporary art-world with some of the anarchic energy of the Revolutionary period. Their performances are often extremely satirical at the expense of the Soviet government. In a similar vein, if one considers Sergei Shutov's exuberant paintings and installations in the light of the Soviet art-world's former ethical sobriety, they imply not only an artistic, but a social iconoclasm, a challenge to moral austerity.

Developments today suggest that an age analogous to the 1920s, allowing creativity to burgeon in an international context, could come again to Soviet art after a hiatus of more than half a century. As far as one or two artists of the older generation are concerned, notable among them Ivan Chuikov, an internationalist instinct, a peculiarly Western flavour of artistic ideas, has always been cherished through thick and thin. But it is the younger generation, artists such as Irina Nakhova, Svetlana Kopystianskaya and her husband Igor (see Figs 5 and 6) and Sergei Volkov, who seems most emphatically to demand an international arena for their work. The auction was a landmark on the road taking Soviet art in that direction.

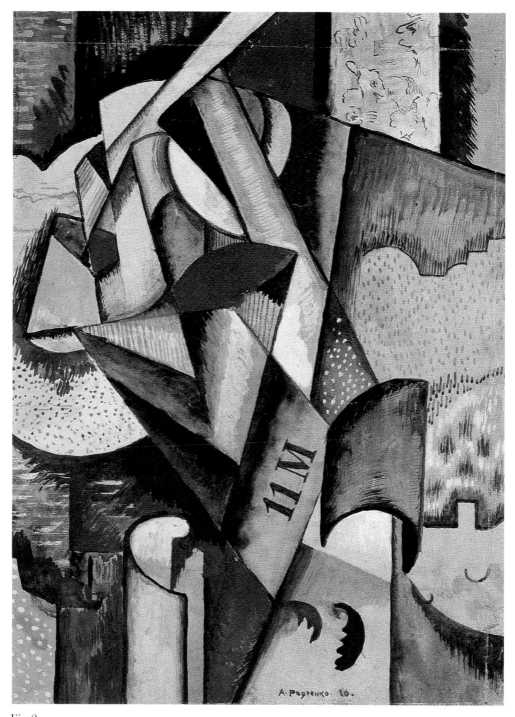

Fig.2
Alexander Rodchenko
COMPOSITION
Gouache on heavy paper, signed and dated '*16*, $10\frac{5}{8}$ by $7\frac{7}{8}$in (27cm by 20cm)
Moscow £198,000 ($340,560). 7.VII.88
From the collection of the Rodchenko family

Fig.3
Ilya Kabakov
THE ANSWERS OF THE EXPERIMENTAL GROUP
Oil, alkit enamel and handwritten text in black ink on board, signed and dated *1970–1971* on
the reverse, 57$\frac{7}{8}$in by 145$\frac{5}{8}$in (147cm by 370cm)
Moscow £22,000 ($37,840). 7.VII.88

Fig.4
Grisha Bruskin
FUNDAMENTAL LEXICON
Oil on thirty-two canvases, each signed; dated *1986* on the reverse,
overall size 86⅝in by 119⅝in (220cm by 304cm)
Moscow £242,000 ($416,240). 7.VII.88

Fig.5
Svetlana Kopystianskaya
LANDSCAPE
Oil, tempera and handwritten text on canvas, signed and dated *1988* on the reverse,
49¼in by 65in (125cm by 165cm)
Moscow £44,000 ($75,680). 7.VII.88

Fig.6
Igor Kopystiansky
RESTORED PAINTING: NO.5
Signed and dated *1987* on the reverse, 76¾in by 61in (195cm by 155cm)
Moscow £44,000 ($75,680). 7.VII.88

Contemporary art

Willem de Kooning
WOMEN SEATED AND STANDING
Pastel and charcoal on paper, signed, 1952, 21⅛in by 24⅜in (53.7cm by 61.9cm)
New York $1,210,000 (£647,059). 2.V.88

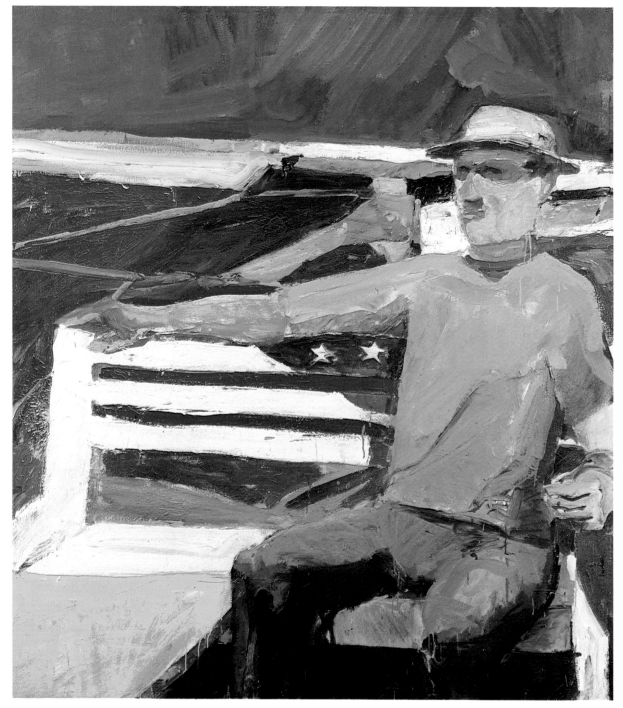

Richard Diebenkorn
JULY
1957, 59in by 54in (149.9cm by 137.2cm)
New York $1,155,000 (£617,647). 2.V.88

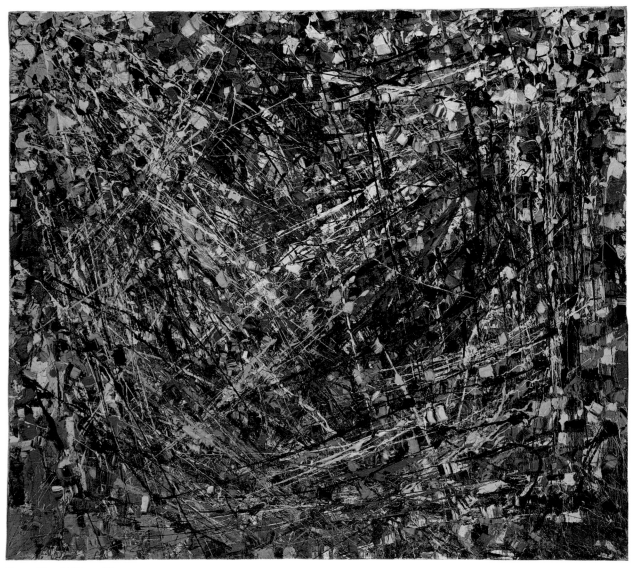

Jean-Paul Riopelle
FILETS FRONTIERE
Signed and dated '51; also signed, titled and dated '51 on the reverse,
41in by 47⅝in (104cm by 121cm)
London £242,000 ($440,440). 30.VI.88
From the collection of the late D. J. Chandris

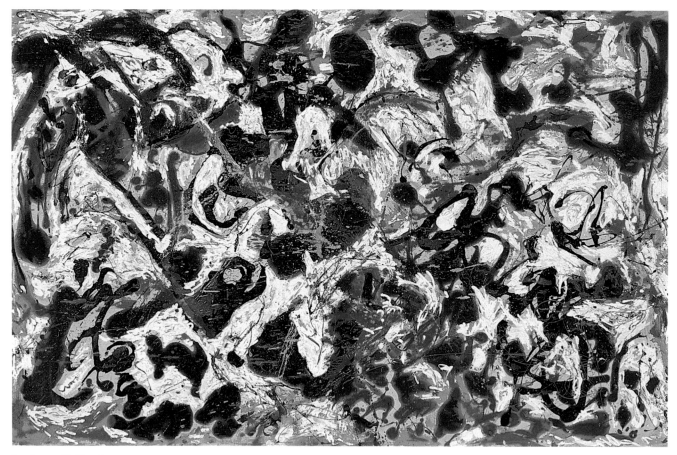

Jackson Pollock
SEARCH
Oil and enamel on canvas, signed and dated *55*, 57½in by 90in (146.1cm by 228.6cm)
New York $4,840,000 (£2,588,235). 2.V.88
From the Estate of Belle Linsky

This is believed to be the last canvas painted by Pollock prior to his death in 1956.

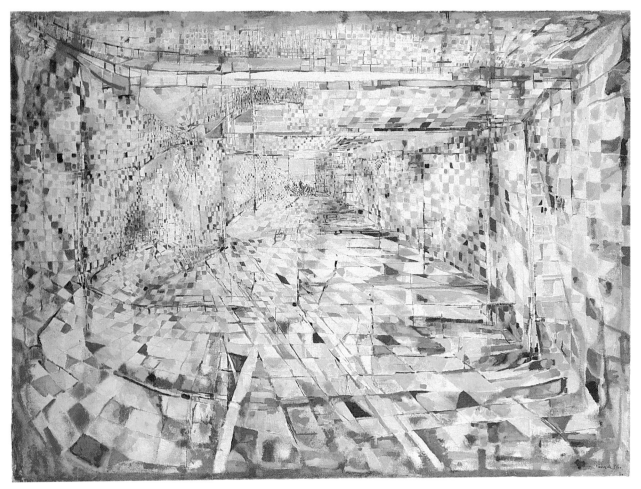

Maria-Helena Vieira da Silva
COMPOSITION (LE REVE)
Signed and dated '49, 50in by 68½in (127cm by 174cm)
London £247,500 ($475,200). 3.XII.87

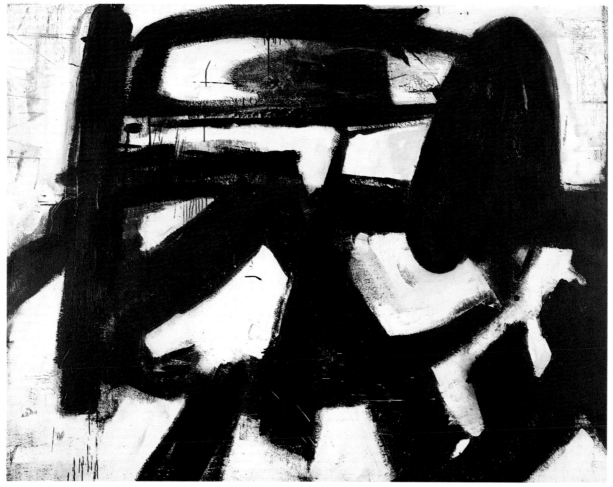

Franz Kline
NINTH STREET
Signed, 1951, 60⅛in by 78in (152.7cm by 198.1cm)
New York $1,870,000 (£1,000,000). 2.V.88
From the Estate of Belle Linsky

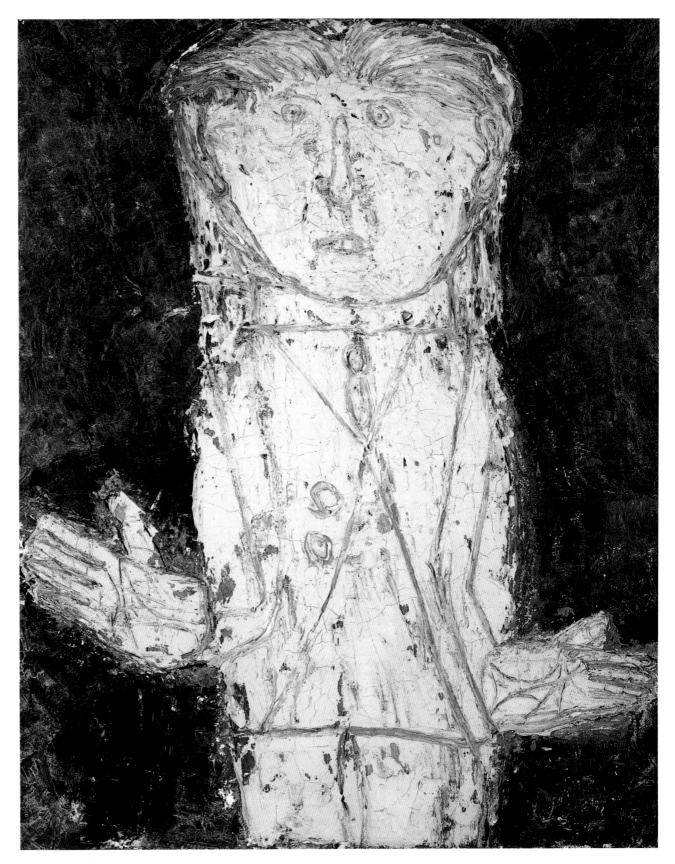

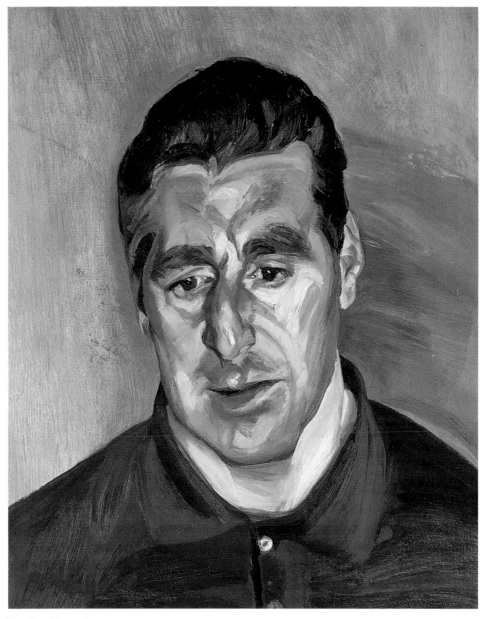

Lucian Freud
HEAD OF A MAN
Signed and dated *1966* on the reverse, 18¼in by 15⅜in (46.5cm by 39cm)
London £275,000 ($500,500). 30.VI.88
From the collection of Mr H. J. Renton

Opposite
Jean Dubuffet
MAAST A CRINIERE (PORTRAIT DE JEAN PAULHAN)
1946, 43¼in by 35½in (110cm by 90cm)
London £616,000 ($1,121,120). 30.VI.88

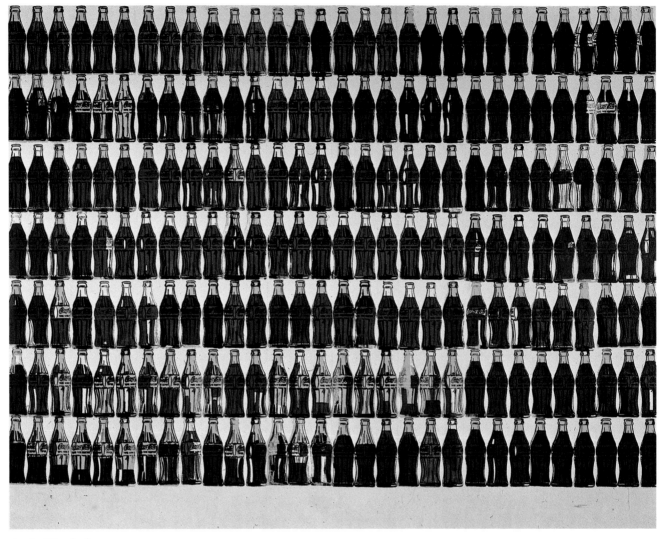

Andy Warhol
210 COCA-COLA BOTTLES
Oil and stencil on canvas, signed and dated *62* on the reverse
82½in by 105in (209.6cm by 266.7cm)
New York $1,430,000 (£764,706). 2.V.88

Malcolm Morley
DAY FISHING IN HERAKLION
Signed; also signed and titled on the reverse, 1983, 80in by 90in (203.3cm by 228.6cm)
New York $396,000 (£226,286). 4.XI.87
From the collection of Xavier Fourcade

This painting was among the artist's works exhibited at the Tate Gallery, London in 1984
when he was awarded the first Annual Turner Prize.

American art

Raphaelle Peale
CAKE AND WINE
Oil on panel, signed and dated *1813*, 8in by 11½in (20.3cm by 29.2cm)
New York $495,000 (£275,000). 3.XII.87

Thomas Moran
THE CLIFFS OF GREEN RIVER, WYOMING
Signed with monogrammed signature and dated *1900*, 20½in by 30½in (52.1cm by 77.5cm)
New York $374,000 (£207,777). 3.XII.87

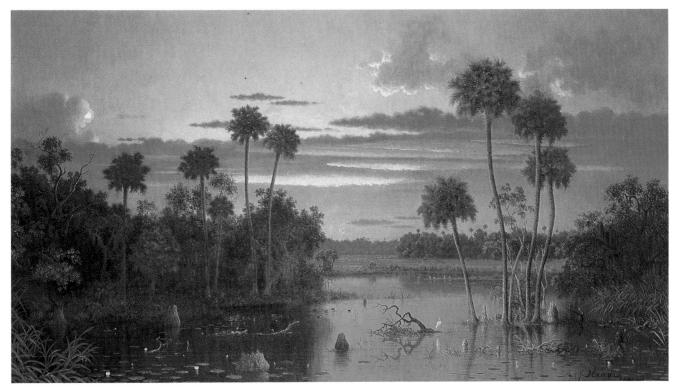

Martin Johnson Heade
THE GREAT FLORIDA SUNSET
Signed and dated *1887*, 53in by 96in (134.6cm by 243.8cm)
New York $1,650,000 (£887,097). 25.V.88

Opposite, above
Martin Johnson Heade
TWO FIGHTING HUMMINGBIRDS WITH TWO ORCHIDS
Signed and dated *1875*, 17½in by 27¾in (44.5cm by 70.5cm)
New York $1,925,000 (£1,069,444). 3.XII.87

This painting, from the collection of the Whitney Museum of American Art, was sold to establish a purchase fund for twentieth-century American art in the name of the donor, Henry Schnakenberg, as a memorial to Juliana Force.

Below
John Frederick Kensett
COASTAL SCENE AT NEWPORT
Signed with monogram and dated *'64*, 20in by 31in (50.8cm by 78.7cm)
New York $616,000 (£342,222). 3.XII.87

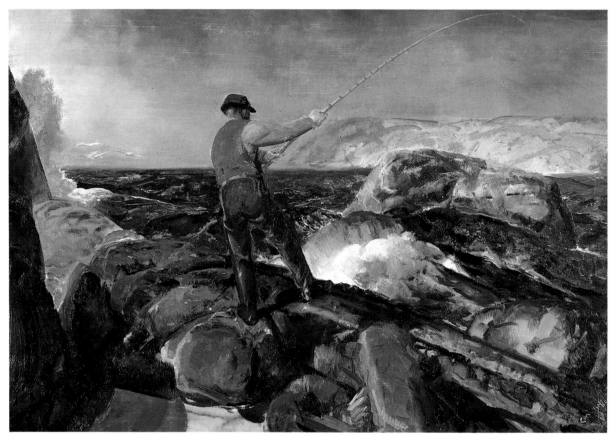

George Bellows
THE FISHERMAN
Signed, 1917, 30in by 44in (76.2cm by 111.8cm)
New York $1,430,000 (£768,817). 25.V.88
From the collection of Mrs Charles Shipman Payson

Opposite, above
Winslow Homer
SUMMER CLOUD
Watercolour, signed and dated *1881*, 13½in by 19½in (34.3cm by 49.5cm)
New York $572,000 (£307,527). 25.V.88

Below
Winslow Homer
WHERE ARE THE BOATS? (ON THE CLIFFS)
Watercolour, signed and dated *1883*, 13in by 19in (33cm by 48.3cm)
New York $638,000 (£354,444). 3.XII.87

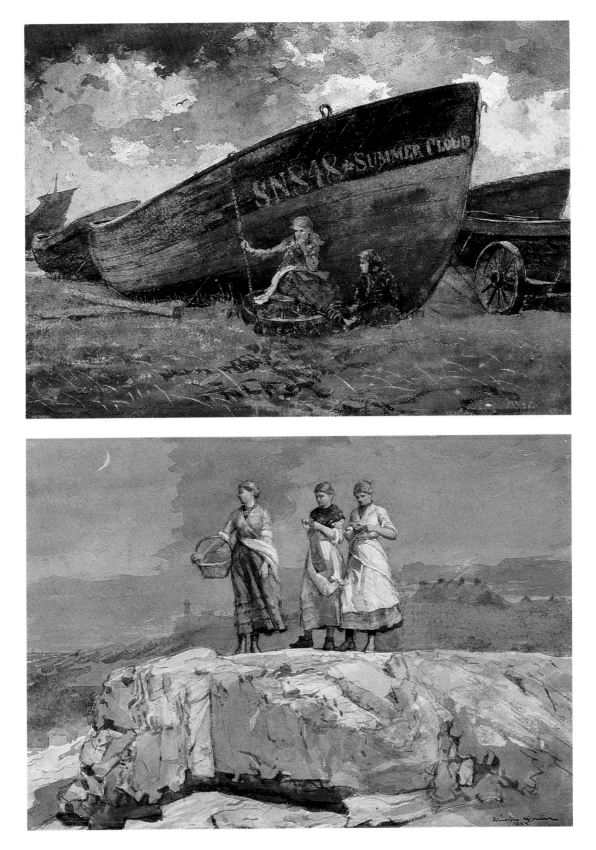

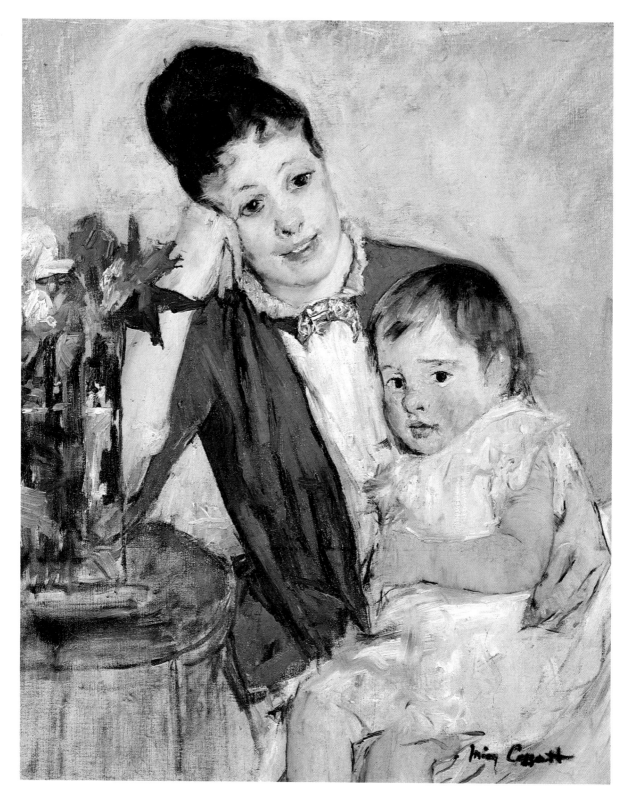

Frederick Carl Frieseke
ON THE RIVER
Signed, 25¾in by 31¾in (65.4cm by 80.7cm)
New York $638,000 (£343,011). 25.V.88

Opposite
Mary Cassatt
MADAME H. DE FLEURY AND HER CHILD
Signed, 1890, 28¾in by 23½in (73cm by 59.7cm)
New York $2,090,000 (£1,123,656). 25.V.88
From the Estate of the late Lillian Bostwick Phipps

Preston Dickinson
STILL LIFE NO.1
Signed, *circa* 1924, 24in by 20in (61cm by 50.8cm)
New York $374,000 (£207,777). 3.XII.87

Opposite
John White Alexander
ALETHEA
Signed and dated '95, 63½in by 52½in (161.3cm by 133.4cm)
New York $517,000 (£277,957). 25.V.88

Willard L. Metcalf
MAYTIME
Signed and dated *1919*, 36in by 39in (91.4cm by 99.1cm)
New York $638,000 (£343,011). 25.V.88

Opposite
Paul Manship
THE DUCK GIRL
Bronze, signed and dated *Roma 1911*, height 62in (157.5cm)
New York $363,000 (£195,161). 25.V.88

Edward Hopper, 1882–1967

Gail Levin

Edward Hopper once remarked of artists in general: 'Ninety per cent of them are forgotten ten minutes after they're dead.' Cynical about the role of critics and changing fashions in the arts, Hopper would never have imagined that twenty years after his death, one of his canvases would sell for more than two million dollars. He felt that his career, which lasted until his death in 1967, just before his 85th birthday, had been one of struggle for recognition. Late in life, Hopper was particularly concerned that his work was unfairly eclipsed by the amount of attention given to the Abstract Expressionists during the 1950s. Since the last major retrospective of Hopper's work toured internationally in 1981, his reputation and his prices have climbed dramatically. His position as the major twentieth-century American realist is now secure.

Admirers of Hopper's work often perceive the alienated artist's preference for solitude as loneliness. This theme is present in both of Hopper's oils sold at record prices last year, *Captain Upton's House* (Fig.1) and *Hotel Window* (Fig.2). These two paintings represent two other Hopper themes: rural New England and the urban environment of New York City.

Hopper, who was born in Nyack, New York, a small town located on the Hudson River just north of New York City, made his home in the City after attending art school there. By 1913, Hopper had settled in a simple studio on the top floor at 3 Washington Square North, where he would remain for the rest of his life. But, from his youth, he was also drawn to the sea and spent most of his summers painting along the rugged New England coast. Initially, this was in artists' colonies such as Gloucester, Massachusetts, or Ogunquit and Monhegan Island, Maine. Beginning in the 1930s, Hopper spent his summers in Truro, Massachusetts, on Cape Cod.

In 1927, Hopper and his wife, the artist Josephine Nivison Hopper, purchased their first automobile which enabled them to travel about at will, visiting more remote locations in search of subject matter. Hopper once remarked: 'To me the most important thing is the sense of going on. You know how beautiful things are when you're travelling.' That summer, they spent much of their time on Cape Elizabeth in Maine, at Two Lights, just south of Portland. There, Hopper was fascinated by the little Coast Guard settlement, where the men slept in the station, isolated from their families. He and Jo met the lighthouse keepers and he named his canvas, *Captain Upton's House*, after its caretaker. Views of this building also appear in his watercolour, *Hill and Houses* (1927), as well as in his oils *Lighthouse Hill* (1927) and *The Lighthouse at Two Lights* (1929). On his return to Cape Elizabeth in 1929, Hopper also painted several watercolours of this same structure.

Fig.1
Edward Hopper
CAPTAIN UPTON'S HOUSE
Signed, 1927, 28½in by 36¼in (72.4cm by 92.1cm)
New York $2,310,000 (£1,283,333). 3.XII.87

Fig.2
Edward Hopper
HOTEL WINDOW
Signed, 1956, 40in by 55in (101.6cm by 139.7cm)
New York $1,320,000 (£733,333). 3.XII.87

Although a realist, Hopper freely altered his compositions to suit his expressive needs. In this case, comparison with the subject itself, or a photograph of the structure, indicates that Hopper subtly changed the relative proportions, making the building appear to be more vertical than it is in reality.

The summer sojourns in New England provided subject matter for many of Hopper's paintings including *Cape Ann Granite* (1928) and *Dauphinée House* (Fig.3), which became the Cape Cod summer home of his neighbour and friend, the artist, Henry Varnum Poor. This house so intrigued Hopper that he painted it twice, preceding his oil with a watercolour that he called *Captain Kelly's House* (1931). Jo Hopper, too, painted her version of this house in oil. Drawing also occupied Hopper during these summer vacations. He drew *Maine in Fog* (1929), as a study for a pale, unresolved canvas of a beached boat that remained in his possession at his death.

In *Hotel Window*, Hopper maintained that he did not record a particular place, but rather an improvisation of many 'cheesy hotels' that he had observed walking on Manhattan's West Side just below Times Square. Painted in Hopper's New York studio in December 1955, the canvas depicts a lone woman sitting in a hotel lobby with her fur-collared winter coat about her shoulders. She turns and gazes out of the

Fig.3
Edward Hopper
DAUPHINEE HOUSE
Signed, 1932, 34in by 50¼in (86.4cm by 127.6cm)
New York $687,500 (£381,944). 3.XII.87

window, perhaps awaiting someone. The extant preparatory sketch for this work reveals that Hopper originally included a seated man reading. Placed directly across from the woman at the window, the man would have appeared to ignore her, suggesting a lack of communication.

Hopper produced a number of powerful paintings set in hotel rooms and lobbies. He began these works with his monumental *Hotel Room* (1931) and continued this interest in *Hotel Lobby* (1943), *Hotel by a Railroad* (1952) and *Western Motel* (1957). *Hotel Window*, like the latter painting, seems to express a yearning for that which is absent. Among the complex emotions that Hopper communicated with the hotel theme were impatience, longing, anxiety, and melancholy. The hotel became for him a symbol of transience and a poignant setting for the displaced soul adrift, but searching for solace.

Hopper painted in a traditional representational style, simplifying reality through the careful elimination of unnecessary detail. The characteristic that makes his painting modern and allows his work to speak so powerfully today is his radical content. He expressed emotional truths with a direct and forceful clarity. Just as his Maine lighthouse stands starkly alone, intentionally set apart from its surroundings, the woman in *Hotel Window* allows us to feel her uneasy separateness. This is Hopper's poetry and his drama.

Georgia O'Keeffe's flower studies

November 1987 marked the centenary of the birth of Georgia O'Keeffe, an event commemorated by a comprehensive retrospective of her work at the National Gallery of Art in Washington that included the large-scale studies of flowers and foliage and cityscapes of her early years in the East, and the luminous images of the desert – the hills, the sun-bleached bones, the high white clouds – that captured her imagination in New Mexico. A more intimate view of Georgia O'Keeffe's work was afforded by the ten paintings that her sister Anita O'Keeffe Young selected for her own collection.

Georgia and Anita O'Keeffe were born and raised in Sun Prairie, Wisconsin, but as adults, their lives could not have been more opposite. Anita married Robert B. Young, who became the Chairman of the New York Central Railroad, and together they maintained spectacular residences in New York, Newport and Palm Beach. Georgia, as the protégée and wife of Alfred Stieglitz, was completely immersed in the intellectual avant-garde of New York. Nonetheless, the O'Keeffe childhood experiences on the prairie had a lasting effect on both women. This background gave Georgia an acute sensitivity to nature, and a similar influence drew Anita consistently to Georgia's paintings of flowers and trees.

The earliest of the paintings in her collection, *Petunia No. 2*, was executed in 1924, the year usually designated as the first in which O'Keeffe produced large-scale floral subjects, and also the year of her marriage to Stieglitz. Describing these magnified flowers, Jack Cowart has written:

'O'Keeffe made of a flower, with all its fragility, a permanent image without season, wilt or decay. Enlarged and reconstructed in oil on canvas or pastel on paper, it is a vehicle for pure expression rather than an example of botanical illustration. In her art, fleeting effects of natural phenomena or personal emotion become symbols, permanent points of reference.'

Three of the other paintings in Mrs Young's collection revealed O'Keeffe's sustained interest in floral subjects. *Black Hollyhock with Blue Larkspur* (Fig.1), painted during her first summer in New Mexico, is one of two versions of the subject and one of the paintings selected by Daniel Catton Rich for the first O'Keeffe retrospective at the Art Institute of Chicago in 1943.

A desert flower, the jimson weed, is the subject of the two other paintings. O'Keeffe described it as 'a beautiful white trumpet flower with strong veins that hold the flower open and grow longer than the round part of the flower. . .'. Painted in 1932, *Jimson Weed* (Fig.2) is a classic example of the magnified floral studies in which O'Keeffe reproduced the essence of the subject, rather than just its external form, and conveyed her personal experience of the flower. A comparison of this painting and *Two Jimson Weeds* of 1939 (Fig.3) reveals a progression towards a semi-abstract statement, in which design and colour have been subdued and simplified, an evolution that embodies O'Keeffe's method of working.

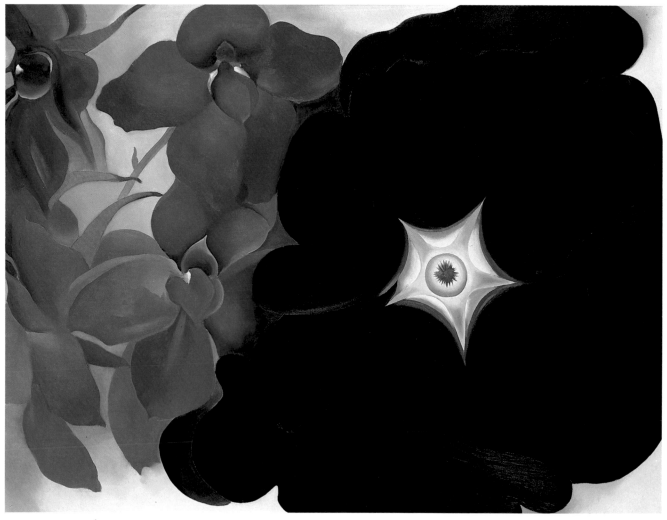

Fig.1
Georgia O'Keeffe
BLACK HOLLYHOCK WITH BLUE LARKSPUR
Signed with initials and a star, titled and dated *–29* on the backing,
30in by 40in (76.2cm by 101.6cm)
New York $1,980,000 (£1,100,000). 3.XII.87
From the estate of Anita O'Keeffe Young

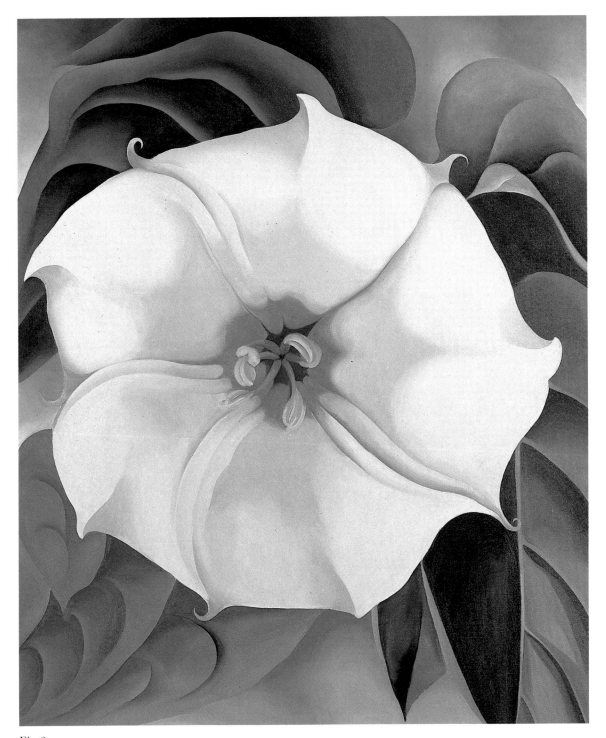

Fig.2
Georgia O'Keeffe
JIMSON WEED
Signed with initials and a star, and titled on the backing, 1932,
48in by 40in (121.9cm by 101.6cm)
New York $990,000 (£550,000). 3.XII.87
From the estate of Anita O'Keeffe Young

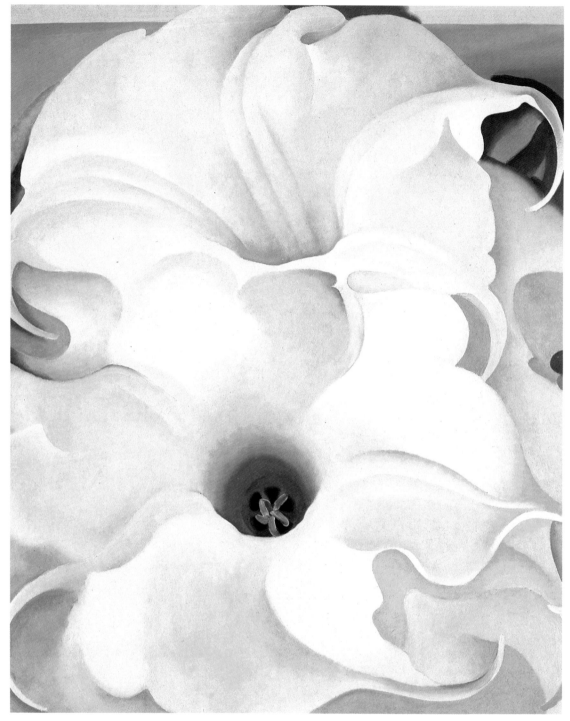

Fig.3
Georgia O'Keeffe
TWO JIMSON WEEDS
Inscribed *Ditura-Hawaii (1938) by Georgia O'Keeffe* by Alfred Stieglitz on the backing, 1939,
36in by 30in (91.4cm by 76.2cm)
New York $1,210,000 (£672,222). 3.XII.87
From the estate of Anita O'Keeffe Young

Latin American, Australian and Canadian art

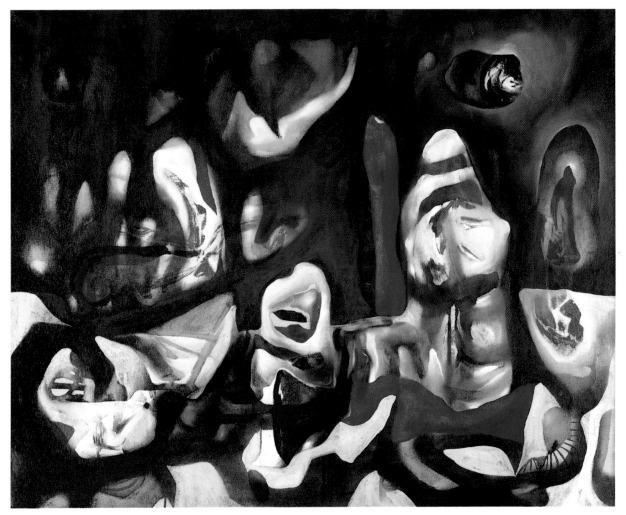

Matta
PSYCHOLOGICAL MORPHOLOGY #34
Circa 1938, 36⅛in by 28½in (91.8cm by 72.4cm)
New York $236,500 (£132,865). 18.XI.87
From the collection of Gordon Onslow-Ford

In 1938 Gordon Onslow-Ford and Matta travelled to Brittany where the latter painted his first oils, known as the 'psychological morphologies'. Matta worked on this series until 1942 by which time he had moved to New York with Tanguy.

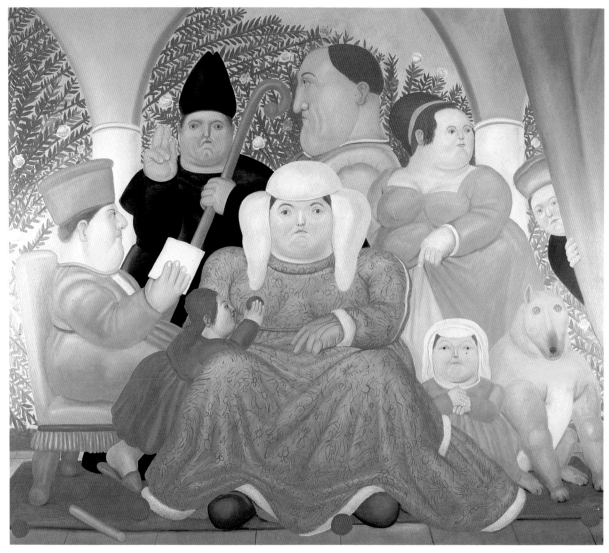

Fernando Botero
<small>AFTER MANTEGNA</small>
Signed and dated *80*, 93½in by 108in (237.5cm by 274.3cm)
New York $341,000 (£183,333). 17.V.88

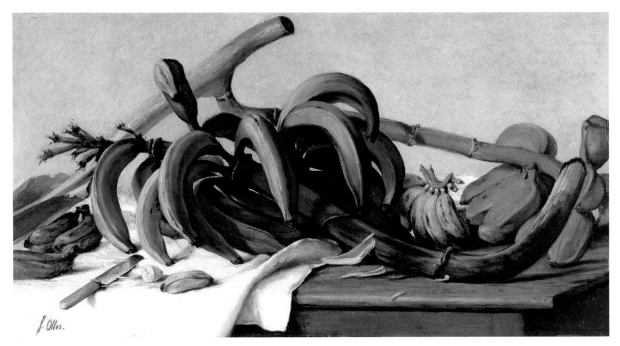

Francisco Oller

PLANTAINS AND BANANAS

Oil on board, signed, *circa* 1893, 19in by 35¾in (48.3cm by 90.8cm),
$132,000 (£70,968)

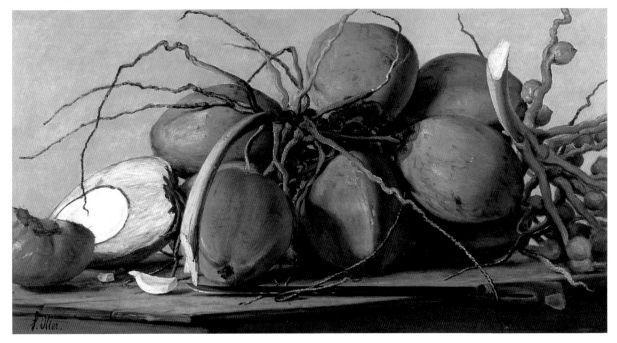

Francisco Oller

STILL LIFE WITH COCONUTS

Oil on panel, signed, *circa* 1893, 19in by 35¾in (48.3cm by 90.8cm),
$132,000 (£70,968)

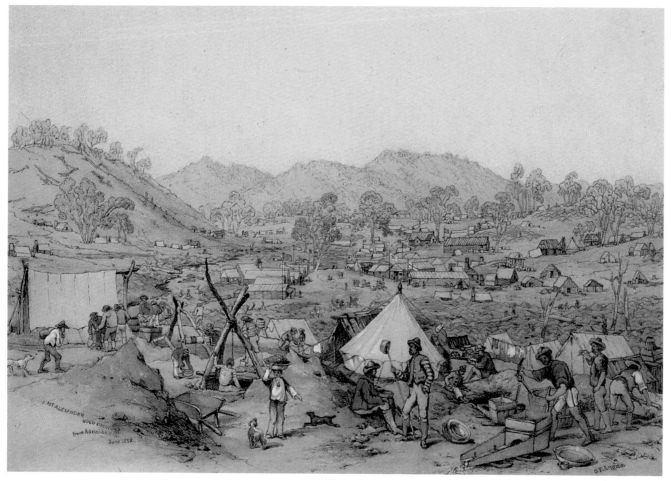

George French Angas
MOUNT ALEXANDER GOLD DIGGINGS FROM ADELAIDE HILL
Watercolour, signed, inscribed with the title and dated *June 1852*,
9⅝in by 13½in (24.4cm by 34.4cm)
Melbourne Aus$93,500 (£37,103:$68,750). 28.III.88

The paintings illustrated on the opposite page were sold in New York on 17th May 1988.

Conrad Martens
FUNERAL OF REAR ADMIRAL PHILLIP PARKER KING CROSSING SYDNEY HARBOUR, 1856
Watercolour heightened with bodycolour, signed and dated *Sydney 1856*,
$17\frac{7}{8}$in by $25\frac{3}{4}$in (45.5cm by 65.5cm)
Sydney Aus$308,000 (£199,844:$205,333). 29.X.87

Cornelius David Krieghoff
THE STEAMSHIP QUEBEC
Signed; also signed with initials on front deck and dated *1853*,
26½in by 36in (67.3cm by 91.4cm)
Toronto Can$297,000 (£130,837:$241,463). 31.V.88

Painted by Krieghoff for the ship's master, Captain A.M. Raddall, the steamship *Quebec* was
built at Quebec City in 1844.

The Andy Warhol Collection

'I really believe in empty spaces,' Andy Warhol maintained. 'I want to live in a studio. In one room. That's what I've always wanted, not to have anything – maybe put everything on microfilm or holographic wafers – and just move into one room.' But somehow the microfilming never took place and the shopping expeditions never stopped, and last April, Warhol's vast collections filled Sotheby's galleries in New York – a space totalling over three acres. One gallery displayed the American Indian art; four cases were required for the cookie jars; tables stacked with Fiesta ware lined the walls. An entire floor was devoted to the Art Deco collection, the American Federal furniture, the folk art and the modern and contemporary paintings and drawings. Tucked away at one side were a dozen cases of watches and jewellery and parked outside on the corner was the Warhol Rolls-Royce.

Much of the collection had been housed in a formal Georgian townhouse on East 66th Street in Manhattan, which Warhol said had once belonged to 'someone's Wasp granny.' This elegant setting, with its elaborately carved marble fireplaces, intricately stencilled walls, and luxurious damask draperies, was just as astonishing as the extent and variety of the collections within. The revelation of an unknown aspect of the life of such a prominent personality immediately captured the public's imagination. In spite of his international celebrity, Warhol had remained elusive, essentially unengaged and aloof, and these objects and the secrets they might reveal about their owner were an intensely tantalizing prospect.

The basic sequence of Warhol's collecting is well known – Surrealist works and American folk art in the fifties and early sixties, jewellery and watches in the mid-sixties and seventies, Art Deco in the early seventies, American Federal furniture in the mid seventies to furnish the 66th Street house (Fig.1), and a late enthusiasm for sculpture of all periods from antiquity to the twentieth century. As an artist he was naturally interested in the work of his contemporaries, acquiring important works by Twombly, Johns and Rauschenberg and his fellow Pop artists Lichtenstein and Rosenquist, and supported younger artists, Basquiat, Arman, and Haring among them. In *Popism*, Warhol recorded his encounters with Johns and Rauschenberg and some of his uncertainties and aspirations in dealing with his fellow artists. Henry Geldzahler, a former curator of twentieth-century art at the Metropolitan Museum of Art, described the acquisition of such works as 'a deliberate gesture [that was] both an homage and a kind of apprenticeship to his fellow painters.' Perhaps the work which addressed his interaction with other artists most directly was the sensitive portrait drawn by David Hockney in Paris in 1974; the same year Warhol made a portrait of Hockney based on photographs taken during the visit.

In his collecting, Warhol has been variously described as an 'indefatigable accumulator,' and 'obsessive hoarder,' a 'manic bargain hunter' and a collector in the tradition of Lorenzo de Medici and William Randolph Hearst, 'knowingly following

Fig.1
The Federal drawing room in the Warhol house (photograph by Norman McGrath).

A painted and stencilled brass-mounted slate-top centre table attributed to John Finlay,
Baltimore, *circa* 1825, height 30¼in (76.8cm), $82,500 (£43,883)
One of a pair of carved and gilded mahogany recamiers, Philadelphia, *circa* 1835,
length 76in (193cm), $44,000 (£23,404)

Both these pieces from the Andy Warhol Collection were sold in New York on
30th April 1988.

a pattern of profligate over-accumulation to be succeeded in good time by soul-searching de-acquisition.' He was a notorious shopper, usually spending two or three hours a day visiting galleries and auction houses and on Sundays the flea markets on the West Side. As Fred Hughes, his confidante and manager, once explained, Warhol believed shopping was part of his job. The search and the moment of acquisition were as important, if not more so, than the subsequent ownership of the object. In his friend Jed Johnson's view, he was 'in it for the action,' and he especially loved the unpredictable nature of bidding in the saleroom.

Beneath the apparent randomness, Warhol's collecting pattern was surprisingly well defined. 'Andy was an omnivorous observer and recorder of everything and his collecting habits were in some ways an extension of this,' commented Fred Hughes. Just as he believed that ordinary people were entitled to a few moments of glory, so were commonplace objects worthy of serious if fleeting attention. 'This pursuit of masterpieces did not prevent him from finding objects of interest at all ranges of quality,' his shopping cohort Stuart Pivar observed. 'On the quest for bronzes of fine patination or *ciselure*, he would buy Rodin's *Le Penseur* in black glazed ceramic for $26 at the flea market.'

Perhaps the most remarkable aspect of Warhol as a collector was this versatility, the ability to turn with ease from one subject to another and to see the style – and very often the humour – in such extraordinarily diverse objects. Usually, in fact, he was among those who recognized it first, buying forties jewellery (Fig.5), Fiesta ware and American Federal furniture, before others 'rediscovered' them. Warhol's Art Deco collection was certainly the best example. Acquired in the early 1970s, largely in Paris, this group included important pieces by Ruhlmann and Dunand as well as an exceptionally rare suite by Pierre Legrain (Fig.2). The wealth of handsomely designed silver by Puiforcat was discovered in a dusty showcase in their Paris showroom in 1969 and purchased *en masse* (Fig.4).

The Art Deco collection was the first to be auctioned, and throughout the ten-day sale, the bidders were just as diverse and unexpected as the objects they sought. A few, such as Gedalio Grinburg, now the world's cookie jar tsar, and Matt Belgrano, a punk rocker with a scarlet mohawk who flew in from London for the event, became famous for just over the requisite fifteen minutes. Others were more circumspect, like the anonymous collector who paid $170,000, more than twenty times the estimate, for a tremendously stylish Egyptian revival chair.

Equally, the major pieces in the collection attracted serious international competition. A European dealer purchased the Legrain consoles for a total of $418,000; the severe black centre table designed by Charles Rennie Mackintosh for Hill House brought a record $275,000 from an American private collector (Fig.3); a major East Coast museum acquired the elegant Federal sideboard attributed to Joseph Barry of Philadelphia for $104,000. Among the jewellery and watches, the dramatic, over-scaled designs of the forties were in great demand, with many pieces selling for four or five and in some cases ten times their estimates. Predictably, the highest prices were reserved for the contemporary art with an untitled work by Twombly reaching a record $990,000 (Fig.6) and Johns's *Screen Piece* realizing $660,000. In all, the Warhol Collection totalled more than $25 million and the proceeds benefited the Andy Warhol Foundation for the Visual Arts.

Fig.2
The second floor landing of the Warhol house (photograph by Norman McGrath).

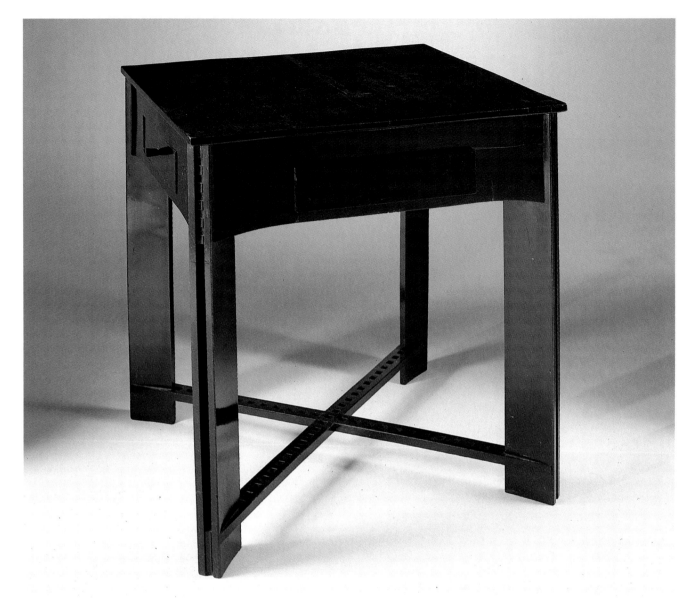

Fig.3
An ebonized wood centre table designed by Charles Rennie Mackintosh for Hill House,
Helensburgh, *circa* 1902–03, width 29½in (74.9cm)
New York $275,000 (£146,277). 23.IV.88
From the Andy Warhol Collection

Preceding page
Two galuchat and sycamore throne chairs by Pierre Legrain, *circa* 1917,
height 41¾in (106cm), $242,000 (£128,723)
A galuchat and sycamore console by Pierre Legrain, *circa* 1920, height 30½in (77.5cm),
$209,000 (£111,170)

Both these pieces from the Andy Warhol Collection were sold in New York on
23rd April 1988.

Fig.4
A silver and rosewood four piece tea and coffee set by
Jean E. Puiforcat, Paris, *circa* 1925–30,
height of coffee pot 5½in (14cm)
New York $44,000 (£23,404). 23.IV.88
From the Andy Warhol Collection

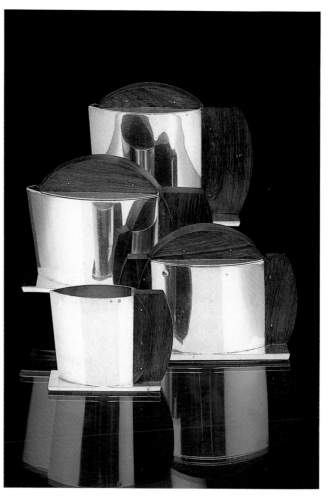

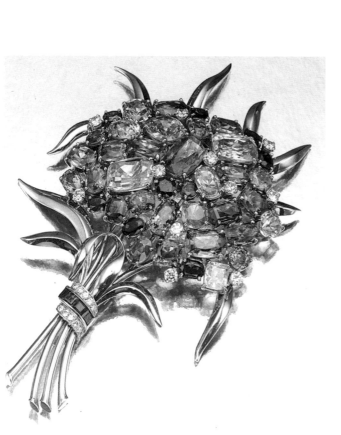

Fig.5
A blue and yellow sapphire and diamond flower brooch by
Cartier, *circa* 1940
New York $30,800 (£16,471). 27.IV.88
From the Andy Warhol Collection

Fig.6
Cy Twombly
UNTITLED
Oil and crayon on canvas, 1967, 79in by 104in (200.7cm by 264.2cm)
New York $990,000 (£529,412). 2.V.88
From the Andy Warhol Collection

David Forrester Wilson, RSA
'THE WIND'
Signed, 58¼in by 90in (148cm by 228.6cm)
New York $110,000 (£58,511). 29.IV.88
From the Andy Warhol Collection

Old master prints from the Blum Collection

Nearly 300 prints from the collection of the late Dr Albert W. Blum were dispersed in a highly successful sale in New York in February 1988. The appearance at auction of such a large number of rare and fine quality impressions created a startling event in the field of old master prints. Collectors, dealers, and museum curators from all over the world arrived in unusually large numbers to view and then to bid enthusiastically in a saleroom filled to capacity. The sale totalled nearly $5 million (nearly £3 million), almost doubling its expected high estimate, with many individual works bringing more than triple their estimates.

Dr Blum's collection ranged from early German, Dutch and Italian prints from the fifteenth and early sixteenth centuries, to German and Dutch seventeenth-century etchings and engravings. The second and third lots were the only extant impressions of anonymous German fifteenth-century hand-coloured woodcuts, *Christ on the Cross* and *The Good Shepherd* (Fig.6). They fetched $60,500 and $143,000 respectively, many times their estimates, and set the tone for the rest of the sale. One of the most extraordinary works from the concluding section of seventeenth-century prints was the rich impression of *The Standard Bearer* by Prince Rupert of the Rhine, the inventor of the mezzotint engraving (Fig.3).

Rarities amongst Dr Blum's early-sixteenth-century Italian prints included very fine impressions of Jacopo de' Barbari's *The Three Prisoners* and the highly important engraving which records one of the first uses of the cannon to effect a victory, *The Two Armies at the Battle of Ravenna*, by the Master Na-Dat with the Mousetrap (Fig.2).

Among the many Dürer prints were outstanding examples of the engraving *St Eustace* (Fig.4), and two woodcuts, *The Bath House* and *The Martyrdom of St Catherine*. Other highlights included a group of woodcuts, mainly early impressions and seldom seen on the market, by Hans Baldung Grien: *Martyrdom of St Sebastian* and *St Catherine*, the only impression recorded by Hollstein with the early text below. Early impressions of etchings by Daniel Hopfer, engravings by Heinrich Aldegrever, and etched landscapes by Augustin Hirschvogel excited the interest of print collectors and fetched remarkable prices.

Lucas van Leyden was well represented in the sale, which included two superb early impressions of unobtainably rare woodcuts: *Abraham's Sacrifice* and *Samson and Delilah* (Fig.5).

The highest prices were reserved for the exceptional groups of Rembrandt etchings, including two superb and quite different impressions of the first and second states of Rembrandt's famous portrait of his friend, *Jan Lutma, Goldsmith*. The first state, with the background unfinished, is a brilliant, spontaneous work on oriental paper (Fig.1), and the second state, with the window added, is a very fine, rich impression with warm, smokey tone printed on Japan paper.

Fig.1
Rembrandt Harmensz. van Rijn
JAN LUTMA, GOLDSMITH
Etching and drypoint, on oriental paper, first state of three, 1656, 7¾in by 5⅞in
(19.6cm by 14.9 cm)
New York $506,000 (£285,876). 27.II.88
From the collection of the late Dr Albert W. Blum

The second state of the same subject made $429,000 (£242,373) at auction on the
same day.

Fig.2 *Above*

Master Na-Dat with the Mousetrap

THE TWO ARMIES AT THE BATTLE OF RAVENNA
Engraving, first state of three, *circa* 1512–13,
5$\frac{7}{8}$in by 8$\frac{5}{8}$in (15cm by 21.9cm)
New York $46,200 (£26,102). 27.II.88
From the collection of the late Dr Albert W.
Blum

This engraving of the Battle of Ravenna of
1512 records one of the first uses of the
cannon to effect a victory.

Fig.3 *Right*

Prince Rupert of the Rhine

THE STANDARD BEARER
Mezzotint, after P. della Vecchia, second
state of three, dated *1658*, 11in by 7$\frac{7}{8}$in
(27.8cm by 20cm)
New York $90,750 (£51,271). 27.II.88
From the collection of the late Dr Albert W.
Blum

Fig.4 *Above*
Albrecht Dürer
ST EUSTACE
Engraving, Meder *b* (of *k*), *circa* 1501,
14⅛in by 10⅛in (35.8cm by 25.9cm)
New York $225,500 (£127,401). 27.II.88
From the collection of the late Dr Albert W. Blum

Fig.5 *Above, right*
Lucas van Leyden
SAMSON AND DELILAH
Woodcut, Filedt Kok *a* (of *c*), *circa* 1514,
16⅜in by 11½in (41.5cm by 29.1cm)
New York $96,250 (£54,379). 27.II.88
From the collection of the late Dr Albert W. Blum

Fig.6 *Right*
Anonymous German
THE GOOD SHEPHERD
Woodcut, with early hand-colouring, *circa*
1460–70, 9⅞in by 7¼in (25.3cm by 18.4cm)
New York $143,000 (£80,791). 27.II.88
From the collection of the late Dr Albert W. Blum

Prints

Edouard Manet
POLICHINELLE
Gouache and watercolour over lithograph
in black, a proof of the rare first state, with
Théodore de Banville's verse inscribed in
red ink, *Féroce et rose avec du feu dans sa
prunelle,| Effronté, saoul, divin, c'est lui,
Polichinelle!*', 1874, 18⅞in by 12¾in
(48cm by 32.4cm)
New York $187,000 (£99,468). 13.V.88

'Polichinelle' parodies the character of the
unpopular president of the Republic,
Maréchal MacMahon, called 'Maréchal
Bâton'.

Anonymous German
THE PIETA
Woodcut, with extensive early hand-colouring, *circa* 1440–55,
16in by 11¼in (40.5cm by 28.4cm)
London £225,500 ($390,115). 27.VI.88

Ernst Ludwig Kirchner
WINTERMONDNACHT
Woodcut, hand printed in seven colours, signed in pencil and inscribed *1 Probedruck*, 1919,
12in by 11⅝in (30.5cm by 29.5cm)
London £198,000 ($342,540). 27.VI.88

The painting of this subject was, according to Kirchner's correspondence, conceived early on
20th January 1919 at the farmhouse *In den Lärchen*. The woodcut, of which nine impressions
in different colour combinations have been recorded, was executed shortly after.

Emil Nolde
MÜHLE AM WASSER
Lithograph printed in orange, grey, green and overprinted from the same stone in black, on
buff paper, signed, titled and inscribed in pencil *In dieser Fassung ein Druck*, 1926,
sheet size 25⅝in by 32¼in (65.2cm by 81.9cm)
New York $121,000 (£64,361). 13.V.88

Henri Matisse
JAZZ
Two of a complete portfolio edition of twenty unfolded stencils, printed in colours, after collages and cut paper designs, signed on the justification page and numbered *6* from the edition of 100, published by Tériade, Paris, 1947, sheet size approximately
25¾in by 16⅝in (65.5cm by 42.3cm)
New York $451,000 (£251,955). 13.XI.87

Pablo Picasso
NATURE MORTE SOUS LA LAMPE
Linocut printed in colours, signed in pencil and numbered *28/50*, 1962,
20¾in by 25⅛in (52.7cm by 63.8cm)
London £68,200 ($130,944). 3.XII.87

David Hockney

THE WEATHER SERIES
One of a set of six lithographs, signed in crayon, numbered *44/98* and dated *'73*, blind stamp
of the publisher Gemini G.E.L.
London £39,600 ($68,904). 28.VI.88

Richard Diebenkorn
GREEN
Etching, aquatint and drypoint, printed in colours, initialled in pencil and inscribed *AP 1*
published by Crown Point Press, 1986, 44⅞in by 35⅝in (114cm by 90.5cm)
New York $49,500 (£26,191). 14.V.88

Photographs

Man Ray
UNTITLED
Original rayograph, signed, inscribed and dated in pencil by the photographer
31 bis rue Campagne Premiere, 1926, and *ORIGINAL* stamps on the reverse of the
mount, 13¾in by 10⅞in (34.9cm by 27.6cm)
New York $37,400 (£20,000). 4.V.88

Edward Steichen
'BROADWAY LIGHTS'
Photomontage, signed and inscribed *#4 north wall* in pencil by the photographer on the reverse, 1933, 40½in by 34½in (102.9cm by 87.6cm)
New York $40,700 (£21,765). 5.V.88

This photomontage was created by Steichen specifically for the New York Building at the 1933 Chicago World's Fair.

Reverend Calvert R. Jones
STUDY OF MARGAM
Whole plate daguerreotype, signed and inscribed on the backing *March 9t 1841 9h. 30m.*
A.M.| In the Camera 26min. Sun clear throughout.| Mercury 7 min. rising. 9 falling. 1841
London £14,300 ($27,027). 6.XI.87
From the collection of Christopher Rice Mansel Talbot

Opposite
Robert Howlett
MEN AT WORK BESIDE THE LAUNCHING CHAINS
Albumen print, mounted on card stamped *Robert Howlett Photographic Institution 168 New Bond*
Street and dated in the negative *Nov 18 57*, 1857, 11⅛in by 14in (28.3cm by 35.5cm)
London £12,100 ($22,869). 6.XI.87
From the estate of Isambard Kingdom Brunel

Lewis Carroll

XIE KITCHIN ASLEEP ON SOFA
Albumen print, numbered in
the negative *108*, inscribed *2157*
in ink by the photographer on
the reverse, *circa* 1870,
6⅛in by 8⅜in
(15.6cm by 21.2cm)
London £5,060 ($10,120).
22.IV.88

Watkins's Yosemite images

Recently discovered in the attic of a country house in the Scottish highlands, this monumental four-part, double-sided folding screen contains landscape photographs of late-nineteenth-century America. The screen displays twenty-eight mammoth-plate photographs under glass, twenty-six by Carleton Watkins and two attributed to George Barker. Carleton Watkins, a pre-eminent photographer of the American West, is known primarily for his views of Yosemite Valley in California. This screen includes some of his most famous images of the valley taken in the 1860s and 1870s. His work was praised by contemporary photographers, and according to Peter Pamquist, 'by the mid-1860s Watkins's Yosemite images had become a standard for evaluating landscape photography.' Albert Bierstadt referred to Watkins as the 'prince of photographers'. Comments such as these had a national impact – even members of Congress displayed his Yosemite images in their Washington offices. Watkins's photographs were also used to champion America's wilderness; his large and impressive landscapes of this beautiful valley helped persuade Congress to preserve the area and in 1864 President Lincoln signed the Yosemite Bill into law.

Although its origins are a mystery, the screen may have been fashioned for a Scottish traveller who sought to display souvenir images of his 'Grand Tour' of America. This theory is supported by the photographs of popular tourist spots, such as the two of Niagara Falls attributed to George Barker as well as some taken by Watkins along the route of the transcontinental railroad.

Following the completion of the railroad in 1869, Europeans flocked across America to San Francisco, gathering souvenir photographs of railroad landscapes. His boyhood friendship with Collis P. Huntington, owner of the Central and Southern Pacific Railroads, allowed Watkins unlimited access to rail travel. He took great advantage of this, expanding the number and range of images in order to supply the increased demand for his work in Europe, where his reputation had been established at the 'Exposition International' in Paris in 1867.

The screen itself, fashioned of English oak during the late 1870s or 1880s, is stylistically reminiscent of the decorative panelling seen in many English interiors, designed or refurbished in the late nineteenth century, which displayed collections of prints or drawings.

Today, the screen recalls the fascination with which Europeans regarded the untamed American West of a century ago, and it remains as a symbol of that formerly rugged frontier and the possibilities it held for those adventurous enough to make the journey. The individual photographs are historical documents, recording some of the earliest views of what soon became a rapidly changing American wilderness.

Carleton Watkins
A four-fold, double-sided oak screen composed of twenty-eight mammoth-plate albumen
prints including two attributed to George Barker, the majority numbered in the negative or
in ink on the image with a letterpress title label affixed to the image and titled in an
unidentified hand in pencil on the reverse, the photographs *circa* 1861–74, twelve
approximately 20½in by 15½in (52.1cm by 39.4cm), fourteen approximately 15½in by 20½in
(39.4cm by 52.1cm), two approximately 14in by 17in (35.6cm by 43.2cm)
New York $30,250 (£17,385). 2.XI.87

Printed books, autograph letters and music manuscripts

Guido Columna
Ein hübsche histori von der künnglichenn stat troy wie si zestörett wartt, copy of Wolfgang zu Fürstenberg (1465–1509), 105 woodcuts including the Dream of Hecuba on *verso* of title, contemporary doe skin binding over wooden boards, Martin Schott, Strassburg, 13th March 1489
London £35,200 ($65,824). 23.VI.88
From the library of Philip Robinson

Julius Pollux and Stephen of Byzantium
Onomasticon and *Opera*, second Greek editions, both works bound in contemporary calf in one volume, from the library of François Rabelais, B. Giunta, Florence, 1520–21
London £27,500 ($51,425). 23.VI.88
From the library of Philip Robinson

Opposite
The Dicts of the Philosophers, printed by William Caxton, the first dated book printed in England, Westminster, 1477
New York $330,000 (£196,429). 23.X.88
From the collection of Raymond E. Hartz

Ere endeth the book named the dictes or sayengis
of the philosophhres enprynted /by me William
Caxton at Westmestre the yere of our lord +M+
CCCC+ Lxxvij+ Whiche book is late translated out of
Frensshe into englyssh . by the Noble and puissant lord
Lord Antone Erle of Ryuyers lord of Scales & of the
Jle of Wyght /Defendour and directour of the siege aps=
tolique /for our holy Fader the Pope in this Royame of
Englond and Gouernour of my lord Prynce of Wales
And Jt is so that at suche tyme as he had accomplysshid
this sayd Werke /it liked him to sende it to me in certayn
quayers to ouersee /Whiche forthwith J sawe & fonde therin
many grete . notable . and Wyse sayengis of the philosophres
Accordyng vnto the bookes made in frensshe Whiche J had
ofte afore redd /But certaynly J had seen none in englissh
til that tyme /And so afterward J cam vnto my sayd
lord & told him how J had red & seen his book / And
that he had don a meritory dede in the labour of the transla=
cion therof in to our englissh tunge /Wherin he had deseruid
a singuler laude & thank &c /Thenne my sayd lord desired
me to ouersee it and There as J sholde fynde faute to cor=
recte it /Wherin J ansuerd vnto his lordship /that J coude
not amende it /But if J sholde so presume J might apaire
it /For it Was right Wel & connyngly made & translated
into right good and fayr englissh /Notwithstondyng he
Willed me to ouersee it & shewid me dyuerse thinges Whi
che as him semed myght be left out as diuerse lettres ms
siues sent from Alisandex to darij and aristotle & eche to
other +Whiche lettres Were lityl apertinent vnto to dictes

Books from the John Rylands University Library of Manchester

Charlotte Brown

The John Rylands Library was founded by Mrs Rylands as a memorial to her husband John who died in 1888. On learning in 1892 that Earl Spencer had decided to sell the Althorp library, formed by his grandfather, George John, second Earl Spencer, she acted promptly and bought the entire collection for £210,000.

George John, Earl Spencer, born in 1758, was one of the greatest book collectors the world has ever known. His taste for early books was inspired by his purchase in 1790 of the library of a Hungarian nobleman Count Reviczky, who had formed a splendid collection of first editions of the Greek and Latin classics.

In 1972 the John Rylands Library merged with the library of the University of Manchester to form the John Rylands University Library of Manchester and in 1987 the John Rylands Research Institute was established with the purpose of promoting the awareness of the rich store of research material in the library. In order to fund in part this new enterprise, it was decided to send for sale some 100 duplicate editions from its holdings. Many of these were first or early editions of major classical and Renaissance texts from the collections of Earl Spencer. Approximately half of the books were printed by the great Venetian printer Aldus Manutius, mostly folios, including all but eleven of the entire Aldine output before 1500. The sale also contained many very fine examples of early Greek printing including two works printed by Zacharias Callierges – Ammonius *In quinque voces Porphyrii commentarii*; its border, heading and initial on the first page printed in gold using a technique employed by only two men in the fifteenth century, Erhard Ratdolt and Callierges – bound with Simplicius *In Aristotelis categorica scholia* (Fig.1).

Fine specimens of Roman letter printing were at an equally high premium including a copy of the first edition of Apuleius printed by Sweynheym and Pannartz in Rome in 1469, with illumination characteristic of this press, and a copy on vellum of the first edition of Solinus's *De situ et memorabilibus orbis capitula*, printed by Jenson (Fig.2). The highest price of the sale was for a beautiful copy of one of the finest illustrated books of the Italian Renaissance, *Hypnerotomachia Poliphili*, from the library of the famous sixteenth-century French bibliophile Jean Grolier (Fig.3). It was one of nine books from the library of Jean Grolier formerly in the collection of Earl Spencer.

Fig.1 *Above*

Ammonius

In quinque voces Porphyrii commentarii, one of
ten known copies with the border, heading
and initial on first page printed in gold,
bound with Simplicius *In Aristotelis categorica
scholia*, both first edition of the Greek text,
printed by Callierges, Venice, 1500 and 1499
London £71,500 ($138,710). 14.IV.88

Fig.2 *Above, right*

Caius Julius Solinus

De situ et memorabilibus orbis capitula, first
edition, printed on vellum by Nicolaus
Jenson, Venice, 1473
London £77,000 ($149,380). 14.IV.88

Fig.3 *Right*

Hypnerotomachia Poliphili, first edition, 172
woodcuts, bound in calf, *circa* 1552–55 by
the royal binder of Henri II, Claude de
Picques for Jean Grolier, printed by Aldus
Manutius, Venice, 1499
London £187,000 ($362,780). 14.IV.88

The books illustrated on this page are from
the John Rylands University Library of
Manchester.

Lord Horatio Nelson's quill pen with which he allegedly wrote his unfinished and last
letter to Lady Hamilton before the Battle of Trafalgar, with note of provenance,
length 8½in (21.6cm)
London £2,200 ($4,290). 15.XII.87
From the collection of C. Seton-Watson

Left
Mahatma Gandhi
A collection of more than 80 letters,
most to his disciple and legal partner
Henry Polak and his wife Millie,
including telegrams and
photographs, 1905–1950s
London £104,500 ($185,749).
22.VII.88
From the collection of P. M. Polak

Right
Arthur Wellesley, first Duke of
Wellington's death mask, by George
Adams, cast three days after
Wellington's death, 17th September
1852, height 9½in (24.1cm)
London £14,300 ($25,418).
22.VII.88

Edgar Allan Poe
Tamerlane and Other Poems, first edition of the author's first book, twelfth known copy, in original printed wrappers, Calvin F.S. Thomas, Boston, 1827
New York $198,000 (£109,392). 7.VI.88

Einstein's Theory of Relativity

Albert Einstein, 1948, by Yousuf Karsh

This extraordinary document, Einstein's fullest treatment of the Special Theory of Relativity, was purchased by an anonymous collector for $1,155,000, a record price for a manuscript sold in America. Commenting on its importance, the new owner said that it 'represents the highest intellectual achievement of our century, which can only be placed along with that of Aristotle, Leonardo, and Newton.'

As Albert Einstein's earliest surviving manuscript on relativity, this document includes his famous equation, $E = mc^2$. The 72 page article is his longest discussion of this revolutionary theory, which discards earlier concepts of time and space as absolute entities and views them as relative moving systems of frames of reference.

Commissioned for the fifth volume of Professor Erich Marx's *Handbuch der Radiologie*, this manuscript was prepared before World War I as a general treatise on the Theory of Relativity – what we now call the Special Theory of Relativity. As a result of the war and other difficulties, as Marx wrote to Einstein, the publication of this volume was postponed; and when it finally appeared after the war, Einstein's contribution was omitted. Yet the very existence of this article may well be attributed to the fact that it was never published, for during this period Einstein systematically discarded the manuscripts of his published writings.

Written for a general scientific audience, the document explains every significant feature of the theory fully and clearly. At the same time, it is a working scientific manuscript full of emendations and references to other questions that Einstein was pondering. He works through the theory twice, first using the algebra that had become the standard way of writing the equations and a second time using the tensor calculus introduced by Minkowski. Lines, paragraphs, and entire sets of equations are crossed out and rewritten; even his equation $E = mc^2$ is reconsidered.

Albert Einstein
An autograph manuscript on the Special Theory of Relativity, including the famous
equation $E = mc^2$, unpublished, 72 leaves, Prague or Zurich, *circa* 1912
New York $1,155,000 (£638,122). 2.XII.87

Pl. LXXXXI.

Above, left and right
Moses Harris
A collection of 30 original watercolours of insects and
plants, on vellum, all but three signed and published in
The Aurelian, circa 1773
London £96,800 ($181,016). 5.XI.87

Right
Basilius Besler
Hortus Eystettensis, third edition, 367 engraved plates of
flowers and plants with contemporary colouring,
engraved title by Wolfgang Kilian, Ingolstadt, 1713
London £165,000 ($320,100). 15.IV.88

Opposite
Pierre-Joseph Buchoz
Collection precieuse et enluminée des fleurs, two volumes,
200 hand-coloured engraved plates,
bound in contemporary French red morocco, Paris, 1776
London £44,000 ($82,280). 5.XI.87

Franz Anton von Scheidl
A volume of watercolours of flowers, plants, vegetables and fruit, 161 leaves, Austria, *circa*
1765–70
London £170,500 ($318,835). 5.XI.87

Harry Clarke
A watercolour of a woman
in an elaborate gown, signed
and dated *1914*,
20½in by 11⅞in
(52.2cm by 30.2cm)
London £27,500 ($50,325).
3.VI.88

This is one of the earliest
major watercolours by
Harry Clarke, commissioned
for a calendar by John
Duthie, a friend of the artist's
father.

Longus
Daphnis et Chloé, limited edition of 250, two volumes, 42 colour lithograph plates by Marc
Chagall, signed on the justification page, the morocco binding by Paul Bonet signed and
dated *1964*, Tériade, Paris, 1961
New York $286,000 (£158,011). 7.VI.88

Marc Chagall
Cirque, number 185 from the edition of 250, 36 lithographs, 23 of them in colour,
signed, Tériade, Paris, 1967
Monte Carlo FF1,076,700 (£107,670:$187,252). 23.II.88

CHÜTE DU STAUBBACH DANS LA VALLÉE DU LAUTERBRUNNEN

Karl Bodmer
Prince Maximilian's Travels in the Interior of North America, two volumes, 81 aquatint plates
partly printed in colours, some further colour added by hand and heightened with gum
arabic, Ackermann & Co., 1843–44
London £121,000 ($223,850). 24.VI.88

Opposite, above
Rudolf Hentzy
Vues remarquables des Montagnes de la Suisse, 42 colour-printed engraved plates by Caspar Wolf,
Charles Melchior Descourtis, Rosenberg, Patria, Clément, Füsly and others, J. Yntema,
Amsterdam, 1785
London £46,200 ($85,470). 24.VI.88

Below
Thomas and William Daniell
Oriental Scenery, a six-part work on India, 132 hand-coloured aquatint plates and 8 hand-
coloured engraved plans contained in two contemporary portfolios, 1795–1807
London £82,500 ($160,050). 15.IV.88

Abraham Lincoln
The autograph draft of the President's letter to the
defeated Army of the Potomac, with five autograph
emendations, Washington, 22nd December 1862
New York $236,500 (£125,132). 16.IV.88

The United States Constitution, the 'official edition' and first
printing of the final text of the Constitution, preceded only by
the two 'draft' editions, Dunlap and Claypoole, Philadelphia,
15th–17th September 1787
New York $165,000 (£87,302). 16.IV.88

Above

Ludwig van Beethoven

An autograph manuscript of revisions and alterations for the Ninth Symphony, four pages, with some additional annotations by the copyist, Ferdinand Wolanek, late 1824–early 1835
London £93,500 ($184,195). 6.V.88

This manuscript was hitherto undocumented and unknown and contains a passage of twenty-seven bars of the 'Ode to Joy'; it is the only manuscript to appear on the market containing this material. Written in Beethoven's usual haphazard style, the alterations to the Ninth are not in any order but jotted down at random, moving backwards and forwards between the movements. The Ninth Symphony was composed between 1822 and 1824 and was first performed in May 1824 in Vienna. It was next played in London in March 1825 by the Philharmonic Society of London.

Right

Franz Liszt

An autograph manuscript of a hitherto undocumented and unpublished piano work, a fantasy on a 'Chansonette', including an early version of the main material of 'La Chapelle de Guillaume Tell' from 'Années de Pèlerinage', 36 pages in the composer's hand, Paris, early 1830s
London £71,500 ($135,850). 27.XI.87

Tondal's Vision

Roger S. Wieck

While reaching for a plate of food at a dinner party, the worldly knight Tondal is suddenly struck with a tremor in his breast. He clutches at his heart and, to the horror of his dinner companions, falls over in a death-like stupor. Tondal's soul leaves his body and, for three days, is led by his guardian angel on a pilgrimage through the torments of hell, the pains of purgatory, and the joys of heaven. After this journey, Tondal's soul is reunited with his body; he reawakens, gives his earthly possessions to the poor and leads an exemplary life, urging others to do likewise. This is the story of *Les visions du chevalier Tondal*, the Irish knight's fantastic journey to the Next World in the year 1149. It was a popular text in the Middle Ages, predating by some 150 years Dante's own version of a similar pilgrimage, and was translated into all European languages.

Despite its popularity, there exists only one illustrated manuscript of the text, the present codex acquired by the J. Paul Getty Museum (now their MS 30) by private treaty through Sotheby's. In spite of its singularity, or, indeed, perhaps because of it, this manuscript emerges as one of the most important – and beautiful – creations of Flemish illumination. It is the product of a uniquely felicitous moment in time when the right patron hired the most talented scribe and the most subtle of artists to fashion an illuminated manuscript totally different from anything that had ever been, or would ever be, created.

As the colophon so proudly informs us, the manuscript was commissioned by Margaret of York, Duchess of Burgundy. Margaret was the third wife of Charles, the last Duke of Burgundy, nicknamed 'the Bold' or, more accurately, 'the Rash'. Margaret's motto, 'Bien en adviengne' (Good will prevail), along with her and her husband's initials joined by a love knot, appear frequently within the foliage of the borders (see Fig.1). Sister of the bibliophilic King Edward IV of England, Margaret was herself an ardent bibliophile and she indulged her bookish passion for moralizing and religious texts while duchess of one of the richest realms of late medieval Europe. The colophon of the manuscript also informs us that it was written by David, Margaret's 'most unworthy scribe'. This scribe is none other than David Aubert, the great historian, translator, publisher and scribe who had been serving the dukes of Burgundy, Philip the Good and then Charles, and court patrons since the 1450's. His *littera batarda* is the apogee of elegant and legible calligraphy. He wrote the manuscript in March 1474 in Ghent having just completed, in the previous month, its companion volume, Guy de Thurno's *La vision de l'âme* (now Getty MS 31). Court records tell us that Margaret was in Ghent while Aubert was working on both texts.

Fig.1
Heavenly reward for monks and nuns, from *Les visions du chevalier Tondal*, folio 39 *verso* from a manuscript in French by David Aubert, with miniatures by Simon Marmion, signed in Ghent, March 1474
The manuscript was sold by private treaty through Sotheby's to the J. Paul Getty Museum, Malibu, California (now their MS 30).

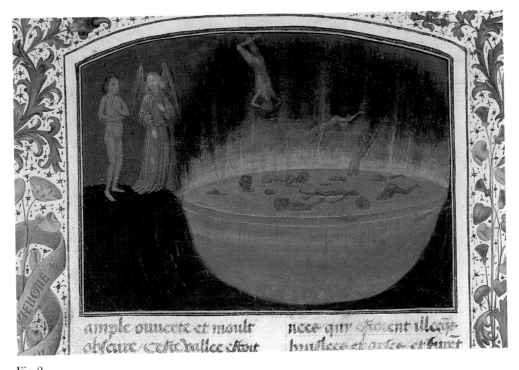

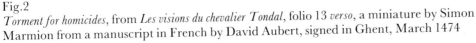

Fig.2
Torment for homicides, from *Les visions du chevalier Tondal*, folio 13 *verso*, a miniature by Simon Marmion from a manuscript in French by David Aubert, signed in Ghent, March 1474.

While the *Tondal* fascinates us because we know so much about it – its patron and scribe, its date and place of execution – its twenty miniatures represent its real importance. These pictures, which at first puzzle, then bewitch, and ultimately dazzle us, constitute the best work by the Flemish illuminator and panel painter, Simon Marmion. Already called 'prince de l'enluminure' in the sixteenth century, he is, along with the Master of Mary of Burgundy, the creator of miniatures whose subtlety, light palette, and delicate touch offer their viewers some of the greatest pleasures of all Flemish illumination. What makes the miniatures of *Les visions* so special, and so pleasantly so, is their originality. Confronted with a text that had never before been illustrated, Marmion's imagination was freed from the constraints of traditional medieval iconography. A careful reading of the text shows that Marmion, too, carefully read *Les visions* and the miniatures he painted for Margaret do not just decorate, but illustrate, this strange story. There exists an unparalleled symbiotic text/picture relationship in this manuscript.

The first torment Tondal's soul witnesses on his hellish experience is the punishment meted to homicides (folio 13v; Fig.2). The text describes and the picture shows a unique vision of a very unusual torture. The angel leads Tondal through an impenetrable darkness to a great valley filled with the glow of burning coals. Over this valley is a vast round lid of iron, also red-hot, onto which the souls of murderers tumble out of the gloom. On the searing surface of the lid the souls are roasted and burned until,

Fig.3
Punishment for the proud, from *Les visions du chevalier Tondal*, folio 15 *verso*, a miniature by Simon Marmion from a manuscript in French by David Aubert, signed in Ghent, March 1474

'like a sauce passing through a sieve', they liquefy and, melting through the iron, fall into the fire below.

Another huge valley in this hell is reserved for the proud and the presumptuous (folio 15v; Fig.3). As the text tells us and Marmion shows, this vast pit is so deep that Tondal could not even see its bottom, to which a multitude of tormented souls were relegated. He could, however, smell them for there arises from the depths a noxious and foul stink, an assaulting mixture of sulphur and rotting flesh. Across this abyss stretched a long but narrow footbridge that Tondal had to negotiate, doing so only through the reassuring encouragement offered by his angel.

Heaven is a prettier place. Among the many felicities are those enjoyed by good monks and nuns. These, faithful to their religious vows while on earth, inhabit richly coloured silk tents where they sing praise to God and make harmonious music (folio 39v; Fig.1). Tondal is not allowed to enter the tents, but he is permitted to peek inside where he observes that their joy makes these souls look like angels. These angels, in turn, bear a striking resemblance to their musical counterparts in the *Ghent Altarpiece* painted by Jan van Eyck and this miniature is Marmion's tribute to his artistic godfather.

In private hands since its creation, *Les visions du chevalier Tondal* can now be enjoyed by a larger public. We eagerly await the complete publication of its fascinating miniatures and text.

Manuscripts

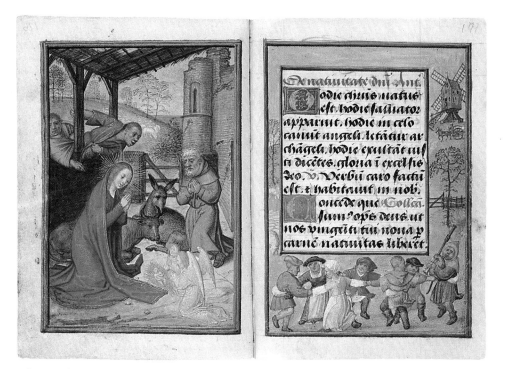

The Imhof Prayerbook, a manuscript on vellum, in Latin and Flemish, illuminated by Simon Bening, Antwerp, 1511
London £770,000 ($1,455,300). 21.VI.88

This is the earliest dated manuscript by Simon Bening.

Opposite
The Hours of Albrecht of Brandenburg, a manuscript on vellum, in Latin with a few words in German, illuminated by Simon Bening for Cardinal Albrecht of Brandenburg (1490–1545), Bruges, *circa* 1522–23
London £1,210,000 ($2,286,900). 21.VI.88
From the collection of William Waldorf Astor, first Viscount Astor

Book of Hours, an illuminated manuscript on vellum, in Latin, from the workshop of Simon
Bening, Bruges, *circa* 1530
London £63,800 ($122,496). 1.XII.87

Opposite
The Great Hours of Galeazzo Maria Sforza, a manuscript on vellum, in Latin with a few rubrics
in Italian, written and illuminated for Galeazzo Maria Sforza, Duke of Milan (1466–76),
Milan, *circa* 1461–66
London £770,000 ($1,455,300). 21.VI.88
From the collection of William Waldorf Astor, first Viscount Astor

INCIPIT OFFICIV BEATISSIME
VIRGIS MARIE SECVNDV COSVE
TVDINE ROMAE CVRIE AD MA
TVTINVM · INCIPIEDO A SEPT
AGESIMA VSQVE AD PASCHA
RESVRRETIONIS VIDELICET
DIE DOMENICO DIE LVNE
ET DIE IOVIS VERSVS ·

Pater noster et Aue maria. totum sub silentio. Versus.
Omine labia mea aperies ℟. Et os
meum annunciabit laudem tuam. ℣.
Eus in adiutorium meum inten
de. ℟. Domine ad adiuuá
dum me festina. ℣. Gloria pa
tri et filio et spiritui sancto. ℟. Sicut
erat in principio et nunc et semper et
in secula seculorum. ℟. Amen. Laus
tibi domine rex eterne glorie Inuitatorium. ue maria gratia
plena dominus tecum. psalmus.
Enite exultemus domino. iubilemus deo salutari nostro pre
occupemus faciem eius in confessione. et in psalmis iubilem
ei. Inuitatorium. Aue maria gratia plena dominus tecum. Vers.
Quoniam deus magnus dominus et rex magnus super omnes

G3 MA

Qur'an, an illuminated Mamluk manuscript leaf, in *naskhi* script in gold, Egypt, *circa* 1313,
13⅜in by 9⅞in (34cm by 25.1cm)
London £16,500 ($32,175). 14. XII.87

Najm al-Din Ali Khan watching a nautch of seven girls with musical instruments, gouache with gold on paper, signed by Kalyan Das, Mughal, *circa* 1750, 16¾in by 11⅝in (41.7cm by 29.4cm) London £16,500 ($32,175). 14.XII.87

Judaica

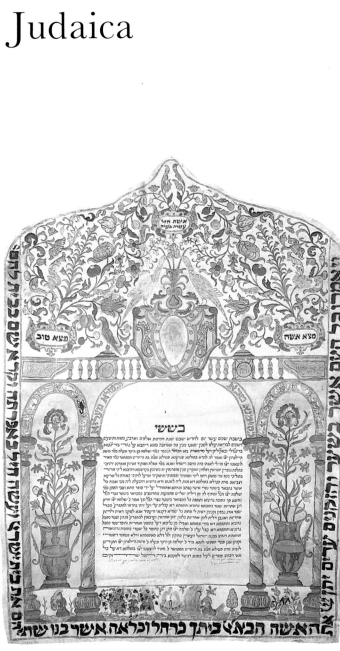

An illuminated marriage contract on vellum in square Italian
Hebrew script, dated *Padua 1732*
Jerusalem US$47,300 (£24,010). 6.V.88

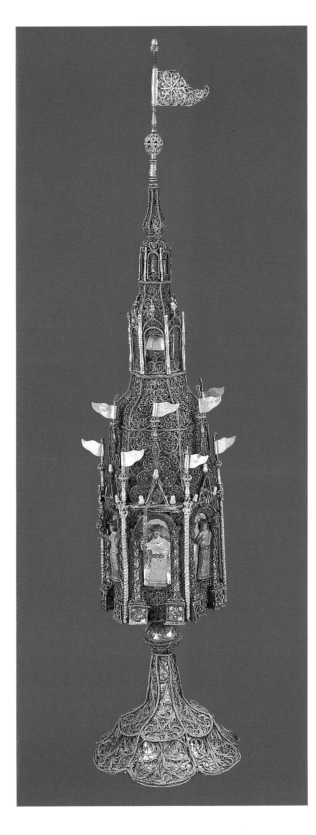

A continental silver filigree parcel-gilt and enamel spice tower,
eighteenth century, height 20⅛in (51cm)
Jerusalem US$92,400 (£46,904). 5.V.88

The Trial of the Jews of Trent, a German manuscript on paper in German Gothic
script interspersed with Hebrew script, *circa* 1478
New York $176,000 (£95,652). 14.XII.87
From the collection of the American Jewish Historical Society

This manuscript is the only copy known to exist in German from the records of the
trial of the Jews wrongly accused of the ritual murder of the Christian infant
Simon of Trent. The document records the 'confession' of the Jews extracted after
their torture.

Islamic art

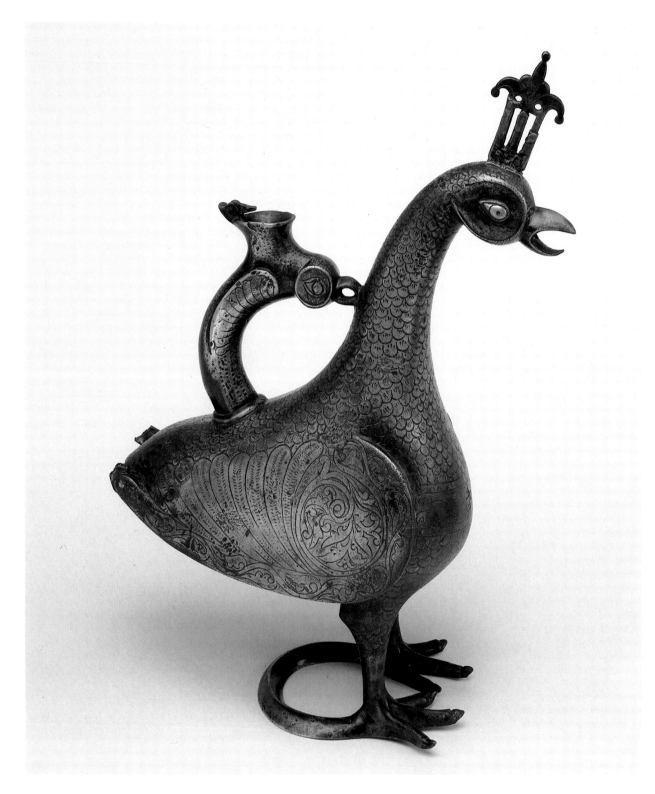

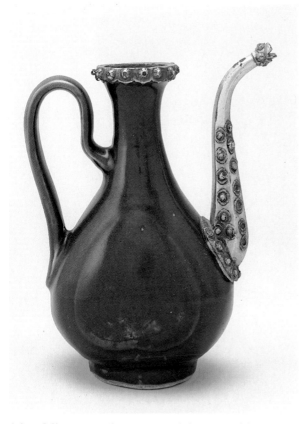

A late Ming monochrome porcelain ewer with
Ottoman tombak bejewelled mounts, sixteenth
century, height 8½in (21.6cm)
London £11,000 ($21,560). 13.IV.88

A Safavid monochrome moulded pottery bottle with
tombak mounts, seventeenth century,
height 10⅝in (27cm)
London £11,000 ($21,560). 13.IV.88

Opposite
An Islamic Mediterranean bronze zoomorphic aquamanile, eleventh–twelfth century,
height 14in (35.6cm)
London £220,000 ($385,000). 14.X.87

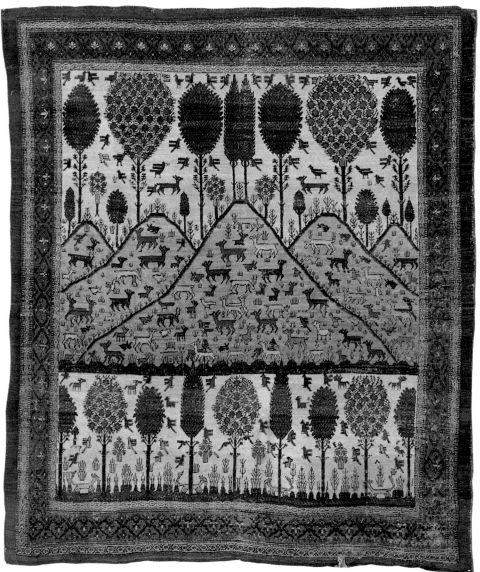

A Bakshaish rug, North Persia, last quarter nineteenth century,
approximately 6ft 9in by 5ft 11in (205.7cm by 180.3cm)
New York $52,250 (£29,028). 4.VI.88

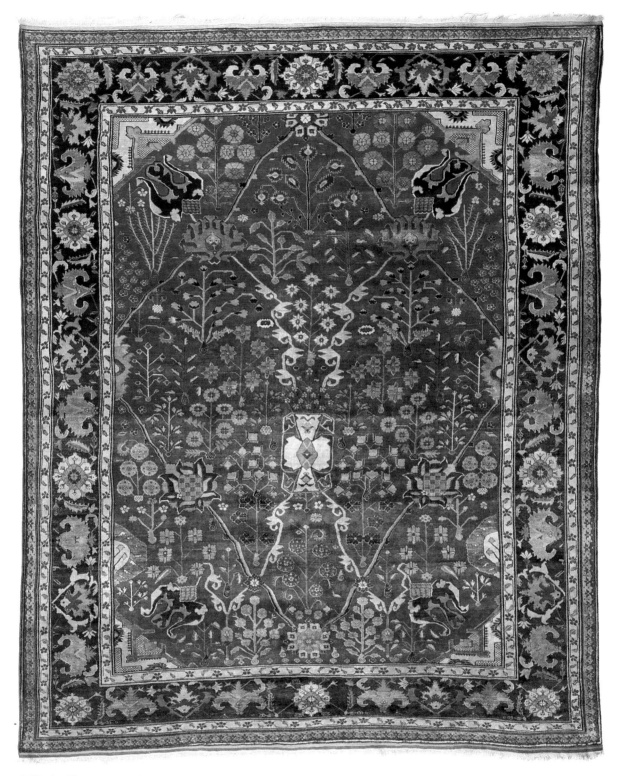

A Heriz silk carpet, 10ft by 8ft 4in (305cm by 254cm)
London £39,600 ($69,300). 14.X.87

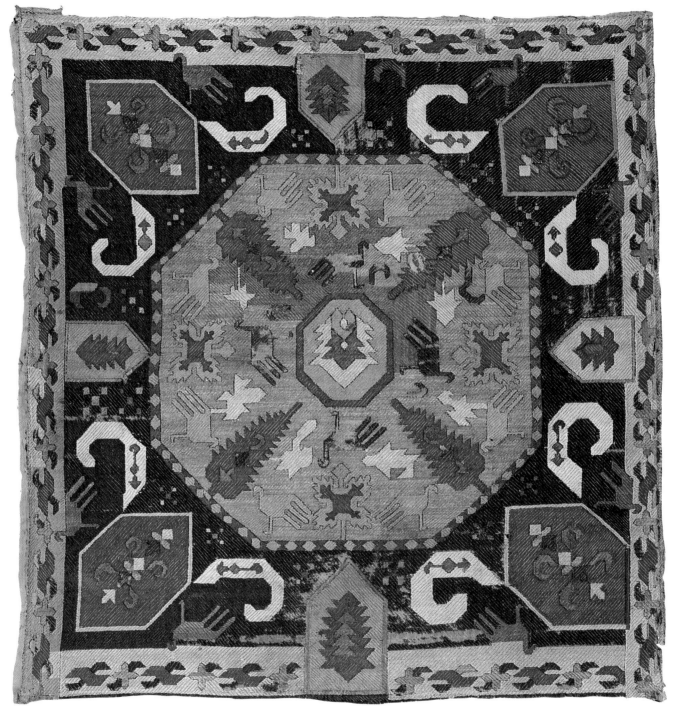

A Caucasian silk embroidery, seventeenth century, 2ft 9in by 2ft 7in (83.8cm by 78.7cm)
New York $49,500 (£27,500). 5.XII.87

A 'Polonaise' carpet, Persia, seventeenth century,
13ft 5in by 5ft 8in (409cm by 172.7cm)
New York $264,000 (£146,666). 4.VI.88

A similar silk and metallic thread Persian carpet was
mislabelled 'Polonaise' (Polish) at the Paris
International Exhibition of 1876; the name now remains
synonymous with some 230 carpets of this type.

Islamic Art

Professor John Carswell

Fig.1
Süleyman the Magnificent, an engraving
by Melchior Lorchs, 1559

Islamic art embraces neither a period nor a specific commodity, rather, it ranges over a whole culture, that of Islam, which has endured as one of the world's major religions for 1,400 years, and whose influence has been felt all the way from the Atlantic to China. In the western world, Islam has always been treated with a certain wariness, and it has been much misunderstood in the past. Certain stereotypes of Moslem culture have also biased an objective appreciation of works of art produced in the Islamic world. The wide diversity and stylistic complexity of Islamic art and architecture have been appreciated by no more than a handful of connoisseurs.

Strangely enough, a group of collectors of Islamic art were active with remarkable success at the beginning of this century. Among these was Frederick DuCane Godman, who amassed what was undoubtedly the greatest collection of Turkish ceramics in existence in his Edwardian mansion outside Horsham in Surrey, before the First World War. The Godman Collection was inherited by his two daughters, and the Misses Godman magnanimously bequeathed the entire collection to the British Museum in 1983. At the same time, in Paris, Calouste Gulbenkian was avidly acquiring examples of Turkish and Islamic art; this extraordinary collection is now in the Gulbenkian Museum in Lisbon.

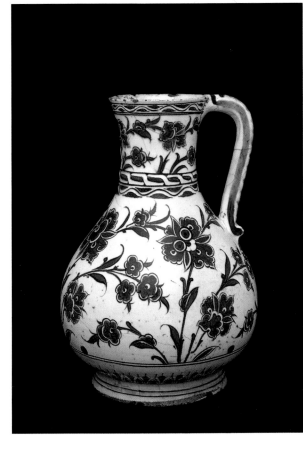

Fig.2
An Iznik blue and white pottery jug, mid sixteenth century,
height $10\frac{7}{8}$in (27.7cm)
London £15,400 ($30,184). 13.IV.88

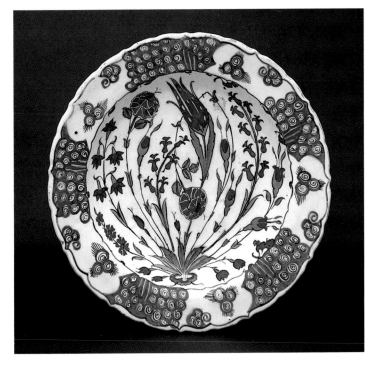

Fig.3
An Iznik pottery dish, second half sixteenth century,
diameter $11\frac{7}{8}$in (30.2cm)
London £23,100 ($45,276). 13.IV.88

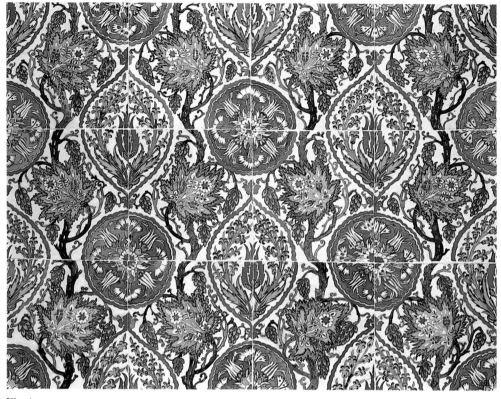

Fig.4
An Iznik tile panel, second half sixteenth century, 29$\frac{3}{8}$in by 38$\frac{3}{8}$in (74.5cm by 97.5cm)
London £60,500 ($118,580). 13.IV.88

In the Near East, a group of collectors, mostly Greek in origin, were pioneers in this field. Their passion for Islamic art led to one of the first major exhibitions devoted to it, the 'Exposition d'Art Musulman' organised by Gaston Migeon in Alexandria in 1925. Of the collectors represented, the most active was Antony Benaki, and his comprehensive collection of Islamic art, including fine examples of ceramics, glass, metalwork, stone and wood carving and textiles, was donated to his native country and is now housed in the museum bearing his name in Athens. It is an interesting reflection on Benaki that he considered Islamic art as a logical extension of Hellenism and the natural successor of the Classical tradition.

Exhibitions have done much to publicize particular aspects of Islamic art, such as the exhibition of Persian Art held at Burlington House in 1931, and more recently the 'Festival of Islam' in London in 1976. The 'Festival of Islam' was not, in fact, just one exhibit, but a whole series of exhibitions, symposia, lectures and musical performances designed to give Islamic art the wider context which is so often lacking. Major museums in Europe, such as the British Museum, the Victoria and Albert Museum, the Louvre, and those in Vienna, East and West Berlin, all have permanent

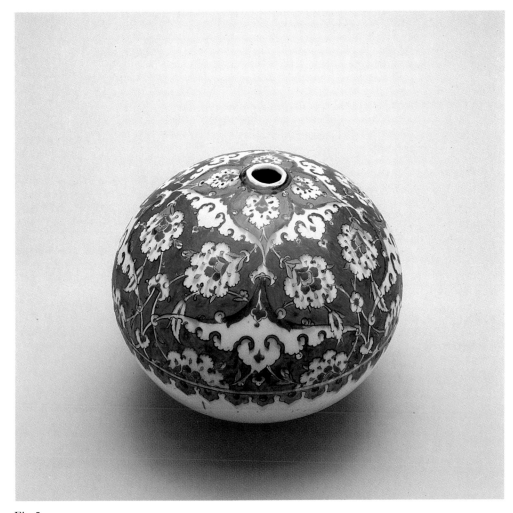

Fig.5
An Iznik pottery spherical hanging ornament, second half sixteenth century,
diameter 11¾in (30cm)
London £99,000 ($194,040). 13.IV.88

representative collections of Islamic art. These are paralleled by collections further afield, for instance in the Metropolitan Museum in New York, and in Washington, Chicago and Los Angeles. In the Islamic world itself, there are major collections of Islamic art in Cairo, Baghdad, Damascus, Istanbul and Tehran. One of the finest, and the newest, is the recently created museum of Islamic Art in Kuwait.

This past year an important imperial collection has been travelling in Europe and the United States – that of the Ottoman Sultans, normally kept in the palace of Topkapi Saray in Istanbul. The court treasures on display consist of gold and silver, pottery and porcelain, inlaid woodwork, silks and kaftans, and every conceivable

variety of applied art, including illuminated Korans and official decrees, as well as illustrated histories of the Ottoman dynasties. Normally such treasures, under Turkish law, would not have been allowed to travel outside Turkey; in order that the exhibition could take place, the law had to be changed. As a result, the exhibition of Turkish works of the sixteenth century has brought a new awareness of Turkish art, and a civilization contemporary with Renaissance Europe, Safavid Persia, Mughal India, and the Ming dynasty in China. The exhibition focuses on the personality of Sultan Süleyman (1522–66); perhaps the greatest statesman in the history of the Ottoman empire, he was also a vigorous patron of the arts, and an accomplished poet in his own right (Fig.1).

Any visitor to the exhibition is struck by the extraordinary consistency in the decoration of the works on display. This is due to the fact that a guild of court designers, the *nakkaşhane*, supplied the designs for the individual craftsmen to execute. Rather than leading to tedious imitation, in effect there is striking inventiveness based on a common core of designs. Ottoman art inherited various Islamic traditions, with a continuing fascination with geometry and form, and the elaboration of the arabesque. At the same time, the Ottomans were fascinated with the natural world, and there is a profusion of floral motifs in their art, such as the tulip, hyacinth, carnation and the rose. There is also a powerful interest in the objective depiction of the real world, expressed in annotated maps, cartography, and illustrations of military campaigns. Süleyman himself commissioned a laudatory work, the *Süley-mānnāme*, a work in many volumes devoted to his life and military campaigns.

Influence on Islamic art from the Far East came about through the import of Chinese blue and white porcelain. The Near East was a major market for such wares from the fourteenth century onwards, and the Ottoman Sultans had one of the largest collections of blue and white and celadon, still surviving in Topkapi Saray. The Turkish potters must have been aware of the Chinese material for its influence is easily detectable on their products. A pottery vase demonstrates just such a kind of influence, with blue and white floral sprays which can be traced back to Chinese early-sixteenth-century porcelain (Fig.2). The fine Iznik dish (Fig.3), with a unique potter's mark incised under the rim, of a pair of birds drawn in a few elegant arabesque strokes, combines an Islamic sensibility with motifs clearly drawn from a Chinese repertoire. Another work of art of particular note is the panel of Iznik tiles, in brilliant, scintillating colours, typical of the mature phase of the Iznik factories (Fig.4). From the same period and displaying a similar palette is the magnificent hanging ornament, for suspension above a mosque lamp, decorated with floral designs and palmettes (Fig.5).

A group of objects of a very different nature epitomises another aspect of Ottoman art – the art of warfare. The helmet (Fig.6), the dagger (Fig.7) and the chamfron, or horse armour (Fig.8), all of tombak (gilt-copper), rely on simplicity of form for their aesthetic appeal. The chamfron is marked with the insignia of the Ottoman armoury, kept in what was once the Byzantine church of St Eirene, next to Topkapi Saray.

Though their contextual and historic associations, such objects evoke a powerful sense of the environment in which they were created. Islamic works of art – unfamiliar though they may be to many a western eye – are tangible evidence of one of the world's major cultures.

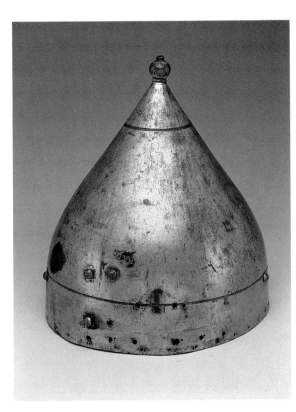

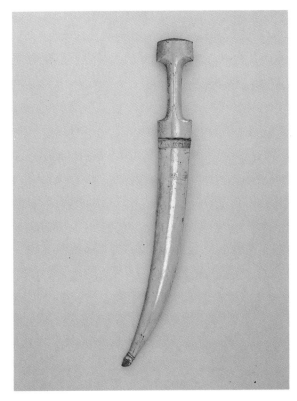

Fig.6 *Above*
An Ottoman tombak helmet, sixteenth century,
height 10½in (26.7cm)
London £17,600 ($34,496). 13.IV.88

Fig.7 *Above right*
An Ottoman tombak dagger, seventeenth century,
length 22in (56cm)
London £5,500 ($10,780). 13.IV.88

Fig.8 *Right*
An Ottoman tombak chamfron, sixteenth century,
length 22⅛in (56.2cm)
London £28,600 ($56,056). 13.IV.88

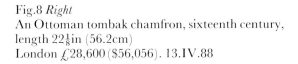

Japanese art

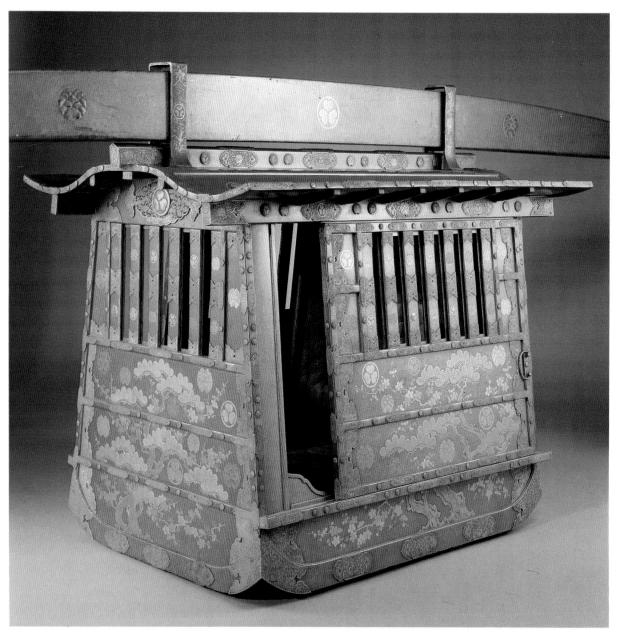

A lacquer *norimono*, eighteenth century, height with pole 47in (119.4cm)
New York $110,000 (£62,147). 17.XI.87

A Japanese cypress-wood figure of
Sho-Kannon Bosatsu, late Heian
period, *circa* AD 1100,
height 60½in (153.5cm)
London £121,000 ($227,480).
12.XI.87
From the collection of the
Comtesse Bernard
d'Escayrac-Lauture

Katsushika Hokusai
IN THE HOLLOW OF THE GREAT WAVE OFF KANAGAWA OKI NAMIURA, OBAN YOKO-E
One of forty-one prints from the series *The Thirty-Six Views of Fuji*, together with five prints
from the supplementary series of ten, mounted together as an album in Japan, *circa* 1831-34
London £605,000 ($1,149,500). 8.XII.87

A *netsuke* of two rats by Kihodo Masaka, signed, Okimono-style, late nineteenth century, length 2⅜in (6cm)
London £11,550 ($21,830). 20.VI.88

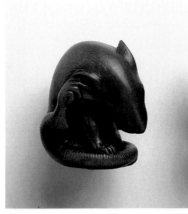

A wood *netsuke* of a rat by Ikkan, signed, nineteenth century, length 1¼in (3.2cm)
London £11,550 ($21,830). 20.VI.88

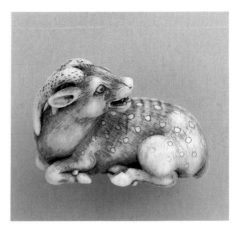

An ivory *netsuke* of a deer by Okatomo, signed, late eighteenth century, length 1⅞in (4.8cm)
London £24,200 ($45,738). 20.VI.88

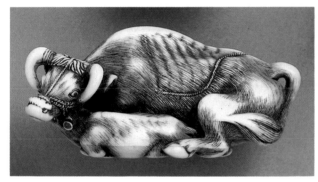

An ivory *netsuke* of a cow and calf by Masanao of Kyoto, eighteenth century, length 2¾cm (7cm)
London £35,200 ($68,640). 10.III.88

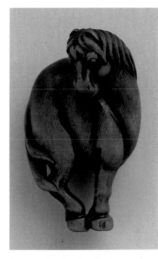

A wood *netsuke* of a horse by Tomotada, signed, eighteenth century, height 2⅛in (5.4cm)
London £24,200 ($45,738). 20.VI.88

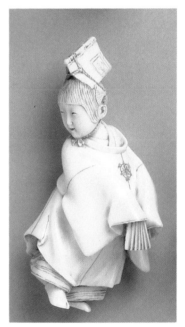

An ivory *netsuke* of a boy by Kawara Ryo, signed, late nineteenth–early twentieth century, height 2⅜in (6cm)
London £15,400 ($29,106). 20.VI.88

Opposite
Watanabe Shusen
MAKIMONO
Handscroll, ink, colour and *gofun* on silk, signed, with the seal of the artist, late eighteenth–early nineteenth century, length approximately 315in (800cm)
London £35,200 ($66,528). 20.VI.88

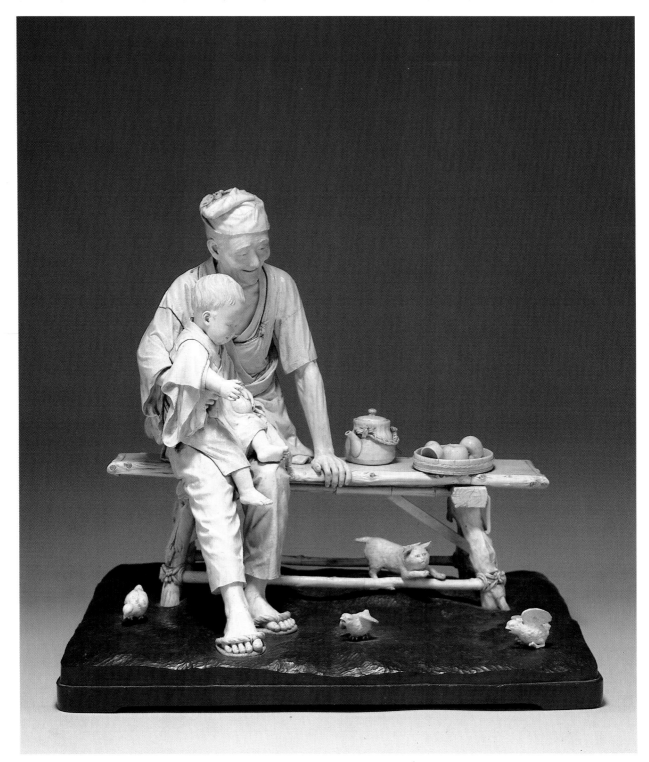

An ivory group of father and son by Yoshida Homei, signed, Tokyo School, Meiji period,
height 25⅝in (65cm)
London £50,600 ($95,634). 20.VI.88

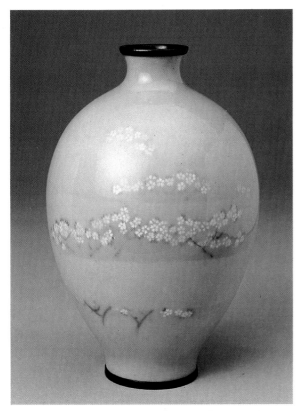

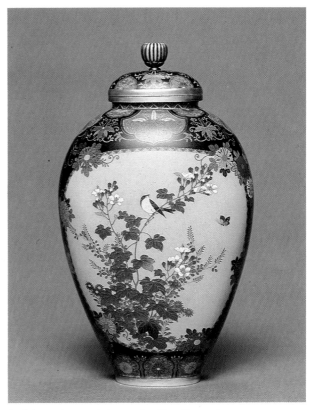

A Musen enamel vase by Namikawa Sosuke, with the
seal of the artist, Meiji period, height 6⅛in (15.5cm)
London £9,900 ($18,612). 13.XI.87

A cloisonné vase and cover by Namikawa Yasuyuki, signed,
Meiji period, height 6⅛in (15.6cm)
London £15,400 ($29,106). 20.VI.88

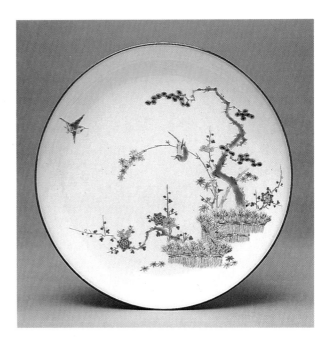

A Kakiemon dish, late seventeenth–early
eighteenth century, diameter 8½in (21.6cm)
London £24,200 ($47,190). 10.III.88

Chinese art

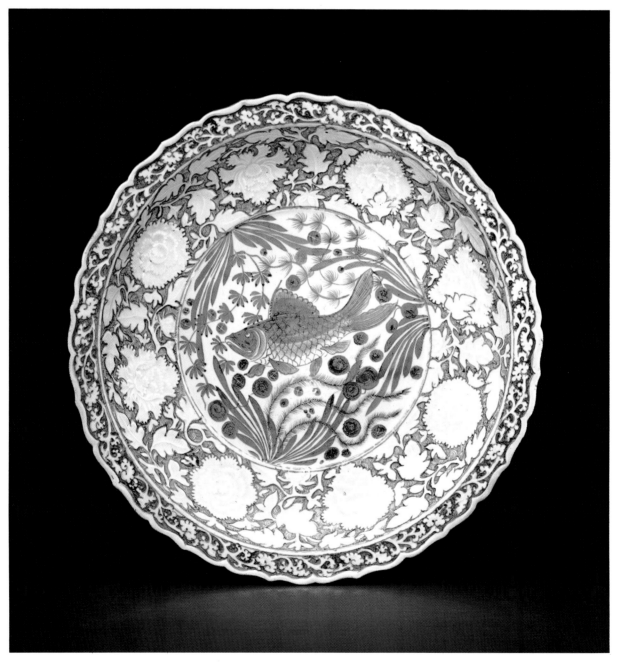

A Yuan blue and white dish, diameter 19in (48.3cm)
New York $1,100,000 (£611,111). 9.XII.87

A Yuan blue and white dish, diameter
18¼in (46.5cm)
London £473,000 ($922,350). 15.XII.87

It is remarkable that these very rare Yuan
dishes should have appeared on the market
during this season and each in excellent
condition.

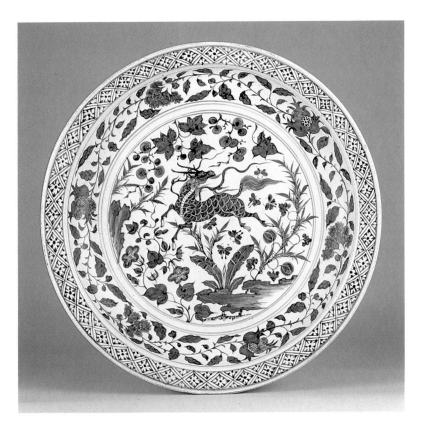

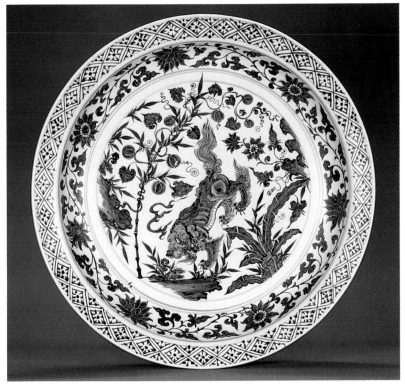

A Yuan blue and white dish, diameter
18⅜in (46.7cm)
Hong Kong HK $7,480,000
(£536,201:$960,205). 24.XI.87

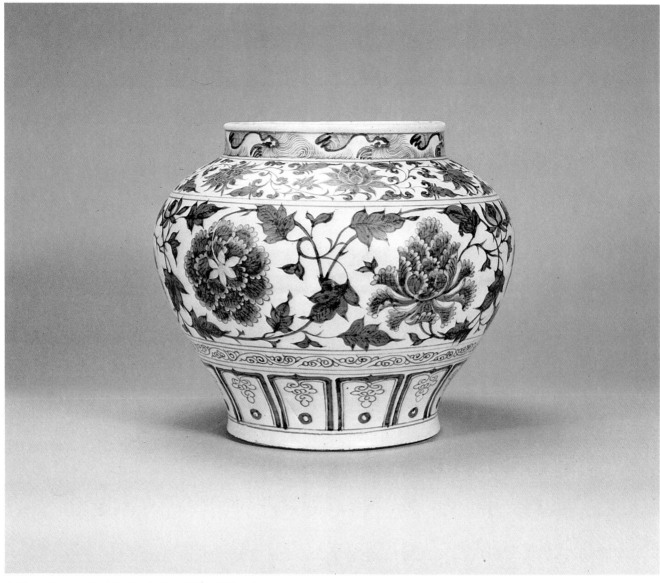

A Yuan blue and white jar, height 13⅜in (34cm)
London £605,000 ($1,161,600). 7.VI.88

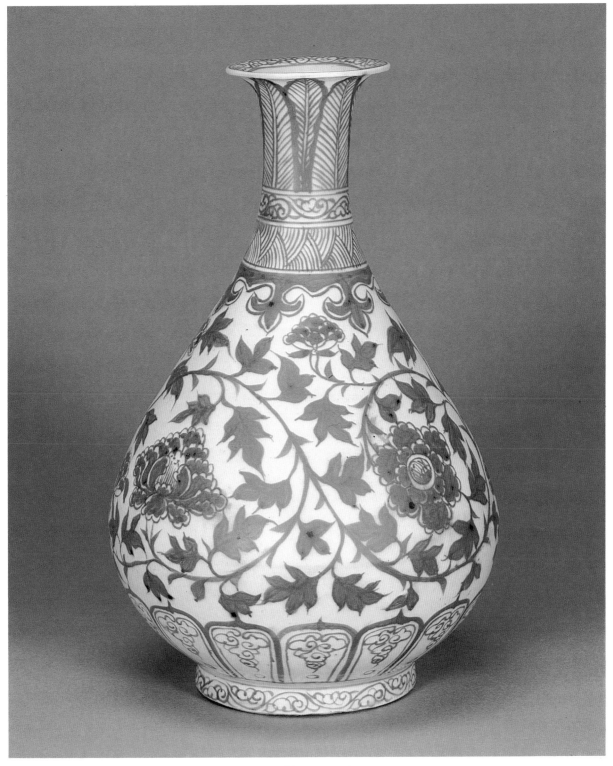

A Ming copper-red glazed vase, Hongwu, height 12¾in (32.4cm)
Hong Kong HK$17,050,000 (£1,299,543:$2,185,897). 17.V.88

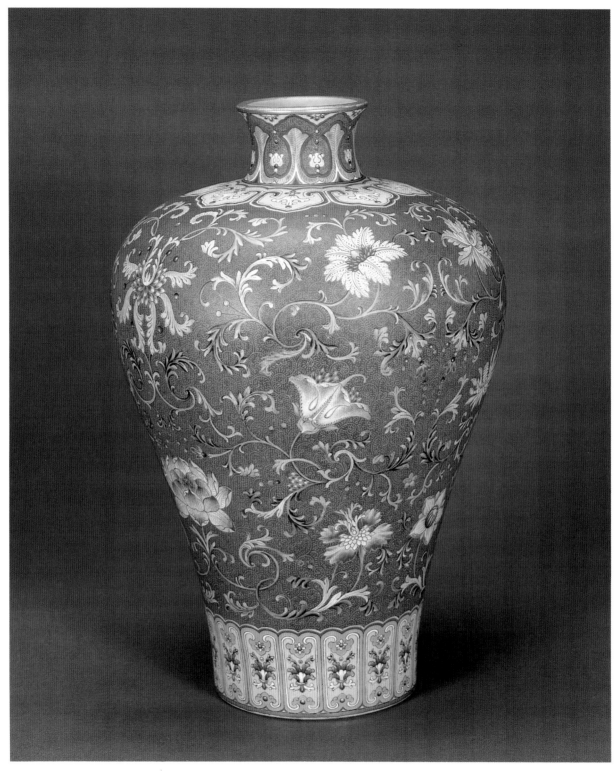

A ruby-ground *famille rose meiping*, mark and period of Qianlong, height 14¾in (37.5cm)
Hong Kong HK $1,870,000 (£142,531:$239,744). 17.V.88

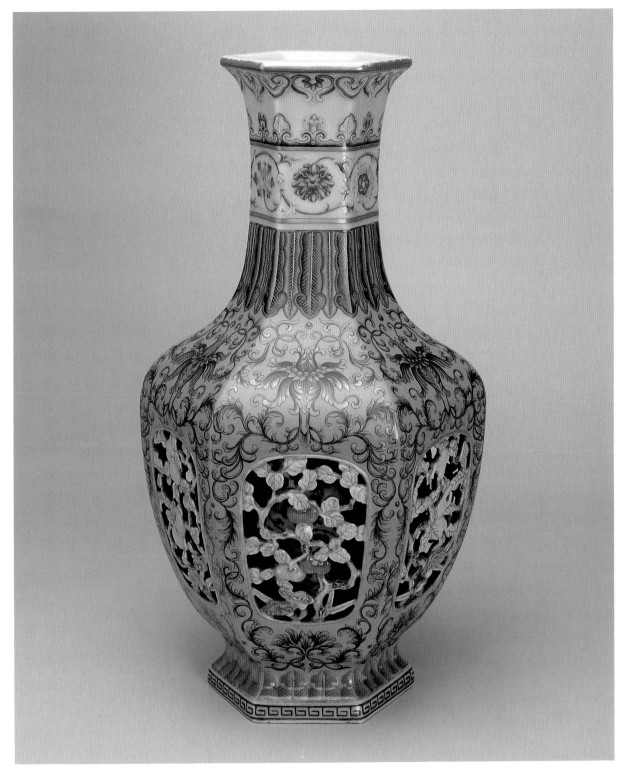

A *famille rose* vase, mark and period of Qianlong, height 15$\frac{7}{8}$in (40.3cm)
Hong Kong HK$1,870,000 (£142,531:$239,744). 17.V.88

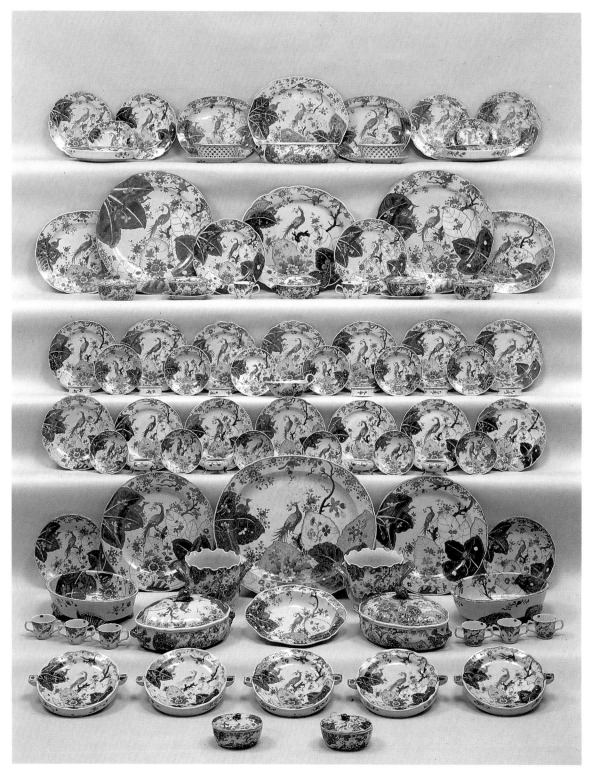

An export *famille rose* 'tobacco-leaf' dinner service comprising 195 pieces, Qianlong
London £515,130 ($952,991). 3.XI.87

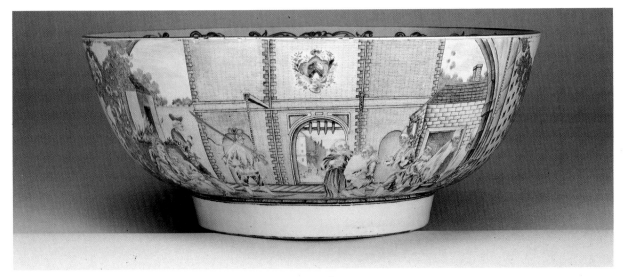

An export armorial punch bowl, *circa* 1750–55, diameter 15⅞in (40.3cm)
New York $34,100 (£19,157). 27.I.88
From the collection of Mrs Rafi Y. Mottahedeh

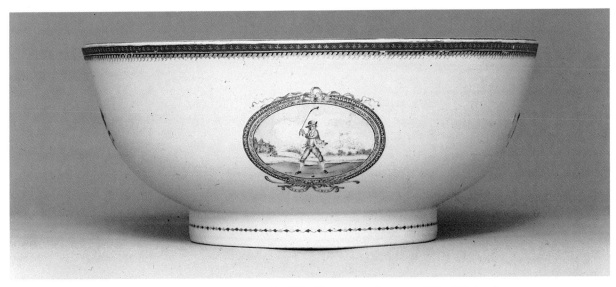

An export 'golfing' punch bowl, inscribed *VI ET ARTE*, Qianlong, diameter 11¾in (29.8cm)
London £22,000 ($40,700). 3.XI.87
From the collection of François Hervouët

This piece is one of the most important from the sale of Chinese export porcelain from the Hervouët Collection. Formed by Nicole and François Hervouët of Nantes, the latter includes Chinese export porcelain depicting European subjects. When Chinese painters were asked to decorate Jingdezhen porcelain in European style, they were often provided with Western reference drawings or prints, such is the case with this bowl illustrating a golfer swinging his club. One of the earliest works of art relating to golf, the bowl is decorated on two sides with a medallion taken from a drawing by David Allen which figured on Edinburgh's Honourable Company of Golfers' letterhead. This bowl, highlighting a particularly Scottish theme interpreted by a Chinese artist, is one of few export pieces decorated with a golfing scene.

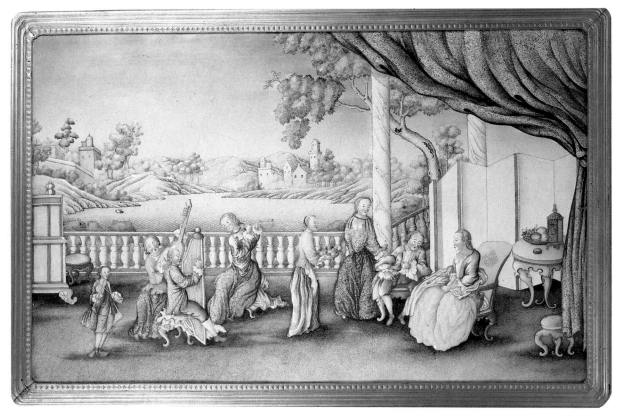

An Imperial Canton enamel plaque, Qianlong,
23⅝in by 38¼in (60cm by 97.2cm)
London £48,400 ($88,088). 30.X.87

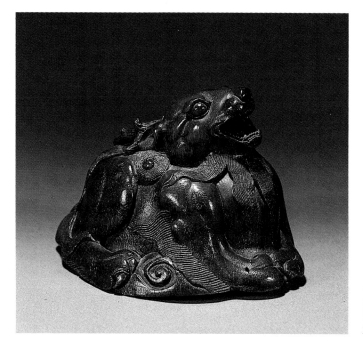

A rhinoceros horn cup, signed *Bao Tiancheng*,
mark and period of Wanli, height 3⅝in (9.3cm)
Hong Kong HK $737,000 (£52,832:$94,609).
25.XI.87

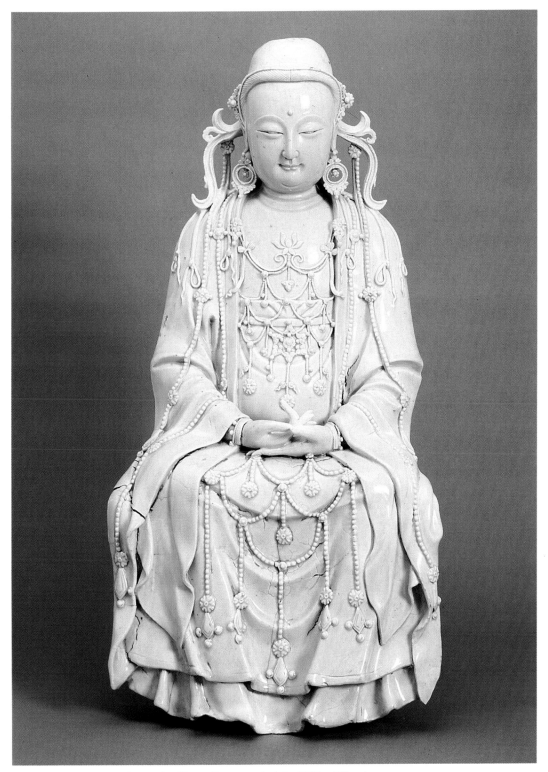

A Yingqing figure of Guanyin, Yuan Dynasty, height 26¾in (67cm)
Hong Kong HK $3,300,000 (£236,559:$423,620). 24.XI.87

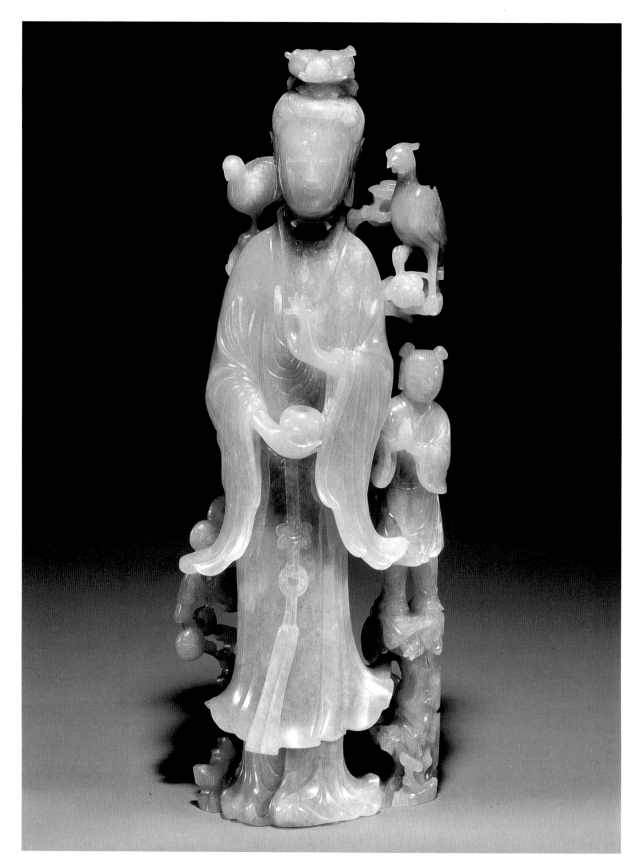

A jadeite bead necklace
Hong Kong HK$6,600,000 (£503,049:$846,154). 18.V.88

Opposite
A jadeite figure of Guanyin, nineteenth century, height 16in (40.7cm)
Hong Kong HK$3,850,000 (£293,445:$493,590). 18.V.88

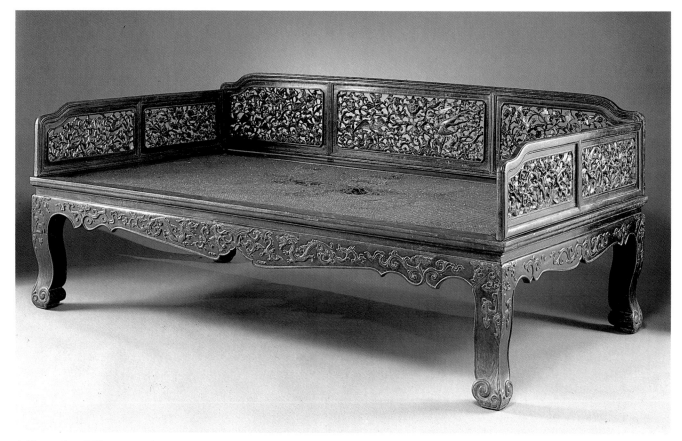

A Huanghuali Kang couch, seventeenth century, width 84in (213.4cm)
New York $77,000 (£40,958). 8.IV.88

Opposite, above, from left to right
A bronze head of a monkey, *circa* 1750, height 19in (48.3cm), $165,000 £100,000)
A bronze head of a boar, *circa* 1750, height 12¾in (32.4cm), $104,500 £63,333)

These two bronze heads, from the collection of Mr Stuart Blaine and Mr Robert Booth, were
part of an elaborate horological water fountain conceived by Giuseppe Castiglione and
Père Michel Benoist for the Emperor Qianlong at the Imperial Summer Palace in Peking
(see opposite, below). Both bronzes were sold in New York on 9th October 1987.

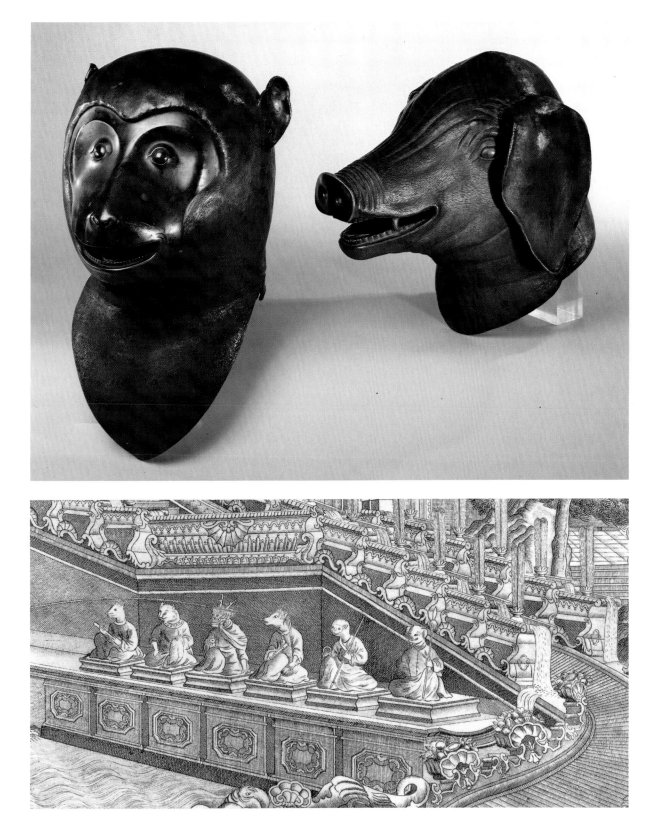

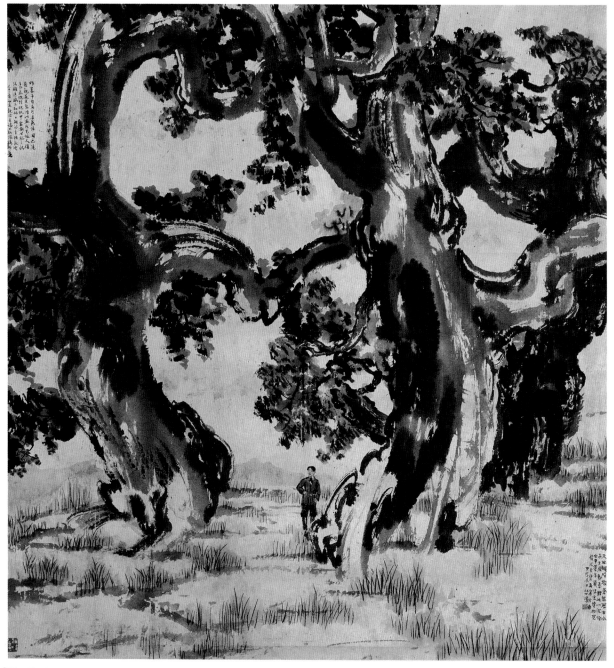

Xu Beihong

SELF PORTRAIT IN A LANDSCAPE

Hanging scroll, ink and colour on paper, signed, inscribed and dated 1934, with two seals of
the artist, 42⅛in by 40in (107cm by 101.5cm)
Hong Kong HK $990,000 (£75,457:$126,923). 19.V.88

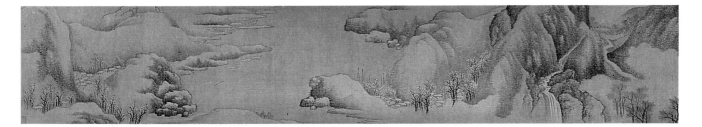

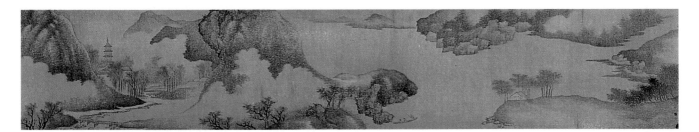

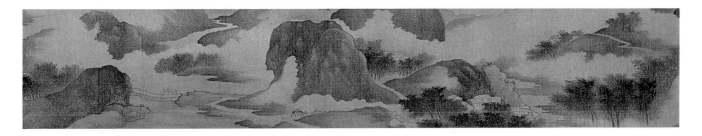

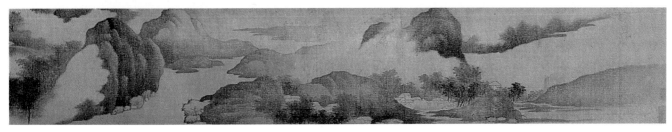

Fan Qi

LANDSCAPE OF THE FOUR SEASONS

Handscroll, ink and colour on silk, signed and dated July 4, 1692, with seals of the artist, the calligrapher and various collectors, $7\frac{5}{8}$in by $157\frac{1}{4}$in (19.4cm by 399.4cm)
New York $242,000 (£133,702). 1.VI.88

Tribal art

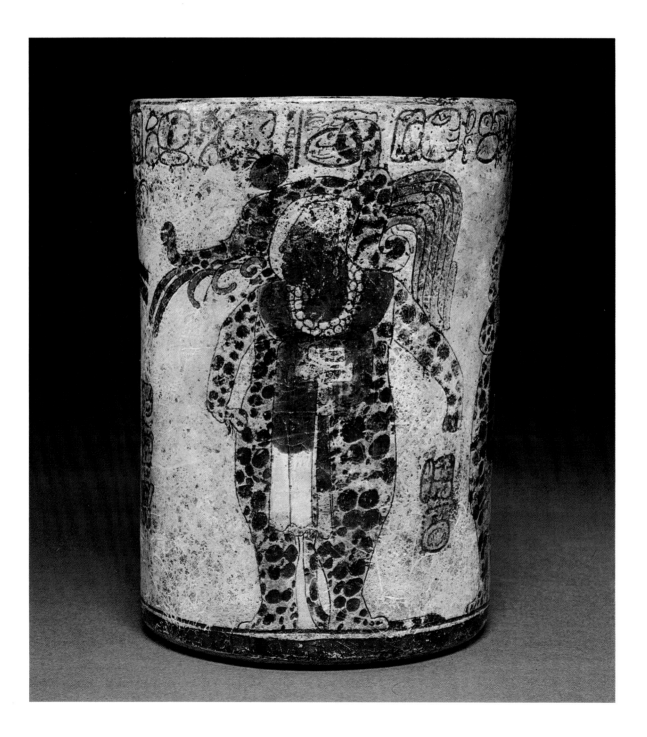

A Rarotonga wood head of a staff god,
height 18⅞in (48cm)
London £220,000 ($396,000). 11.VII.88

Opposite
A Mayan polychrome cylinder vessel, Lowlands,
late classic, *circa* AD 550–950,
height 7⅝in (19.4cm)
New York $28,600 (£15,376). 17.V.88

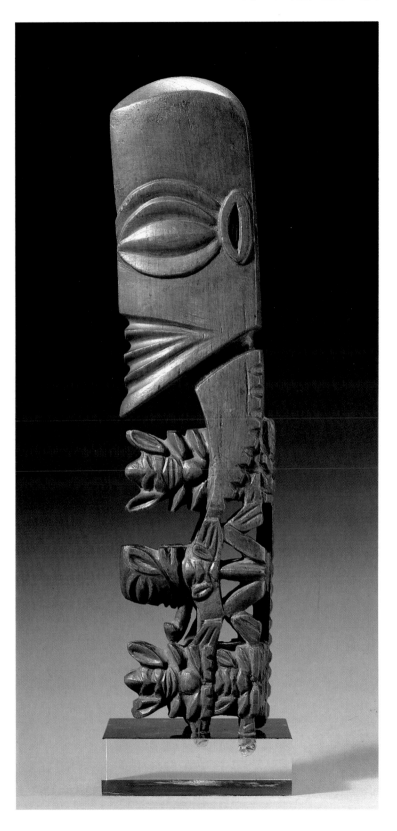

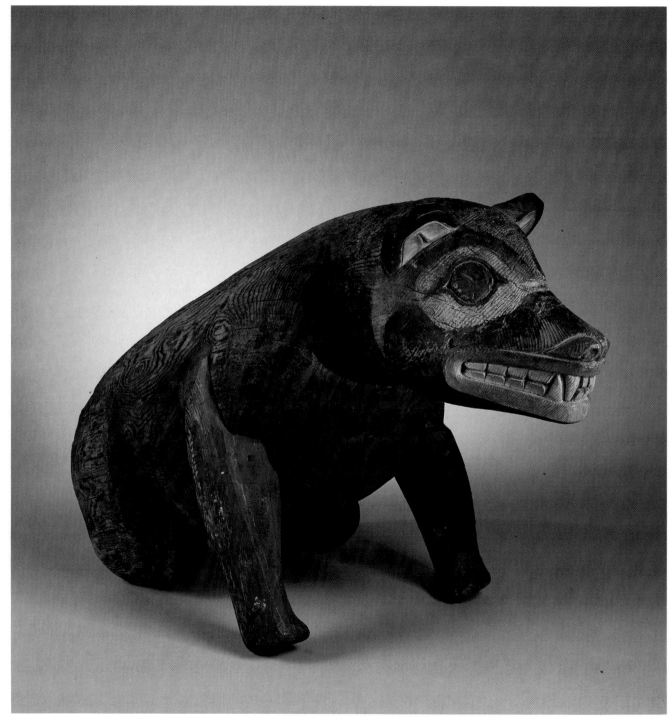

A Haida painted wood figure of a bear, length 54in (137.2cm)
New York $38,500 (£20,588). 28.IV.88
From the Andy Warhol Collection

The large size of this bear suggests that it was originally part of a totem pole.

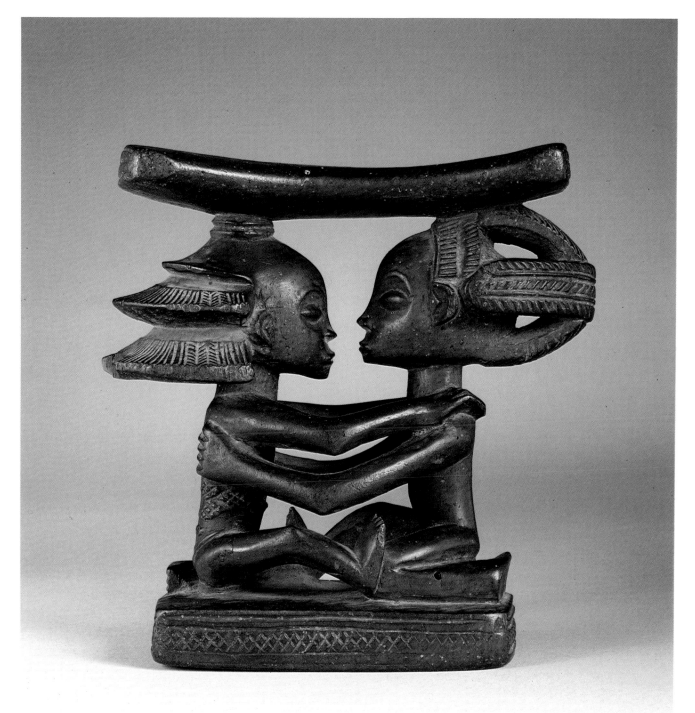

A Luba Shankadi neckrest, Zaire, height 7¼in (18.4cm)
New York $209,000 (£111,170). 10.V.88

The maker is known as the 'Master of the Cascade Coiffures'.

Antiquities and Asian art

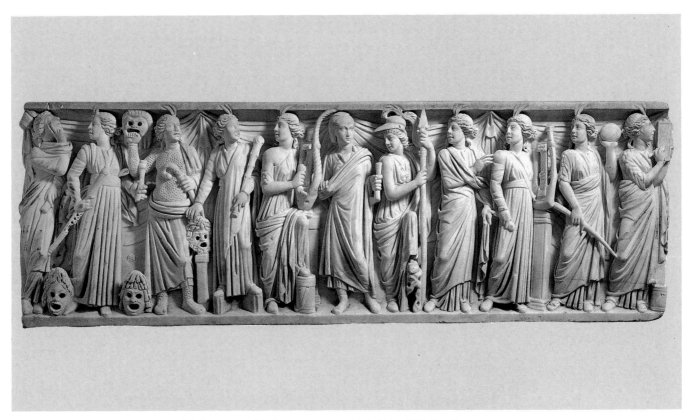

A Roman marble sarcophagus, third quarter third century AD, width 94in (238.8cm)
New York $264,000 (£147,486). 24.XI.87

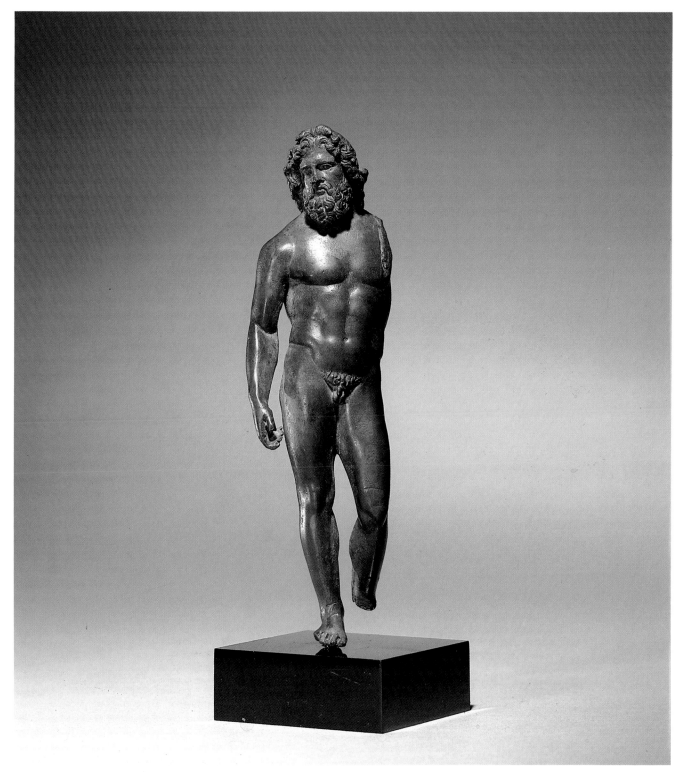

A Roman bronze figure of Jupiter, *circa* second century AD, height 5⅜in (13.7cm)
London £63,800 ($114,840). 11.VII.88

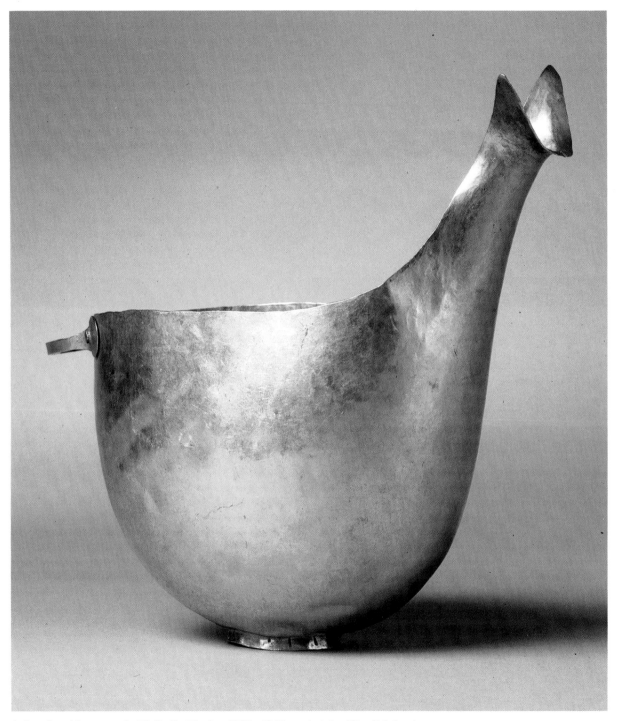

A Greek gold cup, early Helladic II, *circa* 2700–2500 BC, height 6½in (16.5cm)
New York $341,000 (£190,503). 15.VI.88

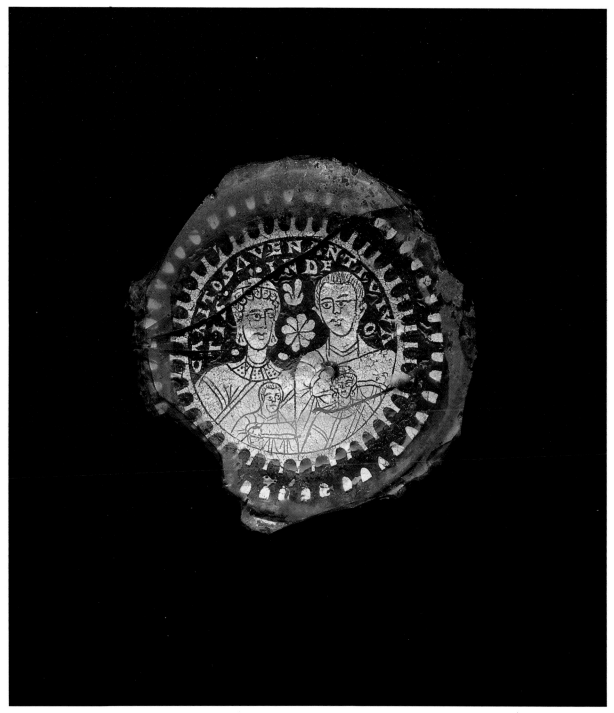

A 'gold-glass' fragment inscribed *CARITOSA VENANTI VIVATIS IN DEO*,
circa fourth century AD, diameter 4⅛in (10.5cm)
London £28,600 ($54,054). 20.XI.87

This fragment would originally have formed the base of a secular vessel. The vast majority of
fragments of this type are found impressed into the walls of catacombs.

The Constable-Maxwell
cameo glass *skyphos*

Dr Jennifer Price

This small two-handled drinking cup or *skyphos*, decorated with scenes of chariot racing, is one of about a dozen cameo glass vessels which have survived from the ancient world in a substantially complete condition. Some of the others are the Portland vase, the Auldjo jug and the Blue Amphora from Pompeii, the flasks from Florence and Estepa, the Morgan cup and the Getty bottle and two-handled cup. Such cameo glass vessels and inlays first appeared at the beginning of the Roman Empire, in the late first century BC, and continued in production until around the middle of the first century AD, examples being found throughout the Roman world.

The Constable-Maxwell cup has a dark blue translucent ground colour with an outside layer of opaque white glass. Cameo glass imitated semi-precious stones such as chalcedony, agate and sardonyx, which were worked as gem-stones and also occasionally as vessels. The glass was complicated and time-consuming to produce, though the precise methods of forming the layers of coloured glass and bonding them together are not completely understood. Here, the opaque white overlay has been cut away and carved to create the figured scenes; these are divided by the handles, which have a carved youthful mask below the lower attachment.

One scene shows the horses with raised and extended forelegs being urged on by the charioteer, holding the reins in his left hand and a raised whip in his right. The second scene shows the horses with raised and bent forelegs being reined in.

The two-handled drinking cup was a popular shape in contemporary silver and it was used quite frequently for cameo glass vessels. No other vessel with a similar scene has survived, though one or two flat fragments from plaques or plates show part of a spoked wheel and a chariot. The vessel most closely comparable in shape with the Constable-Maxwell piece is the Getty cup, which is decorated with bacchic scenes; a number of other cup fragments have bacchic or Egyptianizing scenes, or vine and leaf motifs.

Cameo glasses are found much less frequently than other kinds of early Imperial luxury glassware. They must have been rare and costly, not easy to replace: there is ample evidence, for example from the Portland vase and one of the panels from the House of Fabius Rufus in Pompeii, that when pieces were damaged their owners in antiquity repaired them. Great wealth existed in the Roman world during the late Republic and early Empire, and it is clear that private individuals in many parts of the Empire collected luxury objects. It is very likely that the Constable-Maxwell cup was a prized personal possession of this kind.

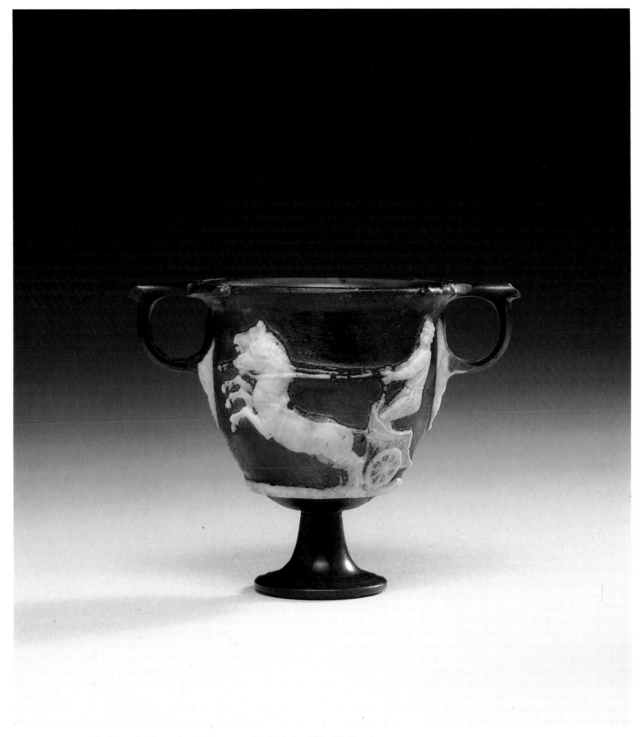

A cameo carved glass *skyphos*, *circa* 25 BC–AD 25, height 3¼in (8.3cm)
London £352,000 ($665,280). 20.XI.87
From the collection of Mr and Mrs Andrew Constable-Maxwell

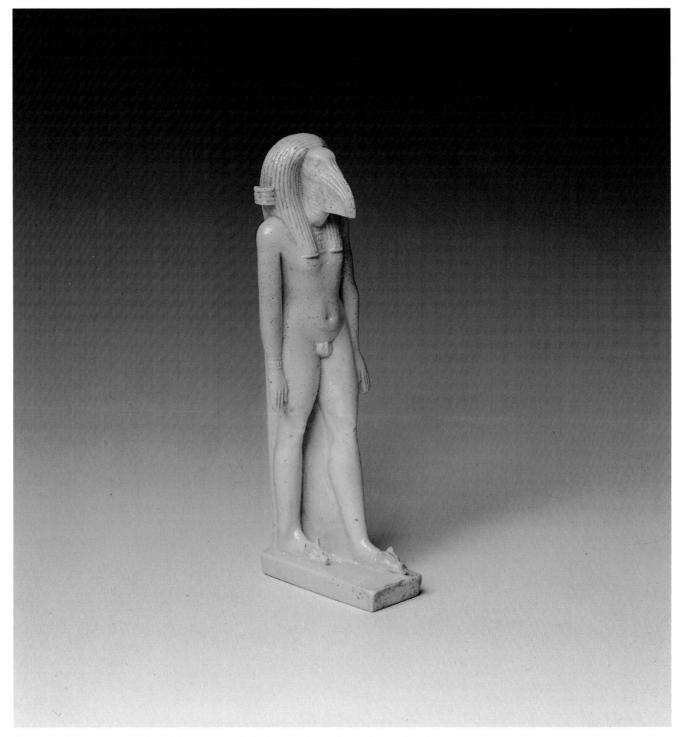

An Egyptian turquoise-glazed faience amuletic figure of Thoth, Ptolemaic Period,
circa 400–30 BC, height 4¾in (12cm)
London £24,200 ($43,560). 11.VII.88

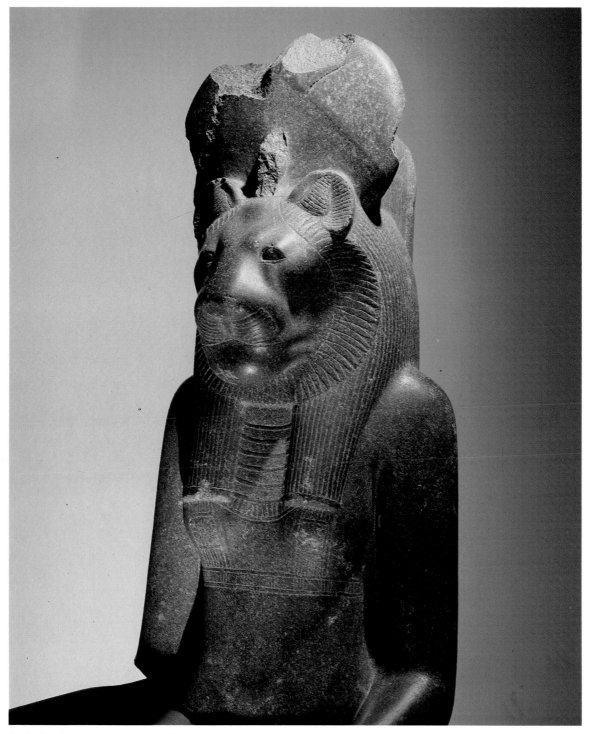

A diorite figure of the goddess Sekhmet, Thebes, Eighteenth Dynasty, reign of
Amenhotep III (1403-1365 BC), height 43in (109.2cm)
New York $495,000 (£276,536). 24.XI.87
From the collection of the Cranbrook Academy of Art Museum

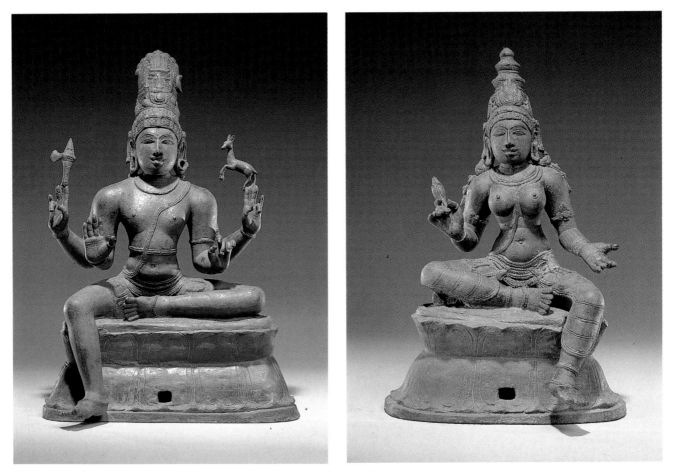

Two bronze figures of Shiva and Parvati, probably a pair, Chola, eleventh century,
heights 21½in and 16¾in (54.6cm and 42.5cm)
New York $231,000 (£124,865). 16.III.88
From the collection of Mrs Nelson A. Rockefeller

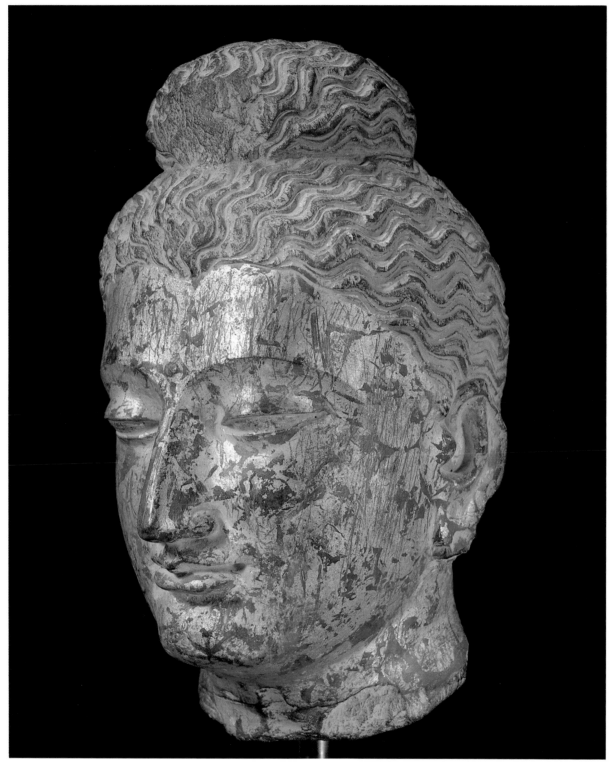

A Gandhara gilded schist head of Buddha, third–fourth century AD, height 11⅜in (29cm)
London £52,800 ($97,152). 13.VI.88

Antiquities and works of art from the collection of Martine, Comtesse de Béhague

Richard Camber

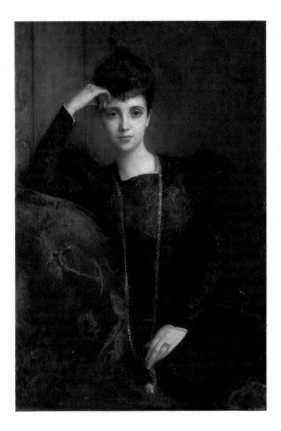

Cultivated, leisurely, free from commonplace values and passionately devoted to all that was new in art and literature, this was the world of the legendary French collector, Martine, Comtesse de Béhague (1870–1939). In her Paris home in the rue St Dominique, its walls hung with paintings by Titian, Watteau, Fragonard, Renoir and Degas, the poets d'Annunzio and Paul Valéry rubbed shoulders with Isadora Duncan and Fortuny. Every year the Comtesse herself, much in the manner of her somewhat older fellow collectors J.P. Morgan and Baron Edmond de Rothschild, cruised the Mediterranean aboard her yacht *Nirvana*, constantly in search of antiquities and other vestiges of past civilizations wherever the anchor was dropped. A world that is now lost, but one that gave birth to some of the greatest of European collections.

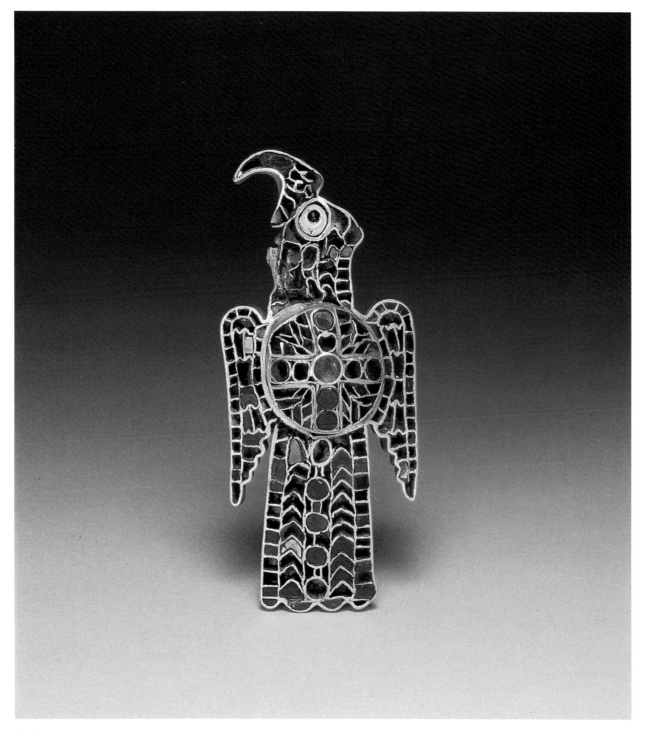

Fig.1
An Ostrogothic gold and garnet cloisonné cloak brooch, from the Domagnano Treasure,
fifth century AD, height 4¾in (12.1cm)
Monte Carlo FF14,430,000 (£1,443,000:$2,576,786). 5.XII.87
From the collection of the late Martine, Comtesse de Béhague

Martine Marie Pol de Béhague was one of the two daughters of Comte Octave de Béhague, who had married into the fabulous wealth of the well-known Haber banking family. Introduced into the world of art collecting by her sister's father-in-law, the Marquis de Ganay, her remarkable independence of taste and judgement soon revealed itself, most notably in the formation of an unusual and idiosyncratic collection of antiquities and early works of art. This was published during the brief period of her marriage to Comte René de Béarn by one of the curators of the Louvre, Wilhelm Froehner, and, although she was to revert to her maiden name after her divorce, it was under the name of the Comtesse de Béarn that the international renown of the collection was first established. With no children of her own, she appointed her nephew, Hubert de Ganay, as her heir after her death, and it was his sons, the present Marquis de Ganay and his brothers, who sent the collection for sale at Sotheby's in Monaco in December 1987.

Ranging in date from the First Dynasty in Egypt (*circa* 3200–2980 BC) to sixteenth-century Renaissance France, the collection reflected the eclectic tastes of the Comtesse herself. Among its highlights were a magnificent Ostrogothic gold and garnet eagle brooch of the fifth century AD from the Domagnano Treasure, the pair to which is now in the Germanisches Nationalmuseum in Nuremberg (Fig.1); a Babylonian rock crystal votive jar dedicated to the shepherd god Amurru; two miniature Egyptian carved figures of young women, one in ivory, now in the Louvre (Fig.2), which was acquired at Port Said in the course of a round-the-world cruise on the *Nirvana*, and the other in wood (Fig.3); a stunning Ptolemaic faience group of Isis and Horus; the so-called 'Béhague Apollo', a small Greek bronze of the fifth century BC with an important dedicatory inscription to Artemis (Fig.4); a rare Early Christian ivory relief of the sixth century AD showing scenes from the Life of the Virgin; a middle Byzantine steatite relief of Saint Demetrios, dating from the eleventh or twelfth century and two very rare examples of Saint-Porchaire faience of the sixteenth century, one combining the arms of France, the royal monogram of Henri II and the emblem of his mistress, Diane de Poitiers (Fig.5). Varied but by no means comprehensive, this brief overview omits more than two hundred and eighty other items, ranging from Greek vases to Renaissance hardstone carvings, from Roman bronzes to a pair of German or Russian silk cuffs of about 1700.

Formed during that halcyon period before the First World War when important antiquities were more freely available than they are today and when the great museums of London, Paris, Berlin and New York were still active participants in the market, the Comtesse's collection might be considered by current standards to have been unduly erudite and archaeological in character. While it is true that scholars of the calibre of de Rossi, Schlumberger, Maspero and Furtwängler, not to mention Froehner himself, were to make valuable contributions to its study, their clinical and systematic approach seems to be the very antithesis of the spirit that guided its formation. The Comtesse herself appears not to have been guided by any spirit of antiquarianism, nor even by that more familiar syndrome, the desire to amass a representative series of objects; it was rather the intrinsic beauty of the object and, above all, its power to evoke the past that captivated her. Attic black-figure vases, Egyptian antiquities, Barbarian jewels, Medieval ivories and Renaissance faience all had equal power to evoke an image of the past and no distinction was made between

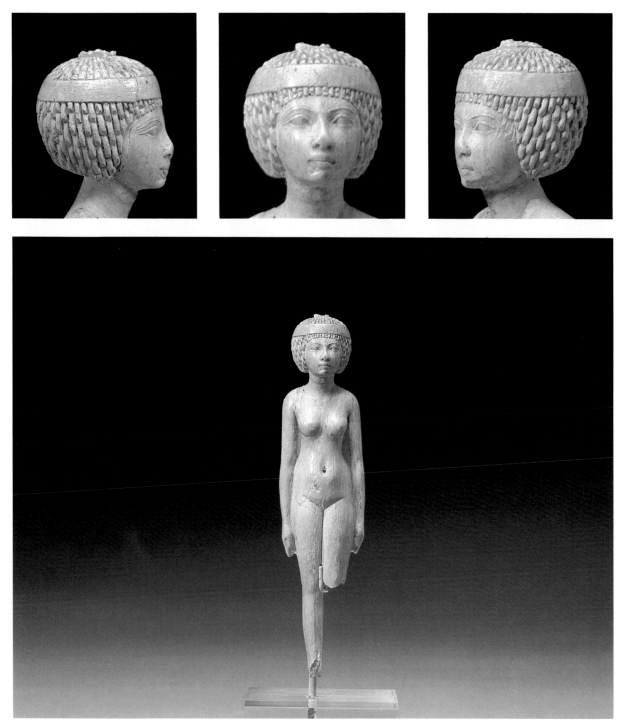

Fig.2
An Egyptian ivory figure of a nude young woman, New Kingdom-Late Period,
circa 1567–30 BC, height 4⅛in (10.5cm)
Monte Carlo FF3,108,000 (£310,800:$555,000). 5.XII.87
From the collection of the late Martine, Comtesse de Béhague

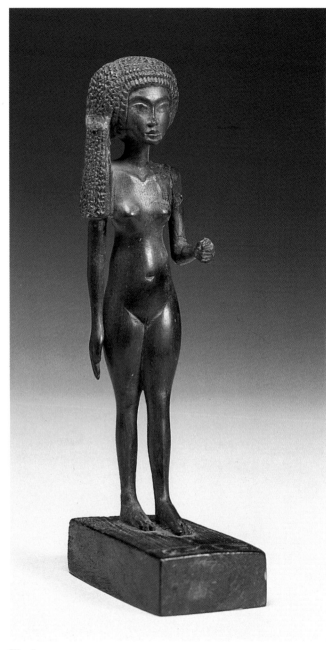

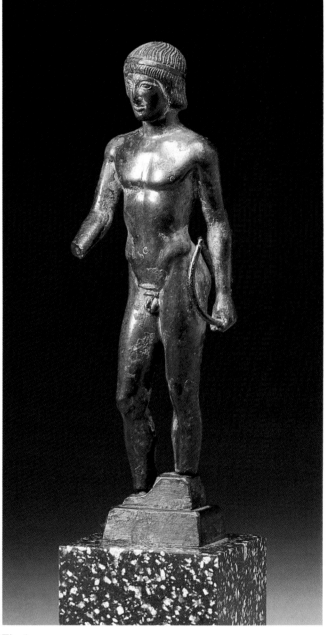

Fig.3
An Egyptian wood figure of a nude young woman,
New Kingdom, Eighteenth Dynasty, *circa* 1350 BC,
height 7¼in (18.4cm)
Monte Carlo FF3,996,000 (£399,600:$713,571). 5.XII.87
From the collection of the late Martine, Comtesse de
Béhague

This figure probably represents a concubine of the Royal
Harem. She is wearing a Nubian-style wig and stands on
a base inscribed with her name, *Nebet-ia*.

Fig.4
A Greek bronze figure of Apollo, fifth century BC,
height 4¾in (12.1cm)
Monte Carlo FF8,325,000 (£832,500:$1,486,607).
5.XII.87
From the collection of the late Martine, Comtesse de
Béhague

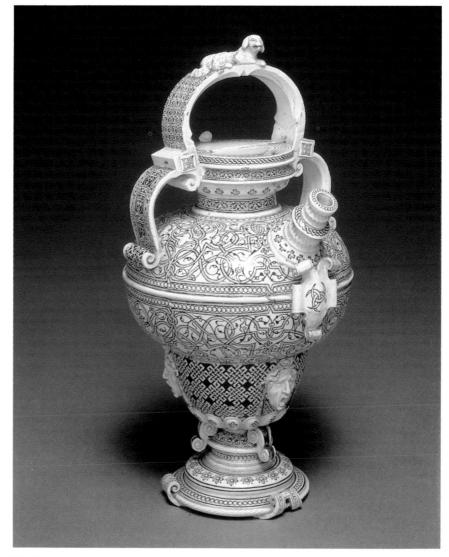

Fig.5
A Saint-Porchaire 'Biberon', *circa* 1530–40, height 9in (23cm)
Monte Carlo FF4,107,000 (£410,700:$733,393). 5.XII.87
From the collection of the late Martine, Comtesse de Béhague

sacred and profane, Christian and pagan: Isis and Horus, Apollo, Saint Demetrios and Diane de Poitiers were all members of the same pantheon.

Personal as the collection may have been in that it reflected her own highly developed taste and judgement, she was nevertheless a child of her time and the world of late-nineteenth-century Symbolism is never far beneath the surface. Seen from this vantage point, the collection emerges as an important milestone in the history of modern sensibility – this was, after all, the age of Proust, Strauss and Maeterlinck.

Works of art

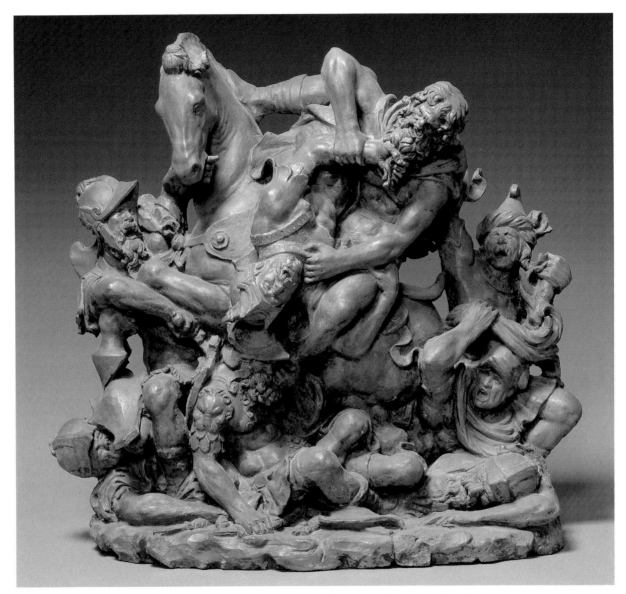

A Florentine terracotta group of a battle scene attributed to Giovanni Francesco Rustici,
first half sixteenth century, height 21¼in (54cm)
London £275,000 ($547,250). 21.IV.88

Opposite
A North Spanish polychrome and giltwood altarpiece from the workshop of Guiot, Juan and
Mateo Beaugrant, second quarter sixteenth century, height 190¾in (484.5cm)
London £462,000 ($919,380). 21.IV.88
From the collection of the Bernheimer family

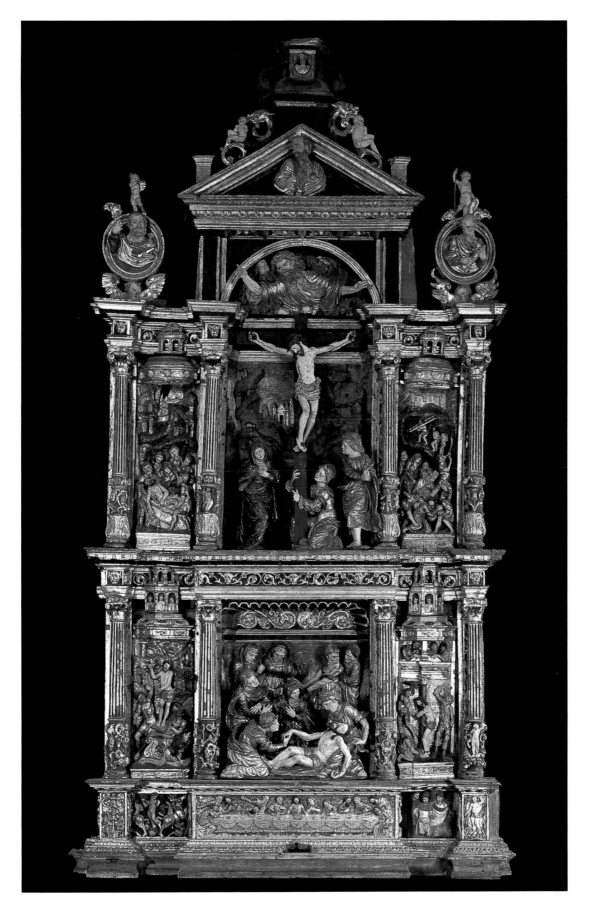

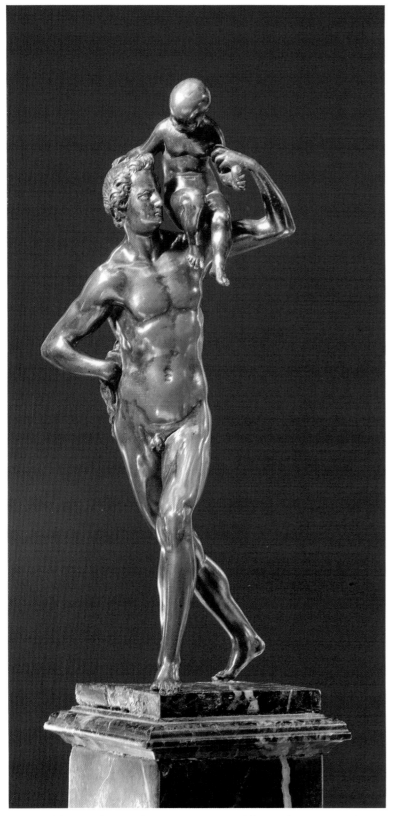

A French bronze figure of a man carrying a child, early seventeenth
century, height 9¼in (23.5cm)
New York $330,000 (£184,358). 24.XI.87

Opposite, left
A bronze figure of Venus Urania, probably South
German, *circa* 1580, height 14¼in (36.2cm)
London £60,500 ($115,555). 10.XII.87
From the collection of the late Lord Clark of
Saltwood

Right
A French bronze figure of Neptune attributed to
Michel Anguier, mid seventeenth century,
height 19½in (49.5cm)
London £93,500 ($178,585). 10.XII.87

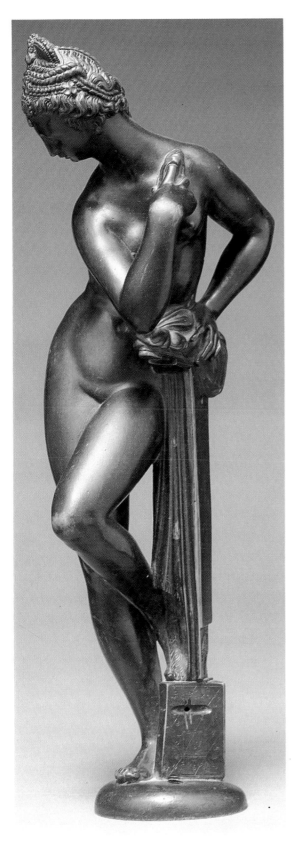

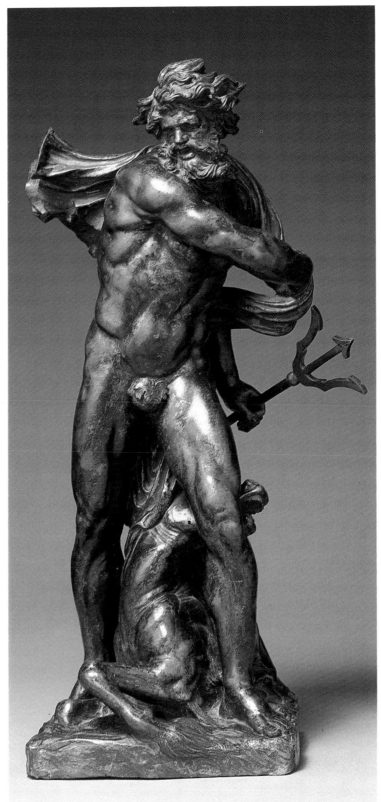

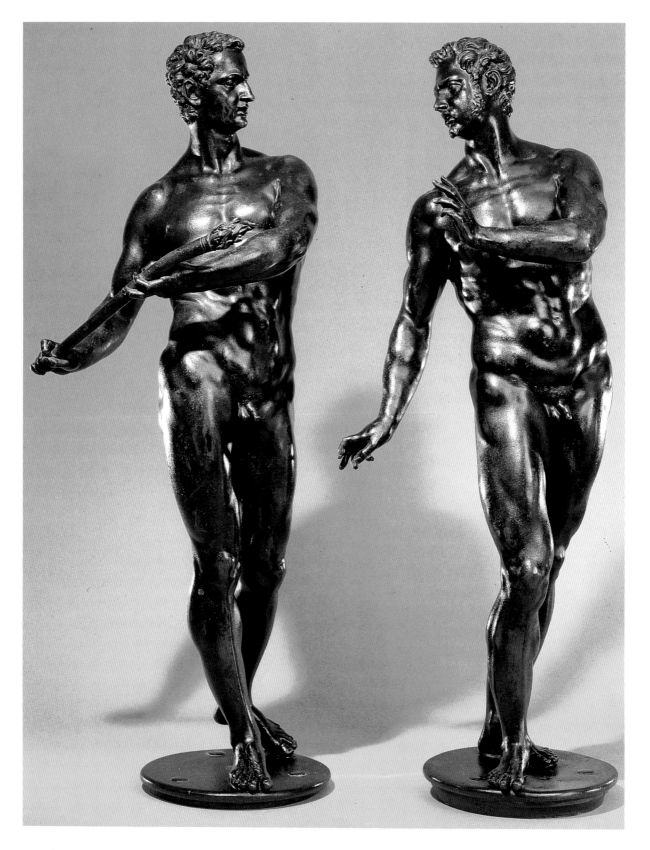

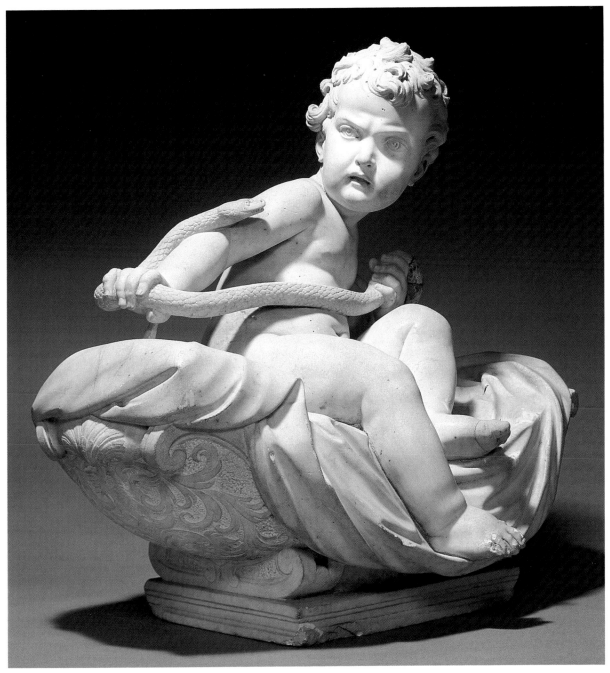

A Roman marble group of the infant Hercules by Ercole Ferrata, inscribed *HER.FER.*,
mid seventeenth century, width 24in (61cm)
London £110,000 ($210,100). 10.XII.87

Opposite
Two North Italian bronze figures attributed to Tiziano Aspetti, late sixteenth century,
height 29½in (74.9cm)
New York *left* $770,000 (£413,979), *right* $577,500 (£310,484). 20.V.88
From the Estate of Belle Linsky

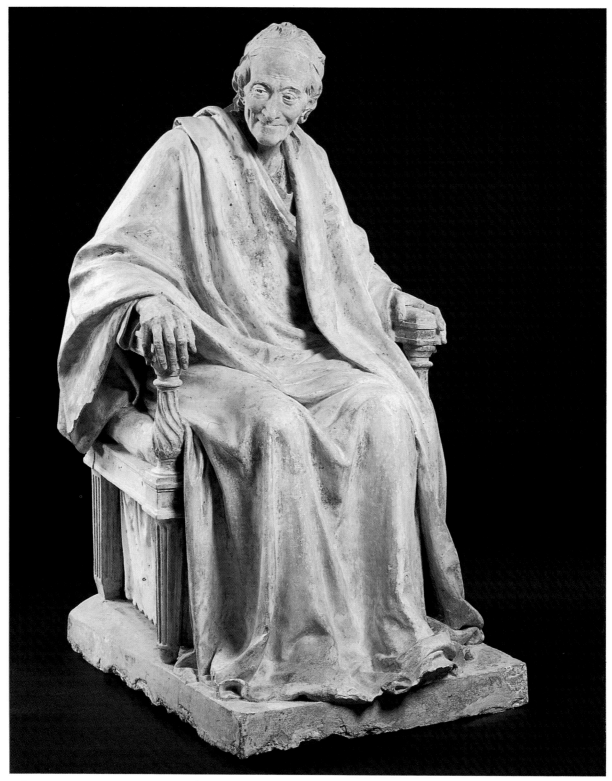

A French plaster portrait figure of Voltaire by Jean-Antoine Houdon, *circa* 1780–90,
height 52½in (133.5cm)
Monte Carlo FF 821,400 (£82,140:$142,852). 21.II.88

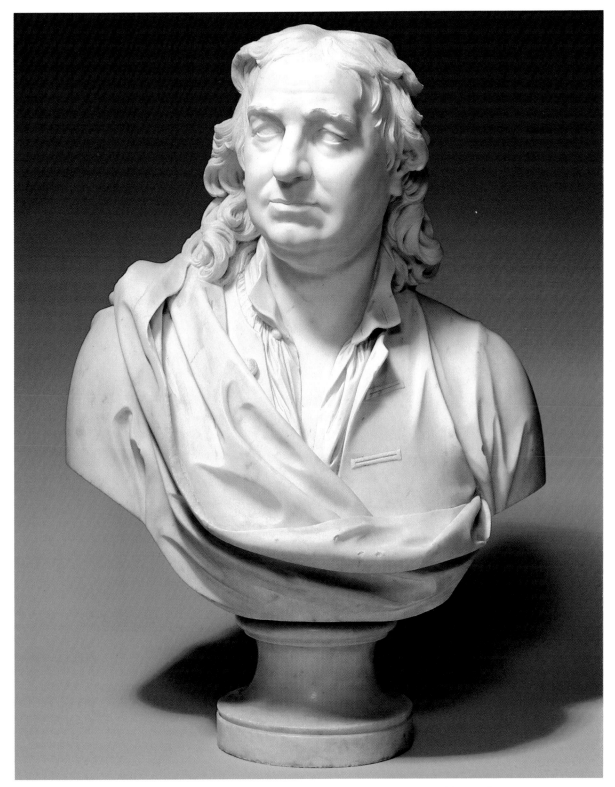

An English marble bust of Francis Smith of Warwick by Michael Rysbrack, mid eighteenth
century, height 23¾in (60.3cm)
London £165,000 ($297,000). 7.VII.88
From the collection of the late Marcus McCausland

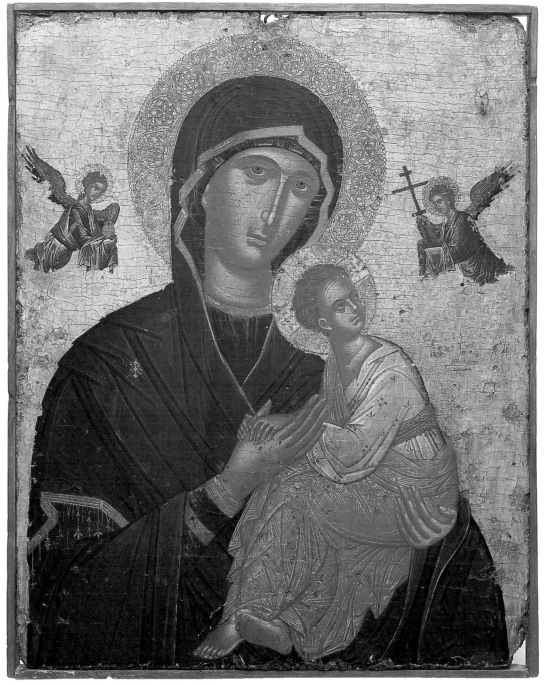

A Cretan icon of the Mother of God of the Passion, second half fifteenth century,
25½in by 20¾in (65cm by 53cm)
London £63,800 ($124,410). 18.XII.87

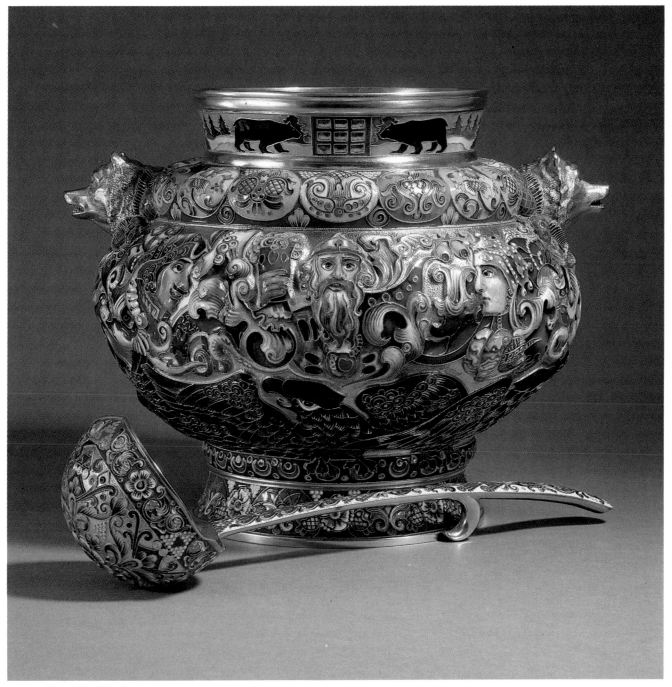

A silver-gilt and shaded enamel pictorial punch bowl and ladle by Fyodor Rückert, Moscow,
circa 1910, diameter 12in (30.5cm)
New York $74,250 (£40,574). 15.XII.87

Above
A Fabergé gold-mounted enamel box,
workmaster H. Armfeldt, St Petersburg,
circa 1899–1908, width 7⅛in (18cm)
Geneva SF66,000 (£27,049:$48,175).
12.XI.87

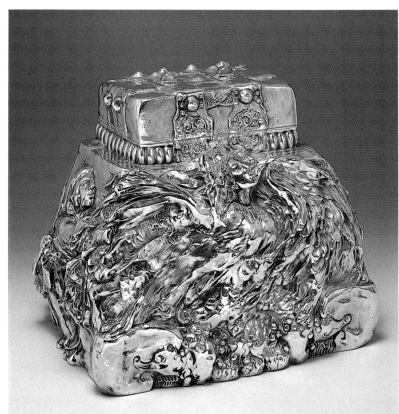

Right
A Fabergé silver casket, Moscow,
circa 1908–17, height 7⅞in (20cm)
Geneva SF37,400 (£15,328:$27,299).
12.XI.87

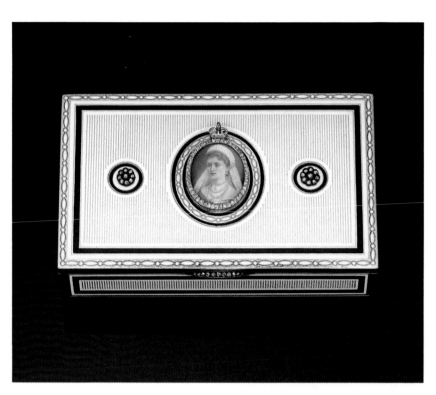

A Fabergé gold, enamel and jewelled Imperial presentation compact with a miniature of Alexandra Feodorovna, workmaster H. Wigström, St Petersburg, *circa* 1910, length 3⅝in (9.2cm)
New York $93,500 (£49,471). 19.IV.88
From the collection of the late Clare Boothe Luce

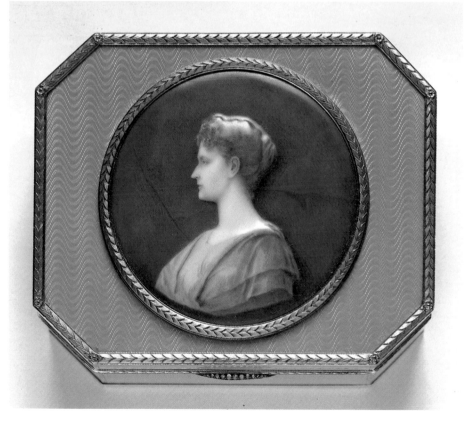

A Fabergé Imperial silver-gilt and enamel cigarette box mounted with a low relief profile of the Empress Alexandra Feodorovna, workmaster H. Wigström, St Petersburg, *circa* 1908–17, width 4⅜in (11cm)
London £82,500 ($141,025). 18.VII.88

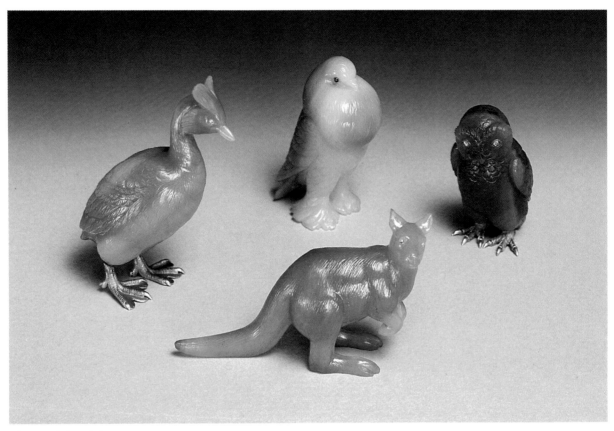

Top row, left to right
A Fabergé hardstone carving of a greater crested grebe, workmaster H. Wigström,
St Petersburg, late nineteenth century, height 2¾in (7.1cm), SF29,700 (£12,172:$21,679)
A Fabergé chalcedony carving of a fancy pigeon, *circa* 1900, SF46,200 (£18,934:$33,723)
A Fabergé hardstone carving of an owl, workmaster H. Wigström, St Petersburg, late
nineteenth century, height 1¾in (4.5cm), SF55,000 (£22,541:$40,146)
Lower centre
A Fabergé hardstone carving of a kangaroo, signed, *circa* 1900, length 2¾in (7cm),
SF57,200 (£23,443:$41,752)

The carvings illustrated above were sold in Geneva on 12th November 1987.

A Fabergé mother-of-pearl, diamond
and gold model of a crane, St
Petersburg, *circa* 1900, height 3¾in (9.5cm)
New York $37,400 (£20,894). 16.VI.88

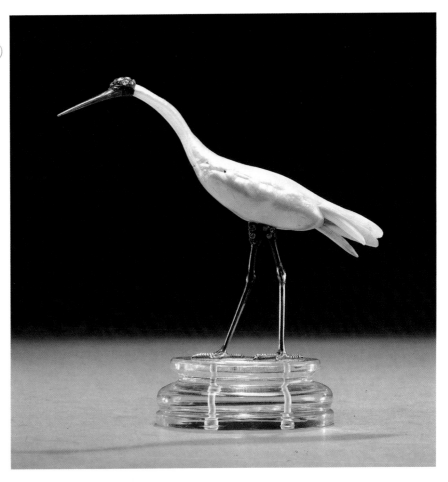

A Fabergé rose topaz pug dog puppy,
circa 1900, height 3in (7.7cm)
Geneva SF170,500
(£69,877:$124,453). 12.XI.87

A gold and enamel snuff box by Frantz Bergs, Stockholm, 1759, width 3in (7.5cm)
Geneva SF93,500 (£38,320:$68,248). 12.V.88

A gold and specimen hardstone snuff box by Johann Christian Neuber, Dresden,
circa 1775–80, diameter 2⅝in (6.6cm)
Geneva SF176,000 (£72,131:$128,467). 12.V.88

Pierre Rouvier
A LADY
Signed and dated *178–*,
height 2½in (6.2cm)
Geneva SF9,900
(£4,057:$7,226). 12.V.88

Richard Cosway
ANNE, DUCHESS OF CUMBERLAND
Circa 1785, height 1⅝in (4.2cm)
London £7,920 ($14,018).
18.VII.88

Jean-Baptiste-Jacques Augustin
A LADY
Signed and dated *178–*,
diameter 2¾in (7cm)
Geneva SF30,800 (£12,623:$22,482).
12.V.88

French School
A YOUNG BOY WITH A VIOLIN
Circa 1785, height 2⅛in (5.4cm)
Geneva SF13,200
(£5,409:$9,635). 12.V.88

Jean François van Dael
A STILL LIFE
Signed with initials, *circa* 1790,
diameter 2¾in (7cm)
Geneva SF29,700
(£12,172:$21,679). 12.V.88

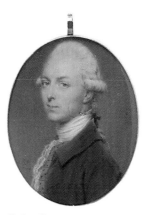

John Smart
A GENTLEMAN
Signed with initials and
dated *1779*,
height 1⅞in (4.7cm)
London £9,900 ($17,523).
18.VII.88

Clocks and watches

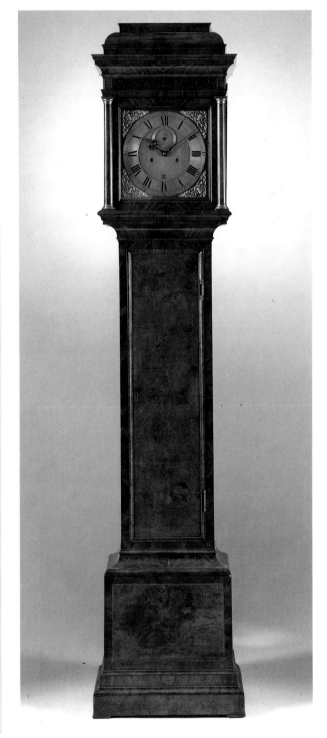

Opposite page
An ebony veneered *grande sonnerie* bracket clock by Joseph Knibb, London, *circa* 1680, height 13⅛in (33.5cm)
London £110,000 ($218,900). 28.IV.88

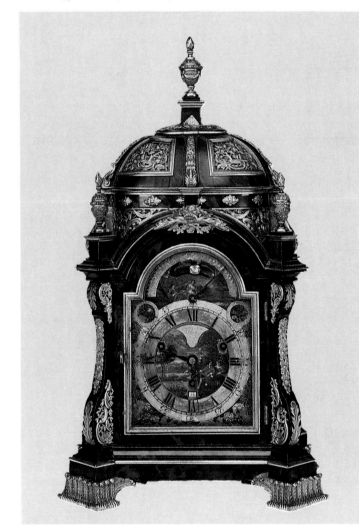

A George III tortoiseshell veneered repeating and musical bracket clock by Eardley Norton, London, height 16½in (42cm)
Amsterdam DF120,400 (£35,833:$64,731). 2.XII.87

A walnut longcase clock, signed *Geo. Graham*, London, *circa* 1720, height 7ft 5½in (227cm)
New York $79,200 (£44,246). 23.I.88
From the collection of the late Ralph H. Billington

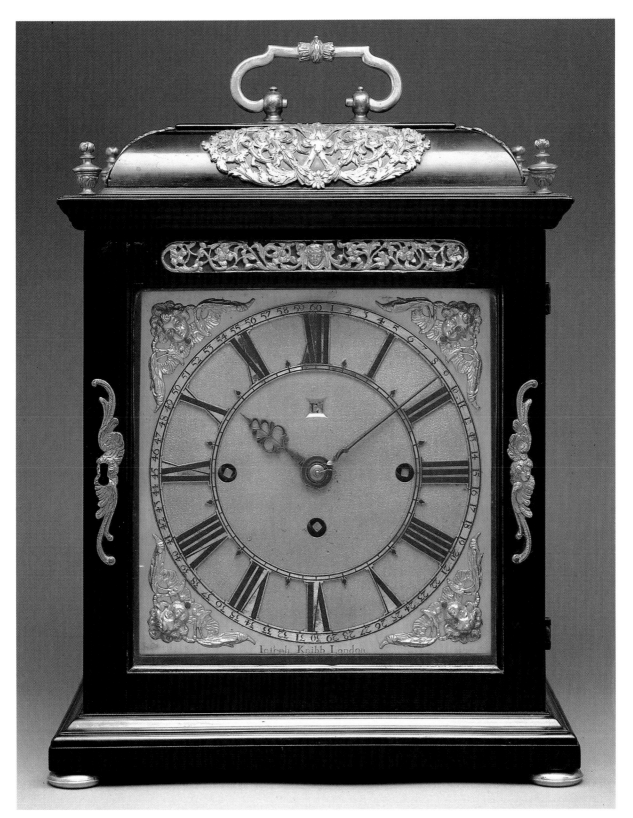

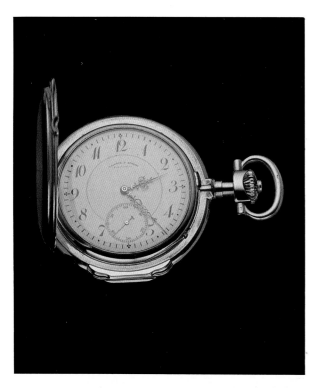

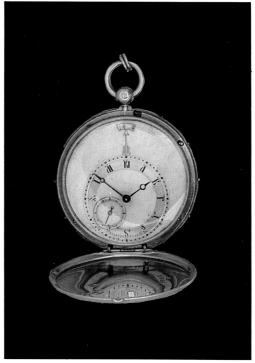

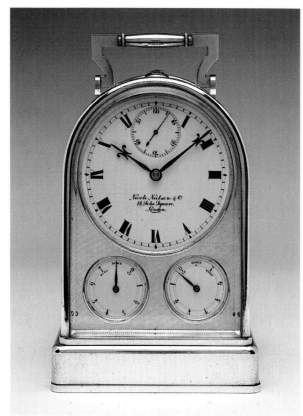

Above, left
A gold keyless lever hunter cased watch by
A. Lange & Söhne, Dresden, *circa* 1900,
diameter 2¼in (5.9cm)
Geneva SF26,400 (£11,629:$18,857). 12.V.88

Right
A silver and gold cased ruby cylinder *montre à
tacte* by Breguet, diameter 1¾in (4.4cm)
London £19,250 ($33,688). 22.X.87

A part silver *grande sonnerie* tourbillon carriage
clock by Nicole Nielsen & Co., *circa* 1905,
height 5½in (14cm)
London £55,000 ($96,250). 22.X.87

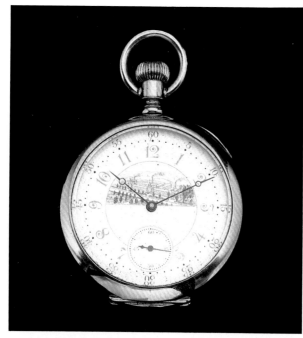

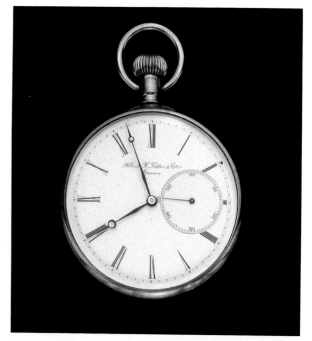

A gold openface watch with rock crystal movement, plates and enamelled scene of the Waltham Watch Factory by John Logan, Waltham, Massachusetts, *circa* 1890, diameter 2⅛in (5.4cm)
New York $20,900 (£11,875). 5.II.88

A one minute tourbillon by Albert H. Potter & Co., Geneva, *circa* 1880, diameter 2⅛in (5.4cm)
New York $24,200 (£13,520). 21.VI.88
From the Warner D. Bundens Collection

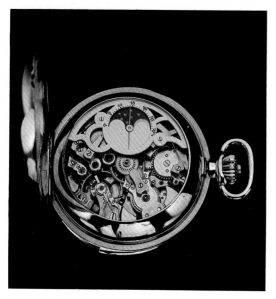

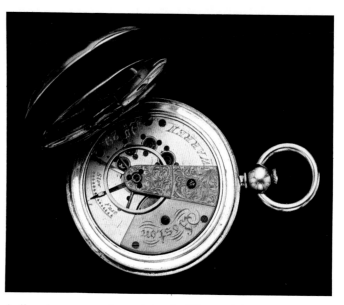

A white gold hunter cased double dial minute repeating digital calendar watch by Audemars Piguet, Geneva, *circa* 1930,
diameter 1⅞in (4.9cm)
New York $44,000 (£25,000). 5.II.88

A silver hunter cased watch by the Warren Manufacturing Co., Boston, *circa* 1853, diameter 2⅛in (5.35cm)
New York $29,700 (£16,592). 21.VI.88
From the Warner D. Bundens Collection

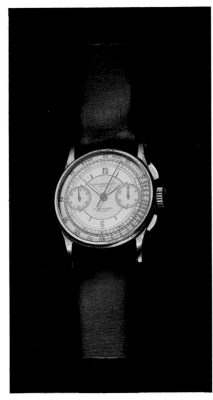

Above, from left to right
A gold chronograph wristwatch with tachometer and register
by Patek Philippe & Co., Geneva, *circa* 1945, diameter 1¼in (3.2cm)
Geneva SF38,500 (£16,960:$27,500). 12.V.88

A gold bracelet watch by Cartier, 1936, width ⅞in (2.3cm)
Geneva SF38,500 (£16,960:$27,500). 12.V.88

A gold chronograph wristwatch with tachometer and registers by Rolex, *circa* 1945,
width 1⅛in (3cm)
New York $27,500 (£16,177). 27.X.87

A white gold wristwatch with calendar and moon phases by E. Gubelin, Lucerne,
1924, length 1⅜in (3.65cm)
New York $115,500 (£67,941). 27.X.87

Above, from left to right
A gold cushion-form single-button chronograph wristwatch with pulsemeter and register
by Vacheron & Constantin, Geneva, *circa* 1930, width 1¼in (3.3cm)
New York $38,500 (£21,751). 22.VI.88

A platinum world time wristwatch by Patek Philippe & Co., Geneva, *circa* 1945,
diameter 1¼in (3.1cm)
New York $132,000 (£75,000). 5.II.88

A gold sweep seconds wristwatch by Patek Philippe & Co., Geneva, *circa* 1949,
diameter 1⅞in (4.8cm)
New York $37,400 (£21,130). 22.VI.88

Above, from left to right
A gold calendar wristwatch by Patek Philippe & Co., Geneva, *circa* 1935,
diameter 1¼in (3.3cm)
New York $198,000 (£112,500). 5.II.88

A gold perpetual calendar chronograph with moon phases, by Patek Philippe, Geneva,
circa 1945–50, diameter 1⅜in (3.5cm)
London £20,900 ($40,755). 17.XII.87

A stainless steel chronograph wristwatch by Patek Philippe, Geneva, *circa* 1945-50,
diameter 1¼in (3.2cm)
London £12,100 ($24,079). 28.IV.88

A gold wristwatch by Cartier, 1928, inscribed *Felix from Fred '29*, a gift from Fred Astaire to
racehorse trainer Felix Leach Jr., length 1⅞in (4.6cm)
London £18,700 ($33,473). 19.VII.88

Jewellery

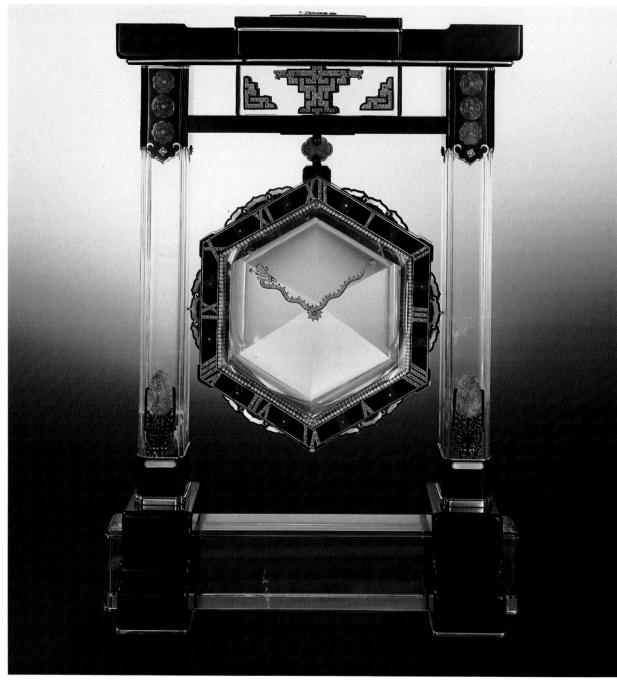

A crystal, jade, onyx and diamond mystery clock by Cartier, *circa* 1924,
height 14⅜in (36.5cm)
Geneva SF 770,000 (£315,574:$562,044). 11.XI.87

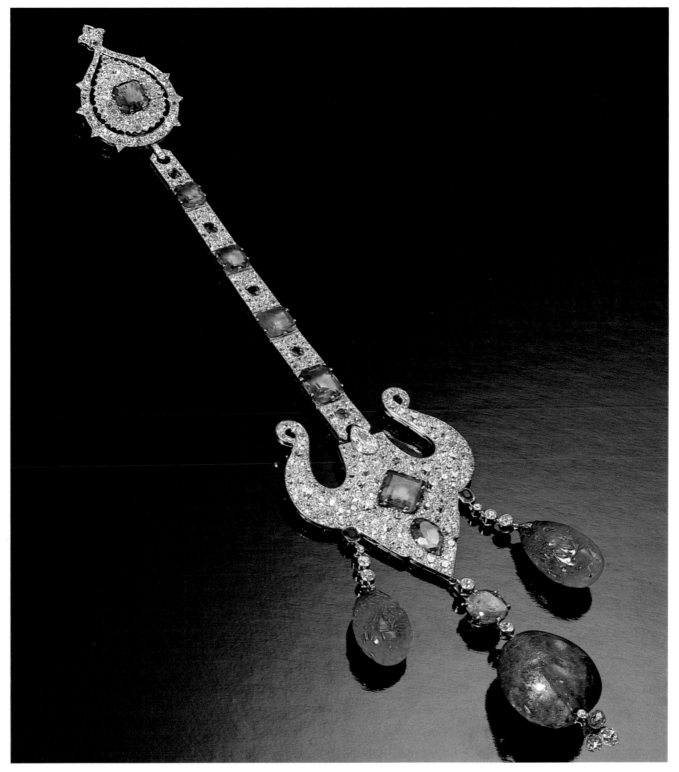

A diamond and emerald epaulette by Cartier, Paris, *circa* 1920
London £231,000 ($450,450). 24.III.88

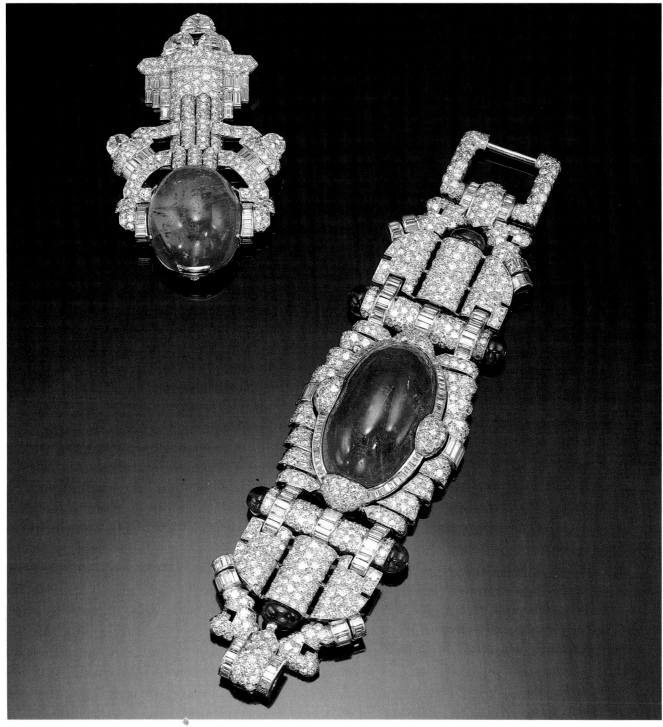

A cabochon emerald and diamond clip/pendant combination, *circa* 1935,
$110,000 (£61,453)
A cabochon emerald and diamond bracelet, *circa* 1935, $82,500 (£46,089)

These two pieces from the collection of Carolina Herrera de Molinari were sold in New York
on 14th June 1988.

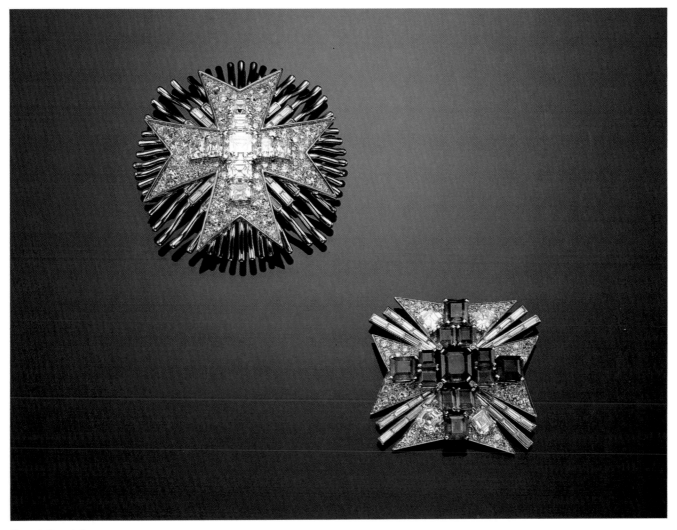

From left to right
A gold and diamond Maltese Cross pendant-brooch by Verdura, 1944, $52,250 (£27,646)
An emerald and diamond Maltese Cross brooch by Verdura, *circa* 1945, $48,400 (£25,608)

These two pieces, from the collection of the late Clare Boothe Luce, were sold in
New York on 19th April 1988.

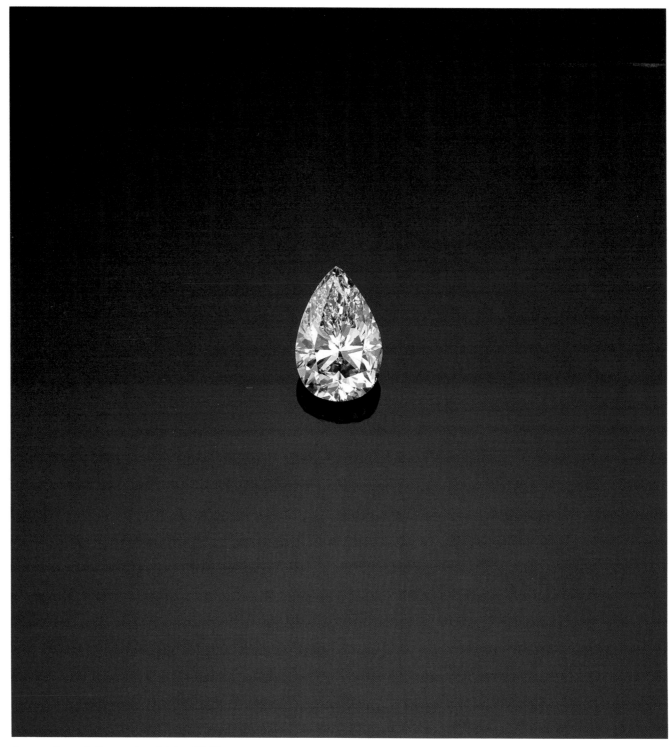

A pear-shaped diamond weighing 85.91 carats
New York $9,130,000 (£4,805,263). 19.IV.88

This diamond is the most expensive jewel ever sold at auction.

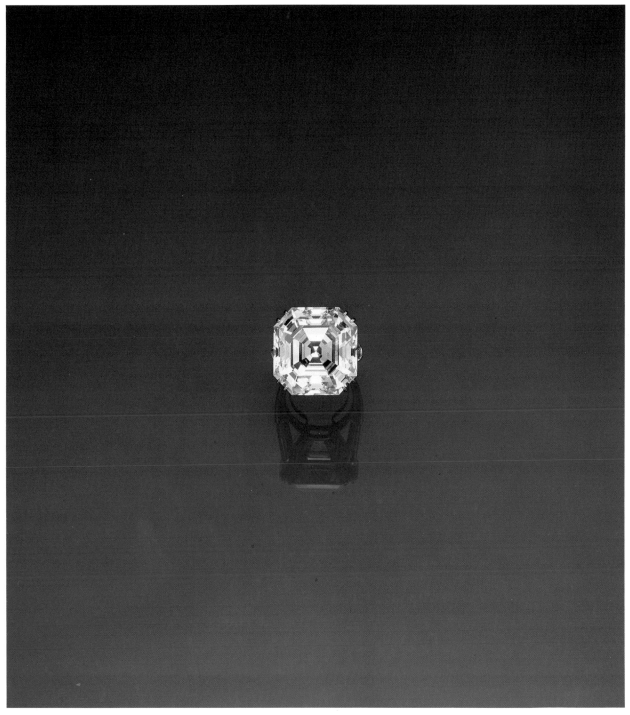

The Porter Rhodes diamond weighing 54.99 carats, mounted as a ring by Harry Winston
New York $3,850,000 (£2,291,666). 20.X.87

This stone, discovered in South Africa by Porter Rhodes in 1880, helped dispel the belief that
diamonds from South Africa were not of the finest quality. The exceptional whiteness of the
stone prompted the Empress Eugénie to describe it as 'simply perfection'.

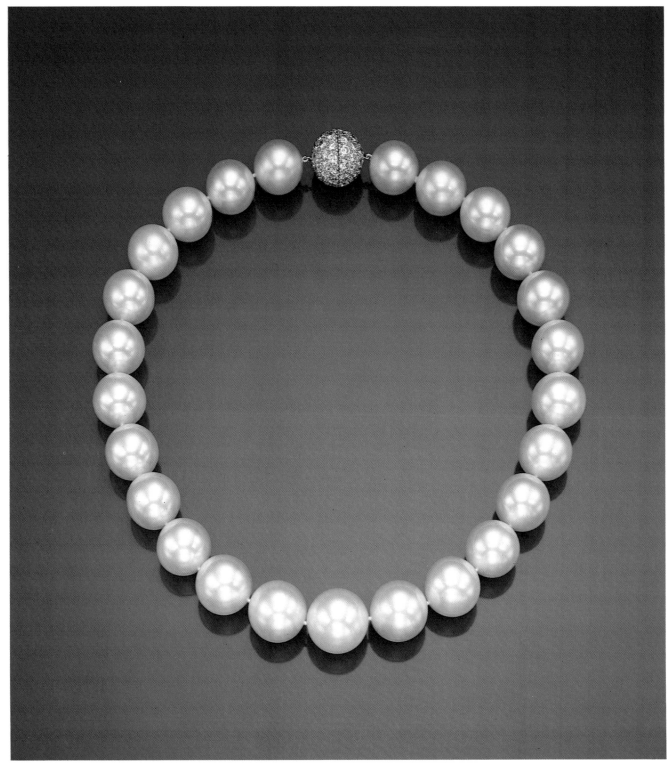

A cultured pearl necklace
New York $1,265,000 (£665,790). 19.IV.88

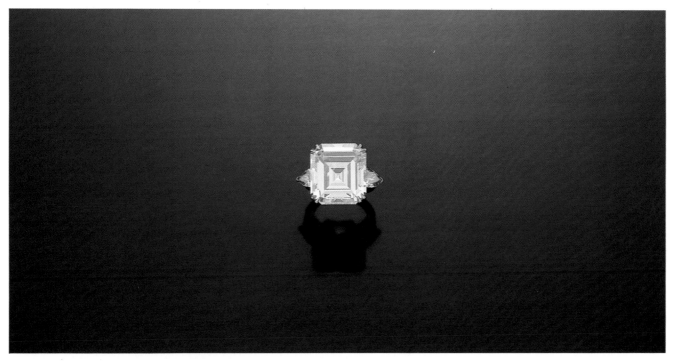

A fancy pink diamond weighing 20.00 carats, mounted as a ring
New York $4,730,000 (£2,489,474). 19.IV.88

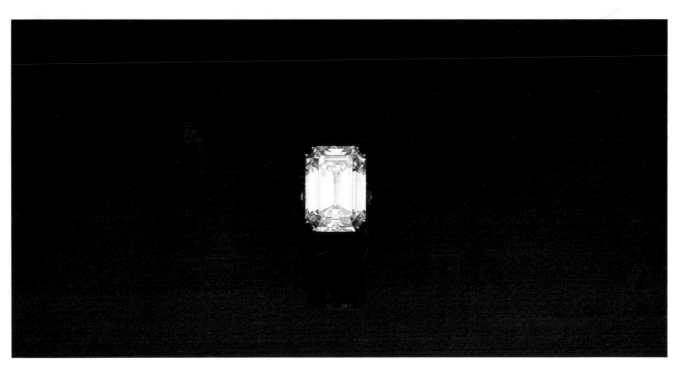

The Jonker No.4 diamond weighing 30.70 carats, mounted by Harry Winston
New York $1,705,000 (£952,514). 8.XII.87

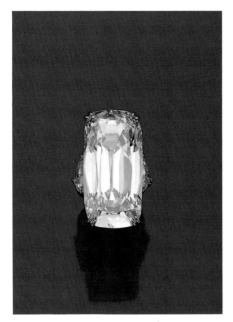

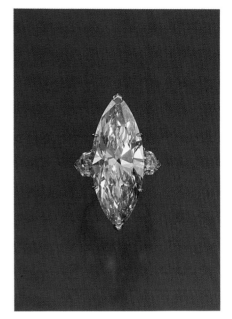

The Ashoka diamond weighing 41.37
carats, mounted as a ring by Harry
Winston
St Moritz FF5,390,000
(£2,200,000:$3,850,000). 20.II.88

A sapphire and diamond ring, weight
of sapphire 62.02 carats
St Moritz FF3,960,000
(£1,616,327:$2,828,571). 20.II.88

A fancy pink marquise diamond
weighing 22.84 carats, mounted as a
ring by Harry Winston
Geneva SF2,695,000
(£1,104,508:$1,967,153). 11.XI.87

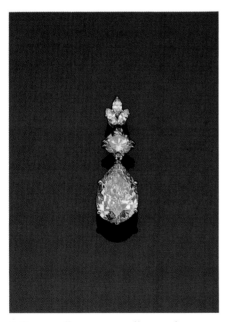

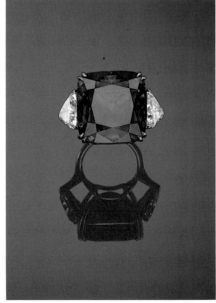

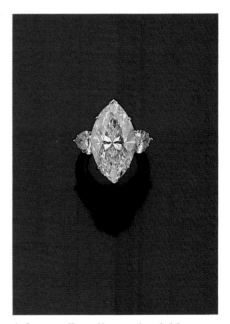

A fancy yellow-orange diamond
weighing 8.93 carats, mounted as
a pendant
Geneva SF2,640,000
(£996,226:$1,885,714). 11.V.88

An emerald and diamond ring by
Harry Winston, weight of emerald
32.65 carats
Geneva SF1,870,000
(£705,660:$1,335,714). 11.V.88

A fancy yellow diamond weighing
14.00 carats, mounted as a ring
St Moritz FF1,650,000
(£673,469:$1,178,571). 20.II.88

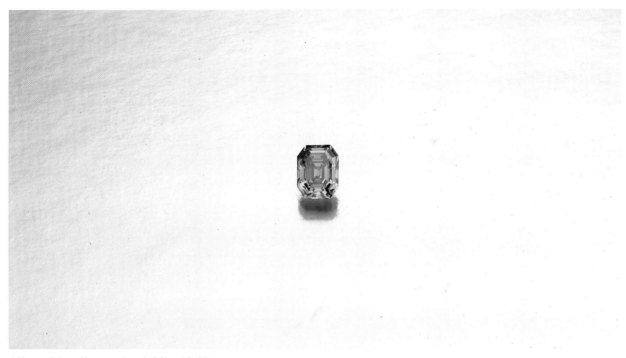

A fancy blue diamond weighing 10.07 carats
New York $2,200,000 (£1,309,524). 20.X.87

A Colombian emerald weighing 22.52 carats, mounted as a ring by Harry Winston
New York $1,540,000 (£810,526). 19.IV.88

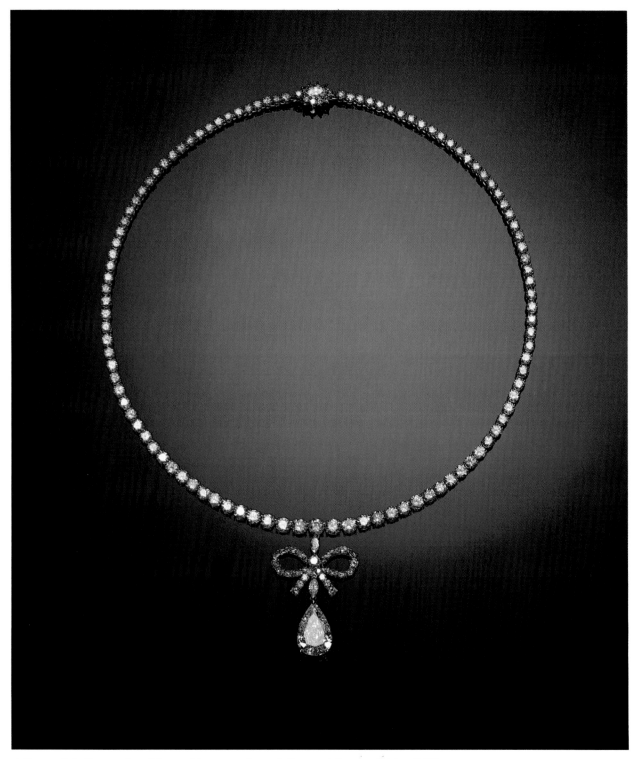

A fancy pink diamond necklace with a pear-shaped diamond drop weighing 5.57 carats
Geneva SF 2,310,000 (£871,698:$1,650,000). 11.V.88

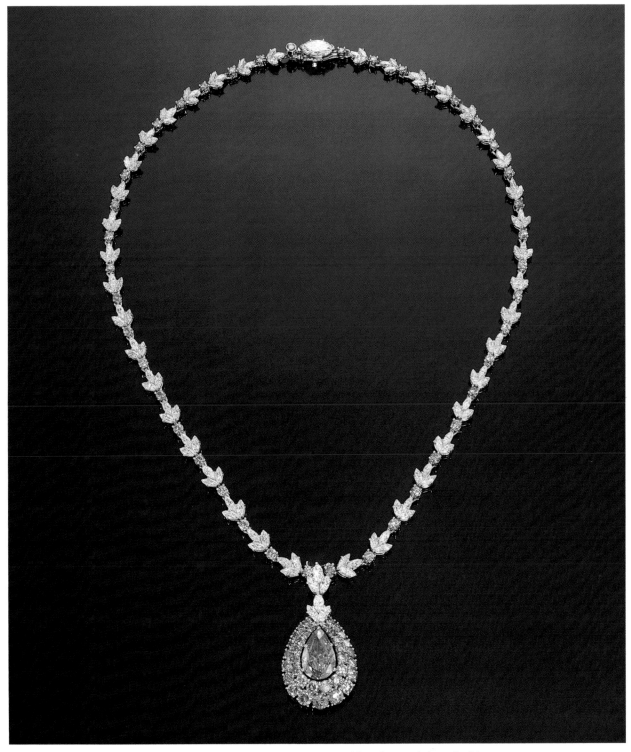

A fancy yellowish-green diamond weighing 3.02 carats, mounted in a fancy pink and white diamond necklace
New York $1,705,000 (£897,368). 19.IV.88

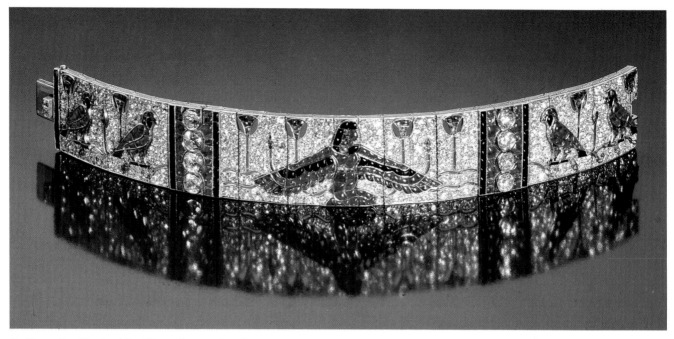

An Egyptian Revival Art Deco diamond and gem-set bracelet, French, *circa* 1925
New York $253,000 (£133,158). 19.IV.88

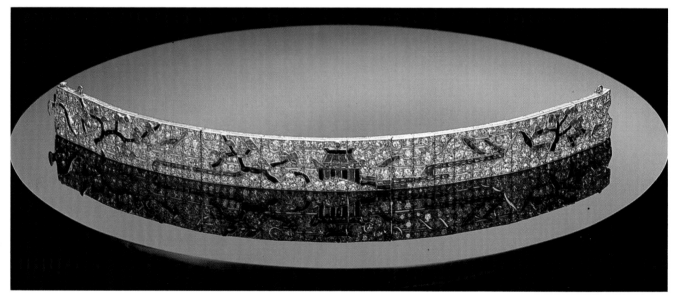

An Art Deco diamond and gem-set bracelet by Van Cleef & Arpels, Paris, 1924
New York $143,000 (£85,119). 20.X.87

Opposite
A diamond rivière, last quarter nineteenth century, £82,500 ($160,875)
A pendant and earrings, *circa* 1820, £176,000 ($343,200)

The pieces illustrated on the opposite page were sold in London on 24th March 1988.

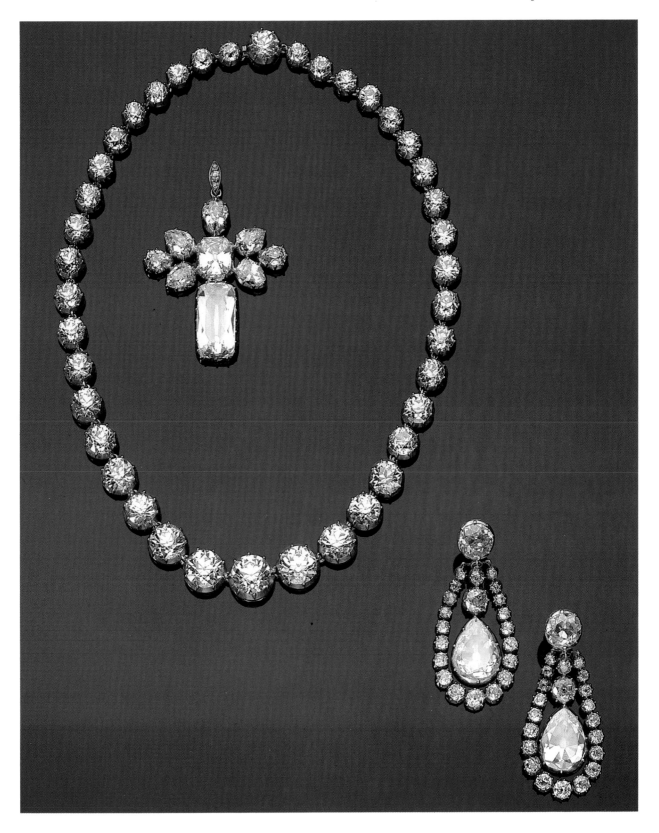

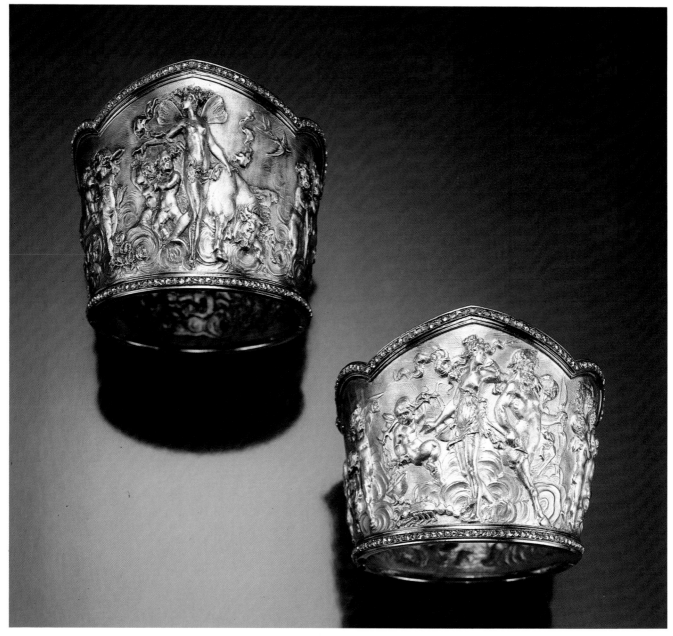

A pair of gold repoussé manchettes by Jules Brateau for Maison Boucheron, 1878
New York $137,500 (£76,816). 14.VI.88

A suite of three gold and gem-set acrostic bracelets commemorating events in the life of Marie-Louise and Napoleon, nineteenth century London £52,800 ($92,400). 8.X.87

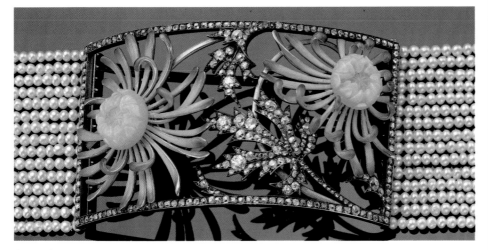

A pearl, enamel, opal and diamond choker by René Lalique, signed Geneva SF126,500 (£47,736:$90,357). 11.V.88

Jean-Baptiste-Claude Odiot (1763–1850)

Olivier Gaube du Gers

Jean-Baptiste-Claude Odiot was not, as is often assumed, the founder of the House that today still bears his name. He was descended, in fact, from a long line of goldsmiths whose origins can be traced to the beginning of the seventeenth century, and he succeeded his father as the head of the family business in 1785. On the eve of the French Revolution, he had already established a fine reputation, acknowledged even by the King. On 3rd June 1789, he completed a pair of goblets for Thomas Jefferson from Jefferson's own design, as well as a tea fountain. During the Reign of Terror he was clever enough to enlist in the army, doubtless to escape the perils of that troubled period, entrusting the business to his wife.

Odiot received his first official recognition in 1802 at the 'Exposition de l'Industrie', when the *médaille d'or* was awarded jointly to him and Henri Auguste. This association was particularly significant for Odiot. Under his predecessors, the firm had never achieved such prominence while Auguste, son of the great goldsmith Robert Joseph Auguste, was well established even before the Revolution. At the time of Napoleon's coronation in 1804, Odiot and Auguste both received exceptionally grand commissions. Shortly thereafter, however, Auguste went bankrupt and fled the country, leaving Jean-Baptiste-Claude Odiot to become the leading goldsmith in France.

Odiot skilfully combined classical motifs symbolic of the Napoleonic era and forms and elements of the antique that the painters David and Giraudet and the architects Percier and Fontaine had brought back into vogue – cameos, nymphs clad in flowing draperies, sphinxes and mythological animals. Among his innovations was the technique of applying ornament *à froid*, using screws and bolts to attach elements that were cast separately, allowing them to be interchanged and reused in a variety of designs. As collaborators, Odiot chose the most celebrated artists of his day: Thomire carved for him and Prud'hon, Percier and Fontaine drew.

One of Odiot's earliest Imperial commissions was the vast dinner service for Napoleon's mother (Figs 1 and 2). The service was completed in 1806, just a year after Napoleon proclaimed her 'Son Altesse Imperiale, "Madame Mère", mère de l'Empereur.' In 1809, in collaboration with Prud'hon and Thomire, he executed one of his masterpieces: the toilette of Empress Marie-Louise. This magnificent ensemble, which included a life size figure of Psyche, a table and mirror, a *fauteuil* and a jewel box, was commissioned by the City of Paris, on the advice of the Prefect, Count Frochot. Universally declared *incomparable*, the toilette cost 800,000 francs.

Two years later, again with Prud'hon and Thomire, Odiot created the cradle for the King of Rome, the infant son of Napoleon and Marie-Louise. The decoration depicts Glory gliding over the world holding aloft Napoleon's *Couronne de Triomphe*. At the foot of the cradle is a young eagle, poised for flight. In all, this sumptuous piece required 280kg of silver and Odiot received 150,000 francs.

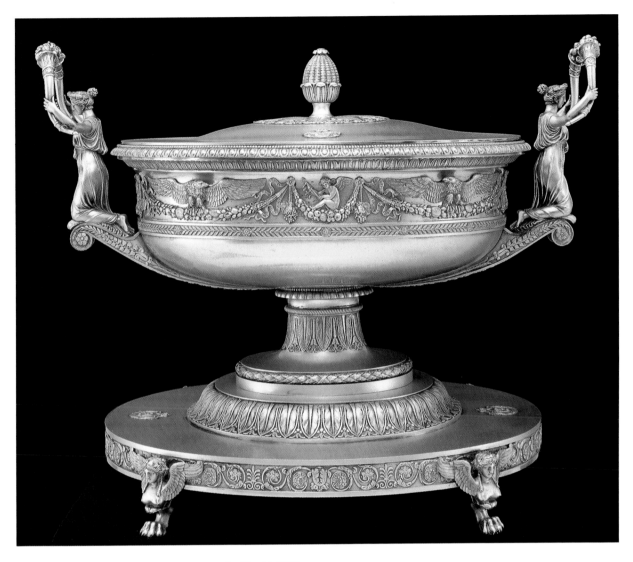

Fig.1
One of a pair of silver-gilt covered soup tureens on
stands, from the Madame Mère service, maker's mark
of Jean-Baptiste-Claude Odiot, Paris, 1806,
height 14¾in (37.5cm)
New York $907,500 (£524,567). 28.X.87

Preliminary drawing for the tureens

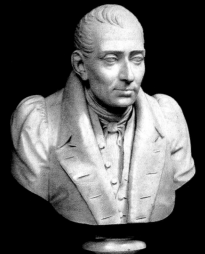

Madame Mère by Gérard (Musée de Versailles) Count Nikolai Demidoff

In 1812 Josephine, the Emperor's first wife, commissioned a magnificent silver-gilt toilette which included jewellery caskets, a glove-tray, a pair of caskets *à racines et à peignes* (for hair ornaments), four *boîtes à pâte* (for make-up) and other accessories. The desk set decorated with a miniature of the portrait of Mme Mère that belonged to Jérôme Bonaparte is now in the collection of the Musée de la Légion d'Honneur.

By this time, Odiot's reputation had reached its greatest height. Beyond the Imperial commissions, he received orders from the most prominent figures of the day, including Count Nikolai Demidoff, a Russian nobleman of vast resources who settled in Paris in 1815. When the Demidoff service (Figs 3 and 4) was exhibited at the Louvre in 1819, it caused a sensation. 'It is unlikely that the art of the silversmith has ever produced anything more magnificent,' a contemporary critic exclaimed. Competition raged among the nobility, each seeking a more lavish display, and Odiot was ideally suited to provide the essential components. No less than three complete services were required for a dinner for fifty.

Commissions also flowed from abroad: Maximilian I, who became King of Bavaria in 1806 through the influence of Napoleon, ordered a service as did Prince Camillo Borghese, the unfortunate husband of the exquisite but fickle Pauline, and the King of Naples, Frederick II. The Russian Court, formerly faithful to his rival Biennais, became Odiot's client in 1815 when Tsar Alexander I arrived in Paris. He ordered a service for the receptions he gave in honour of the Allies and subsequently presented it to his Ambassador, Count Pozzo di Borgo, before he returned to St Petersburg.

The fall of the Empire did not hinder Odiot's career in the least. On the contrary, he was appointed, together with Cahier, goldsmith to the King; to Monsieur, the future Charles X and to the Duc d'Orleans, the future Louis Philippe. The City of Paris commissioned a silver-gilt luncheon service to be presented to the Duchesse de Berry in 1819, and the drawings, signed by the Ministry of the Interior, for a *hookah* to honour the Sultan of Turkey, are still preserved by the Maison Odiot.

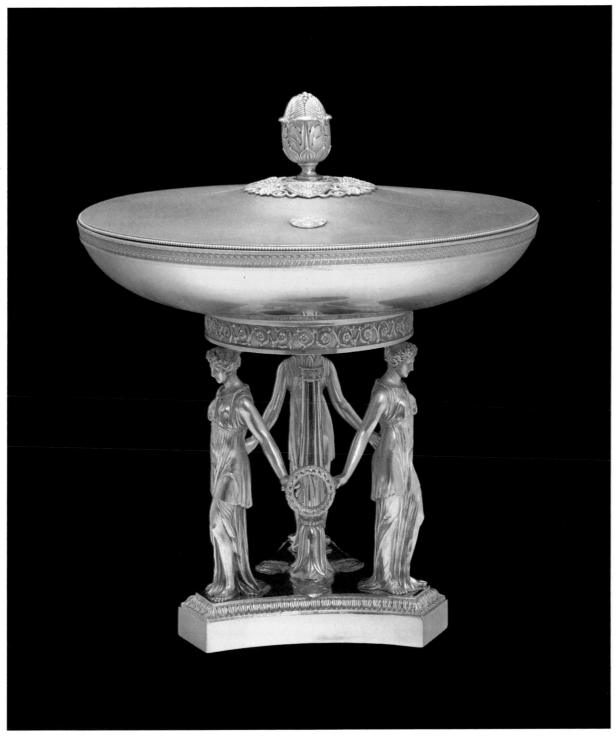

Fig.2
One of a set of three silver-gilt covered dishes on stands, from the Madame Mère service,
maker's mark of Jean-Baptiste-Claude Odiot, Paris, 1806, height 12⅛in (30.8cm)
New York $330,000 (£190,751). 28.X.87

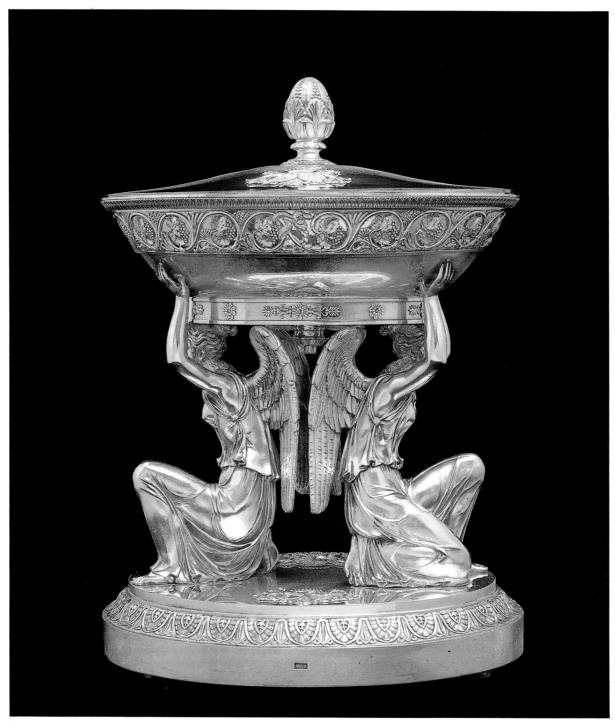

Fig.3
A silver-gilt oval soup tureen and cover, supported by two winged figures of Victory,
from the Demidoff service, maker's mark of Jean-Baptiste-Claude Odiot, Paris, 1817,
height 18¼in (46.4cm)
New York $682,000 (£394,220). 28.X.87

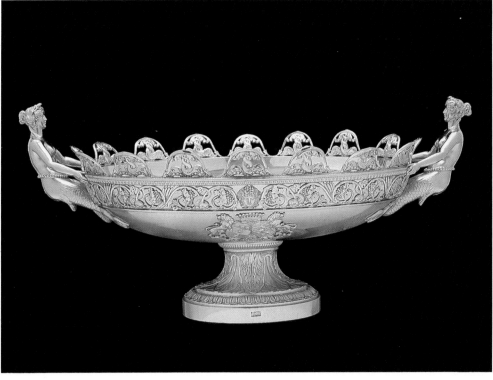

Fig.4
A silver-gilt *verrière*, from the Demidoff service, maker's mark of Jean-Baptiste-Claude Odiot,
Paris, 1817, length over handles 17⅝in (44.8cm)
New York $286,000 (£165,318). 28.X.87

Auguste, Biennais and Odiot were the great silversmiths of the Empire. What
distinguished Odiot from the others was the monumental quality of his designs.
Sculpture played an important part in his work; often both figures in the round
and bas reliefs were applied to the main body of the piece. In every example the
workmanship embodies a flawless combination of design and execution.

Odiot scrupulously respected the strict canons of the Classical Revival. It was
from the antique that he took the style and forms which he adapted to a modern use.
Kraters became wine coolers; amphoras became tea fountains; figures and ornaments
were directly taken from Greek and Roman sculpture or Etruscan vases. The result
is a great homogeneity of style and a grace which is sadly lacking in the decorative
arts of the second half of the nineteenth century.

Jean-Baptiste-Claude Odiot retired in 1827, entrusting the firm to his son Charles.
Until his death in 1850, he lived on the property he owned on the Champs Elysées,
at the time still almost countryside. Today, the great Odiot name continues to
represent the finest design and craftsmanship through the Maison Odiot, which is
still in business in Paris, near the Madeleine.

Silver

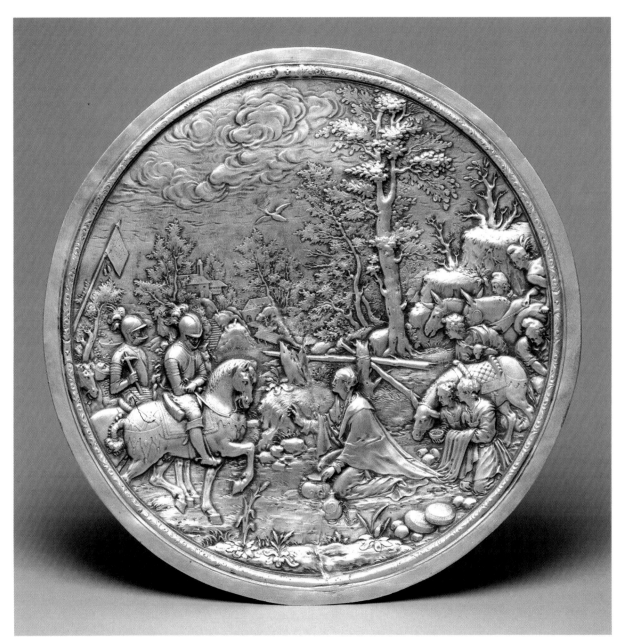

A plaquette depicting the Meeting of David and Abigail, signed *A.D. Viana /F.*, for Adam
van Vianen, Utrecht, *circa* 1620, diameter 7$\frac{5}{8}$in (19.5cm)
Geneva SF308,000 (£125,714:$224,818). 10.XI.87

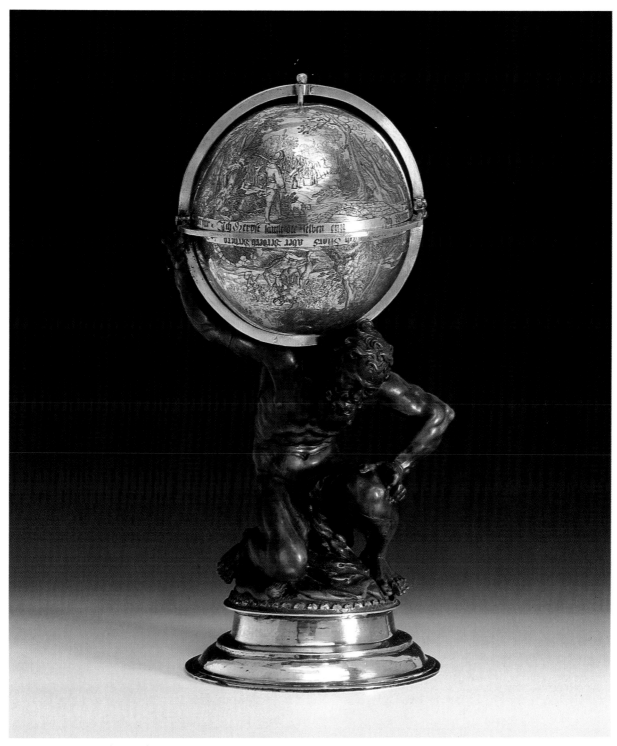

A Swiss parcel-gilt cup and cover in the form of an astrological globe, supported by a
boxwood figure of Hercules, maker's mark of Hans Rudolph Ulrich, Zurich, *circa* 1650,
height 11¼in (28.5cm)
Geneva SF506,000 (£190,943:$358,865). 9.V.88

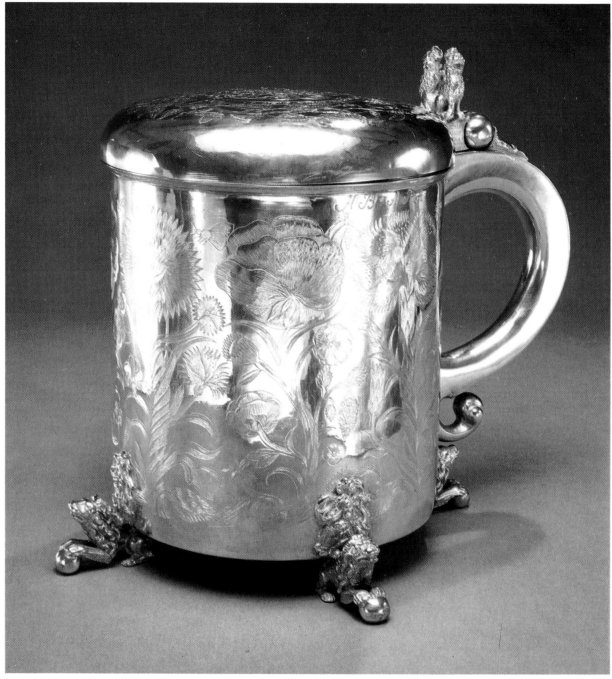

A Norwegian peg tankard, maker's mark of Hans Jorgensen Bull, Trondheim, *circa* 1670,
height 9in (22.9cm)
New York $63,800 (£34,674). 13.IV.88

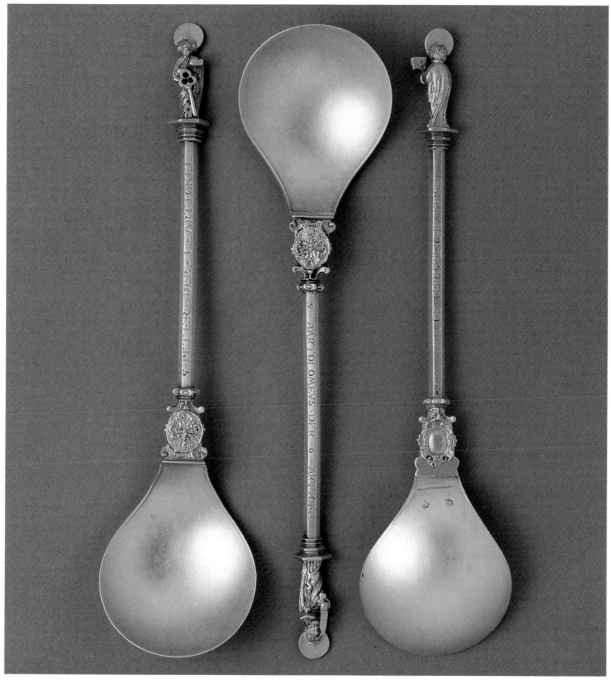

A set of twelve German parcel-gilt apostle spoons, maker's mark of Christoph Stimmel,
Breslau, *circa* 1600, length 9in (22.9cm)
New York $63,800 (£36,879). 28.X.87
From the collection of the late Hellene Roosevelt Poole

Lord Chesterfield's Silver

John Culme

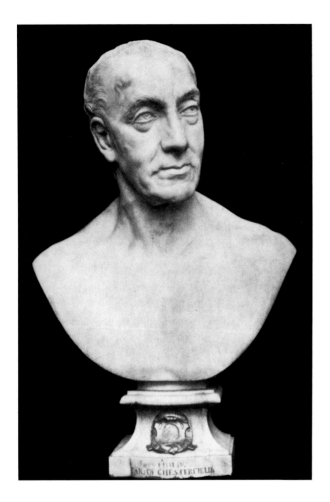

Philip Dormer Stanhope, 4th Earl of Chesterfield (1694–1773), was a man small of stature but large of ambition, who is remembered chiefly as a copious man of letters. 'A Wit among Lords and a Lord among Wits,' according to Dr Johnson, he was accused rather unfairly, by George II of being nothing better than 'a little gossiping tea table scoundrel.' In fact, Chesterfield's distinguished diplomatic career in the public service, first as an MP, then as a diplomat and active member of the House of Lords, claimed the thirty-three years following his coming of age in 1715.

After his father's death in 1726, Chesterfield lost no time in opposing Walpole from the upper chamber, a place which hitherto he had dismissed as a 'hospital for incurables'. Thereafter his rise was swift; within months of George II's accession in 1727 he was nominated Lord of the Bedchamber and a Privy Councillor. Then

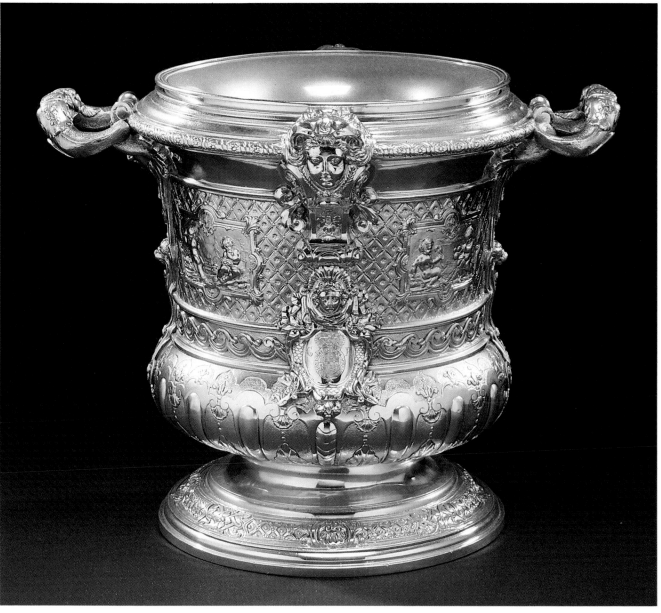

Fig.1
One of a pair of George II wine coolers, engraved with the royal arms, maker's mark of
Paul de Lamerie, overstruck by that of Paul Crespin, London, 1727, height 10⅜in (26.5cm)
London £462,000 ($859,320). 4.II.88
From the Highclere Castle Collection

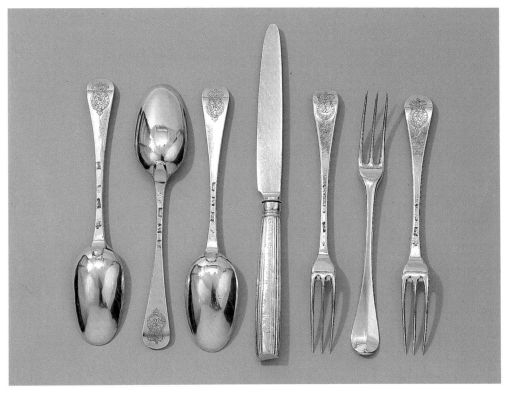

Fig.2
A set of George II silver-gilt tableware, including thirty-six Hanoverian pattern dessert spoons, thirty-four three-pronged forks and eighteen dessert knives, engraved with the contemporary royal cypher and crown, maker's mark of Charles Jackson, London, 1727
London £19,250 ($35,805). 4.II.88
From the Highclere Castle Collection

Walpole, at the King's behest, reluctantly offered Chesterfield the English Embassy in The Hague, a post which he accepted gladly.

As was the custom upon the appointment of an ambassador, the Jewel Office was issued with a warrant, dated 12th September 1727, to supply Chesterfield with 'the usual allowance' of plate: 5,893oz. of white and 1,066oz. of gilt. The order, through John Tysoe the King's principal goldsmith and jeweller, was fulfilled in two parts the following December and March. Besides the magnificent pair of 'Ice pailes' from Paul Crespin (the maker's mark struck over that of Paul de Lamerie), which cost £252. 13s. 9d. (Fig.1), Chesterfield received eleven pairs of candlesticks, 'Sevon [sic] Scallop Shells', several orders of table silver (Fig.2) as well as other items. These included a 'Surtute' or epergne 'finely wrought', weighing over 880oz. The Earl appears to have supplemented this already substantial service of plate with further pieces provided for out of his own large fortune. Ambassadorial silver officially belonged to the crown and was usually engraved with the Royal arms, and customarily kept by the recipient. The silver bearing the date letters for 1726/27 and the Earl's arms (Fig.3) probably belongs to this personal addition of plate.

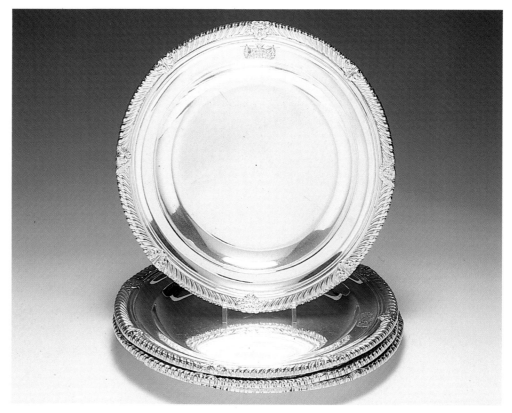

Fig.3
A set of four George I course dishes, engraved with the arms of Stanhope, Earls of Chesterfield, maker's mark of David Willaume, London, 1726, diameter 11¾in (29.9cm)
London £24,200 ($45,012). 4.II.88
From the Highclere Castle Collection

 Thus equipped, the Earl of Chesterfield set out from London with his new staff early on 4th May 1728, arriving at The Hague the next evening. Before long, the noble lord was sweetening the tasks of his office with nightly amusements until he fell abed in a fever. The doctor's prescription, with its note of caution about the goddess Venus, soon had him up and about.

 During his three years at The Hague, Chesterfield's diplomatic skills were well tested and he earned a reputation for the splendour of his hospitalities. In August 1728 he extended the ambassadorial mansion by adding a fifty-foot dining-room, where the grant of plate must have added greatly to King George's prestige, not to mention his own. 'The Earl of Chesterfield,' wrote a contemporary in eager antici- pation, 'is going to give a magnificent dinner to the principal persons here. The Prince of Orange will be among them, and the populace are to have as much wine and victuals as they can devour.'

 Chesterfield retired from public life in 1748, after which he increasingly devoted himself to peaceful pursuits and the company of friends. He died at the age of 78, on 24th March 1773.

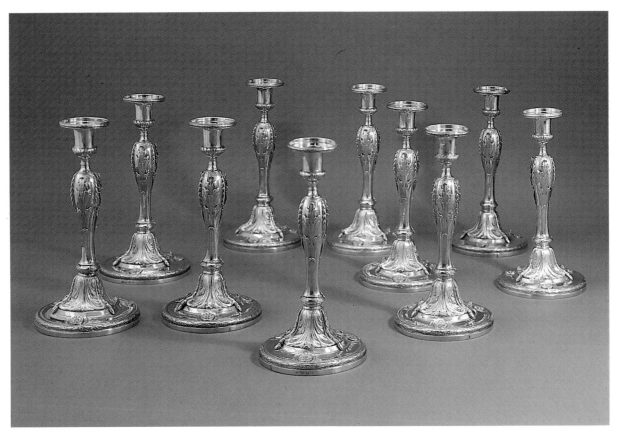

A set of ten George III silver-gilt table candlesticks, maker's mark of Thomas Heming,
London, 1776, height 11¼in (28.5cm)
London £55,000 ($102,300). 4.II.88

These candlesticks originally formed part of the service of plate belonging to the Governors
of the Russian province of Tula who were provided with silver by Catherine II.

Opposite, below
A pair of George IV silver-gilt wine buckets, maker's mark of John Bridge for Rundell,
Bridge & Rundell, London, 1827, height 6⅜in (16.2cm)
London £49,500 ($93,060). 19.XI.87

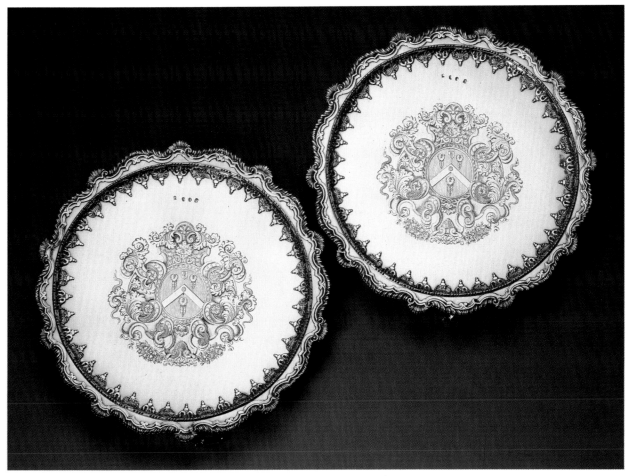

A pair of Queen Anne silver-gilt salvers, maker's mark of Simon Pantin, London, 1713,
diameter 15⅛in (38.3cm)
London £253,000 ($475,640). 19.XI.87

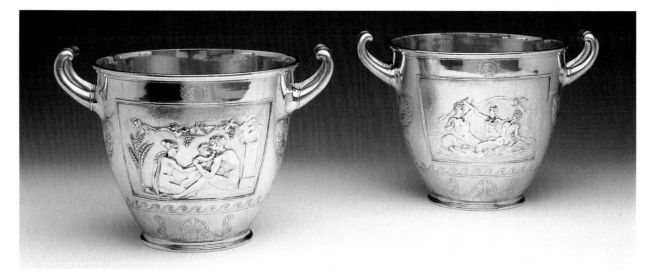

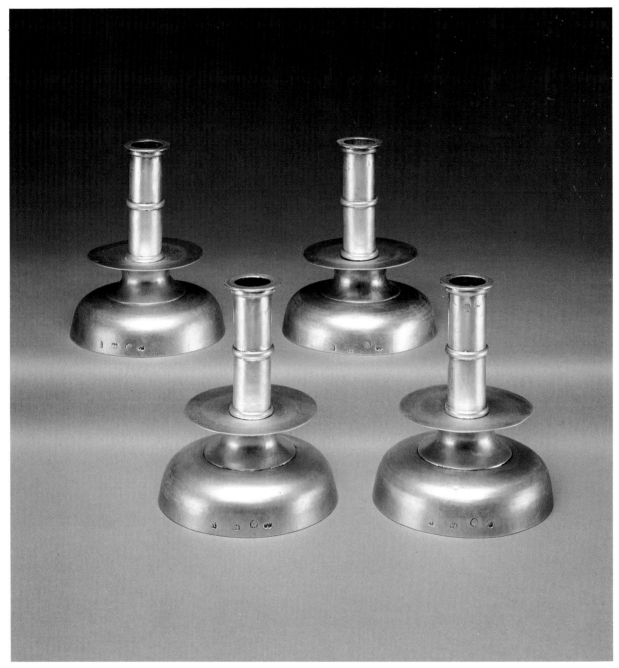

A set of four Charles I table candlesticks, maker's mark of *WG* in a heart, London, 1637,
height 5½in (14cm)
New York $341,000 (£197,110). 28.X.87
From the collection of Cortright Wetherill and the late Ella Widener Wetherill

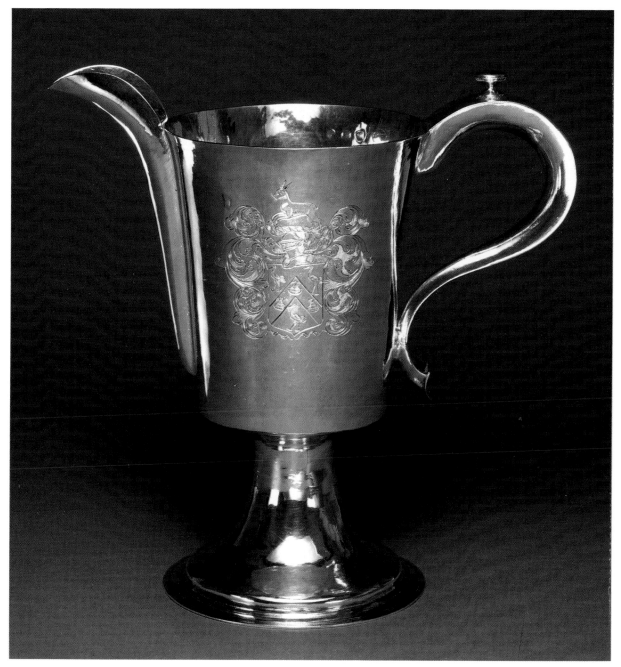

A Charles II ewer, maker's mark of *RS* between mullets, London, 1664, height 10⅜in (26.4cm)
New York $89,100 (£48,424). 13.IV.88
From the collection of Mrs Winston F.C. Guest

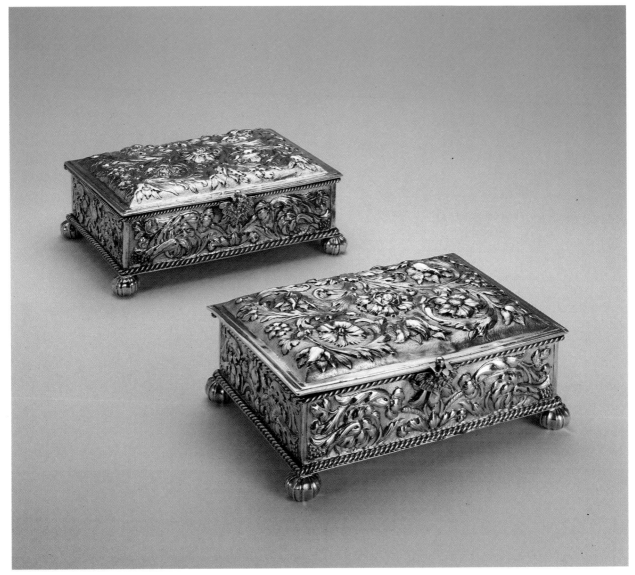

A pair of Charles II caskets, maker's mark of Ralph Leake, London, 1673, length 8⅞in
(22.5cm)
London £82,500 ($155,100). 19.XI.87

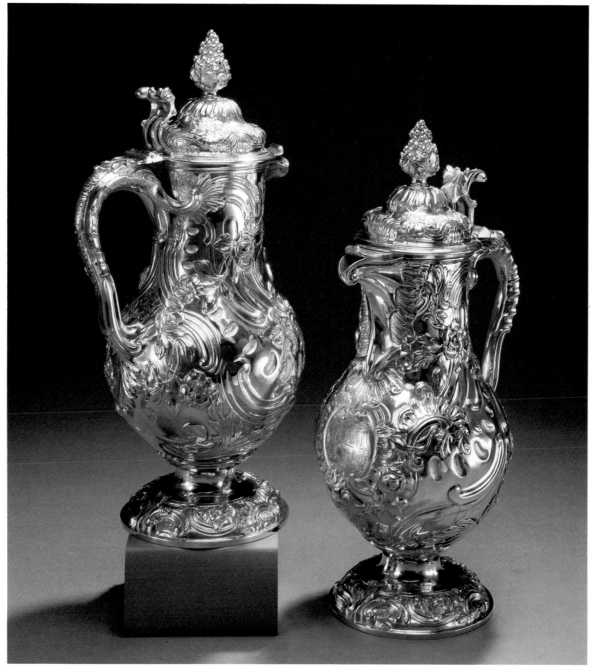

A pair of George II wine jugs, maker's mark of Thomas Gilpin, London, 1755,
height 14⅛in (35.9cm)
New York $159,500 (£92,197). 28.X.87

The collection of Ritter Rudolf von Gutmann

The sales of the collection of the late Rudolf von Gutmann provided a chance to catch a glimpse of the otherwise lost world of collecting and high society in the Austro-Hungarian Empire during the early years of this century.

Successful owners of mining and iron-founding concerns, as well as the Gebrüder Gutmann bank, the Von Gutmann family played an important part in the life of imperial Austria-Hungary. They owned a large mansion in the Beethovenplatz in Vienna and numerous country estates. Rudolf von Gutmann was the second son and did not at first play a leading role in the family enterprises, preferring instead to devote his energies to art and to the land, with vast resources at his disposal. He began his collecting career with prints, spending much time at the Albertina, where for several years he had his own study. As his judgement matured he widened his horizons assembling paintings, porcelain, silver, furniture and works of art; the following pages illustrate the diversity and fine quality of his taste.

On the night of the *Anschluss* on 13th March 1938, Rudolf von Gutmann fled to Czechoslovakia, and then to Geneva; his collection was later seized by the Nazis. Some parts of the collection were never recovered, notably the prints, although after the Second World War the Austrian government co-operated in a remarkable act of restitution. The collection, sold in London, Geneva, Monte Carlo and Amsterdam during late 1987 and early 1988, totalled over £2 million.

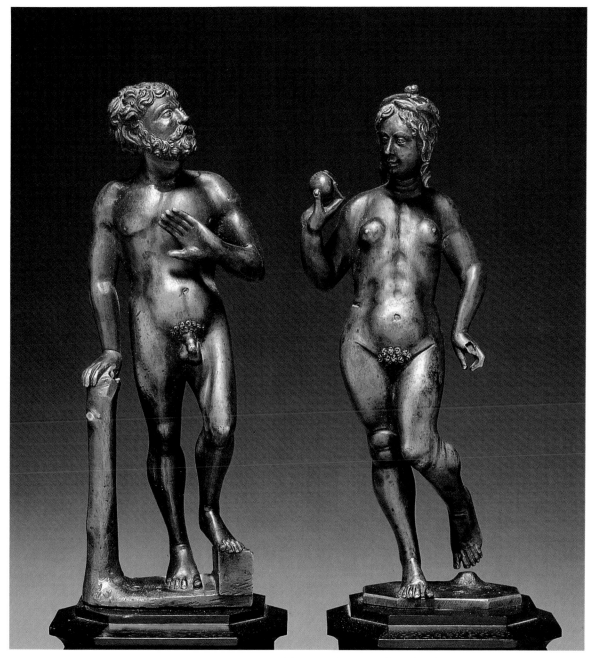

A pair of South German bronze figures of Adam and Eve, attributed to Leonhard Magt,
circa 1520, height 9⅛in (23.2cm)
London £143,000 ($274,130). 10.XII.87
From the collection of the late Ritter Rudolf von Gutmann

A Vienna jardinière painted by Joseph Nigg, signed, *circa* 1817, height 17¾in (45cm)
Geneva SF57,200 (£23,347:$41,751). 9.XI.87
From the collection of the late Ritter Rudolf von Gutmann

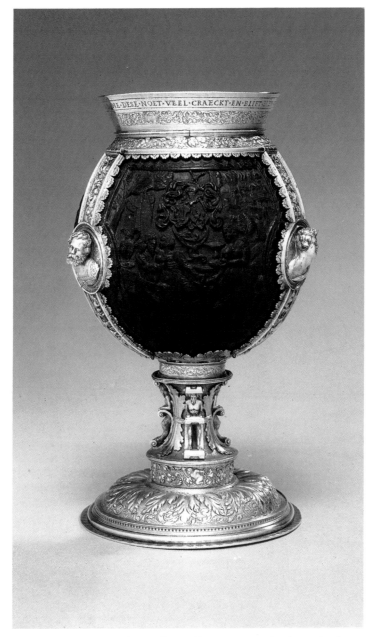

A coconut cup with frisian silver-gilt mounts, maker's mark of a
heart in a shaped shield, Leeuwarden, *circa* 1582,
height 8⅝in (21.8cm)
Geneva SF275,000 (£112,245:$200,730). 10.XI.87
From the collection of the late Ritter Rudolf von Gutmann

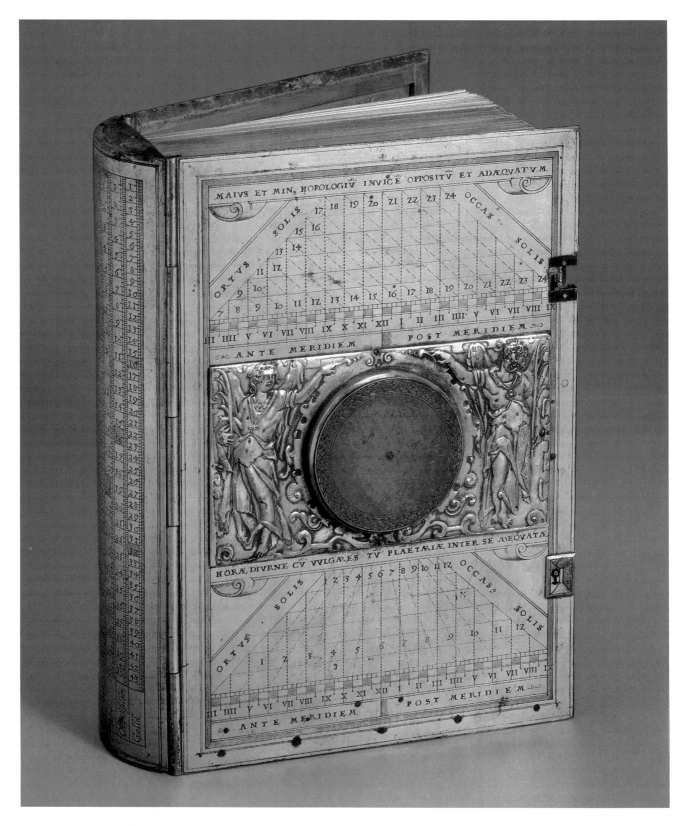

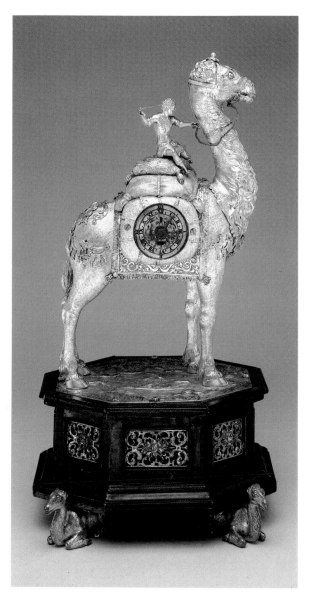

Left
A silver and gilt quarter-striking dromedary clock,
early seventeenth century, height 16½in (42cm)
London £71,500 ($139,425). 17.XII.87
From the collection of the late Ritter Rudolf von Gutmann

Below
A gilt-metal table clock, in the manner of Jeremias Metzger,
sixteenth century, height 13¾in (35cm)
London £79,200 ($154,440). 17.XII.87
From the collection of the late Ritter Rudolf von Gutmann

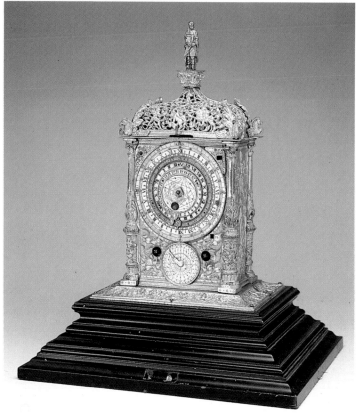

Opposite
A gilt-brass and silver combined astronomical
compendium and book binding by Erasmus
Habermel, signed and dated *Pragae 1597*,
8¼in by 6¼in by 2½in (21cm by 16cm by 6.5cm)
London £181,500 ($335,775). 16.XI.87
From the collection of the late Ritter Rudolf von
Gutmann

Ceramics and glass

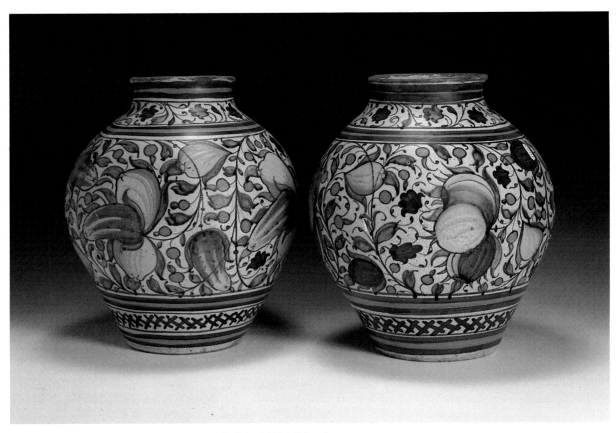

A pair of Venice maiolica jars, 1520–30, height 14$\frac{1}{8}$in (36cm)
London £28,600 ($52,624). 22.II.88

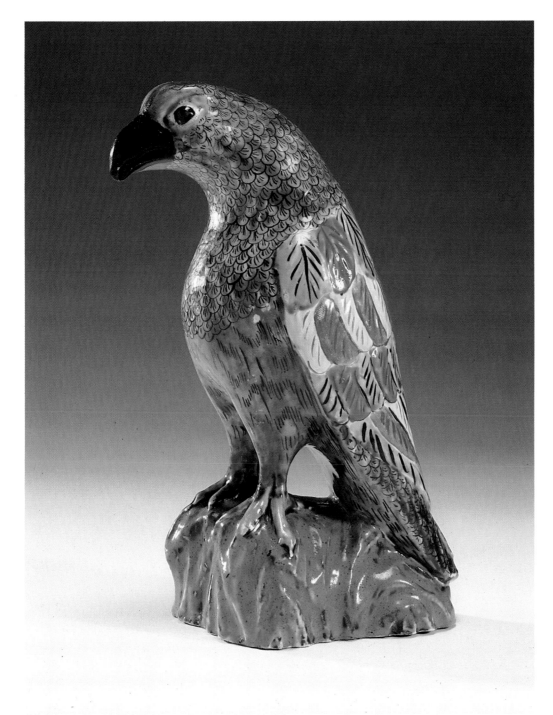

A Staffordshire saltglaze figure of a hawk, after a Chinese original, *circa* 1755, height 7½in (19cm)
London £35,200 ($65,824). 23.II.88

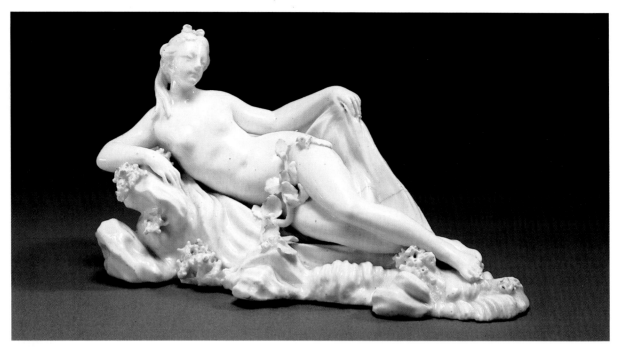

A Vincennes figure entitled *la Baigneuse*, inspired by a François Boucher sketch of '*Vénus et l'Amour*' dated *1742*, *circa* 1752, length 7½in (19cm)
Geneva SF25,300 (£9,620:$18,123). 10.V.88

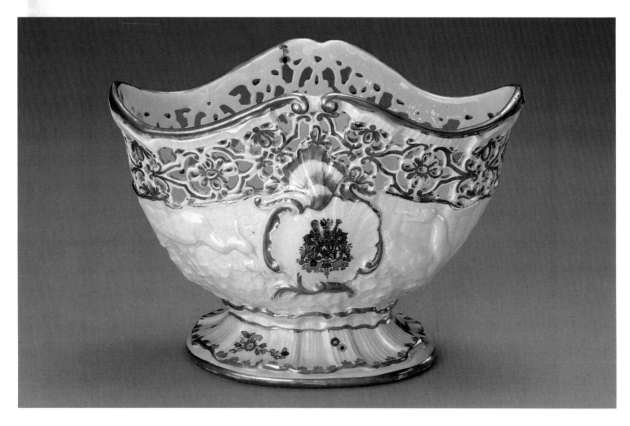

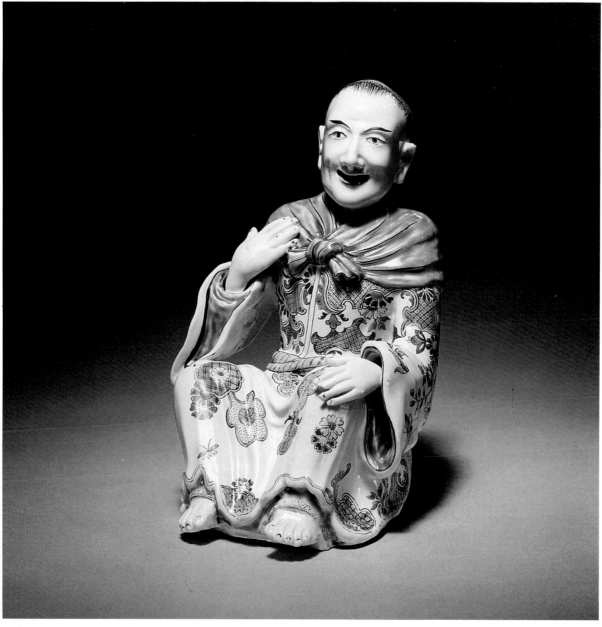

A Chantilly figure of a Chinaman, *circa* 1735, height 5⅞in (15cm)
Geneva SF46,200 (£18,857:$33,723). 9.XI.87

Opposite
A Meissen wine-bottle stand from the Swan Service, modelled by J.J. Kändler and
J.F. Eberlein, marked with crossed swords, *circa* 1738, height 6⅜in (16.3cm)
Geneva SF38,500 (£15,714:$28,102). 9.XI.87

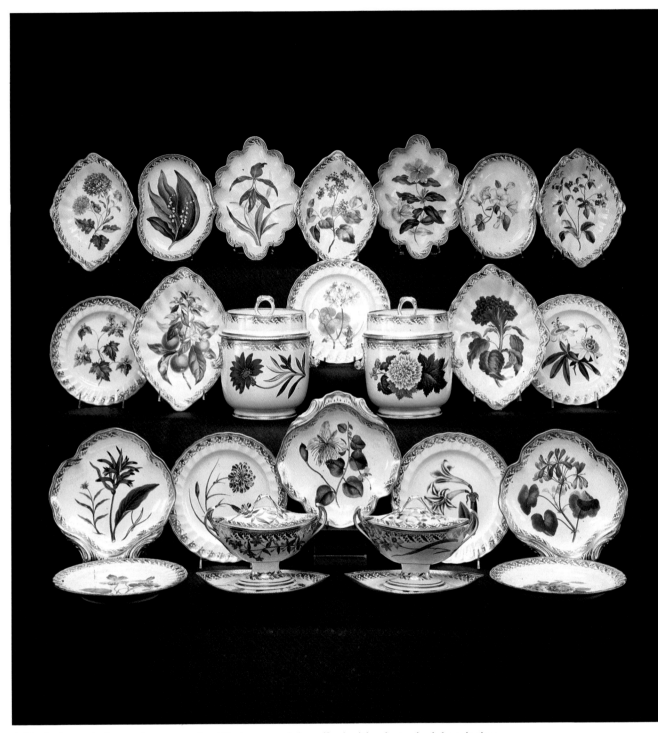

A Derby botanical part dessert service, 58 pieces, each inscribed with a botanical description, some in Latin, marked with crowned crossed batons and *D*s, 1795–1800
New York $121,000 (£72,455). 16.X.87

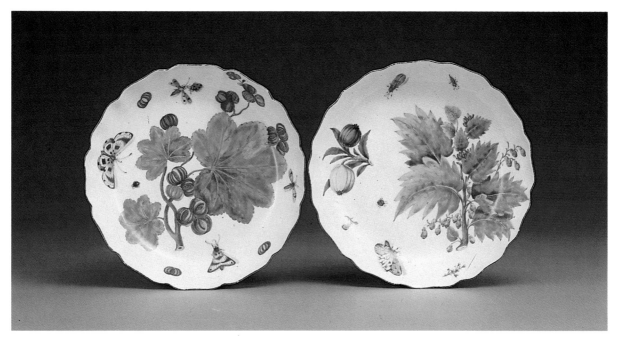

A pair of Chelsea 'Hans Sloane' dishes, marked with red anchors, *circa* 1755,
diameters: *left* 8in (20.3cm), *right* 8⅛in (20.7cm)
New York $30,800 (£16,471). 6.IV.88
From the collection of the late Mary C. Early

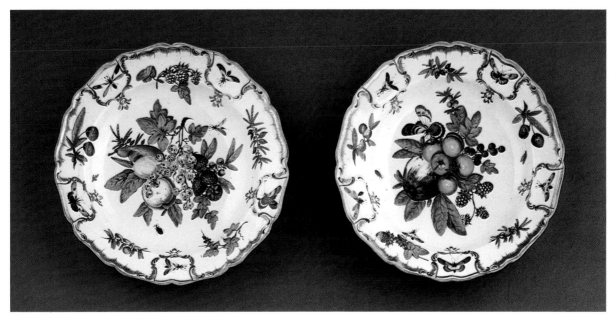

A pair of Worcester plates from the 'Duke of Gloucester' service, marked with gold crescents,
1775–78, diameters 9in (22.7cm)
New York $38,500 (£20,588). 6.IV.88
From the collection of the late Mary C. Early

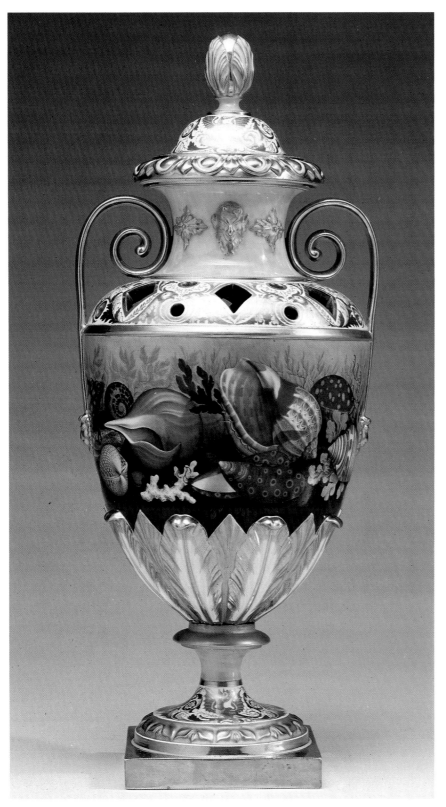

Opposite, left
A cameo plaque entitled *The Pearl Necklace* by George Woodall, signed, *circa* 1890,
height 6⅜in (16cm)
London £17,600 ($34,320). 15.III.88

Right
A Viennese transparent-enamelled topographical beaker depicting St Stephen's Cathedral, Vienna, painted by Anton Kothgasser, initialled and inscribed, *circa* 1820,
height 4⅜in (11cm)
London £4,180 ($7,691). 22.II.88

Left
A Flight, Barr and Barr shell-decorated vase, possibly painted by John Barker, *circa* 1820, height 18⅜in (46.7cm)
New York $41,250 (£24,701). 16.X.87

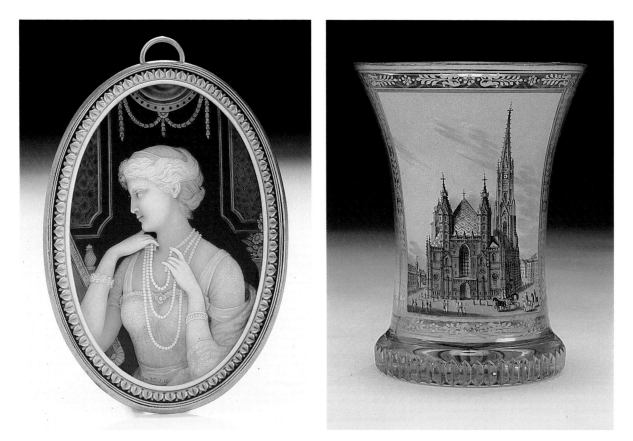

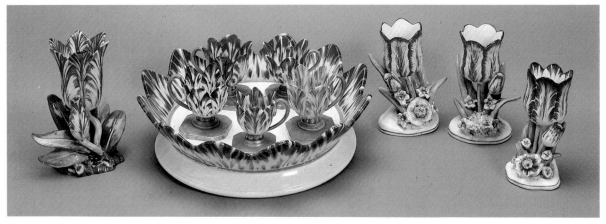

Left to right
A Derby-type tulip vase, early nineteenth century, height 6in (15cm), £5,280 ($9,016)
A set of five Spode tulip cups and stand, *circa* 1820, diameter of stand 11¾in(29cm), £13,200 ($22,539)
A pair of Rockingham-type tulip vases, *circa* 1830, height 5⅛in (13cm), £4,950 ($8,452)
A Rockingham-type tulip vase, *circa* 1830, height 5⅛in (13cm), £2,420 ($4,132)

The vases illustrated above were sold in London on 12th July 1988.

A documentary Vincennes *inventaire*

Antoine d'Albis

Until the innovations of Höroldt at the Meissen factory, probably even until 1725, the only polychrome decorated porcelain known in Europe came from China or Japan. It was decorated in only ten or twelve colours, the majority of which were translucent yet had the vivid, full-bodied appearance which high-temperature firing lends to enamel colours. However, from the technical point of view, these Chinese colours were difficult to apply, and could not achieve, through the application of different thicknesses of enamel, the gradations in shade necessary for the impressions of perspective and *trompe l'œil*. Nothing is more difficult to apply than manganese purple or the transparent green of a *famille verte* palette.

The Orientals hardly concerned themselves with such problems, preferring instead to limit the use of technique in order to give greater stimulus to the imagination. This appeal to the senses was misunderstood in Europe. One has only to quote the commentary of the dealer Gersaint in his catalogue of the collection of the Vicomte de Fonspertuis in 1748. 'One would wish that the drawings with which the Chinese decorated their porcelain were more precise and that the gradation of colour was better observed in the subjects that they wish to portray.' In his account of his visit to the St Cloud factory in 1698, Dr Martin Lister goes even further than Gersaint, and does not hesitate to say 'Our painters are far better artists in that medium than the Chinese.' As for the encyclopaedists, their judgement is unequivocal. 'There is nothing of merit in Chinese porcelain but bright colours and outlandish shapes.' Opinions have certainly altered since then.

In the eighteenth century enamelled-metal watch-cases and snuff boxes were introduced. Thus, it was the enamellers who were called upon to perfect a palette of colours for porcelain. The enamels that they used all vitrified at different temperatures. The painter inserted his work into the white-hot kiln, watched carefully over the firing, and then, armed with a pair of tongs, removed the work from the heat when he considered the enamel to have set. Selecting his colours by families, he took care to fire the hardest colours first and the softest last; the metal on to which they were applied withstood these multiple firings with ease. There was no question, however, of submitting porcelain to this kind of harsh treatment. It was far too fragile and would not have stood up to the changes in temperature. The problem lay, therefore, in finding a palette of colours which fused at the same temperature. The Meissen factory had already achieved this: all varieties of iron-red, sepia brown, carmine, purple, blue and yellow existed and all the nuances of each shade had been perfected, resulting in a collection of some fifty different shades. Their success was resounding and internationally acclaimed.

Fig. 1
A Vincennes *inventaire*,
signed and dated *Armand Lainee*,
ce 9 juillet 1749, height 1¾in (4.5cm)
London £19,800 ($37,026). 23.II.88

(Side A)
Below signature
 l.R – red + Taunai's purple
 B..N.8 – dark reddish-brown
 (N) + very brownish-green (8)
 5.V.8 – yellowish-brown (5) +
 very brownish-green (8)
 5.V.32 – yellowish-brown (5) +
 yellowish-brown for foreground
 areas (32)

The interpretations of the
references of Armand the elder's
inventaire make no claim to strict
exactitude. They were drawn up
with the help of the report
compiled by Jean Hellot in June
1752. This report is preserved in
the archives of the Comte de la
Croue who has kindly provided
Sèvres with a copy (archive
heading Y 72).

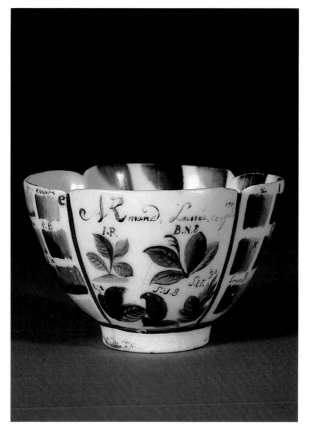

In France, St Cloud and then Chantilly had, like the Chinese, mastered only a small number of colours. Through lack of technical ability their style was reminiscent of the Oriental and fashionable dealers such as Lazare Duvaux paid them little heed. German porcelain was the fashion of the day. Nevertheless, the quality of Vincennes porcelain, with its whiteness and its translucency, had by 1741 attracted the attention of the Marquis de Fulvy. He was intendent of finances, director of the Compagnie des Indes and the brother of the Minister of Finance. He took an active interest in the three workmen who had invented this white porcelain and who were installed in one of the eight towers at the Château de Vincennes. He got them into debt, extracted the secret from them, had them turned out of the Château and then financed the company himself. Close to the seat of power, in 1745 the Marquis de Fulvy won a Royal Privilege: permission to produce porcelain in the German style. It is to his ambition at that time 'to paint and gild the human form' that we owe the existence of Sèvres.

In order to perfect the necessary palette, he turned, as had the Germans, to the enamellers. Their names: Taunai, Liot, Mathieu and Caillat are documented in books preserved in the archives at the Sèvres factory, a fact which leads one to believe that they were, in fact, attached to the business. The most suitable enamels, which can be shaded and which best enable the execution of miniature painting, are finely

Fig.2 (Side B)
Top band
 1 – Taunai's purple
 V.1 – Taunai's no. 1 violet
Second band
 C – Taunai's carmine
 Brun. N – reddish colour from
 Caillat's book
 Ollive – Massue's olive green
Third band
 (Heart) – mixture of yellowish-
 brown and purple
 Rouge – factory Saxon red

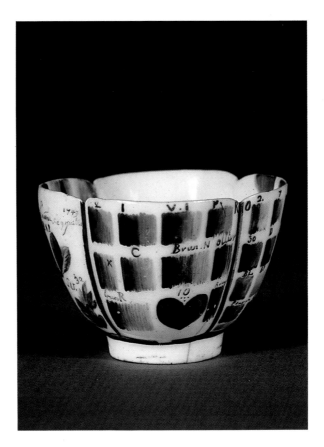

ground opaque colours. With careful brush strokes and the appropriate use of the whiteness of the porcelain, the painter can give life to his decoration. To obtain this opaqueness a 'fusible' or melting glass is mixed with a more heat-resistant metal-oxide such as iron, cobalt, copper or zinc, in powder form. In the firing, these mixtures attach themselves to the porcelain without altering and produce an infinity of colours. Thus, iron-red oxide when fired with zinc oxide produces sepia; if a little cobalt is added it becomes a rich brown; if white antimony oxide is added to red lead oxide, Naples yellow is obtained in the firing. The most fascinating colour is Cassius purple which is liquid and is obtained by pouring tin chloride over gold chloride. If the tin is poured quickly red is produced and when poured slowly purple is achieved. Naturally, each workman had his own special formula but the real problem lay in finding a single flux which, once all the different colours had been blended, would enable them all to be fired at the same temperature.

At Vincennes this was achieved by Jean-Mathias Caillat. An employee of the factory, he was given a bonus each time he discovered a colour, the formula of which he then relinquished to the factory. Taunai had invented formulas for different fluxes which, when mixed with Cassius purple, enabled him to obtain pink, purple and violet. He sold his secretly prepared colours for over one hundred times their actual cost price. These colours were used at Vincennes from 1744 or 1745 onwards. They were known as the 'trois belles couleurs de Monsieur Taunai'.

Fig.3 (Side C)
Top band
 1 – brownish-green
 8 – very brownish-green
Second band
 30 – dark brown
 0 – fine bistre from Caillat's book
 9 – (velvety) blackish-brown
 32 – blackish-brown for the
 foreground areas
Third band
 BL – blue (no reference to
 this in the report)
 B.P – pale blue (no reference
 to this in the report)
 T – sunflower yellow
 Violet F – dark Vincennes violet,
 fine and permanent
 Violet R – reddish-violet
Fourth band
 Pourpre/C/Rose – Probably refer
 to Caillat's different shades of
 purple, of lesser quality than the
 purple of Taunai, but also less
 costly

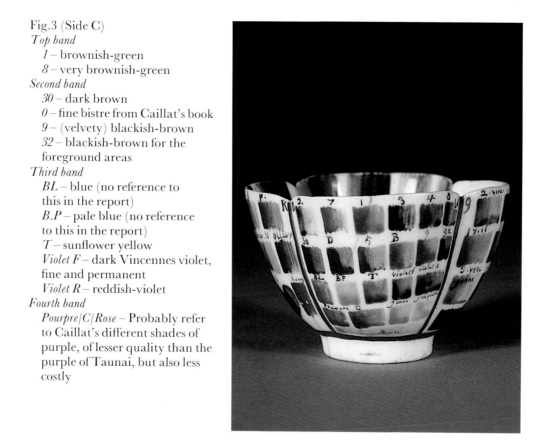

1749 was the year in which Vincennes could claim to have achieved the same standard of technical quality as that of Meissen. The factory had succeeded in producing a palette comprising about sixty colours. Each painter received his colours in powder form, contained in little sachets on which were inscribed the allotted numbers of the particular shades. As these powders altered slightly in the firing, it was up to each painter to compile an inventory for himself. Jean Hellot, director of the Académie des Sciences, and responsible in 1751 for noting down all the factory secrets for the information of Louis XV, describes the way in which these palettes were produced, in the following manner:

'They take a piece of white porcelain, fired and glazed with a crystalline coating, and paint a small square patch as large as a thumbnail, with downward strokes of the brush beginning from the left, without adding any more colour to the brush so that the first strokes of the brush-point are of the most intense colour, becoming paler towards the right. Thus, in this small square patch, are all the different shades which can be obtained from the colour being tested. If several colours are tested on the same piece of porcelain, this series of little squares of colour becomes known as an inventory and each square is numbered with the same number or letter marked on the colour sachet.'

Louis-Denis Armand, known as 'Armand l'aîné', formerly a painter of lacquered furniture in the Chinese taste, had joined the Vincennes factory in 1745 at the age of twenty-two. He was paid sixty livres a month and was the brother of Louis-Philippe

Fig.4 (Side D)
Top band
 2. – blackish-brown + green
Second band
 1. Pourpre – Caillat's green + purple
 1. No. – Caillat's green + black
Third band
 9. Verre Jonne – bright green no. 9 + yellow
 4.0. – fine bistre from Caillat's book + black
 8.30. – greenish-brown (8) + dark brown (30)
Fourth band
 5.V. – yellowish-brown (5) of Vincennes (?)

Armand who had supervised from 1750 the use of an enamelling tunnel-oven with a mobile load – another innovation of the Vincennes factory. The kiln was introduced in 1748 and was the predecessor of the modern industrial kiln which began to be used after the Second World War. This kiln, which facilitated the firing of each piece virtually according to its own specific requirements, enabled the Vincennes factory to achieve, with such success, their famous coloured grounds. In order to judge the firing, a touch of purple was painted on a porcelain flower and placed in the kiln. When the colour had blended with that of the porcelain, the right temperature had been reached and the piece could be allowed to cool.

Armand the elder's palette is a small, lobed bowl quite typical of the wares being produced at the Vincennes factory between 1748 and 1751 (see Figs 1 to 4). In order to boast that they had in fact caught up with Augustus III's factory, craftsmen at Vincennes marked certain pieces with two crossed electoral swords. One of these bowls developed a hazardous crack in the base during firing. Like Taunai's bowl, preserved at the Sèvres Museum, which was accidentally chipped before firing, this piece was glazed and fired especially as a painter's palette. A painter of landscapes and birds, Armand the elder required muted, subdued, blended soft colours for the depictions of planes and horizons and for the foreground areas, he required browns, burnt sienna and black.

On one lobe we can admire Taunai's colours: purple no.1, the patch of carmine labelled 'C' and violet labelled 'V.1' (Fig.2). Near the base is painted a heart in a mixture of purple and 'brun jaunatre' and beside it, to the right, a rectangular patch surmounted with the inscription 'rouge'. The five letters of this word can be seen to frame the strokes applied at the four notches of the lobes. This red bears the name 'rouge de Saxe' or 'needle red' at the factory. The method by which it was obtained, described by Jean Hellot in June of 1752 in the report he submitted to the Minister of Finance, remained unchanged until the first part of the twentieth century.

'Take a small quantity of needles, about a hundred or so, pour some oil of vitriol [sulphuric acid] over them and leave for eight to ten minutes . . . Then pour on a little hot water . . . filter this mixture . . . evaporate the liquid from it . . . and crystals will form at the bottom . . . which should then be dried . . . Put a small amount of these into a crucible in a muffle kiln and calcinate until they cease to give off smoke . . . leave them for a short while, taking care that they do not blacken, for then the substance would be ruined. Grind this red with three times its weight in flux and keep it in an extremely dry place or even better in your pocket . . . this operation is very difficult and may make the artisan who undertakes it unwell because the aqua fortis vapours, which he cannot help but inhale while burning the crystals, attack the lungs.'

Other processes prescribed pendulum springs or English razor blades in place of needles. A solution of iron-sulphate once calcinated and turned into iron oxide, according to which temperature was used in preparation, produced orange, red, violet or even black.

The lobe to the right of this is painted with pure colours, that is to say, in exactly the form in which he had received them (Fig.3). We see here shades that he would later apply quite thickly for foreground and middle-distance subjects. There are also three rather unsuccessful purples. These are not Taunai's colours: they are Caillat's purple, carmine and pink. These shades appear on certain flowers and were probably used at that time for economic reasons on pieces of lesser importance. On another of the lobes (Fig.4), Armand the elder has tested blended colours only; these are the deliberately subdued colours which are necessary for landscape painting, the soft tones of which offer the lovers of Vincennes porcelain of the first period such esoteric and justified satisfaction.

After the death of the Marquis of Fulvy in 1751, the style at Vincennes suddenly changed. The manner of decoration quickly began to conform to the Royal destiny of the factory. A taste for much more brilliant colours evolved. The coloured grounds, *bleu-lapis*, *bleu-céleste* and green appeared. The closer the patron to the court, the finer and more lavish were the gilded scrolls applied to these grounds. The Marquise de Pompadour was undoubtedly no stranger to these changes. A letter from Jean Hellot, dated 30th November 1752 and addressed to the Marchault d'Arnouville, is indicative of this evolution: 'When the good painters at Vincennes develop more originality in their painting . . ., when they master to perfection the use of enamel colours without mixing too many on their palettes, when they fire the colours as they do in Germany, then, Sir, you will have what you wish for.'

Vincennes no longer trailed in the wake of Germany; it had ascended to the status of Royal Porcelain Manufacture.

Furniture and tapestries

A George III mahogany serpentine commode, attributed to William Vile, *circa* 1765,
width 4ft 7in (140cm)
London £242,000 ($440,440). 8.VII.88

Opposite
One of a pair of George II parcel-gilt and ebonised wall lanterns, workshop of Jean Cuenot
to the designs of G. B. Borra, *circa* 1755, height 5ft (152cm)
London £110,000 ($200,200). 8.VII.88

These lanterns were designed for Norfolk House, London, which was built for the 9th Duke
of Norfolk by Matthew Brettingham, former assistant to William Kent.

A pair of early George III walnut stools, *circa* 1760, height 1ft 6in (45.7cm)
New York $25,300 (£14,134). 23.I.88
From the collection of Audubon Canyon Ranch Inc.

Opposite, above
A George II mahogany side table, *circa* 1755, width 7ft (214cm), £37,400 ($70,686)

Below
A Regency mahogany library table, *circa* 1810, height 3ft 1½in (95cm), £44,000 ($83,160)

Both tables illustrated opposite were sold in London on 20th November 1987.

A Queen Anne gilt-decorated japanned bureau bookcase, *circa* 1700, height 7ft 3in (221cm)
New York $165,000 (£98,802). 17.X.87
From the collection of the Fogg Art Museum and Busch-Reisinger Museum, Harvard
University

One of four identical George II mahogany library armchairs, in the manner of Thomas
Chippendale, *circa* 1755
London £429,000 ($780,780). 8.VII.88

A George III inlaid mahogany breakfront bookcase, third quarter eighteenth century,
height 9ft (274.3cm)
New York $55,000 (£32,934). 16.X.87

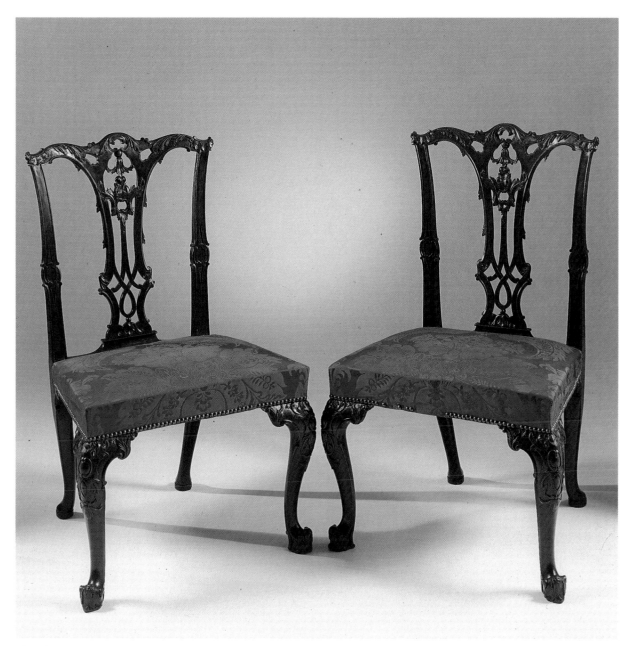

Two from a set of six George III mahogany side chairs, after a design by Thomas
Chippendale, *circa* 1760
New York $137,500 (£82,335). 17.X.87

The design for these chairs appears in Chippendale's *A Gentleman and Cabinetmaker's Director*,
third edition, 1762.

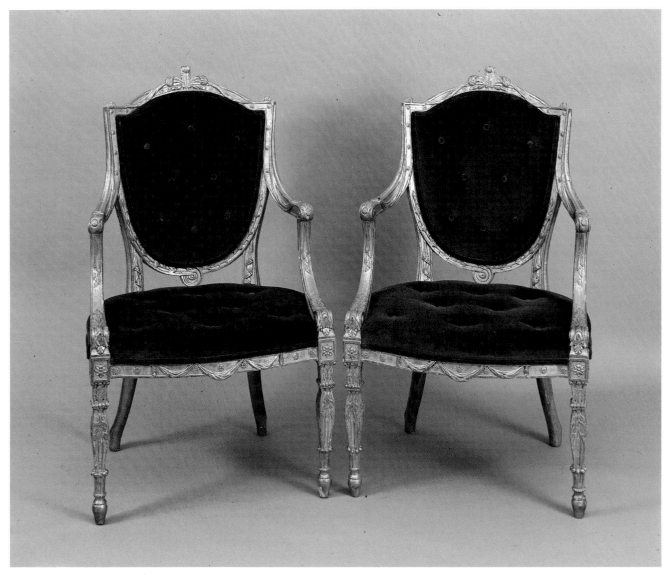

A pair of George III giltwood armchairs, in the manner of Thomas Chippendale, *circa* 1780
New York $85,250 (£47,361). 3.VI.88

Opposite, above
A pair of Louis XVI giltwood pliants, probably by Nicolas Quinibert Foliot, last quarter
eighteenth century, height 18½in (47cm)
New York $93,500 (£54,361). 31.X.87

Nicolas Quinibert Foliot was received Master in 1745. These pliants were delivered on
24th December 1773 for the Comtesse d'Artois' bedchamber at Versailles.

Below
A pair of Louis XV/XVI ormolu-mounted Chinese porcelain ewers, the porcelain Kangxi,
the ormolu *circa* 1765, height 21½in (54.6cm)
New York $132,000 (£70,968). 21.V.88

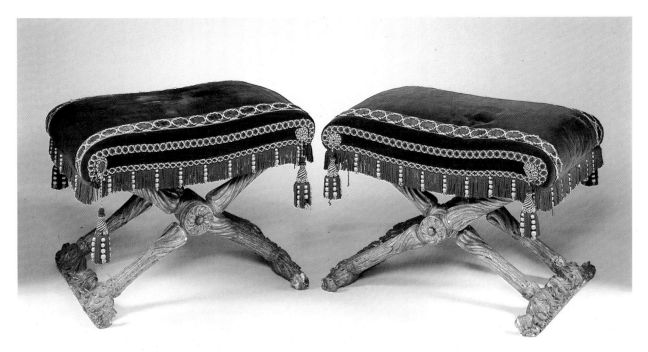

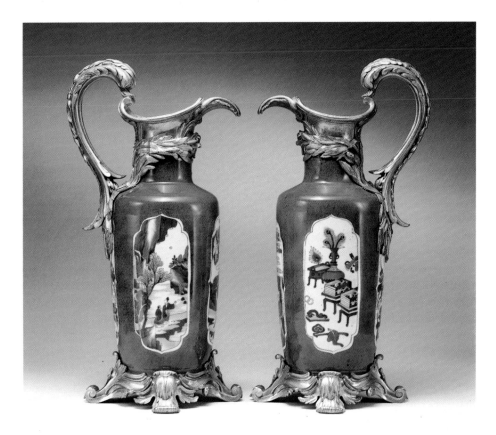

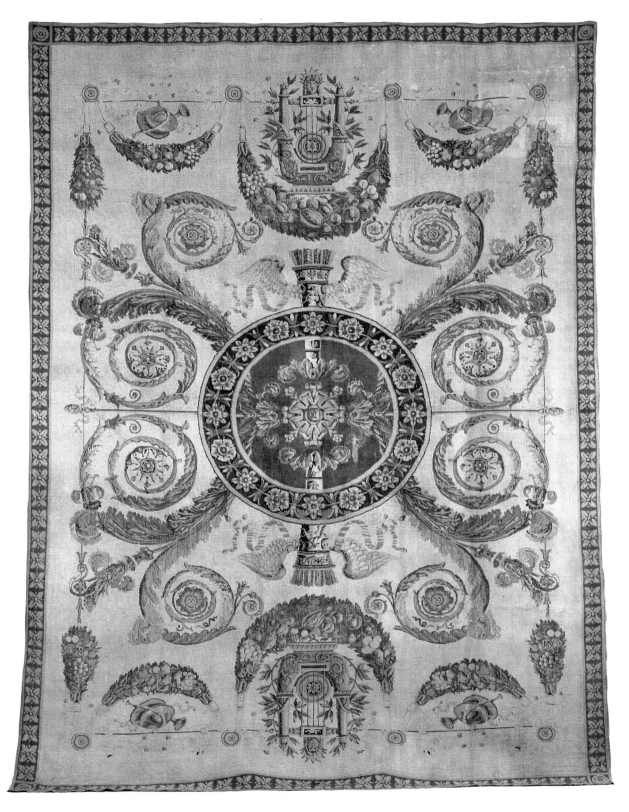

A Louis XV ormolu-mounted lacquer commode, stamped *D.F.*, by Jean Desforges,
mid eighteenth century, width 4ft 2¾in (128.9cm)
New York $286,000 (£153,763). 21.V.88
From the Estate of Belle Linksy

Jean Desforges was received Master in 1739.

Opposite
A Savonnerie carpet, France, *circa* 1810, 18ft 10in by 14ft 1in (574cm by 429.3cm)
New York $154,000 (£85,555). 4.VI.88
From the collection of the late Caroline Ryan Foulke

A Louis XVI marquetry cylinder bureau stamped *D Roentgen, circa* 1785, height 4ft 3in (129.5cm)
London £275,000 ($508,750). 24.VI.88

This bureau is the only recorded piece to be stamped by the maker in this way.

A pair of Louis XVI ormolu-mounted Sèvres blue and white *pots-pourris* vases, *circa* 1780,
height 29⅞in (76cm)
Monte Carlo FF721,500 (£72,150:£125,478). 21.II.88

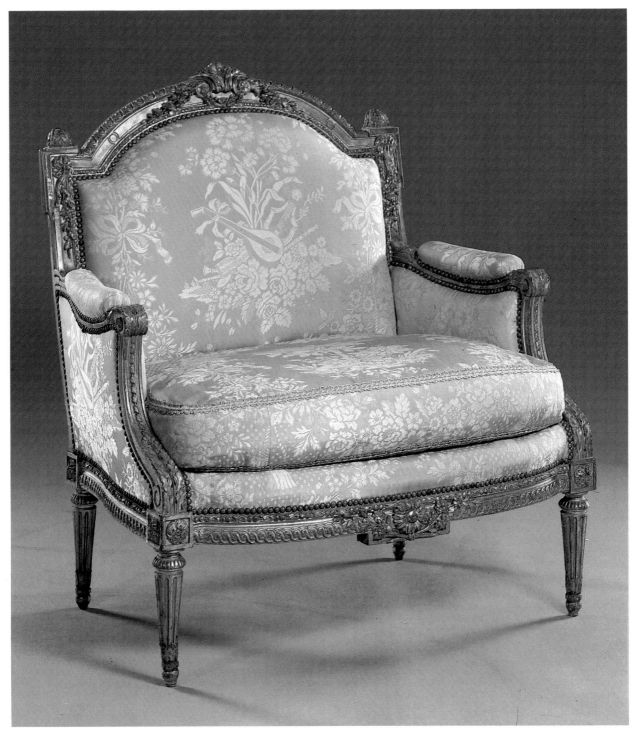

One of a pair of early Louis XVI giltwood marquises, stamped with the mark of Jean-Baptiste
Tilliard II, *circa* 1775, width 3ft 3½in (100cm)
London £231,000 ($427,350). 24.VI.88

Jean-Baptiste Tilliard II was received Master in 1752.

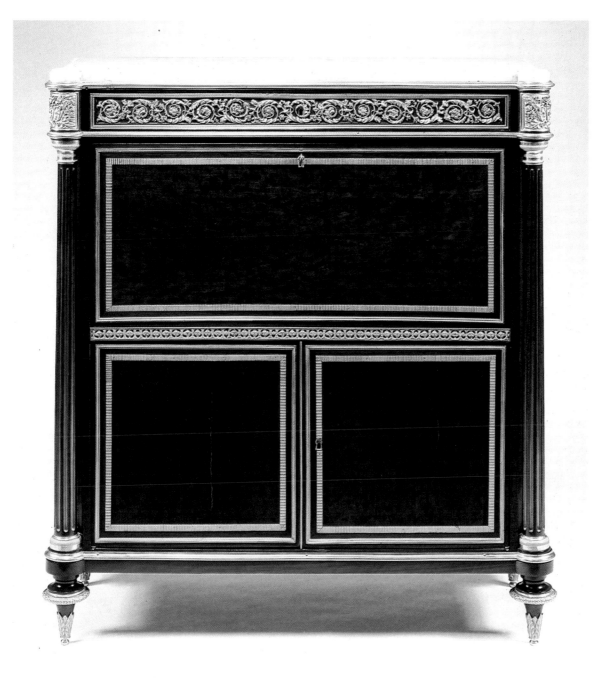

A Louis XVI ormolu-mounted mahogany *secrétaire à abattant*, stamped *M. Carlin*, *JME*,
last quarter eighteenth century, height 4ft 1½in (125.7cm)
New York $418,000 (£224,731). 21.V.88
From the Estate of Belle Linsky

Martin Carlin was received Master in 1766.

A pair of Louis XIV pedestal cabinets

This magnificent pair of Louis XIV pedestal cabinets, attributed to the *ébéniste* André-Charles Boulle, was once part of the famous collection of the 10th Duke of Hamilton (1767–1852).

The Hamilton Palace sale, held at Christie's in 1882, was one of the most important auctions of French furniture, and pieces sold from the Duke's collection are now in the Louvre, the Château de Versailles, the Metropolitan Museum of Art, the J. Paul Getty Museum and the James A. de Rothschild Collection at Waddesdon Manor. The pedestals were among the few items illustrated in the catalogue of the sale. Also of particular note was the number of pieces of royal provenance, including a black lacquer commode and matching *secrétaire à abattant* made by Riesener for Queen Marie-Antoinette at Saint-Cloud, now in the Metropolitan Museum of Art, and a commode signed 'Levasseur' and delivered in 1777 for the Comte d'Artois at the Hôtel du Temple. This piece is now at Versailles.

The history of the pedestals has been traced by Ronald Freyberger who tentatively identified them as lot 217 in the 1827 auction of the collection of the Chevalier Féréol Bonnemaison, an artist and restorer who had previously acted as an intermediary between the Duke and Jacques-Louis David.

This identification is supported by a document in the Hamilton archive, signed by a member of the Bonnemaison household, which describes two octagonal columns by Boulle bought for the Duke in 1827. According to Freyberger, the date of this document indicates that the Duke acquired the pedestals privately from Bonnemaison, prior to the auction, but after the catalogue had been prepared. Further evidence is indicated by the absence of an annotated price for lot 217 in otherwise priced copies of the Bonnemaison sale catalogue examined by Freyberger.

In the inventory of Hamilton Palace, drawn up in 1835 and added to until 1840, the pedestals and the objects which surmounted them are listed among the contents of the Duke of Hamilton's dressing-room. Freyberger also noted that later, in 1876, the pedestals stood in the bedroom of the suite of Tapestry Rooms at Hamilton Palace.

In the absence of documents or drawings, an attribution to André-Charles Boulle must remain tentative, since he never signed his furniture and the only two works by him recorded with certainty are two commodes delivered between 1708 and 1709 for Louis XIV at the Trianon. However, the high quality of craftsmanship together with stylistic features, lead to the conclusion that the pedestals indeed originate from Boulle, whose name is associated with this technique combining brass, tortoiseshell and ebony highlighted with gilt-bronze mounts. Some of the motifs on these pedestals are known to have been used by Boulle and can be found on other works attributed to him, for instance, the overlapping acanthus leaf designs, based on two drawings by Boulle in the Musée des Arts Decoratifs, Paris.

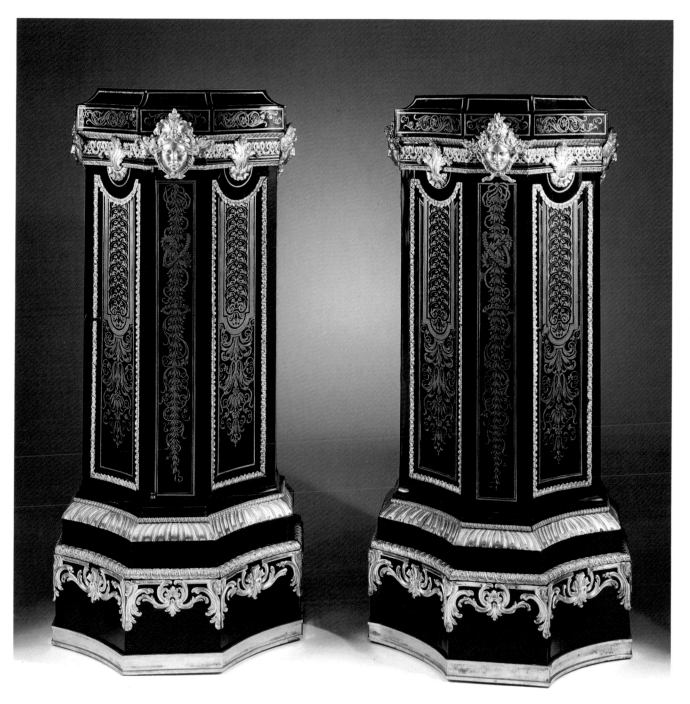

A pair of Louis XIV ormolu-mounted, brass, tortoiseshell and ebony pedestal cabinets,
attributed to André-Charles Boulle, *circa* 1710, height 49⅝in (126cm)
New York $990,000 (£575,581). 31.X.87

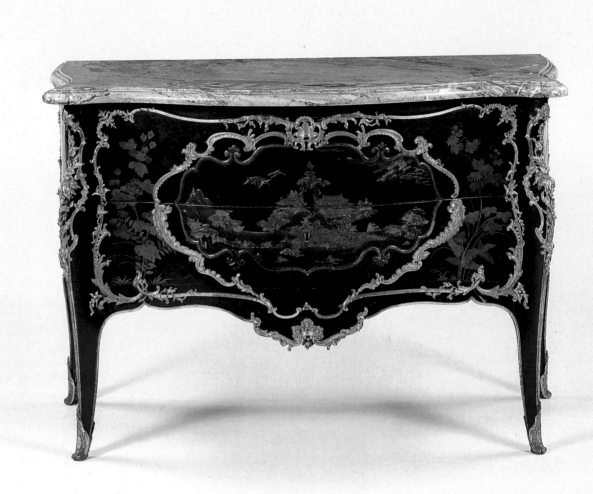

A Louis XV japanned commode, stamped *B.V.R.B.*, *circa* 1737, height 2ft 9½in (85cm) Monte Carlo FF8,880,000 (£845,714:$1,480,000). 17.VI.88

Ordered by Queen Mary Leczinska, this piece was delivered to Fontainebleau in 1737 by the furniture merchant Hébert and is the oldest known piece executed by Bernard van Risamburgh.

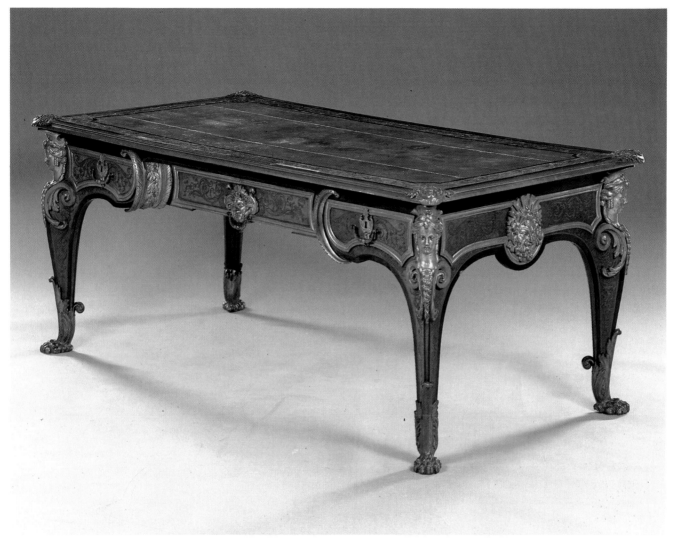

A late Louis XIV bureau plat attributed to André-Charles Boulle, *circa* 1710,
width 6ft 6in (198cm)
London £638,000 ($1,180,300). 24.VI.88

The bureau plat is based on a drawing by André-Charles Boulle.

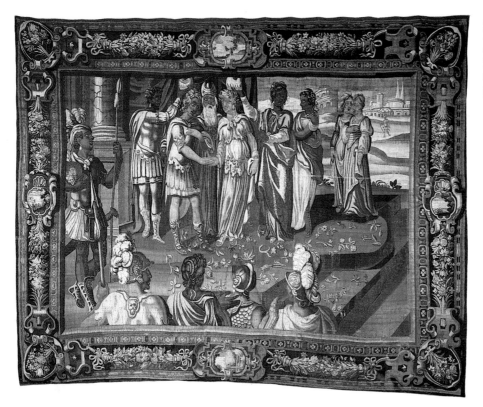

A Paris tapestry from the atelier of
Frans van den Planken and Marc
de Comans, *circa* 1620, 10ft by 12ft
3in (305cm by 374cm)
Château de Cleydael
BF650,000 (£193,452:$317,073).
13.X.87

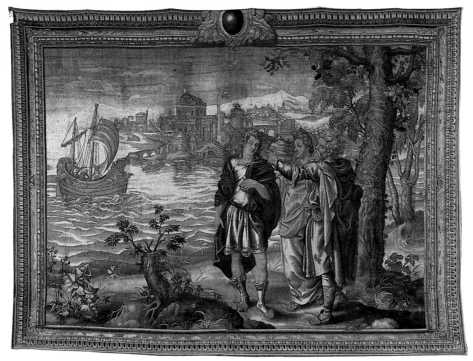

A Mortlake tapestry of Hero and
Leander after Francis Cleyn, mid
seventeenth century, 10ft 6in by
14ft 6in (320cm by 442cm)
London £24,200 ($47,674).
20.V.88

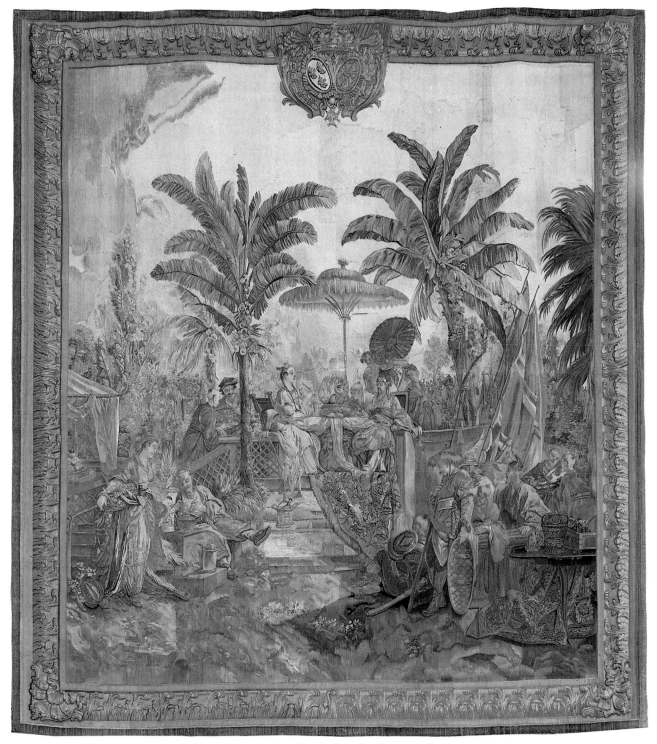

The Chinese Banquet, a Beauvais 'Chinoiserie' tapestry after designs by François Boucher and
cartoons by Jean-Joseph Dumons, *circa* 1758, 11ft by 10ft 1in (335.3cm by 307.3cm)
New York $74,250 (£39,919). 20.V.88
From the collection of Mrs John W. Blodgett

Château de La Roche-Guyon

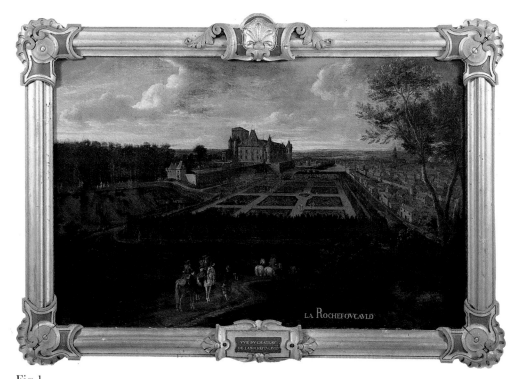

Fig.1
French School
VUE DU CHATEAU DE LA ROCHEFOUCAULD
Late seventeenth century, 50in by 80in (129cm by 203cm)
Monte Carlo FF199,800 (£19,980:$35,679). 7.XII.87
From the collection of the late Gilbert de La Rochefoucauld, Château de La Roche-Guyon

The Château de La Roche-Guyon, an austerely elegant building nestling under chalk cliffs on the Seine twenty miles west of Paris, had been the home of the de La Rochefoucauld family since the seventeenth century. It had not been looted during the Revolution and the contents, sold in Monte Carlo in December 1987, had never left the family who commissioned them.

François, 6th Duc de La Rochefoucauld, was author of the famous *Maximes*. His grandson François married Madeleine-Charlotte Le Tellier, daughter of the Marquis de Louvois, Louis XIV's chief minister. Upon Louvois' death in 1614, Madeleine-Charlotte inherited a share of her father's exquisite collection. From 1730–45, under the aegis of the Duchesse and later her son Alexandre, the Château underwent extensive redecoration.

The furnishings were altered again between 1764 and 1769, in response to the burgeoning spirit of neoclassicism. The Grand Salon was punctuated with Ionic

Fig.2
A view of the Grand Salon, Château de La Roche-Guyon, taken *circa* 1900.

pilasters; between them hung a set of four Gobelins tapestries showing the *Story of Esther*, a theme which elegantly combines romance and morality in a way approved by the new age. A photograph taken around 1900 (Fig.2) shows not only one of the tapestries but also one of a splendid pair of console tables that stood beneath. Its straight fluted legs, the frieze of stylized flowers and laurel wreath detailing show the fully developed repertoire of neoclassical motifs, rich yet restrained. One of the tables is stamped 'Jumel'; there were several makers of that name, but the most likely producer of these pieces is Barthelémy, who lived in the rue de Seine in Paris, the same street as the de La Rochefoucaulds' town house. The pair of consoles sold for FF3,552,000 (£355,200:$634,286).

François, Duc de La Rochefoucauld was only the first of a long line of intellectuals who amassed a library, also sold in December 1987, that amounted to a comprehensive survey of the history of ideas in France from the seventeenth to the nineteenth century. In the 1730s the rationalist search for more information on the physical world led to the acquisition of maps, telescopes and in 1732 a pair of celestial and terrestrial globes by Nicolas Bailleul and Louis Borde respectively (see Fig.4). The pair sold for FF333,000 (£33,000:$59,643). A thirty-three volume composite atlas, with maps from the sixteenth to the eighteenth century sold for double its estimate (Fig.5).

In the second half of the eighteenth century the newly created Duc d'Enville

Fig.3
Le Jugement, one of four Gobelins tapestries depicting the *Story of Esther*, the series after Jean-François de Troy, workshop of Michel Audran and Pierre-François Cozette, marked *Cozette*, *circa* 1768–69, 10ft by 12ft (305cm by 366cm)
Monte Carlo FF3,885,000 (£388,500:$693,750). 6.XII.87
From the collection of the late Gilbert de La Rochefoucauld, Château de La Roche-Guyon

added numerous volumes on economics and philosophy to the library. From this period comes the superb edition of the *Maximes*, produced in 1778 by the Imprimerie Royale. Bound in gilt-tooled red morocco, this great rarity made FF155,400 (£15,400:$27,750) at auction. The Duc d'Enville's circle included Lafayette and Franklin. At the latter's suggestion he made the first complete translation of the Constitution of the United States in French, which featured footnotes by Franklin himself. Only 500 copies were printed and the Duc's personal copy survived in the Roche-Guyon library (Fig.6). The title page has the first appearance in a book of the eagle, stars and stripes seal, a fitting gesture for one who championed America and negro emancipation.

Each lot added one more piece to the de La Rochefoucauld legend, a legend that made the sale so memorable and so significant.

Fig.4
The library, Château de La Roche-Guyon, including the two globes engraved by Louis Borde and Nicolas Bailleul.

Figs 5 and 6 *Below and right*
Composite world-atlas, 33 volumes, with approximately 1,847 maps, most
hand-coloured, compiled mid eighteenth century, green wove paper binding,
stamped with family's arms, FF2,053,500 (£205,350:$366,969).
French translation of the American Constitution by Louis Alexandre, Duc de
La Rochefoucauld-d'Enville, contemporary red morocco and gilt binding,
stamped with family's arms, Paris, 1783, FF777,000 (£77,700:$138,750).

These books from the library of the late Gilbert de La Rochefoucauld, were
sold in Monaco on 8th December 1987.

Nineteenth-century decorative arts

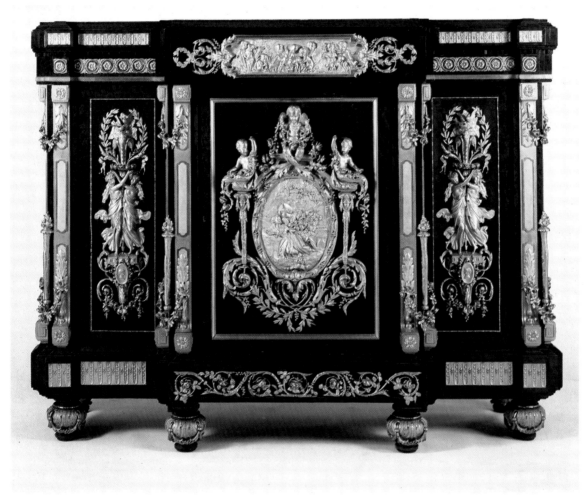

A gilt-bronze-mounted mahogany side cabinet in the style of Louis XVI by Charles-
Guillaume Diehl, inscribed *Exhibition De Vienne/1873/Diehl/Rue Michel Le Comte 19/
Paris, circa* 1873, height 5ft 3¾in (162cm)
New York $44,000 (£26,506). 19.IX.87

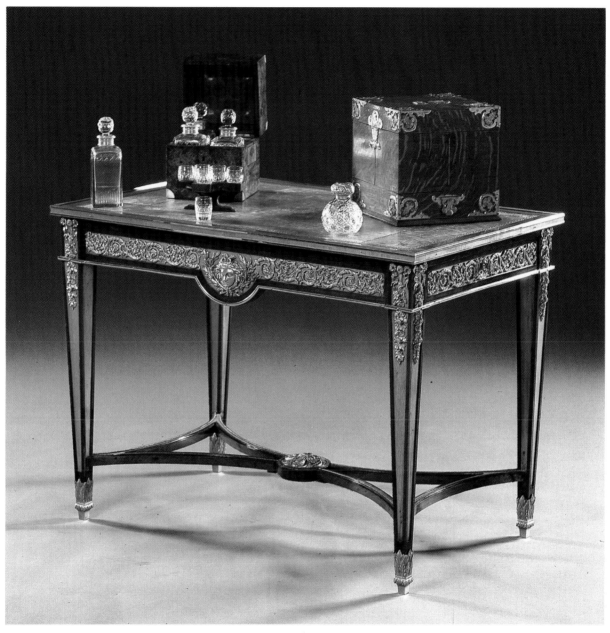

A gilt-bronze-mounted writing table in Louis XVI style, *circa* 1800,
length 3ft 3¾in (101cm), £3,300 ($6,237)
A Louis-Philippe burr-walnut decanter set, comprising six glasses and four
decanters, *circa* 1840, height of decanters 9in (23cm), £1,705 ($3,222)
A royal presentation oak and gilt-metal travelling eau-de-cologne case containing
four bottles with silver-gilt lids and engraved Prince of Wales labels, *circa* 1870,
height of bottles 10in (25.5cm), £3,960 ($7,484).

The items illustrated on this page were sold in London on 6th November 1987.

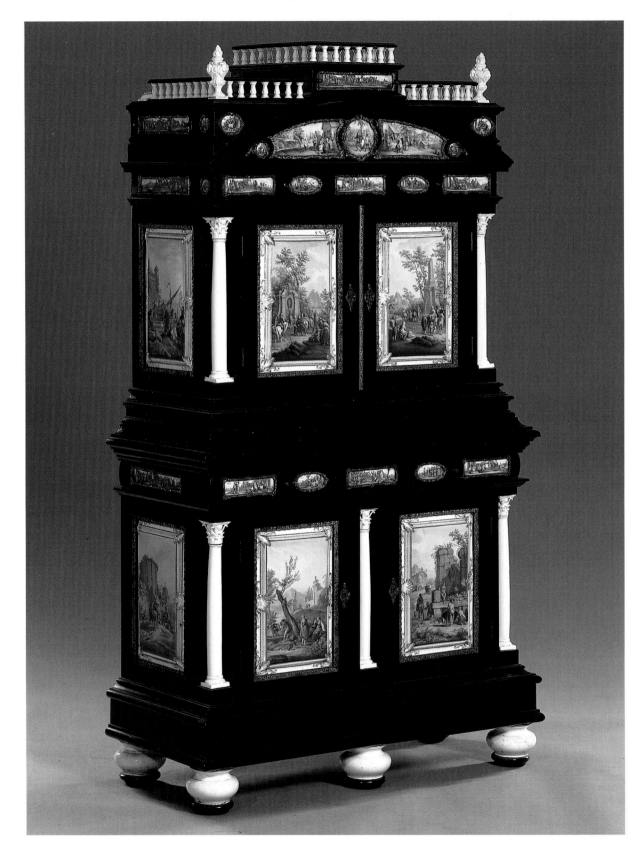

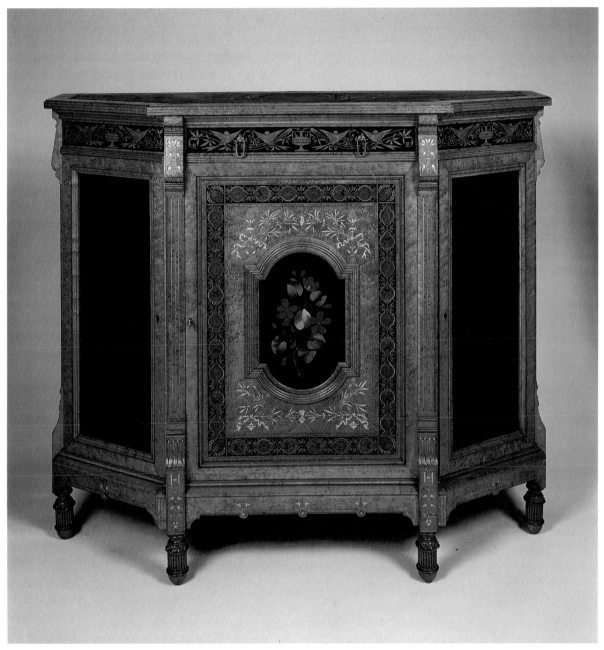

A gilt-incised and ebonized *pietra dura*-mounted maple side cabinet attributed to Herter
Brothers, New York, *circa* 1880, height 4ft ½in (123.2cm)
New York $24,200 (£12,872). 30.IV.88
From the Andy Warhol Collection

Opposite
A Dresden porcelain-mounted ebonised side cabinet, the porcelain panels painted in
the manner of Teniers, *circa* 1880, height 5ft 11½in (182cm)
London £59,400 ($114,642). 10.VI.88

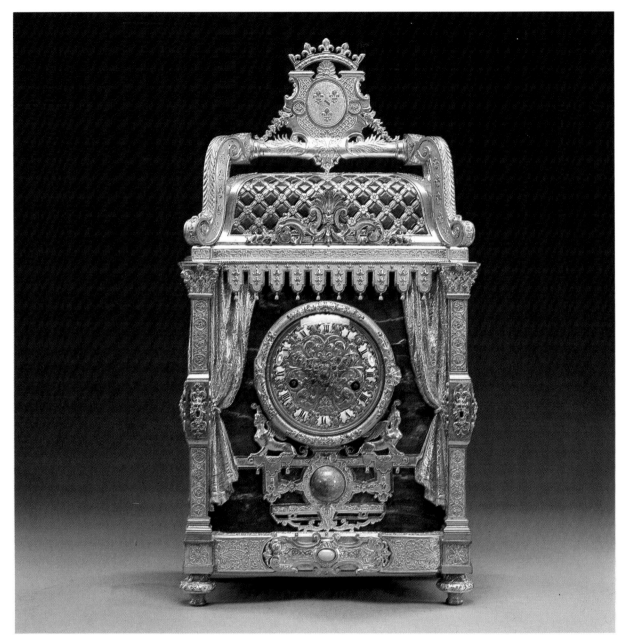

A Louis-Philippe lapis-lazuli and semi-precious stone-mounted gilt-bronze mantel clock,
engraved with the initials *BY*, the mark of Alfred Beurdeley and the arms and monogram of
the Bourbon-Condé family, *circa* 1830, height 21⅝in (55cm)
London £16,500 ($32,010). 18.III.88

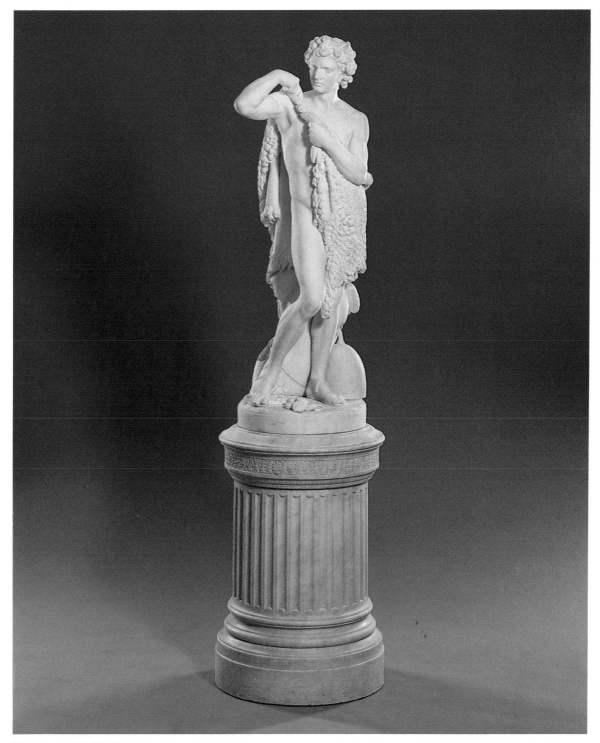

Francesco Fabi-Altini
DAVID RETURNING FROM BATTLE
Marble, signed and dated *Rome 1882*, height 60in (152.5cm)
London £90,200 ($174,086). 10.VI.88

Twentieth-century decorative arts

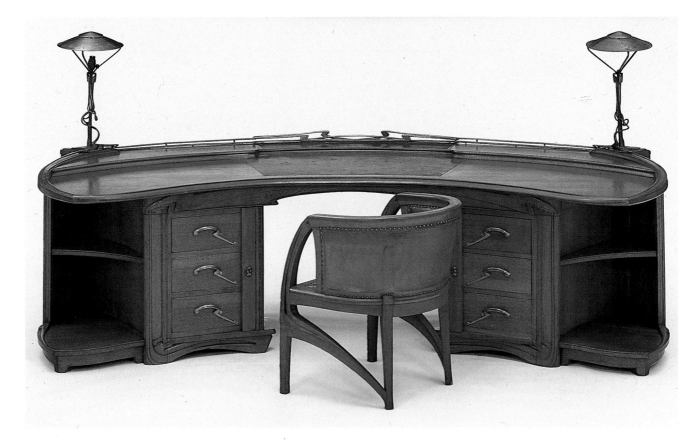

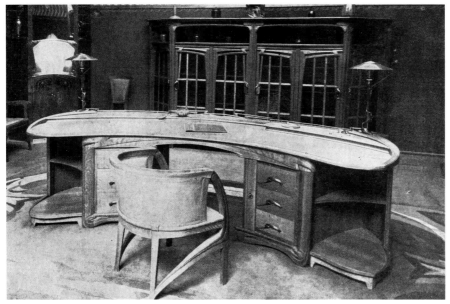

Above
An oak and bronze desk and
armchair, designed by Henry van de
Velde, *circa* 1898–99, height of the
desk including lamps 50⅜in (128cm),
height of the chair 28⅜in (72cm)
Monte Carlo FF1,004,550
(£100,455:$167,425). 11.X.87

Left
A contemporary photograph of Van
de Velde's exhibit at the Salon of the
Munich Secession (reproduced from
L'Art Décoratif, September 1899).

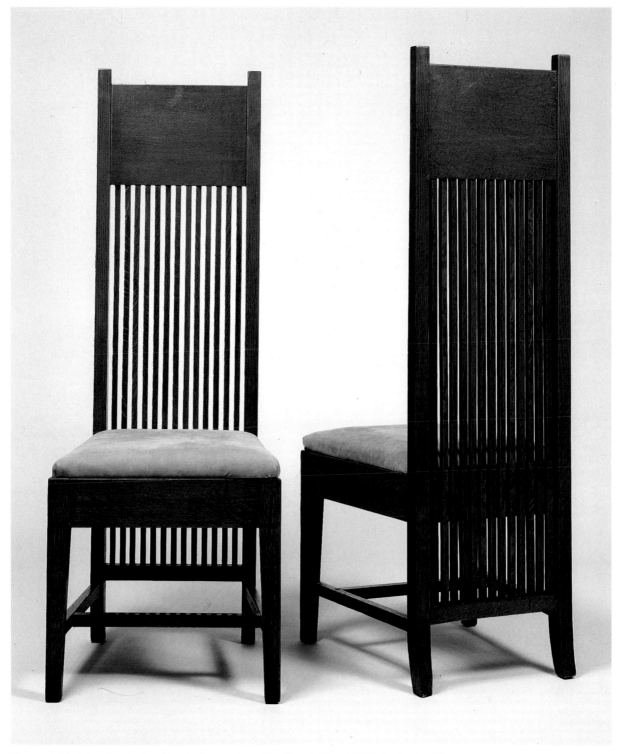

Two oak high-back spindle side chairs, designed by Frank Lloyd Wright for the Warren
Hickox House, Illinois, *circa* 1900
New York $165,000 (£92,697). 20.XI.87

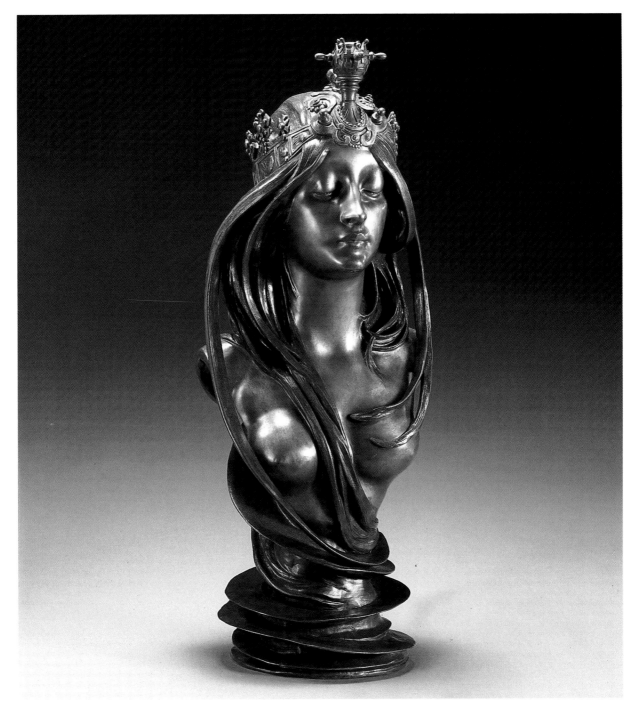

A gilt and patinated bronze bust entitled *La Nature* by Alphonse Mucha, signed, stamped
with founder's mark *Pinedo Paris* and *Bronze garanti au titre Paris*, 1900, height 26⅜in (67cm)
London £115,500($218,295). 17.VI.88

A Lalique *cire perdue* figure of a woman, signed, *circa* 1901–5, height 17⅜in (44.2cm)
New York $148,500 (£83,427). 21.XI.87

A 'red blue' chair, designed by Gerrit Thomas Rietveld, 1918, executed by the artist
circa 1920–21, height 34in (86.5cm)
Amsterdam Dfl 103,500 (£30,896:$52,010). 19.X.87

An aluminium chaise longue, designed by Marcel Breuer, 1932, length 52⅜in (133cm)
London £23,100 ($42,504). 4.III.88

The design and manufacture of this piece coincides with the period when Breuer was
working closely with the Wohnbedorf stores in Switzerland. The store, founded by members
of the Swiss Werkbund, was one of the first home furnishing stores to devote itself to
promoting architect-designed furniture and accessories. Breuer's revolutionary aluminium
furniture was available from Wohnbedorf by early 1933.

American decorative arts

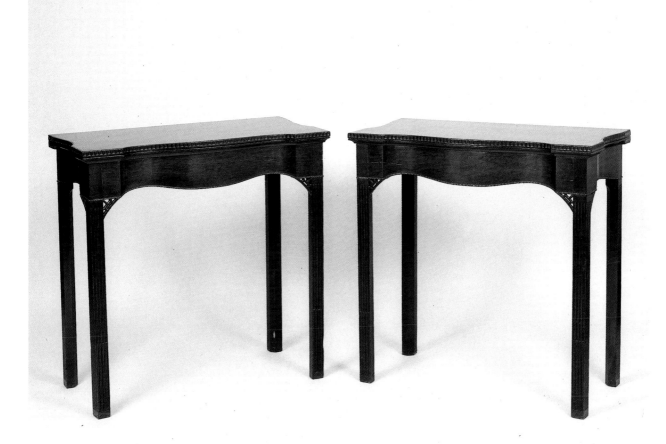

A pair of Chippendale mahogany card tables, Goddard-Townsend School, Newport, Rhode
Island, *circa* 1775, height 29½in (74.9cm)
New York $363,000 (£205,085). 30.I.88
From the collection of Doris and Richard M. Seidlitz

Opposite
The Hollingsworth family Chippendale walnut side chair attributed to Thomas Affleck,
Philadelphia, *circa* 1770
New York $148,500 (£88,393). 24.X.87

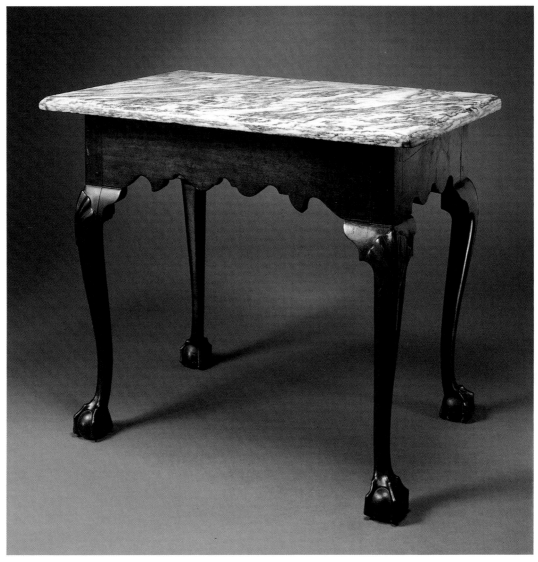

The Franklin family Chippendale walnut and marble-top mixing table, Philadelphia,
circa 1765, height 28in (71.1cm)
New York $418,000 (£234,832). 30.I.88

According to tradition this table was commissioned by Benjamin Franklin for his daughter
Sarah.

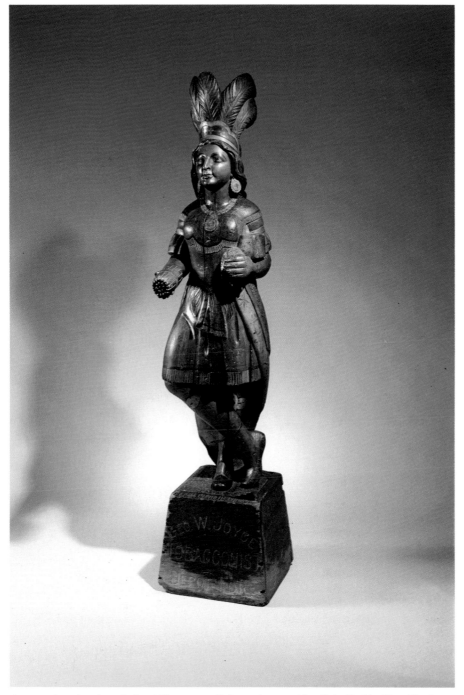

A carved and painted pine 'Cigarstore Princess' carved by S.A. Robb, New York,
circa 1888, height 71in (180.3cm)
New York $74,250 (£42,188). 23.VI.88
From the collection of Howard and Catherine Feldman

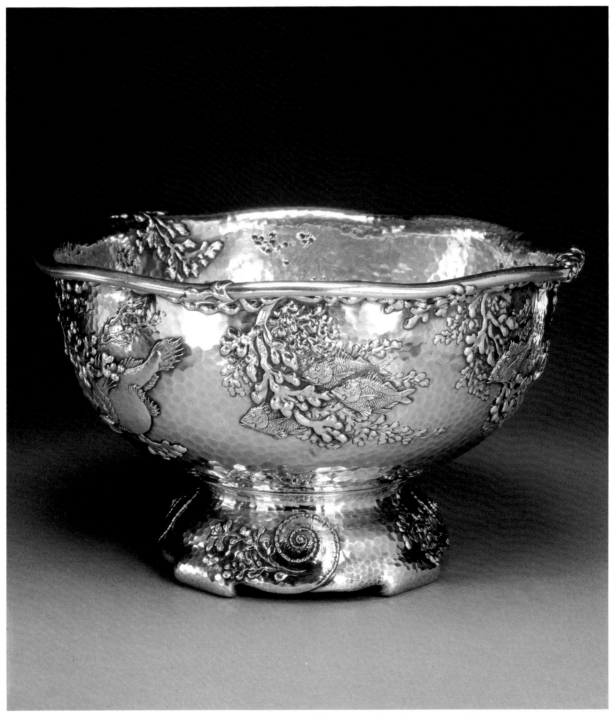

A parcel-gilt 'Japanese Style' punch bowl, maker's mark of Tiffany & Co., New York, 1883, diameter 15½in (39.4cm)
New York $60,500 (£34,375). 23.VI.88

This bowl was awarded by the Seawanhaka Corinthian Yacht Club to the 1883 winner of their annual regatta.

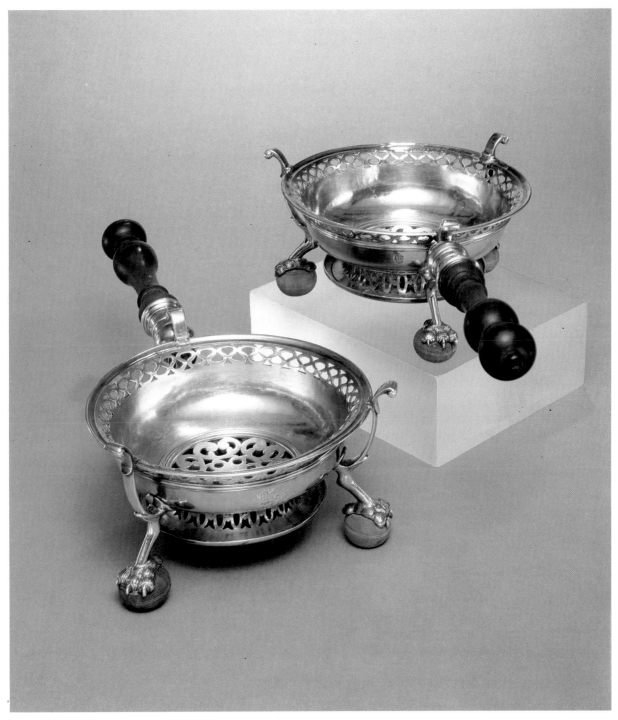

A pair of American silver chafing dishes by John Coney, Boston, *circa* 1710,
diameters 6in (15.2cm)
New York $137,500 (£77,247). 29.I.88

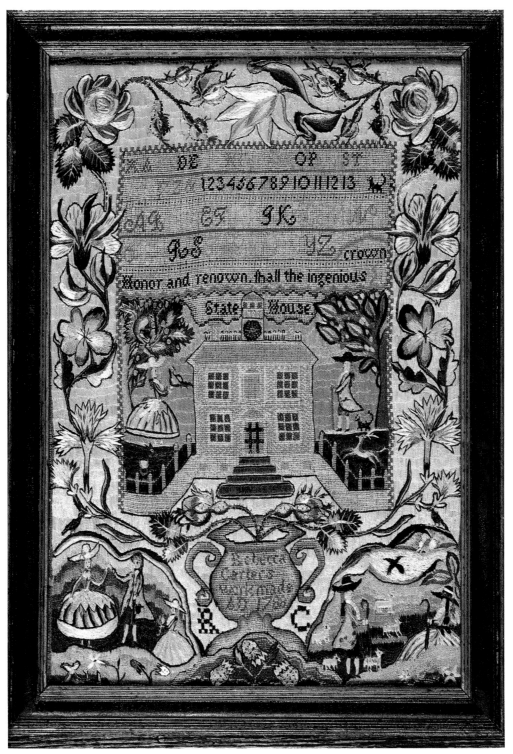

A needlework sampler depicting the State House of Providence, Rhode Island, signed and dated *Rebecca Carter 1788*, 19¼in by 13½in (48.9cm by 34.3cm)
New York $192,500 (£109,375). 23.VI.88

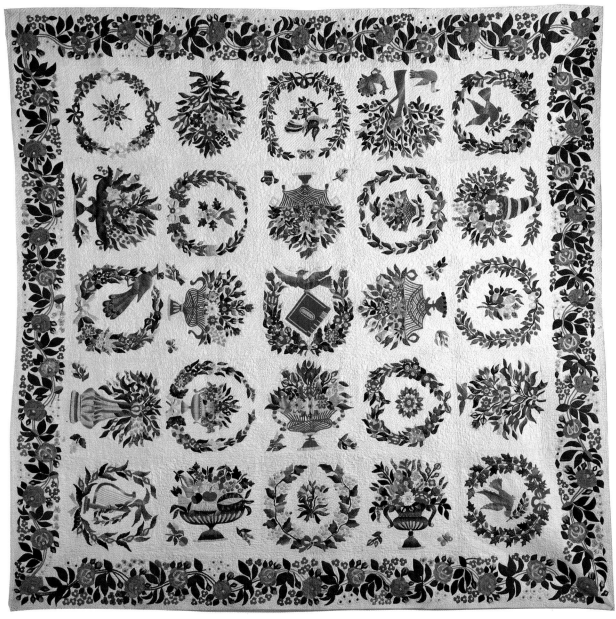

A Baltimore album quilt made for John and Rebecca Chamberlain, probably by Mary
Evans, dated *1848*, 108in by 108in (274.3cm by 274.3cm)
New York $110,000 (£61,798). 30.I.88
From Mary Strickler's Quilt Collection

Joshua Johnson's
Portrait of Emma van Name

The enigmatic portrait by Joshua Johnson, the first black portrait artist in America for whom a significant body of work has been identified, was discovered in Staten Island in the 1950s, and was one of nine paintings by Johnson owned by Edgar William and Bernice Chrysler Garbisch, who assembled one of the earliest and most important collections of American folk art.

Listed in the Baltimore city directories between 1795 and 1824, Johnson was a portrait painter and much of what is known of his life and career is based on traditions handed down through the families of his sitters. One of those associated with the portrait of Sarah Ogden Gustin, Johnson's only signed work, now in the National Gallery of Art in Washington, asserts that he was a valet to a member of the famous Peale family of artists who dominated American painting in Philadelphia and Baltimore at the turn of the nineteenth century. Many of Johnson's earliest commissions came from prominent Baltimore families who had previously patronized the Peales and the influence of Charles Willson Peale and his sons is apparent in these works.

After two decades of research, virtually nothing is known of the child called Emma van Name. Stiles T. Colwill, gallery director of the Maryland Historical Society and co-author of the catalogue *Joshua Johnson: Freeman and Early American Portrait Painter*, has suggested that she may be related to the Van Noemer family of Baltimore. The mystery of the sitter only adds to the charm of the image. Elaborately dressed in pink silk and coral jewellery, Emma stares impassively at the viewer. She cannot resist the strawberries beside her, holding one plump berry to her mouth with her right hand and reaching for more with her left. Although the symbolism of a goblet with strawberries is unclear, this fruit does appear in numerous other portraits by Johnson. The tempering of formality with whimsy and humour pervades Johnson's work but is never more successfully executed than in his portrait of Emma van Name.

Opposite
Joshua Johnson
LITTLE GIRL IN PINK WITH GOBLET FILLED WITH STRAWBERRIES: A PORTRAIT OF EMMA VAN NAME
Circa 1805, 29in by 23in (73.7cm by 58.4cm)
New York $660,000 (£370,787). 30.I.88

This painting, from the collection of the Whitney Museum of American Art, was sold to establish a purchase fund for twentieth-century American art in the name of the donors, Edgar William and Bernice Chrysler Garbisch.

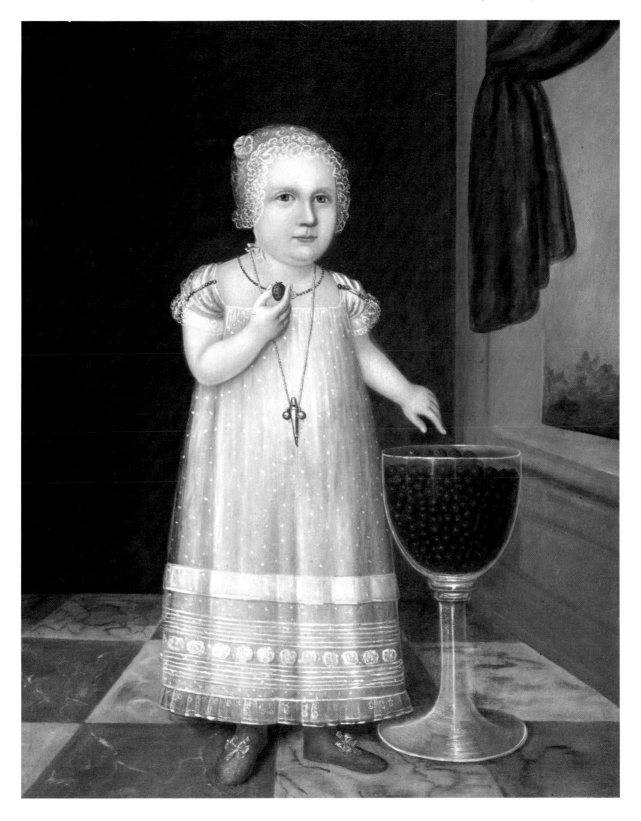

A double portrait by John Brewster, Jr.

Joyce Hill

Acknowledged as one of the most gifted of the early New England itinerant painters, John Brewster, Jr. was born in 1766 in Hampton, Connecticut, the son of a highly respected physician. He was born a deaf mute but was educated to overcome his handicap. Indeed his circumstance seemed to heighten his perceptions, enabling him to portray his portrait subjects with unusual honesty and strength.

As an aspiring young painter, Brewster was fortunate to live initially in Connecticut where painting styles, though diverse, worked to create an unusually interesting and vital art. Professional artists such as Ralph Earl (1751–1801) and John Trumbull (1756–1843) worked intermittently in the region as did such self-taught painters as Joseph Steward (1735–1822). In 1791 Brewster received instruction in painting from Steward, minister as well as portrait painter, then living in Hampton. Steward was much influenced by Ralph Earl, who had studied in England with Benjamin West. Although Brewster developed a linear style quite his own, his early full-length paintings definitely reflect the influence of Steward.

In November 1798 Brewster was in Danbury, Connecticut where he received a commission for portraits of the Comfort Starr Mygatt family. Until 1987, *Comfort Starr Mygatt and his Daughter Lucy Mygatt (Adams)* (Fig.1) was known only through entries in Mygatt's account book (Fig.2). These suggest several other portraits were executed, including *Mrs Mygatt (Lucy Knapp) and son George*, now located at the Palmer Art Museum, Pennsylvania State College.

Comfort Starr Mygatt of Danbury, Connecticut was descended from Joseph Mygatt, who arrived in Boston from England in 1633, aboard the ship *Griffin*. Comfort's father was a distinguished patriot of the Revolutionary War, a well respected merchant and Danbury's representative to the General Assembly of the State of Connecticut. Comfort was born on 23rd August, 1763, and was approaching 36 years of age when the portrait was commissioned.

Fig.1 *Opposite*
John Brewster, Jr.
COMFORT STARR MYGATT AND HIS DAUGHTER LUCY MYGATT (ADAMS)
Signed and dated *March 1st 1799*, inscribed on the reverse *Comfort Starr Mygatt, B.Aug.23, 1763, D.Oct.17, 1823, Lucy Mygatt Adams, July 23, 1794– Mch 8, 1885,* 54in by 39¼in (137.2cm by 99.7cm)
New York $852,500 (£478,933). 30.I.88

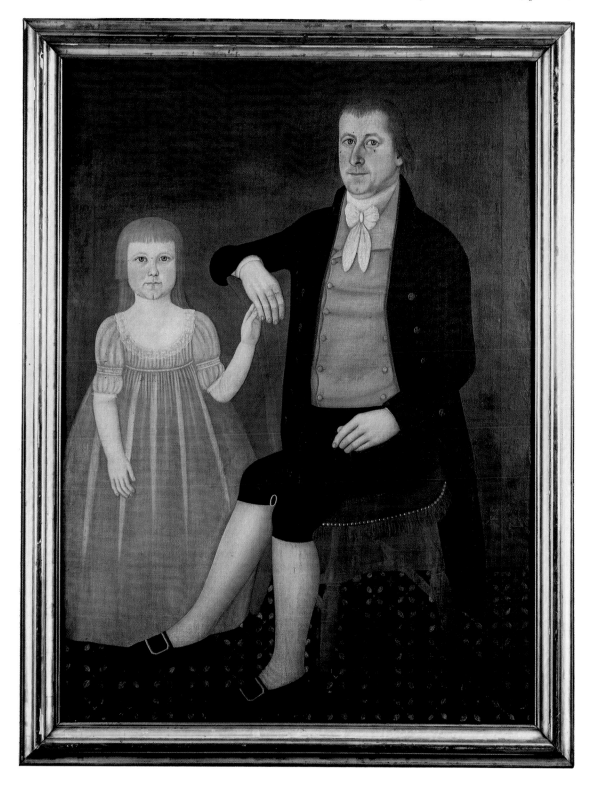

Fig.2
Comfort Starr Mygatt's account book (Reproduced courtesy of Danbury Scott-Fanton
Museum and Historical Society)

The portrait has remained in the family since it was painted in 1799 and is an
exciting rediscovery. One of the few double portraits by Brewster, it is perhaps the
earliest that is both signed and dated, inscribed: 'John Brewster, pinx, March 1st
1799' in red in the lower right-hand corner. The portrait is distinguished by its
clarity and quiet directness which reveal a sensitive tender affection between father
and daughter. Consistent with earlier works by Brewster, the Mygatt portrait is a
large work on a relatively coarse linen. Paint traces on the tacking edge of the
support reveal a grey ground, used frequently by the artist. The seaming of linen,
however, is vertical rather than the horizontal joining more typical of Brewster. In
the several male portraits known to have been completed by the artist prior to 1799,
the figures were posed in seated position, the faces in three-quarter view. Comfort
Starr Mygatt is presented in a characteristic pose, although there is considerably
more modelling in the face and hands than in earlier paintings. However, that linear
quality, ever present in Brewster's work, dominates the Mygatt portrait.

Lucy, almost five years old, is presented in full-frontal pose typical of several
portraits Brewster painted in and around 1800. The symmetrical presentation of the

face suggests that perhaps the painter was familiar with formulations from drawing books. The portrait relates strongly to that of Brewster's half-sister Sophia (born 1795). Sophia posed with a small bird and a rose.

Her death on 24th April 1800 helps to approximate the date of her portrait. The portrait of another half-sister, Betsy Avery (born 1798), probably painted slightly later, is further proof of Brewster's ability to capture the essence of children and childhood with sensitivity, simplicity, forthrightness and occasional whimsy. Betsy is portrayed carrying a basket of berries with a scrawny kitten at her side.

In the autumn of 1801, Brewster worked in Newburyport, Massachusetts, where he stayed with the Prince family and produced some of his most successful and best known portraits. Once again, Brewster depicted father and child, in this case James Prince with son William Henry. Although this painting is more complex spatially with its fully developed interior setting, the portrait subjects are presented as in the Mygatt portrait – father seated with standing child. Once again Brewster used a large canvas ($60\frac{3}{8}$in by $60\frac{1}{4}$in), somewhat larger in size than the Mygatt portrait. The artist also painted other members of the Prince family – Sarah Prince at the pianoforte, and brothers James and Benjamin. In the advertisements in the *Newburyport Herald* he stresses his location 'at Mr James Prince's where a Specimen of his paintings may be seen'.

Brewster seems to have worked largely in Maine and Massachusetts during the next years of his professional life. No longer influenced by the commanding, nearly life-size full-length portraits prevalent in Connecticut in the late seventeenth century, Brewster moved to bust and half-length portraits. During these years, he also began signing some of his portraits in pencil on the stretchers.

In 1806 an intriguing advertisement appeared in the *Portland Gazette* in the issues for 4th, 11th and 18th August. Under the heading 'Likeness', Brewster and Wheeler informed the inhabitants of Portland and its vicinity that they had a newly constructed 'profile machine' which was capable of taking the most accurate likenesses of any that had been in the United States. They also offered likenesses done on canvas and ivory. Profiles were offered 'elegantly engraved in gold and cut on paper.' Whether or not the profile machine was the same or similar to that advertised by Joseph Steward in the *Connecticut Courant* in 1805 remains conjecture. What is known through advertisements is that the Brewster-Wheeler collaboration was short-lived.

In 1817 at the age of 51, John Brewster, Jr. became a student in the first class to enter the newly founded Connecticut Asylum for the Education and Instruction of Deaf and Dumb persons, in Hartford. Understandably, his painting seems to have been put aside temporarily. His next known portraits are dated 1820 and were completed upon his return to Maine.

Brewster's portraiture became increasingly somber, the quiet palette seldom punctuated with the vibrant 'Brewster red' or rich greens used so effectively by the artist in his early paintings. Shadowing is heavier and darker in his later portraits, lacking the more delicate modelling of early years. In 1832, Brewster painted portrait subjects in Denmark, Maine – these are the last recorded.

John Brewster, Jr. lived until he was 88 years old. His silent world spoke through his perceptive depiction of people; sensitive, quiet and honest portraits were his remarkable legacy.

Musical instruments

Above
The 'Cholmondeley', a violoncello by Antonio Stradivari, Cremona, labelled *Antonius Stradiuarius Cremonensis Faciebat Anno 1698*, length of back 29⅛in (74cm)
London £682,000 ($1,288,980). 22.VI.88

The 'Marie Hall', a violin by Antonio Stradivari, Cremona,
labelled *Antonio Stradivarius Cremonensis Faciebat Anno 1709*,
length of back 14⅛in (35.9cm)
London £473,000 ($936,540). 31.III.88

The 'Innes, Loder', a violin by Antonio Stradivari,
Cremona, labelled *Antonius Stradivarius Cremonensis Faciebat
Anno 1729 AS*, length of back 14in (35.7cm)
London £214,500 ($404,405). 22.VI.88

Opposite
A one-keyed rosewood flute by Thomas Stanesby, Jr., London, second quarter eighteenth
century, stamped *Stanesby Iunior*, sounding length 21¾in (55.3cm)
London £17,600 ($33,088). 13.XI.87

The Charles Draeger Collection of antique arms

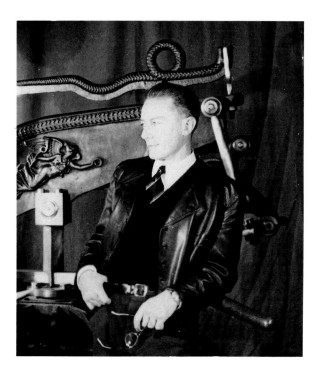

Charles Draeger was born in Paris on 12th November 1899 into a family of well-established art printers, Draeger Frères, and was expected to assist his elders with the business. However, the reminiscences of his grandparents – tales of wars and adventures in the early years of the century – aroused his interest in military history. In 1918 Charles Draeger joined the army and after the war served in Morocco until 1922. During the peace-keeping operations in the Atlas Mountains he studied 'l'art militaire' and the history of weapons, which became his lasting passion.

On returning to France he rejoined the family business. Now able to collect in earnest Draeger bought with care, taste and knowledge; he was also competitive, securing many pieces greatly desired by other serious and wealthy collectors. These firearms from one of the last great collections, selected for their royal provenance, history or superb craftsmanship, represent the finest works of gunmakers from all over Europe and America, as well as North Africa and the Middle East.

The pistols, the most important part of the collection, exemplify mechanisms and decoration from the end of the sixteenth century onwards. The wheel-locks comprise a group of contrasting styles: the heavy ball-butted Saxon 'puffer' (Fig.1) and the elegant pair by the Italian master Giovanni Francino, inlaid with pierced iron panels (Fig.2).

Fig.1
A Saxon wheel-lock 'puffer' pistol, *circa* 1580
Monte Carlo FF210,900 (£21,090:$37,661). 7.XII.89
From the collection of the late Charles Draeger

Fig.2
A pair of Brescian wheel-lock belt pistols, the breeches inscribed *Gio. Batt. Francino, circa* 1640
Monte Carlo FF366,300 (£36,630:$65,411). 7.XII.87
From the collection of the late Charles Draeger

Fig.3
A wheel-lock gun with gilt barrel and mounts, chiselled overall in the manner of the Sadeler
family at the Munich Court, early seventeenth century
Monte Carlo FF555,000 (£55,500:$99,107). 7.XII.87
From the collection of the late Charles Draeger

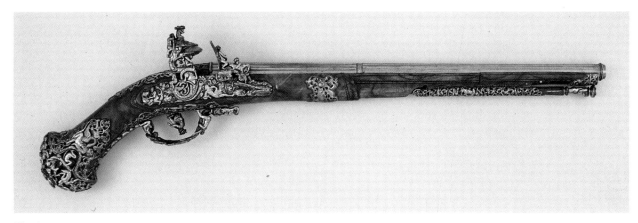

Fig.4
A Brescian flintlock pistol, the breech inscribed *LAZARINO COMINAZZO*, the lock signed
Gio. Batt. Pelegrino deconzi Bresani, circa 1660
Monte Carlo FF466,200 (£46,620:$83,250). 7.XII.87
From the collection of the late Charles Draeger

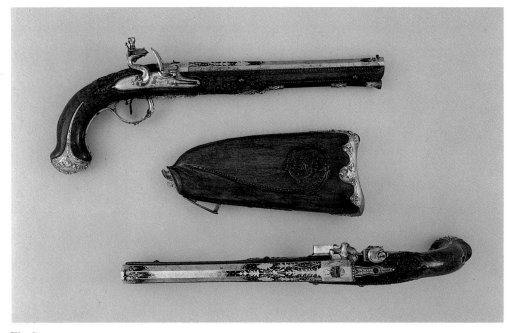

Fig.5
A pair of French silver-mounted flintlock rifled sporting pistols with a shifting butt, the breeches inscribed *SIMON A PARIS, circa* 1800
Monte Carlo FF444,000 (£44,400:$79,286). 7.XII.87
From the collection of the late Charles Draeger

The most striking later arms include the seventeenth-century Brescian flintlock pistols with barrels by Lazarino Cominazzo. This remarkable regional style is best illustrated by the profusely chiselled flintlock by Giovanni Battista Pelegrino (Fig.4). Among the eighteenth-century flintlocks, one must mention a pair of pistols bearing the signature of Charles Simon of Paris, who held appointments to Louis XVI and the Comte d'Artois (Fig.5). From across the channel a pair of double-barrelled flintlocks by Ezekiel Baker of London, bearing the Prince of Wales's feathers in gold (Fig.6), provide an interesting contrast of style and technical excellence.

As nineteenth-century gunmakers concentrated on perfecting the new percussion-lock and breech-mechanisms, there was less demand for ornamentation. However, the Boutet set of percussion duelling and pocket pistols shows finely engraved lockwork depicting game and monsters (Fig.7). Nicolas Noël Boutet was Directeur Artiste of the Versailles State Armoury and produced 'armes de luxe' for the Emperor Napoleon and his Court.

Among the arms with royal provenance, the prime example must be the magnificent wheel-lock gun believed to have been in the cabinet d'armes of Louis XIII (Fig.3). Listed and described in the 1729 'Inventaire Général de Meubles de la Couronne' under no.70, it was probably in the royal collection until the storming of the Bastille in July 1789.

The sale, which comprised over 300 pieces, provided an opportunity to view a remarkable collection previously known to only a few contemporary collectors.

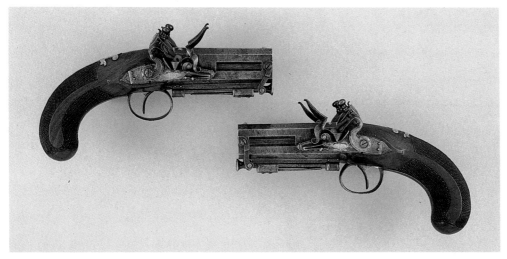

Fig.6
A pair of English double-barrelled flintlock travelling pistols, the top flats and locks inscribed
E. BAKER, made for George IV when Prince Regent, *circa* 1813
Monte Carlo FF199,800 (£19,980:$35,679). 7.XII.87
From the collection of the late Charles Draeger

Now in the Royal Armouries, HM Tower of London.

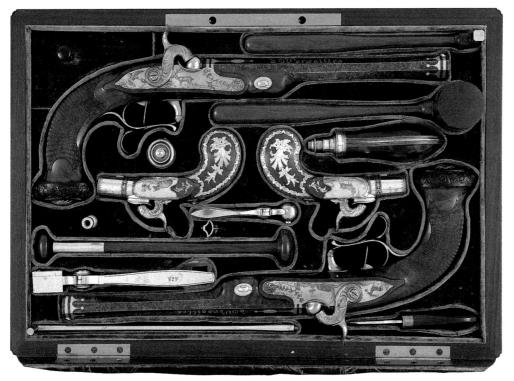

Fig.7
A cased set of French percussion pistols, the duelling pistols inscribed *Boutet et Fils à Versailles*
and numbered *438*, the pocket pistols inscribed *MANUF* re *A VERSAILLES*, with lock-cases
inscribed *BOUTET DIRECTEUR ARTISTE*, in a contemporary rosewood case fitted with
all original accessories, early nineteenth century
Monte Carlo FF688,200 (£68,820:$122,893). 7.XII.87
From the collection of the late Charles Draeger

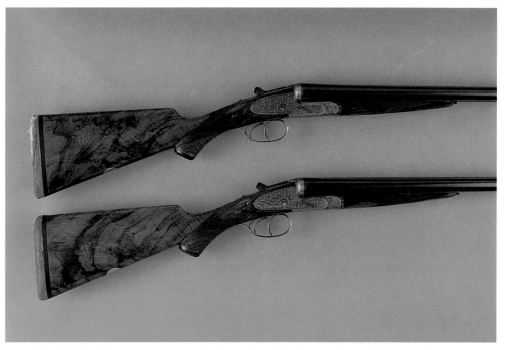

A pair of 12-bore sporting guns by E.J. Churchill, made for Edward, Prince of Wales, 1931
Gleneagles £42,900 ($74,646). 31.VIII.87

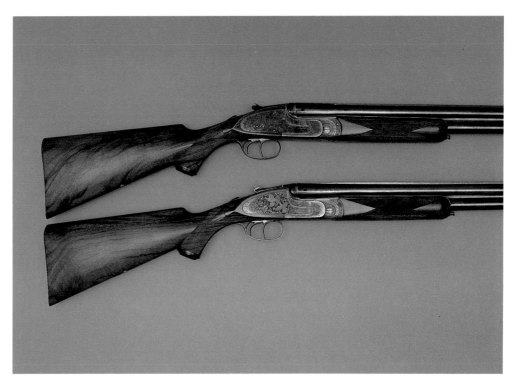

A pair of 12-bore over/under sidelock ejector guns by J. Purdey & Sons, engraved by
Ken Hunt
London £47,300 ($92,235). 17.XII.87

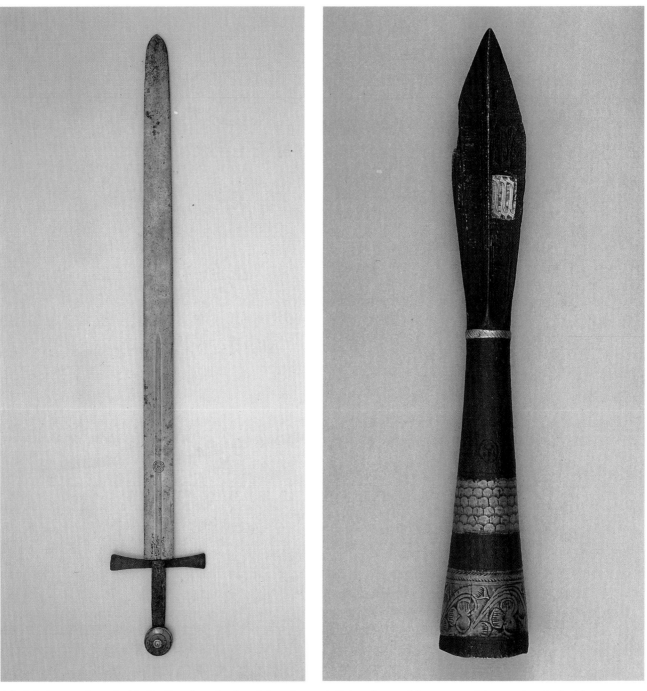

A knightly sword, probably Italian, inscribed and dated 1367 in *naskhi* script, length 42¾in (108.6cm)
London £33,000 ($65,010). 26.IV.88

A Bohemian gothic ceremonial arrowhead, the blade engraved with panels of medieval Czechoslovakian script, the brass collar engraved with the mark of St Irene Arsenal, Constantinople, mid fifteenth century, length 10⅞in (27.5cm)
London £9,350 ($16,737). 28.X.87

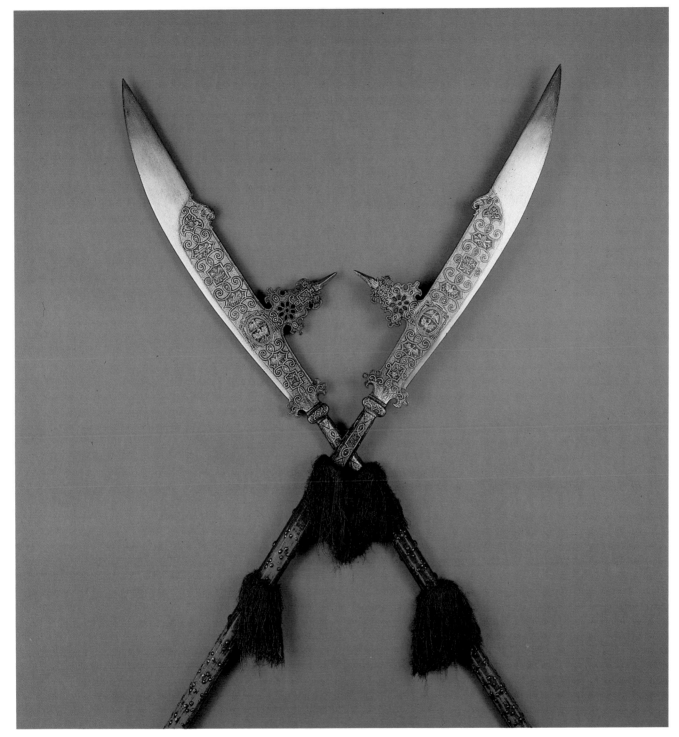

A pair of Italian processional glaives of the Palace Guard of Cardinal Scipione Borghese-Caffarelli, *circa* 1600–10, length of head 35¼in (89.5cm)
New York $35,200 (£18,925). 20.V.88

Coins and medals

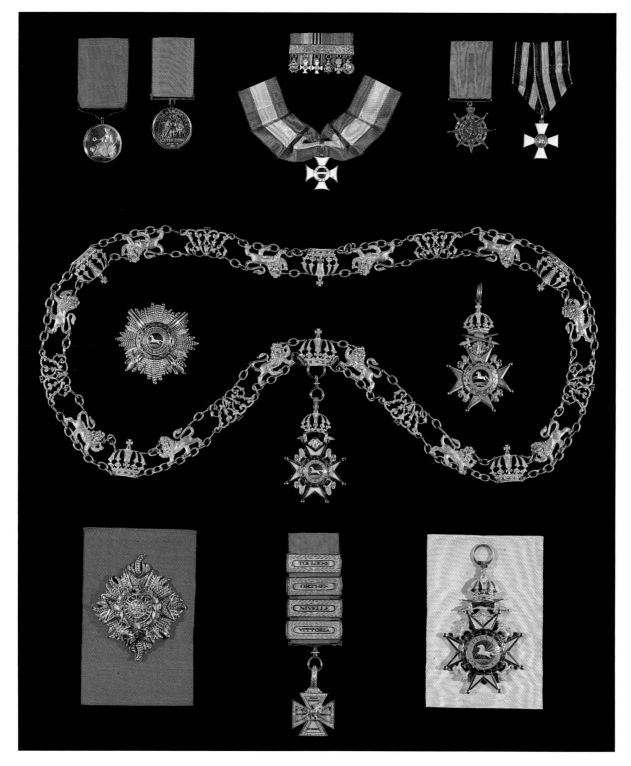

Sarawak, specimen banknote for 100 dollars, 1929, from a full set of 6 notes prepared by Bradbury, Wilkinson and Co.
London £9,350 ($16,176). 1.X.87 (*Illustration reduced*)

Ancient Egypt, gold octodrachm depicting Arsinoe II, *circa* 180–145 BC
London £4,400 ($8,580). 24.III.88

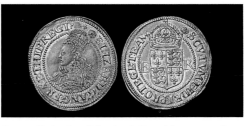

Great Britain, Elizabeth I, gold crown of 5 shillings, struck *circa* 1592
London £1,980 ($3,861). 25.III.88

Hong Kong & Shanghai Banking Corporation, specimen banknote for 100 ticals, 1891, for issue in Bangkok
London £3,410 ($5,899). 1.X.87 (*Illustration reduced*)

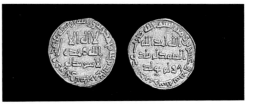

Islamic, Umayyad dinar of Marwan II, AH 127 (AD 744)
London £16,500 ($32,175). 24.III.88

Opposite
A fine Peninsular War group of orders and medals awarded to General Sir Andrew Barnard, GCB, GCH (1773–1855), Colonel of the Rifle Brigade
London £39,600 ($72,072). 30.VI.88 (*Illustration reduced*)

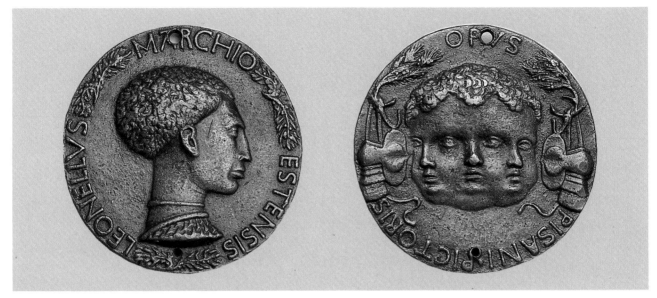

Italian Renaissance, Antonio Pisano, called Pisanello, signed bronze portrait medal of
Leonello d'Este, Marquess of Ferrara (1441–50), from a private collection of Renaissance
coins and medals formed in the 1920s and 1930s
London £7,700 ($15,169). 23.V.88

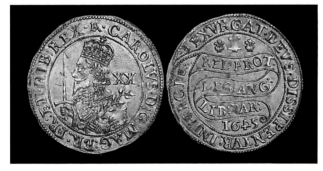

Great Britain, Charles I, gold unite of 20 shillings,
1645, struck at the Royalist stronghold of Bristol during
the Civil War. From the Horace Hird Collection and
formerly *ex* Murdoch Collection (Sotheby's, 1903, £21)
London £16,500 ($32,175). 25.III.88

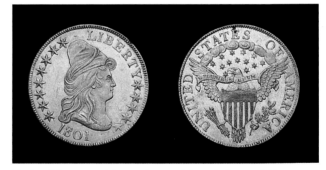

United States of America, gold 10 dollars, 1801
London £5,500 ($10,725). 25.III.88

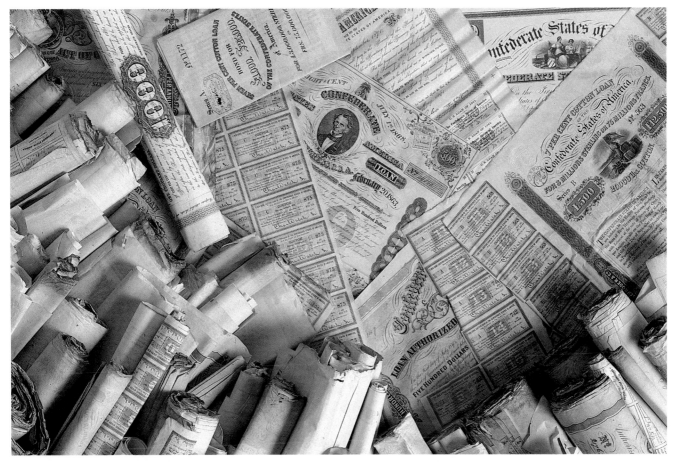

Confederate States of America, a few examples from a vast archive of over 75,000 bearer
bonds sold to European investors supporting the Southern cause during the American Civil
War (1861–65). Following the collapse of the Confederacy, the bonds became worthless in
fiscal terms and were subsequently stored in London for over a century. Including numerous
different types and varieties and mostly in good condition, this historically interesting
portfolio was offered in an unusual single-lot sale
London £352,000 ($661,760). 24.XI.87

Postage stamps

Bechuanaland, 1932 $\frac{1}{2}d$. green, unused block of four imperforate between vertically; offered together with a damaged pair and comprising the only known examples of this variety London £8,800 ($16,544). 12.XI.87

Rhodesia, 1910–13 7s.6d. deep rose-red and grey-blue, unused marginal block of four London £5,390 ($9,486). 23.X.87

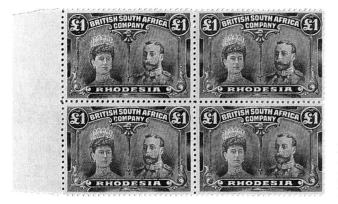

Rhodesia, 1910–13 £1 rose-scarlet and bluish-black, unused marginal block of four London £6,325 ($11,132). 23.X.87 From the collection of Robert M. Gibbs

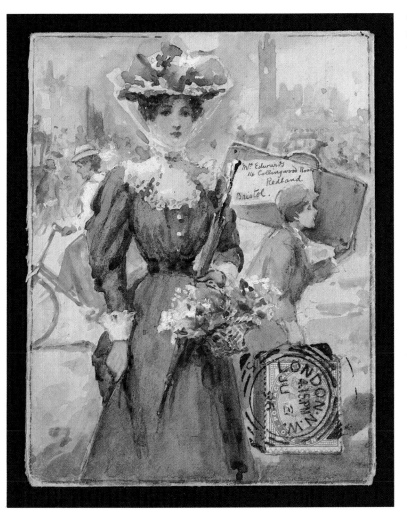

Great Britain, 1896 watercolour envelope
sent by George Henry Edwards, the Bristol
watercolourist, to Mrs Edwards
London £2,970 ($5,910). 9.V.88

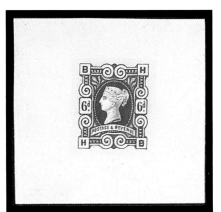

Great Britain, 1884 6*d.* Artist's Essay
submitted to the Stamp Committee
London £1,540 ($2,895). 24.XI.87
From the collection of
Christopher Beresford

Right
Greece, 1862–67 Second Athens Printing
10 lepta yellowish-orange on bluish,
unused block of four
London £2,750 ($5,170). 24.XI.87

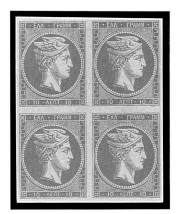

Collectors' sales

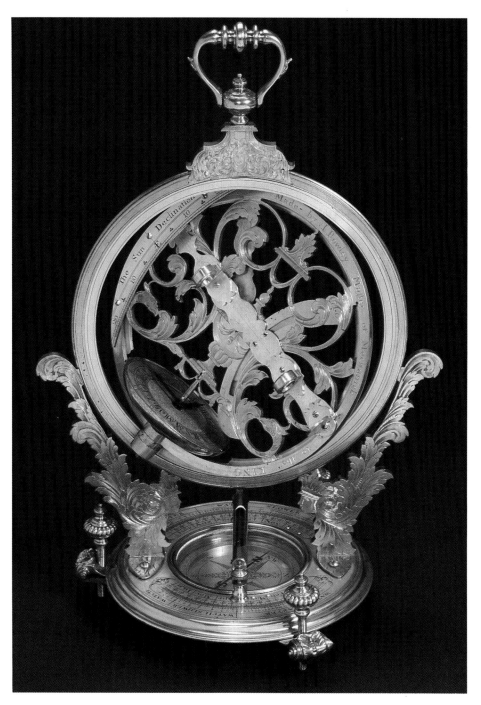

An English silver and gilt-brass mechanical universal equinoctial ring dial by John Rowley, signed and inscribed *Made by I Rowley Mafter of Mechanick to the King, circa* 1715, height 16½in (41.9cm) London £68,200 ($126,170). 16.XI.87

This instrument is similar to the one Rowley designed for Peter the Great, as instructed by George I in 1715.

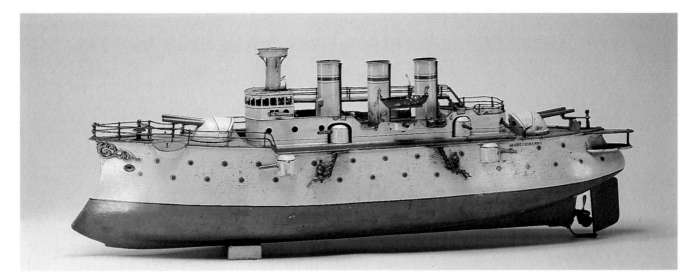

A German painted tin clockwork battleship, *Jaureguiberry* by Bing, *circa* 1902, length 32in (81.3cm)
New York $12,100 (£6,576). 17.XII.87

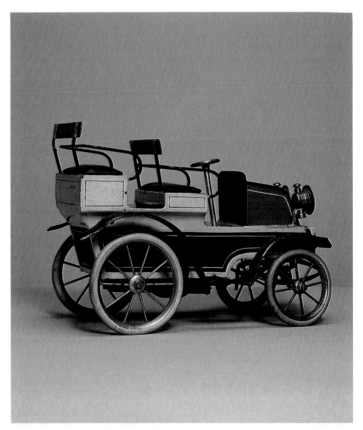

A German tinplate brake by Bing, *circa* 1902, length 10¼in (26cm)
London £23,100 ($39,963). 29.IX.87

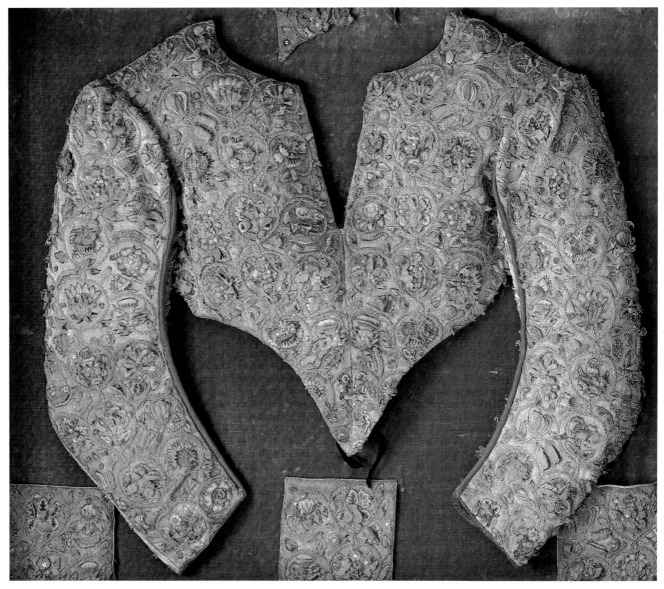

A lady's embroidered stumpwork bodice, English, *circa* 1600–20
London £38,500 ($66,605). 29.IX.87
From the collection of the Viscount Hereford

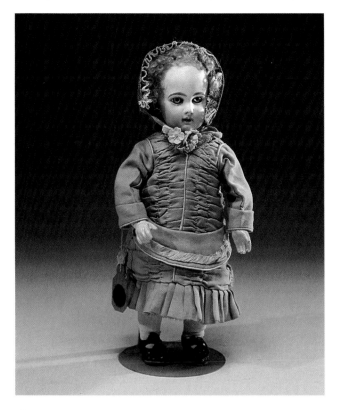

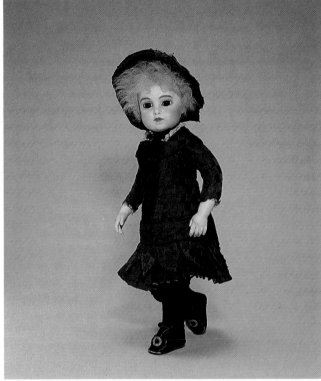

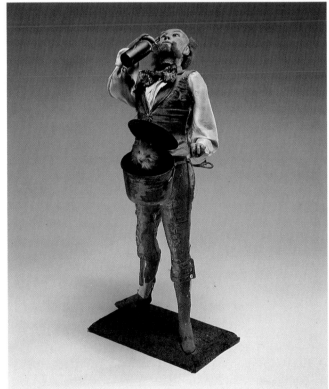

Above
A French bisque-head doll by Emile Jumeau, the head
incised *Depose/ /E 4J*, *circa* 1885, height 12in (30.5cm)
New York $4,125 (£2,317). 17.VI.88

Above, right
A French 'Circle and Dot' doll by Bru, incised with a
circle and dot on the head and *5* on the shoulder,
circa 1875, height 17in (43.2cm)
London £14,850 ($29,255). 19.V.88

Right
A French musical automaton of a cook by Gustave Vichy,
late nineteenth century, height 28in (71.1cm)
New York $14,850 (£8,071). 17.XII.87

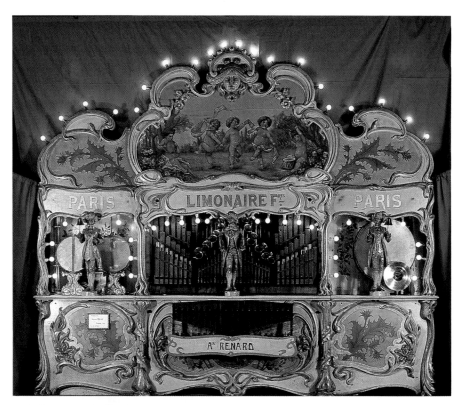

Left
A French concert organ made
specifically for the Paris
Universal Exhibition in 1900 by
Limonaire Frères,
height 12ft 5½in (380cm)
London £132,000 ($260,040).
19.V.88

Left
A Yamaha RGX603S electric
guitar belonging to U2,
autographed by Bono,
Larry Mullen Jr., Adam Clayton
and Edge
New York $7,700 (£4,326).
18.VI.88

Right
A Peter Cook customised fender
electric bass guitar belonging to
John Entwistle of The Who,
length 56¼in (142.9cm)
London £16,500 ($32,670).
7.IV.88

A Walt Disney celluloid from *Lady and the Tramp*, 1955, 12½in by 36in
(31.8cm by 91.4cm)
New York $16,500 (£9,270). 17.VI.87

A set of nine German rabbit skittles by Steiff, *circa* 1913, height 8¼in (21cm),
height of king 10¼in (26cm)
London £4,180 ($7,775). 11.II.88

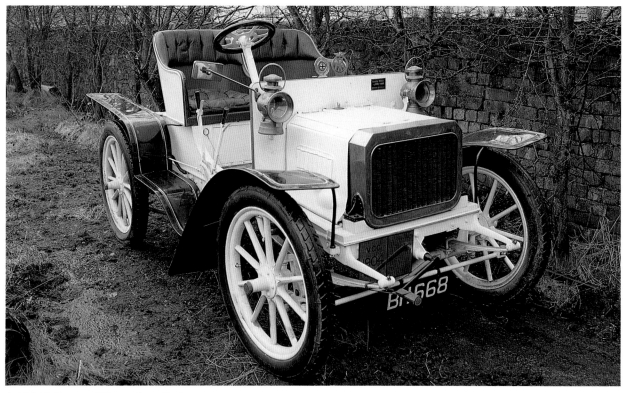

A 1904 Minerva 10hp twin cylinder two-seater
London (Honourable Artillery Company) £36,300 ($71,511). 20.VI.88

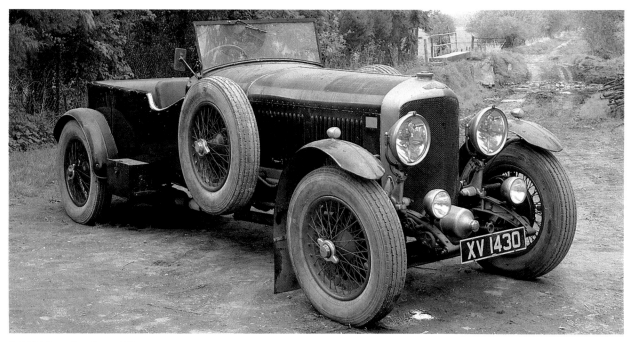

A 1928 Bentley Speed Six tourer
London (Honourable Artillery Company) £261,800 ($515,746). 20.VI.88

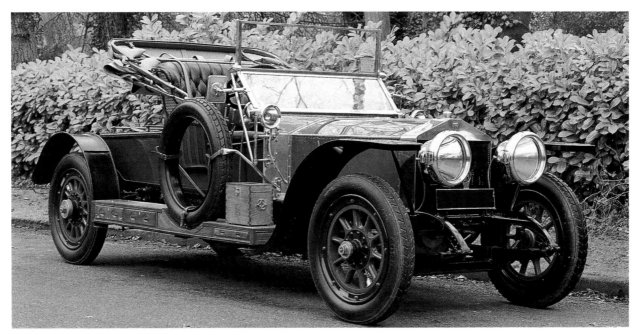

A 1912 Rolls-Royce 40/50hp Silver Ghost Replica of the two-seater 'balloon car' in the style
of Barker
Geneva SF272,800 (£108,685:$197,681). 7.III.88
From the collection of Malcolm Forbes

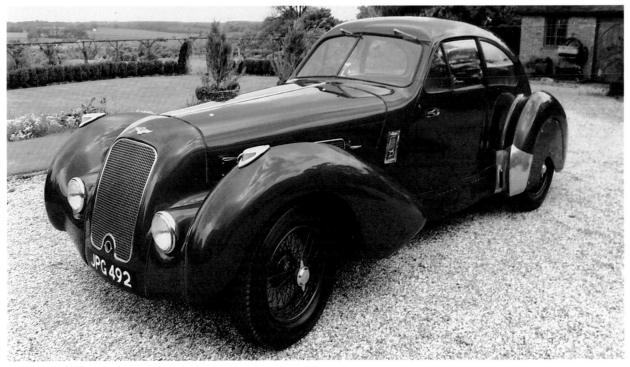

A 1939 Lagonda V12 4½ litre Airline Coupé, with coachwork by Lancefield
London (Honourable Artillery Company) £159,500 ($306,240). 30.XI.87

Garden statuary

Left
A white marble group entitled *A Wood Nymph* by
Charles Birch, the base signed, titled, inscribed *Executed
for the Art Union of London* and dated *Dec. 1, 1865*,
height 60¼in (153cm)
Billingshurst £37,400 ($72,556). 1.VI.88

Below
A Coade & Sealy fountain, stamped *Coade & Se . . .
Lambeth 1805*, height 53in (135cm)
Billingshurst £18,700 ($36,278). 1.VI.88

Right
One of a pair of cast iron lidded urns, late nineteenth century, height 48in (122cm)
Billingshurst £8,580 ($16,645). 31.V.88

Below
One of a pair of bronze urns, French, *circa* 1870, height 33⅛in (84cm)
Billingshurst £28,600 ($55,484). 31.V.88

Wine

Above
A Dutch gold folding-bow corkscrew,
circa 1880, height 2¼in (5.6cm)
London £1,320 ($2,627). 27.IV.88

Right
A japanned Thomason 1802 patent-type
corkscrew with turned bone handle
London £2,860 ($5,463). 9.XII.87

With what looked like a continuing slow slide in prices since May 1985 there was a certain amount of apprehension as to what the new season would bring. To many people's relief and surprise the first sale in September 1987 brought a series of good results and the market remained firm through to the end of the year.

1988 started off rather slowly but momentum increased bringing better than expected results even in the final sale in July. The underlying trend appears to be continued demand for nearly all types of fine wines with sufficient bottle age but a much more unpredictable and erratic price level for younger clarets such as the 1982 and 1983 vintages. Surprisingly the demand and consequent price level of vintage port has been virtually static all season although a price boom is anticipated shortly.

The increasing surplus of top quality young claret stocks, after an unprecedented run of excellent vintages, has been slowed down with the weak and in modern terms substandard 1987 vintage. If 1988 too proves to be below par in both quality and quantity the market could come back into balance. In the short term, however, downward pressure on prices of young claret would seem to be the order of the day.

Wines and spirits of the highest quality or rarity continued to hold the limelight with the usual favourites such as Château d'Yquem regularly selling at the best prices. An important and almost certainly unique collection of vintages of Château

Above, left
Château Mouton Rothschild 1964 CB (one jeroboam), the label by Henry Moore
London £572 ($1,138). 27.IV.88

Right
Three bottles from a collection of Château Latour vintages from 1868 to 1983
London £17,600 ($33,616). 9.XII.87

Latour from 1887 to 1983 with only six vintages missing and supplemented by nine older years fetched an impressive £17,600 in December 1987. There was an increasing trend in the price of white Burgundy with Montrachet 1985 from A. Ramonet making £1,320 per case of twelve bottles and six magnums of Montrachet 1983 from the Domaine de la Romanée Conti fetching £2,970.

Eighteenth-century cognac featured strongly with two bottles of 1788 Clos de Griffier, originally from the Café Anglais in Paris, making £1,650 and £2,310 respectively and a 1789 grande fine champagne cognac making £1,650. Another eighteenth-century item, Tokay, known to be pre-1799 and removed recently from the Wilanow Palace in Warsaw made between £715 and £968 a bottle.

A new record was set for a bottle of port when the very rare Quinta do Noval, Nacional 1931 said to be greatest port wine ever made fetched £1,155.

There were some first rate pieces amongst the collector's items with several corkscrews breaking the £1,000 barrier and a good supply of top quality mature Havana cigars, some in rare sizes, fetched excellent prices.

Sotheby's also conducted the 4th annual sale of fine wines in Tokyo in conjunction with Seibu, held the first wine auction ever in Bangkok at the Oriental Hotel as well as the regular sales in Geneva.

Egyptian antiquities from Eton

Dr Stephen Spurr

When William Joseph Myers landed in Alexandria for the first time in November 1882 at the age of 24, he was both unimpressed by the local population lining the quay and ignorant of Egyptian culture and history. Whirling dervishes, quail shooting, cricket and polo were to provide his main entertainment, and carpets in the bazaar his principal acquisitions. To be fair, it was a difficult first year for a young man. He badly injured his leg, and many soldiers were dying from an alarming outbreak of cholera. It was not until 1st February 1885 when he began his first trip up the Nile that his enthusiasm for Ancient Egypt was really fired. By then he had met Emile Brugsch, assistant curator of the Boulaq Museum, who was to become a close friend and adviser to the aspiring collector.

By the time of his last trip to Egypt in 1896, when he explored the Faiyum, Myers was a respected figure with wide acquaintance among contemporary archaeologists and collectors. His is a fascinating story and one which still remains to be told; a story of the voyage of discovery of a humane and generous man, a dilettante in the best sense of the word, who was rich enough to indulge his wide tastes.

A fine selection of some 250 pieces from his collection was displayed in a loan exhibition at Sotheby's from 16th to 27th May 1988, arranged to mark the retirement of T. G. H. James as Keeper of Egyptian Antiquities at the British Museum.

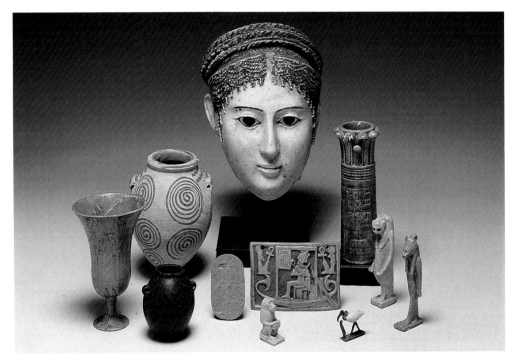

Fig.1
A selection of Egyptian antiquities from the Myers Museum Collection, including,
on the right, the green-glazed steatite cosmetic tube, 1426–1400 BC, height 6¼in (16cm)

Scarcely seen outside Eton since two famous exhibitions at the Burlington Fine
Arts Club in 1895 and in 1921, the exhibits helped renew interest in the Myers
Collection, one of the finest and largest in private hands in Britain, by giving it the
wider recognition it deserves. The collection came to Eton as a generous legacy from
Major Myers who died in action on 30th October 1899 in the Boer War. It
originally numbered some 1,300 items and has been added to over the years by gifts
from other benefactors.

The objects selected for the exhibition spanned the whole course of Ancient
Egyptian history from the Pre-Dynastic period to the Roman conquest and beyond
(3500 BC–AD 500). Craftsmanship was exemplified from the earliest period by a
polished flint knife, its handle covered with a delicate sheath of gold, and from the
second century AD by one of the finest extant 'Faiyum portraits', which originally
would have been placed over the face of a mummy (Fig.2).

It was abundantly clear from the exhibition that Myers had a preference for the
finer details of Ancient Egyptian art, as opposed to monuments and large sculptures.
He had an especial liking for Egyptian glazed work, both steatite and faience. Seven
faience chalices were on display and the one illustrated here (Fig.3), from the
Twenty-first Dynasty (1075–944 BC) is of exquisite craftsmanship and vivid colour.
It is in the form of a half-open lotus flower and is decorated with bands of delicate
relief work. Around the rim, among papyrus reeds, swim ducks; below, abject
prisoners are sacrificed before onlooking deities, while lower down, a pharaoh in

Fig.2
A Faiyum mummy portrait, encaustic on wood, *circa* second century AD,
height 15⅝in (39.5cm)

Fig.3
A faience chalice with relief decoration, Twenty-first Dynasty (1075–944 BC),
height 5¾in (14.6cm)

his two-wheeled chariot surveys the battlefield strewn with dead. There was also an impressive group of faience bowls from the Eighteenth and Nineteenth Dynasties (1540–1190 BC). Steatite pieces were represented by the green-glazed cosmetic tube in the shape of a column with a palm-leaf capital which bears a lengthy inscription vaunting the valour and strength of the Pharaoh Amenhopis II (1426–1400 BC) and depicts some proudly stepping horses from the royal stud (see Fig.1). The immense skill of the early glassworker was evident in a turquoise-blue flask from the Eighteenth Dynasty (1540–1292 BC) with its wavy white and dark-blue line pattern.

In November 1887, just prior to leaving Egypt with his regiment, Myers began a catalogue of his collection with the help of his friend Brugsch. This work continues at Eton where the Provost and Fellows are fully committed to the upkeep of this fine nineteenth-century collection, not only as an inspiration to further generations of Etonians as Myers wished, but also to arouse the interest of the general public. The Sotheby's exhibition has done much to reveal the potential of Major Myers's generous benefaction.

Officers and experts

The Rt.Hon. The Earl of Gowrie
Chairman, Sotheby's UK
John L. Marion
Chairman, Sotheby's North America
Julian Thompson
Chairman, Sotheby's International
Diana D. Brooks
President, Sotheby's North America
Timothy Llewellyn
Managing Director, Sotheby's UK
Simon de Pury
Managing Director, Sotheby's Europe

American decorative arts and furniture
Leslie B. Keno *New York 606 7130*
William W. Stahl, Jnr *606 7110*

American folk art
Nancy Druckman *New York, 606 7225*

American Indian art
Dr Bernard de Grunne *New York, 606 7325*

American paintings, drawings and sculpture
Peter B. Rathbone *New York, 606 7280*

Antiquities and Asian art
Richard M. Keresey
New York, 606 7328
Felicity Nicholson (antiquities)
London, 408 5111
Brendan Lynch (Asian) *408 5112*

Arms and armour
Michael Baldwin *London, 408 5318*
Florian Eitle *New York, 606 7250*

Books and manuscripts
Roy Davids *London, 408 5287*
David N. Redden *New York, 606 7386*
Dominique Laucournet
Paris, 33 (1) 42 66 40 60

British paintings 1500-1850
James Miller *London, 408 5405*
Henry Wemyss (watercolours)
408 5409

British paintings from 1850
Simon Taylor (Victorian)
London, 408 5385
Janet Green (twentieth-century)
408 5387

Ceramics
Peter Arney *London, 408 5134*
Letitia Roberts *New York,*
606 7180

Chinese art
Carol Conover *New York, 606 7332*
Mee Seen Loong
Arnold Chang (paintings) *606 7334*
Julian Thompson *London, 408 5371*
Colin Mackay *408 5145*
Robert Kleiner (Hong Kong sales)
408 5149

Clocks and watches
Tina Millar (watches) *London,*
408 5328
Michael Turner (clocks) *408 5329*
Daryn Schnipper *New York,*
606 7162

Coins and medals
Tom Eden (Ancient and Islamic)
London, 408 5313
James Morton
(English and paper money) *408 5314*
David Erskine-Hill
(medals and decorations) *408 5315*
Mish Tworkowski *New York,*
606 7391

Collectables
Dana Hawkes *New York, 606 7424*
Hilary Kay *London, 408 5205*

Contemporary art
Hugues Joffre *London, 408 5400*
Lucy Mitchell-Innes *New York,*
606 7254

European works of art
Elizabeth Wilson *London,*
408 5321
Florian Eitle *New York,*
606 7250

Furniture
Graham Child *London, 408 5347*
George Read (English)
New York, 606 7577
Thierry Millerand
(French and Continental)
606 7213
Robert C. Woolley *606 7100*
Alexandre Pradère
Paris, 33 (1) 42 66 40 60

Glass and paperweights
Lauren Tarshis *New York,*
606 7180
Perran Wood *London, 408 5135*

Impressionist and modern paintings
David J. Nash *New York,*
606 7351
John L. Tancock *606 7360*
Marc E. Rosen (drawings)
606 7154
Michel Strauss *London, 408 5389*
Julian Barran *Paris,*
33 (1) 42 66 40 60

Islamic art and carpets
Richard M. Keresey (works of art)
New York, 606 7328
William F. Ruprecht (carpets),
606 7380
Professor John Carswell *London,*
408 5153

Japanese art
Peter Bufton *New York,*
606 7338
Neil Davey *London, 408 5141*

Jewellery
David Bennett *London, 408 5306*
John D. Block *New York,*
606 7392
Nicholas Rayner
Geneva, 41 (22) 32 85 85

Judaica
Jay Weinstein *New York,*
606 7387

Latin American paintings
Anne Horton *New York, 606 7290*

Musical instruments
Charles Rudig *New York,*
606 7190
Graham Wells *London, 408 5341*

**Nineteenth-century European
furniture and works of art**
Christopher Payne *London,*
408 5350
Elaine Whitmire *New York,*
606 7285

**Nineteenth-century European
paintings and drawings**
Alexander Apsis *London, 408 5384*
Nancy Harrison *New York,*
606 7140
Pascale Pavageau *Paris,*
33 (1) 42 66 40 60

**Old master paintings and
drawings**
Timothy Llewellyn *London, 408 5373*
Julien Stock *408 5420*
Elizabeth Llewellyn (drawings)
408 5416
George Wachter *New York, 606 7230*
Alexander Nystadt
Amsterdam, 31 (20) 27 56 56
Nancy Ward-Neilson
Milan, 39 (2) 78 39 11
Etienne Breton *Paris,*
33 (1) 42 66 40 60

Oriental manuscripts
Nabil Saidi *London, 408 5332*

Photographs
Philippe Garner *London, 408 5138*
Beth Gates-Warren *New York, 606 7240*

**Portrait miniatures, objects of
vertu, icons and Russian works
of art**
Martyn Saunders-Rawlins (icons)
London, 408 5325
Julia Clarke (vertu) *408 5324*
Haydn Williams (miniatures)
408 5326
Heinrich Graf von Spreti
Munich, 49 (89) 22 23 75
Gerard Hill *New York, 606 7150*

Postage stamps
John Michael *London, 408 5223*

Pre-Columbian art
Stacy Goodman *New York, 606 7330*

Prints
Marc E. Rosen *New York, 606 7117*
Ian Mackenzie *London, 408 5210*

Silver
Kevin L. Tierney *New York, 606 7160*
Peter Waldron (English) *London,*
408 5104
Harold Charteris (Continental)
408 5106
Dr Christoph Graf Douglas
Frankfurt, 49 (69) 74 07 87

Sporting Guns
James Booth *London, 408 5319*

Tribal Art
Dr Bernard de Grunne
New York, 606 7325
Roberto Fainello *London, 408 5115*

Twentieth-century applied arts
Barbara E. Deisroth *New York,*
606 7170
Philippe Garner *London, 408 5138*

Vintage cars
Malcolm Barber *London, 408 5320*
Dana Hawkes *New York, 606 7424*

Western manuscripts
Dr Christopher de Hamel, FSA
London, 408 5330

Wine
David Molyneux Berry, MW
London, 408 5267
Christopher Ross, *408 5271*

Notes on contributors

Antoine d'Albis joined the Sèvres Factory in 1965 where he now directs all laboratory research. Schooled as an engineer, his early experiments with pastes and glazes prompted his interest in the history of Vincennes and Sèvres. He has written technical and historical articles about these factories and addresses lectures to international audiences on the subject.

Charlotte Brown catalogues books at Sotheby's, London. She specialises in early printed and Continental books and bindings.

Richard Camber is a former Director of Sotheby's, London and currently consultant to the European Works of Art Department there. Specialising in Medieval art, he was for a number of years in the Department of Medieval and Later Antiquities at the British Museum. He is a fellow of the Society of Antiquaries, London.

Professor John Carswell is Director of the Islamic Art Department at Sotheby's, London and was formerly Director of the Smart Gallery, The University of Chicago. His numerous publications on oriental art include *Blue and White: Chinese Porcelain and its Impact on the West* (1985), *Islamic Bookbindings and Bookmaking* (1981), and *Kutalya Tiles and Pottery* (1972).

Dr Andrew Causey is senior lecturer in the History of Art Department at Manchester University and most recently chaired the selection committee for 'British Art in the Twentieth Century' held at the Royal Academy, London, in 1987. His many publications include *Paul Nash, a Catalogue Raisonné* (1980).

Matthew Cullerne Bown is an artist and freelance writer who studied at the Slade School of Fine Art, London. He has taught at numerous colleges of art throughout Britain. In 1986–87 he attended the Strogonoff Art Institute in Moscow and is currently working on *Contemporary Russian Art*.

John Culme joined Sotheby's, London in 1971 where he is a researcher for the Silver Department. He is the author of *Nineteenth-century Silver* (1977) and *The Directory of Gold and Silversmiths* (1987). He is currently working on a book about gaiety girls.

Olivier Gaube du Gers owns and runs the present-day house of Odiot in Paris. Trained as an architect in Zurich, his love of formal harmony and neoclassical design has inspired him to conceive a contemporary line of silver plate for Odiot called 'Galet'. The author of several articles on Odiot silver, he is currently writing a forthcoming book about the workshop's history.

George Gordon catalogues old master paintings and drawings at Sotheby's where he has worked since 1980. He is the author of several articles on old master drawings and has recently been a consultant for a televised documentary series about William and Mary.

Joyce Hill is a consulting research curator at the Museum of American Folk Art, New York, where she was curator from 1982 to 1984. An instructor at the Museum of American Folk Art Institute, she has also lectured at the Dublin Seminar. Her publications include an article on John Brewster's portrait miniatures (1983).

Gail Levin, a specialist on Edward Hopper, teaches at Baruch College, The City University of New York. She is the author of *Twentieth-century American Painting* (1988) from the Thyssen-Bornemisza Collection as well as several books on Hopper including *Hopper's Places* (1985) and *Edward Hopper: The Art and the Artist* (1980). Forthcoming are the *Catalogue Raisonné* and a biography on the artist.

Sir Oliver Millar, GCVO, was Surveyor of the Queen's Pictures from 1972 until July of this year and from 1987 he was the Director of the Royal Collection. His numerous publications include *Gainsborough* (1949), *Tudor, Stuart and Early Georgian Pictures in the Collection of HM the Queen* (1963), and the catalogues for the National Portrait Gallery exhibitions *Sir Peter Lely* (1978) and *Van Dyck in England* (1982).

Professor Ronald Pickvance selected the works and wrote the catalogues for the two highly acclaimed Van Gogh exhibitions at the Metropolitan Museum of Art, New York, *Van Gogh in Arles* (October–December 1984) and *Van Gogh in Saint-Remy and Auvers* (November 1986– March 1987).

Dr Jennifer Price is a Senior Lecturer in Archaeology in the Department of External Studies and the Director of the Centre for Archaeological Studies at the University of Leeds. An expert in ancient glass, she is currently preparing a catalogue of the Romano–British glass in the British Museum.

Dr Stephen Spurr is Curator of the Myers Museum at Eton College where he is also an Assistant Master in Classics. He is particularly interested in ancient agriculture and has recently published *Arable Cultivation in Roman Italy* (1987).

Roger S. Wieck is Associate Curator of Manuscripts and Rare Books at the Walters Art Gallery in Baltimore. Most recently author of *Time Sanctified: The Book of Hours in Medieval Art and Life*, his other publications include *Late Medieval and Renaissance Illuminated Manuscripts, 1350–1525, in the Houghton Library*, and *The Spanish Forger*, co-authored with William Voelkle.

Dante Gabriel Rossetti
LADY LILITH
Watercolour heightened with bodycolour and gum arabic, signed with monogram, inscribed
reduced replica from the oil picture and dated *1867*; also inscribed with a verse by the artist on the
reverse, 20½in by 16⅞in (52cm by 43.8cm)
London £115,500 ($218,295). 21.VI.88

Index

A Byzantine icon of Saint Anthony the Great, *circa* 1400, 9⅝in by 6⅝in
(24.5cm by 16.8cm)
London £12,100 ($23,595). 18.XII.87

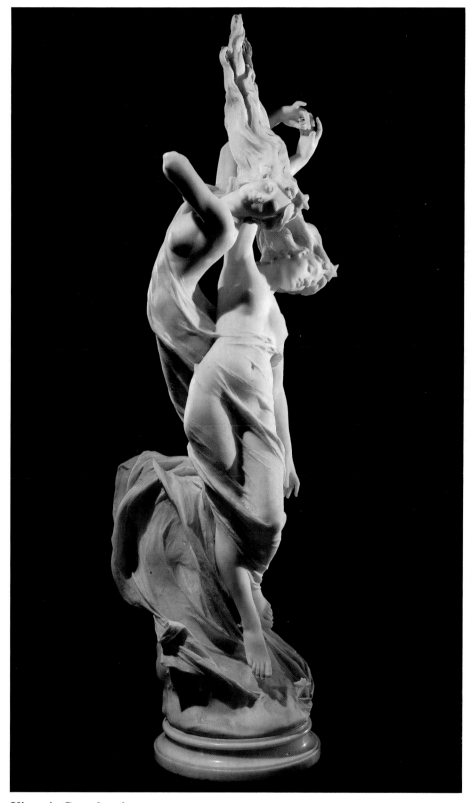

Vittorio Caradossi
A marble group of Dusk, inscribed *Prof. V. Caradossi*, *circa* 1900, height 61in (154.9cm)
New York $61,600 (£37,108). 19.IX.87

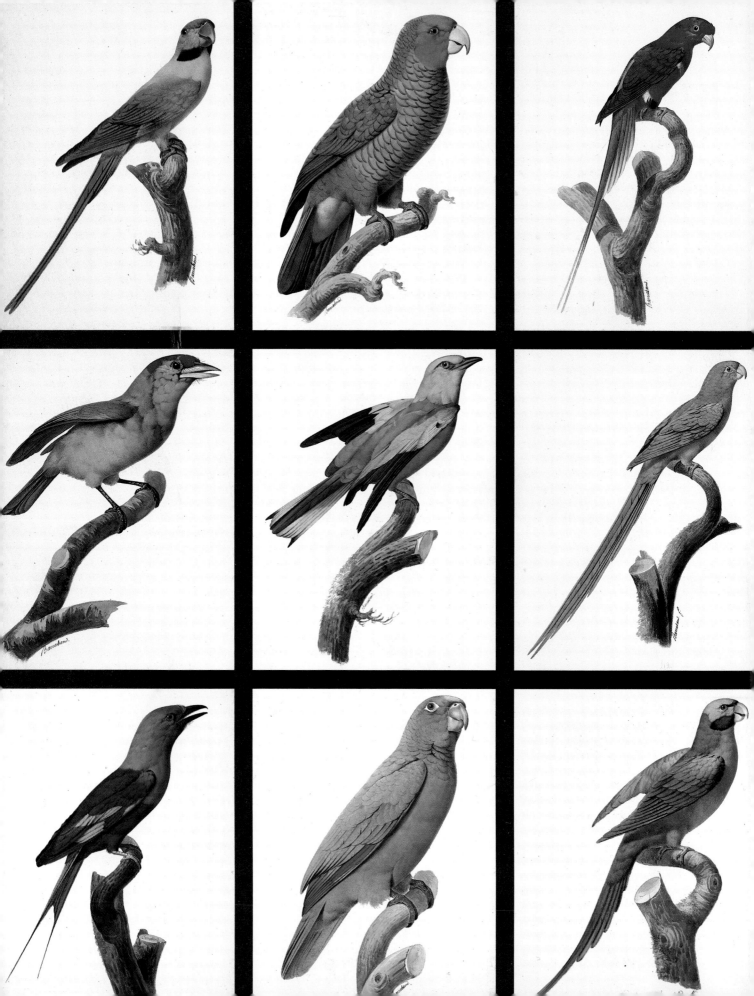